CRITICAL
FASHION
PRACTICE

"Scholarly yet accessible, *Critical Fashion Practice* offers a close critical and contextual reading of key, late 20th-century designers' oeuvres; its innovative theoretical analysis and in-depth case studies make this an original addition to the field."

Emmanuelle Dirix, Manchester Metropolitan University, UK and Antwerp Fashion Academy, Belgium

"Focusing on a handful of contemporary fashion designers whose collections in many ways challenge and critique societal norms, *Critical Fashion Practice* will prove indispensable for anyone teaching and/or studying fashion – or for anyone seriously interested in fashion, for that matter. Just as in their previous book on art and fashion, Geczy and Karaminas again have managed to write about fashion in a most refreshing and engaging manner, here offering nine theoretically astute yet surprisingly accessible case studies that will appeal to a large and varied audience."

Louise Wallenberg, Centre for Fashion Studies, Stockholm University, Sweden

"Geczy and Karaminas have again written an essential book that pries open the critical context of contemporary fashion. Using clear language, they dive deeply into cultural and fashion theory to soundly shore up their research and interpretation on the modernity of male and female fashion and its relationship to the body, gender, art and design. They do so through carefully chosen case studies that add new and fascinating weight to well-known designers such as Westwood, Kawakubo, Viktor&Rolf, Owens, Pugh, and Prada, and introduce the lesser-known designers Aitor Throup and Rad Hourani. Importantly, this book links history and theory with an understanding and acknowledgement of the craft and industry of making clothes. Read it and think."

Alexandra Palmer, Senior Curator, Royal Ontario Museum, Toronto, Canada

"Thinking through the work of key contemporary practitioners from Vivienne Westwood, Miuccia Prada and Rick Owens, this book looks beyond the image to present new frames of reference to both the fashion enthusiast and informed scholar. Richly textured and resourced, this incisive and penetrating read presents fashion as a philosophy, provocation and cultural touchstone. *Critical Fashion Practice* is a cerebral *tour de force* and a must for anyone who has ever suspected there is more to fashion than meets the eye."

Nilgin Yusuf, Creative Director, School of Media & Communication, London College of Fashion, UK

"Geczy's and Karaminas' approach to contemporary fashion is highly refreshing. Their book sheds a new light on the work of some of the most iconic and intriguing designers of the past decade, and adds to the emancipation of fashion as a serious field of academic study. It is a must-have for anyone working within the field of fashion theory and fashion writing."

Kaat Debo, Director MoMu-Fashion Museum, Antwerp

CRITICAL FASHION PRACTICE

From Westwood to van Beirendonck

ADAM GECZY AND VICKI KARAMINAS

Bloomsbury Academic
An imprint of Bloomsbury Publishing Plc

B L O O M S B U R Y
LONDON • OXFORD • NEW YORK • NEW DELHI • SYDNEY

Bloomsbury Academic

An imprint of Bloomsbury Publishing Plc

50 Bedford Square 1385 Broadway
London New York
WC1B 3DP NY 10018
UK USA

www.bloomsbury.com

BLOOMSBURY and the Diana logo are trademarks of Bloomsbury Publishing Plc

First published 2017

© Adam Geczy and Vicki Karaminas, 2017

Adam Geczy and Vicki Karaminas have asserted their right under the Copyright, Designs and Patents Act, 1988, to be identified as Authors of this work.

British Library Cataloguing-in-Publication Data
A catalogue record for this book is available from the British Library.

ISBN: HB: 978-1-4742-6553-9
PB: 978-1-4742-6552-2
ePDF: 978-1-4742-6554-6
ePub: 978-1-4742-6555-3

Library of Congress Cataloging-in-Publication Data
A catalog record for this book is available from the Library of Congress.

Cover design: Adriana Brioso
Cover image © FRANCOIS GUILLOT/AFP/Getty Images

Typeset by RefineCatch Limited, Bungay, Suffolk

To find out more about our authors and books visit www.bloomsbury.com. Here you will find extracts, author interviews, details of forthcoming events and the option to sign up for our newsletters.

To our parents who taught us the value of curiosity

and to take nothing for granted.

CONTENTS

Conclusion: To Alexander McQueen, in Memoriam

LIST OF ILLUSTRATIONS

Figures

Plates

ACKNOWLEDGMENTS

We would like to thank Hannah Crump and Pari Thomson from Bloomsbury for their unwavering support. Vicki Karaminas would like to acknowledge Professor Sally Morgan, Professor Claire Robinson, Professor Tony Parker, Jess Chubb and her colleagues at the College of Creative Arts at Massey University Wellington for their enthusiasm, and creative and intellectual energy. Adam Geczy would like to thank Sydney College of the Arts, of the University of Sydney; Domenica Lowe of the library there; and all those who continued to ask and show interest in the project. As always, to Justine, Dante, Ulrika, Marcel and Julian for their devotion and great big love.

INTRODUCTION: FROM SUBCULTURE TO HIGH CULTURE

Shortly after Malcolm McLaren and Vivienne Westwood met in 1971, they set up shop at 430 King's Road, calling their business "Let it Rock." It would shortly evolve into the now legendary punk boutique with the unambiguously provocative name "SEX." As their contemporaries so frequently reported, theirs was a compatibly productive pairing, while it lasted, that is. They both had the taste for extremes and a delight in the perverse, the love of aesthetic disorder whose anarchic sensibility could not dissociate delirious festivity from gothic melancholy. In its original incarnation, McLaren's overall conception was more germane to an art installation, and certainly something that did not conform to the conventions of what a retail shop stood for in the day.[1] His own interpretation of Situationist *dérives*—dissonant interventions into everyday life to jolt the torpid modern consciousness—gave life to T-shirt slogans such as "Under the paving stones lies the beach." Bones and detritus were sewn onto garments. Clothes were repurposed and degraded with gratuitous rips and holes, some sutured, others left to fray. Impatient and bored with the conservatism of fashions after the war, the McLaren and Westwood pairing combined clothing and dissent. It is one of the significant watersheds in a particular form of fashion, dress and styling that we call "critical fashion."

Criticality, while a strongly modern concept, is one rooted in ancient philosophy, and also in the most ancient Buddhist teachings. In specifying that things are not all as they seem, the student, acolyte or devotee must acquire the cognitive and spiritual tools to be equipped with more forceful insight, reflective skepticism and accurate judgment. Criticality is an essential component to reason in assessing and weighing terms of reference to afford the best framework for understanding. As Theodor W. Adorno wrote at the beginning of his famous essay "Cultural Criticism and Society," "The cultural critic is not happy with civilization, to which alone he owes his discontent."[2] He claims that the cultural critic is society's "salaried and honoured nuisance."[3] This suggests a position that resists the

absorption of the "culture industry" through its insatiable collapsing of difference into the semblance of the same for the purposes of consumption. Adorno is highly critical of the culture critic because of the fakeness of his stance: He pretends to be outside of the culture in which he is embedded. "Cultural criticism shares the blindness of its object."[4] Adorno warns against the critic's blind complicity with what he seeks to challenge.

Another of the more bracing theorists for the understanding of criticality is Michel Foucault, who states that "Critique only exists in relation to something other than itself: it is an instrument . . . it oversees a domain it would not want to police and is unable to regulate."[5] Critique maintains a highly mobile relation to power, attempting to keep its conditions of possibility on the surface so that they are revealed to be what they are, namely, myths and ideological constructs. If critique cannot ever be fully objective, it can nonetheless be a process that is self-aware of its vulnerabilities, and which makes weaknesses and misprisions of the system under critique rise to the surface.

If still a venerable philosophical notion, in art, criticality is pre-eminently modern, sustained by the belief that art has a function within a society that itself transacts socio-political ideas according to continual reassessment, and according to advancements in technology and learning, and in revision of perceived errors and inconsistencies—ideally at least. In this regard, artistic modernism begins decisively with the French Revolution and the example of Jacques-Louis David, whose work, if only rhetorically, reflected public will, virtue and aspiration. This is not in any way to discount wholesale art of preceding eras, which had its share of ironic asides or tendentious allegorical readings. But it was only at the turn of the nineteenth century that art, as with music and literature, sought accountability in the open market and became subject to the popular opinion that it believed it could alter. Works such as Beethoven's *Eroica* symphony (1804), dedicated at first to the revolutionary heroism of Napoleon (later Beethoven changed his mind); or Géricault's *Raft of the Medusa* (1818–1819), a visually grandiloquent fillip at the disastrous consequences of aristocratic nepotism in the return to Bourbon rule; or Goya's *Disasters of War* (1810–1820), a harrowing suite of images in which we are invited to witness the ravages of the Spanish under Napoleonic occupation—all of these were simply not possible a century before, in which any commentary was more veiled and coyly indirect. Nor had there been a public receptive to the messages that these works held. For such works self-consciously inserted themselves within popular opinion, and in their respective ways were intended to create tears in popular perception.

The extent to which this was successful is next to impossible to measure, although the many artistic innovations and aesthetic repositionings of the twentieth century did reflect a growingly diverse and socially sophisticated world in which there was equally diverse and widespread faith in art's ability, and duty, to find superior forms of seeing and understanding that would ramify, through

some mystic osmosis, to the world at large. Postmodernity is the name for the project where modernism returns but without its angelic utopian face. Art after modernism is still engaged in critique, but in a distinctively localized and an increasingly pluralized form, where cultural identity and gender are noticeably priorities. But it was in the wake of the economic boom and crash of the 1980s that, in the 1990s, art's collusion with the media, and its gravitational pull to mass appeal, became cornerstones of the art world—hence the coinage by Julian Stallabrass of the term "High Art Lite" to characterize the aesthetic of the "young British artists" (yBas).[6] These tendencies were coterminous with economic rationalist frameworks that stressed the virtues of accessibility and audience engagement to ensure high visitation numbers, where the number of clicks of the turnstile was the main measure of an exhibition's success. This, and the slow demise of art criticism conspired to create an atmosphere in which art would become a form of entertainment, one less rarified and open to mass appeal whose patterns would uncannily come to resemble that of the fashion industry.[7] Writing in 2002, the eminent art historian T.J. Clark asks:

> Is not visual art in the process of becoming simply and irrevocably *part* of the apparatus of image-life production? Is not this the real sense of the much-noticed fact (a flip through the page of *Parkett* and *Artforum* confirms the fact relentlessly, monotonously) that the line of demarcation between visual art and the fashion industry, for instance, simply no longer exists? Not only does it not exist, but art glories in its nonexistence.[8]

From the beginning of the millennium, when Clark wrote these lines, commentary about art and art criticism's toothlessness has been the subject of widespread comment. Writing a decade later, Hal Foster would lament the era of what he calls the "Post-Critical,"[9] while the younger New York art critic David Geers coined the term "Neo-Modern" for contemporary art mimicking modernism without the slightest regard for any critical reflection or historical justification. Art's shift into a look and something styled and designed is "tied to the art world's becoming a peculiar form of niche industry, equal parts Hollywood and exotic market (Gagosian Gallery, for instance, now sells speed boats designed by Marc Newson)."[10] The new neo-formalism is a cynical counterfeit to the "autonomous art" championed by Adorno, as it is "tethered" to the spectacle "as by an umbilical cord."[11] And the aesthetic philosopher Mario Perniola would, in 2000, characterize "current art" in terms of "idiocy and splendour," these being the two sides of art's compact with the spectacle, endemic of art's losing touch with reality. For paradoxically, the abstraction and de-realizing active in artistic modernism was an attempt to find a deeper sense of self and world, "today's realism" is either disassociative fantasy or the banality of "commentary and advertising."[12] Presaging Geers's observations, Perniola opines that "The zero degree of theory

leads to a flattening from which none is saved. Today's extreme realism makes precisely this claim of showing the existent without any theoretical mediation." The marriage of art and knowledge appears more tenuous and arbitrary than in the modernist heyday, for now art is more, as such writers suggest, simply reflective, or symptomatic, of the knowledge of art's growing impotence due its status of luxury pawn in the commodity game played by the oligarchic elite.

However, to assert the end of art in anything but a figurative or historicist sense (in terms of art's ends in the Hegelian sense or the endgame of art in the 1980s for instance), is no longer a fruitful line of argument or a terribly interesting one. Where "good" art appears is not the concern here. What is of concern is that if this recent devolution of art's criticality in the mainstream be viewed in parallel with the fate of fashion, then we perceive a rise, in a complementary movement, of kinds of fashion, design approaches and staging (catwalk), whose import and effect can feasibly, and quite rigorously, be designated as imbued with the critical qualities formerly afforded by art. This is critical fashion. In certain fashion objects, styles and tendencies—not all fashion—there is a discernible space where cultural critique exists that is as searching and as lasting as that found in good works of art. We might go so far as to suggest that the diminution of criticality in art has not been entropic, but rather it has entered a different space that has, still, not captured the attention of the majority of art critics, fashion theorists and historians for the simple reason is that fashion has not been, in art academia or the art world more widely, a priority for study, or dismissed out of hand for all the traditional and much-cited reasons (ephemeral, frivolous, etc.).

In its relation to status and wealth, fashion and dress has long been a means of registration and difference. In modernity, as in the French Revolution, it was one of the more important ciphers for claiming fealty and belonging to a new order (while also reclaiming the old: antiquity). But this signifying function proper to fashion and dress is not critical fashion as such. Rather, critical fashion sees such signification stretched and exaggerated. It is obtrusive and extension, unconventional.

By way of contrast, we use the term *hermetic fashion* to designate what critical fashion is not. Hermetic fashion is used to avoid the value-laden connotations of *classic fashion*, which is both a commercial term and one associated with straight, heteronormative values, and correspondingly, a certain perenniality.[13] Complimentary and complementary, hermetic fashion is characterized by usefulness and the extent to which it is unobtrusive: The T-shirt, the suit, the black dress—all are examples of hermetic fashion, where the emphasis is to accentuate the person in action and image. Just as we have established that the basis of the valorization classic was strongly inflected by Winckelmann's homoeroticism, ironically the father of hermetic fashion is Beau Brummell, who dispensed with unnecessary frill and emphasized the cut and

execution of clothes. Brummell is a progenitor to the concept of critical fashion (or anti-fashion) in the respect that he helped to introduce a radical new sense of self whose status and signs of quality were not immediately perceptibly worn on the body. Yet Brummell's example becomes absorbed into normative classic styling. By distinction, critical fashion is highly distinctive, at times odd and even sculptural, but is not limited to these qualities, for it can also deploy strategies that challenge gender roles in ways we will elucidate.

While the example of Westwood and McLaren is one of the signal examples of a new kind of fashion that conveys itself in ways analogous to art, the designers that emerge in their wake, as well as Westwood herself evolving into a fashion icon and her own institution, practiced in a different cultural environment. The 1970s was still a period of extreme artistic experiment in which the boundaries of art were distended and unstable. Moreover Situationism, from which McLaren drew inspiration, was not strictly an art movement, but more a strategy of social infraction. Their strategies of *dérive* and *détournement* were interventions in the social sphere intended not so much as traditional offense—although that was an understandable by-product—but to create cracks in the surface of the social conscience, disturbing the lethargy created by the commodity and the spectacle. At the same time, artists in Europe and the United States were actively seeking to integrate art into the outside world in practices that were ephemeral or which exceeded the confines of the white cube gallery structure. In short, art was seeking to become and exist in spaces and in ways that it had not traditionally been for hundreds of years.

While the fashion industry is still engaged in "style" and "stylishness" in the most commonly understood sense, there is a visibly new form of design practice within the fashion industry, which, while many times outrageous, is active in complex forms of commentary. While it has to be acknowledged that fashion in modernism has had a critical and subversive dimension, these were either deflections from a normative code, such as the dandy or the bohemian, or a perversion such as punk and sadomasochistic (BDSM) styling, or transnational and transoriental[14] fashion with its complex relationship to colonialism. Subculture was literally that, and the style presented itself as outside, or anterior. Now, however, these genres have been absorbed into the fashion industry as tropes: subcultural style is part of a language that is far from limited to the subcultures whence they came, but refers to them as a stylistic register. For instance, punk style has arguably been drained of its transgressive effects and transfigured into a set of visual registers that are more about transgression than effecting it.[15] This integration of originally transgressive and expressive styles is generally interpreted as a muting of their impetus and potential, by reducing a gesture into a denotation, an act and a force of being into just another signifier. But this assessment, while valid on one level, is too constrained, as it cannot be limited to just art or fashion. For it is endemic of the developments in global politics and capitalism, the age of

so-called "postdemocracy," corporate homogenization,[16] and what Michel Maffesoli earlier describes as "the time of the tribes."[17] Under this contemporary topology, there is no "outside" to the status quo, in the way that, say, the avant-garde was to the academy. Hence even "anti-fashion" does not sit outside the fashion system, but is rather a subgenre within that system. But while this structural imploding may have been deleterious to art, it has arguably been beneficial to fashion. *Cynicism* is a word frequently aimed at contemporary art, yet the same cannot be said of *contemporary fashion*. Art's crisis of criticality in the 1980s derived from the recognition that there was no longer a viable "critical outside" (actually or mythically) to the mainstream. If the narrative of criticality in art maintains a sort of agonistic nostalgia for an objective outside, in fashion, which has long made its peace with the commodity and the system, critical engagement occurs actively and consciously within that system. We might see a designer such as Westwood and the subcultural style of punk not so much absorbed and domesticated, but more in different terms: Subcultural style is just the first stage of an evolutionary process of a material communication whose final stage is this very absorption from which, as a sign, it can be redeployed, as a component to styling that accounts for and mobilizes cultural, racial and gender differences.

In this respect, *critical fashion* as it is coined and conceived by this book makes quite specific historically periodized claims for itself. There are key antecedents, namely, Schiaparelli's collaborations with Dalí, or Yves Saint Laurent's radical appropriation of Mondrian, but these examples have been commonly used with respect to the art/fashion crossover, while critical fashion proposes a new historical space in both criticism and cultural practice, that can, however, *a posteriori*, embrace such crossovers. Critical fashion is a branch of the fashion industry, and is a quality that is evident to varying degrees in work of particular fashion designers, or in certain collections, and in their modes of display such as catwalks and fashion films.

This book is divided into discrete case studies of designers whose work maps and defines the concept of critical fashion. It is not an exclusive list and there have been some omissions, notably Margiela, Chalayan and McQueen, whose absences are based on the simple logistic that their work has received considerable critical attention in recent years, and that this scholarship can be used as a buttress, or a prelude to the content of this book. Designers such as Westwood and Kawakubo have also had their fair share of critical attention, but their presence here is essential in order to enframe some of the key theoretical coordinates: With Kawakubo, it is her innovations in the structure of the garment, and with Westwood, it is the role of politics and resistance. They are two complementary faces: Kawakubo's innovations are to the garment itself, while Westwood's refer to something immaterially beyond it.

Starting with Westwood and Kawakubo, the analysis jumps to Gareth Pugh, a disciple of McQueen, but also a designer who inherited the taste for extremes,

and in whose work there is always a whiff of some kind of danger. Thereafter the chapter on Miuccia Prada acts as a kind of foil to the first three inasmuch as she imbibes a different aesthetic, although she shares the interest in subverting traditional codes of what is ugly and what is beautiful. Chapter 5 considers Aitor Throup's "anatomical narratives" as we call it. Throup, who considers himself an artist whose by products happen to be fashion objects, approaches the body in the manner of a traditional caster of, say, bronze sculptures. Body parts remain conceived as parts that are not subordinated to the whole. That is, the body that eventuates is not an assembly of limb to torso but as abstract units that eventually cohere. When extrapolated to design, this has unusual consequences for the relation to the body and subjectivity. This chapter is followed by the magisterial duo Viktor & Rolf, and we consider their work according to themes of conceptualism, art installation, but also more abstract notions such as negation and the void. Chapter 7 deals with the comparatively younger designer Rad Hourani with the central emphasis being on gender "agnosticism" and the now somewhat established branch of fashion that does not differentiate between the sexes, commonly referred to as unisex. The following chapter on Rick Owens returns to the issue of gender, looking at his collections and catwalks according to the lavish degree of staging and how this relates to the reading of gender construction in terms of performance. The final chapter, on Walter van Beirendonck, while again raising the questions of gender, also engages with futuristic fashion, fashion for the so-called posthuman body, the body with varying degrees of mediation through technology. This suite of studies is not meant to be exhaustive or exclusive, although the designers are in their way eminences in their field. For while these studies are devoted to each designer in question, they are also used as examples of the contemporary concerns that circulate around the practice, wearing, presentation, representation and consumption of fashion today.

As the titles suggest, each chapter enshrines a different focus relevant to the present, an era labeled the "anthropocene," in which human presence and activity has now had a noticeable effect on the natural environment. It is also an age referred to as "posthuman" or "posthumanist,"[18] where we have renounced, or reoriented, the values bequeathed to us from the humanism that began as early as Descartes but flourished in the eighteenth century with thinkers such as Rousseau, Lessing, Herder and Schiller. As such, this book embraces such themes as the variable and technologized body of the present and the future, the shadows of the past, indeterminacy and uncertainty, the queering of gender and the explosion of heteronormative boundaries, the confusion of reality and science fiction as well as ecology.

There will always be a place in fashion for the Diors and the Valentinos who provide the privileged with the carapace of elegance and glamor they believe is their due. But there is also now a place for a form and practice of fashion whose social and philosophical motivations are worn on the sleeve, and which has the

distinct capacity to delight us not only with its beauty, but also through its thoughtful audacity, and its myriad and original challenges. Critical fashion practice self-consciously occupies both "inside" and "outside." It is a method and attitude to design that enlists vital questions with respect to being-in-the-world, of history, and of desire.

1
VIVIENNE WESTWOOD'S UNRULY RESISTANCE

In the 1960s when Vivienne Westwood (*née* Swire) was entering early adulthood, fashion and dress were undergoing major changes. Depressed and depressive postwar England became swamped with American popular culture, with Jimmy Dean and rock 'n' roll and a new attitude to youthful expression. British subculture seized on these influences in its own particular way, first with the Teddy Boys, or Edwardian dandies, then mods and punks. Unlike most designers who absorb their inspiration from a relative distance, Westwood was at the epicenter of subcultural style, making her dissociable from new wave and punk. Together with her boyfriend Malcolm McLaren, they saw no distinction between what they were doing and art. From the very beginning, Westwood's work was a vehicle for social activism and for giving bohemians, misfits, miscreants and malcontents not only a greater world view, but a stylistic ambience that went along with it. While her earliest collections were rather random and very DIY, what Westwood helped to transfigure was to turn randomness and DIY into a substantive look, and to show how fashion and dress can be integrated into a highly politicized universe.

Before Westwood, fashion was largely defined and guided by wealth and class. Money was needed to be fashionable, and style was measured according to the quality of design, material and manufacture. These were criteria that were as old as civilization itself: Clothing had been and continues to be a modulator of wealth and status. Sumptuary laws were powerful means of ensuring social divisions were maintained, and that certain social codes were not trespassed. With Westwood and the proliferation of punk styling, the pre-existing notions of quality were shattered. For the first time a lack of quality, or the aesthetic of a poor quality, entered into the equation, as did clothing as a vector for ideas that challenged the very notions of wealth, class and status that clothing had always helped to maintain. This also meant that fashion items were given a new autonomy that they previously did not have, which was to have an intentionality and a signifying value that was declamatory, if not brash and abrasive. Typically, fashion had been about integration, albeit a form of integration that was also distinguishing (the most in fashion), but what Westwood offered was fashion as

a social rebarbative mechanism that questioned beliefs in self and society. Punk fashions were also the first of their kind—discounting the language of armor and other forms of the premodern military dress—that used a visual syntax of cruelty that was meted on the self as much as on society. If the corset had tortured women for hundreds of years, it was an endogenous torture; with punk styling, pain was exogenous, directed outward. And what made such gestures more than modern (and hence, in the realm of the postmodern) is that they were not just outward expressions of inner turmoil, but rather more of wearing the ennui of society, reflecting social ugliness back to people.

Westwood and McLaren's partnership in the 1970s is now historically associated with the birth of punk styling, which is a little misleading. While they have been mistakenly referred to as the inventors of punk, their influence was certainly immeasurable, and their collaboration and their concept-shops gave punk styling a particular center of gravity, not only as a discernible look made possible by a series of shops and a sizeable clientele, many of whom would be celebrities that would take this style into a variety of directions.[1] Westwood is a watershed figure when artistic innovation was inextricable from protest, when established power structures, institutions and genres were radically reassessed and new ones created. If we are asking, as Roger Waters was already doing in his renegade Pink Floyd album *The Final Cut* (1983): "What happened to the postwar dream?", which was also the dream that Westwood helped to nourish, it remains to this day in fashion and personal identity through stripping venerable codes from dress, and democratizing the spirit of fashion. In the period of the 1970s and 1980s in which Westwood came of age as a designer, in Luca Beatrice's words, "fashion, still not completely considered art inasmuch as the process of deliverance from ideological fences was at an early stage, [but] became a privileged storehouse of ideas, images and solutions."[2] Westwood was one of the significant figures who turned subcultural style from a concept of abstract dissidence—dressing poorly or shabbily—to one that had a significant role to play in all areas of fashion, high and low. Subcultural style is now no longer just the poorer other of so-called good dressing, it embraced the qualities and perceptions of otherness with a new semblance of autonomy. The shift in subcultural styling in which Westwood was a central figure, not only problematized long-held attitudes to class and clothing, but also accommodated more alternatives to the idea of the body, which included making sexual difference an area of contestation, as to opposed presumption bases on fixed stereotypes. Punk introduced discontinuity into fashion not only on a formal level, but also on a historical level, both a radical break from the past and one that invoked. In retrospect, the oscillation between departure and return would become a typical hallmark in Westwood's work, a dynamic that would call attention to the discontinuity of the presentness of fashion, the future of fashion, and the manner in which fashion's references to the past disturb the present and reshape the past.

Situationism

In seeking to harness and propagate an alternative vision of the world the Situationists were a group that combined art with a special form of political activism that took its cue from Dada and Surrealist events from before World War II. When Westwood met McLaren, he was still an art student and heavily under the spell of Situationism, a spell that would have telling and significant repercussions on their creative futures. Beginning in 1957 and with its main spokesman Guy Debord, Situationism was a form of Marxist revolt that sought to disrupt the advance of advanced capitalism. In *Society of the Spectacle* (1967), the text that would be the central treatise of what became known as the Situationist International, Debord describes how the forces of capitalism had conspired to lull people into a state of torpor, in which they were increasingly divorced from the material conditions of mass culture, and made ignorant of its underlying motivations. As the title of his book—itself intended as a political document as it, famously, is not copyrighted, suggesting that it is available to all—suggests, society had come in thrall to a series of images. Reduced to spectators, they were discouraged from any action that may challenge the status quo.

As a means of countering the delusions imposed by capitalism, the Situationists devised interventions called *dérives*. These were a mixture of political process and artistic performance whose purpose was to jolt people from their lethargy, and thereby, enact a *détournement*, a turning, or radical shift in their perceptions of the world. McLaren adopted the approach that graphic images and the media could be used and exploited through manifestos and collages. (Westwood would later write her own manifesto, *Active Resistance to Propaganda*, which we discuss later in the chapter.) One calls to mind the gestural immediacy of Westwood and McLaren's earliest T-shirt logo designs and slogans, which carried explicit messages of rebellion against the British government and monarchy such as "Anarchy in the U.K.," or "God Save the Queen," depicting Queen Elizabeth II with a safety pin through her nose, or messages of dissent such as "Create Hell and Get Away with It" (Plate 1).

Customized black T-shirts were hand printed and redesigned by ripping or knotting, cutting holes and rolling and stitching the sleeves, while others were made to look old and distressed. The T-shirts were lettered with boiled chicken bones, finely drilled and sewn on the fabric. Some contained the word *rock* and others the word *fuck* or *perv*. The "Beeza" T-shirt was inscribed with brass studs and metal fastenings and the sleeves were trimmed with bike tires. This was an era in which cult fashion, or anti-fashion, met with sex and politics. It was the sign of dissent and the beginning of Westwood's oeuvre as a designer that created garments to agitate and shock the traditional order. The "Smoking Boy" T-shirt that depicted multiple images of prepubescent boys smoking and the

"Cambridge Rapist" T-shirt that featured a leather mask with the words "It's been a Hard Day's Night" were more provocative. Yet it was the "Two Naked Cowboys" T-shirt with two gay cowboys standing opposite each other with their penises touching that drew the attention of the police. Westwood and McLaren were arrested and charged with "exposing to public view an indecent exhibition" and were fined £50 each. The pair appeared in court wearing the naked cowboy T-shirt in defiance. McLaren and Westwood were drawn to Situationism's attitude toward art, which was always vigilant against neat and constrictive boundaries of production and reception. In a more openly political way, Situationism considered art a facilitator of social disturbance, and never for its own sake. McLaren and Westwood's T-shirts often featured the swastika mixed with institutional symbols that they would use to sabotage right-wing politics. The "Destroy" T-shirt depicted a swastika with an inverted image of Christ and a postage stamp depicting the Queen with a severed head.

A dimension that would have attracted McLaren and Westwood (despite being a character who ironically was reluctant to share credit) was the collective nature of Situationism and its treatment of art as tool for exchange, sharing, collaboration and social expansion. Situationism, with its attitude to grass-roots activism and leftist politics, played an important role in the uprisings that occurred in May 1968 in Paris and elsewhere. To all of this, McLaren trained a keen eye. McLaren was especially attracted to Situationism's desire to *épater les bourgeois*, rankle the bourgeoisie, to use Baudelaire's well-known phrase. For McLaren, the longer term political effects of these measures were never really up for much consideration so much as the desire to shock alone. McLaren and Westwood's T-shirts offended the taste of traditional middle class Brits because they protested against the ruling hegemony and depicted images that supported the anti-establishment. The destabilization of boundaries, and the fluidity between genres and disciplines that characterized the Situationist International was also highly congenial to McLaren and Westwood's sensibility, and certainly, the sensibility that would coalesce around their first boutique "Let it Rock," which evolved from a squat on 430 King's Road that they began to inhabit in 1971.

"Let it Rock," "Too Fast to Live, Too Young to Die," "SEX," "Seditionaries" and "World's End"

The first of a series of evolving incarnations of what can only loosely be called a shop, or boutique, "Let it Rock" was more of what in today's curatorial parlance

would be called an artistic laboratory. It was a site in which art, fashion, performance, music and more besides came together in a configuration that was always changing, never static. As McLaren with his characteristic presumption proclaimed, "The place where music and art came together is called fashion . . . creating clothes is like jumping into the musical end of a painting, and number 430 became a natural extension of my artist's studio."[3] His exclusion of Westwood in the equation would also turn out to be something that would, in later years, throw a cloud over the collaboration since it was her many skills, from the graphic arts to crafting and problem solving, that gave McLaren's ideas lasting impetus. In Westwood's own words, she had been "counting on an unexpected moment of glamor and I found it at number 430 King's Road [Figure 1]. In this black hole in the World's End I changed my life, 'Paradise Garage', 'Let it Rock', 'Too Fast to Live Too Young to Die'—I made clothes that looked like ruins. I created something new by destroying the old. This wasn't fashion as a commodity, this was fashion as an idea."[4]

As Westwood's ideas and interests concerning fashion changed, so did the name and interiors of her boutiques. When psychedelic colors and flowing patterned fabrics dominated the hippy movement of the 1960s, Westwood and McLaren were interested in rebellion, in particular rockabilly (a style that was influenced by 1950s fashion and music). Aptly naming their boutique "Let it Rock," they began making garments for the Teddy Boys subculture. Typified by the styles worn by dandies and Edwardians, Westwood designed tapered trousers, waistcoats and long jackets similar to the postwar American Zoot suits. By 1972 the duo's interests had shifted to biker clothing: leather jackets, buckles and zips. The boutique was rebranded with skull and crossbones, and renamed "Too Fast to Live, Too Young to Die" (or the acronym TFTLTYTD) in deference to the late James Dean. The sex and death aesthetic began to generate the perception that their enterprise was connected to a brothel, added to by the many habitués that were sex workers. In addition to those mentioned earlier, other visitors included Iggy Pop, James Williamson and Jimmy Page. The shop drew the attention of the young Ken Russell, who commissioned the pair for a costume for the climax of his film *Mahler* (1974), for which they devised a leather dominatrix suit that had a glittering swastika and a Christ motif on the crotch, finished with a Nazi helmet and whip. It is one of the first examples in mainstream culture that links bondage and sado-masochistic (BDSM) styling with Nazi uniforms.

By 1974 the boutique was renamed "SEX," and the name in four-foot bright pink letters on the graffiti-covered shop front was accompanied with the slogan "Rubber Wear for the Office." If their earlier ventures had prompted suspicions about collusion with prostitution, the décor of "SEX" would have raised yet more hackles. The interior was sprayed with sexually explicit graffiti, the curtains were of rubber and it was stocked with fetish gear, other sexual toys,

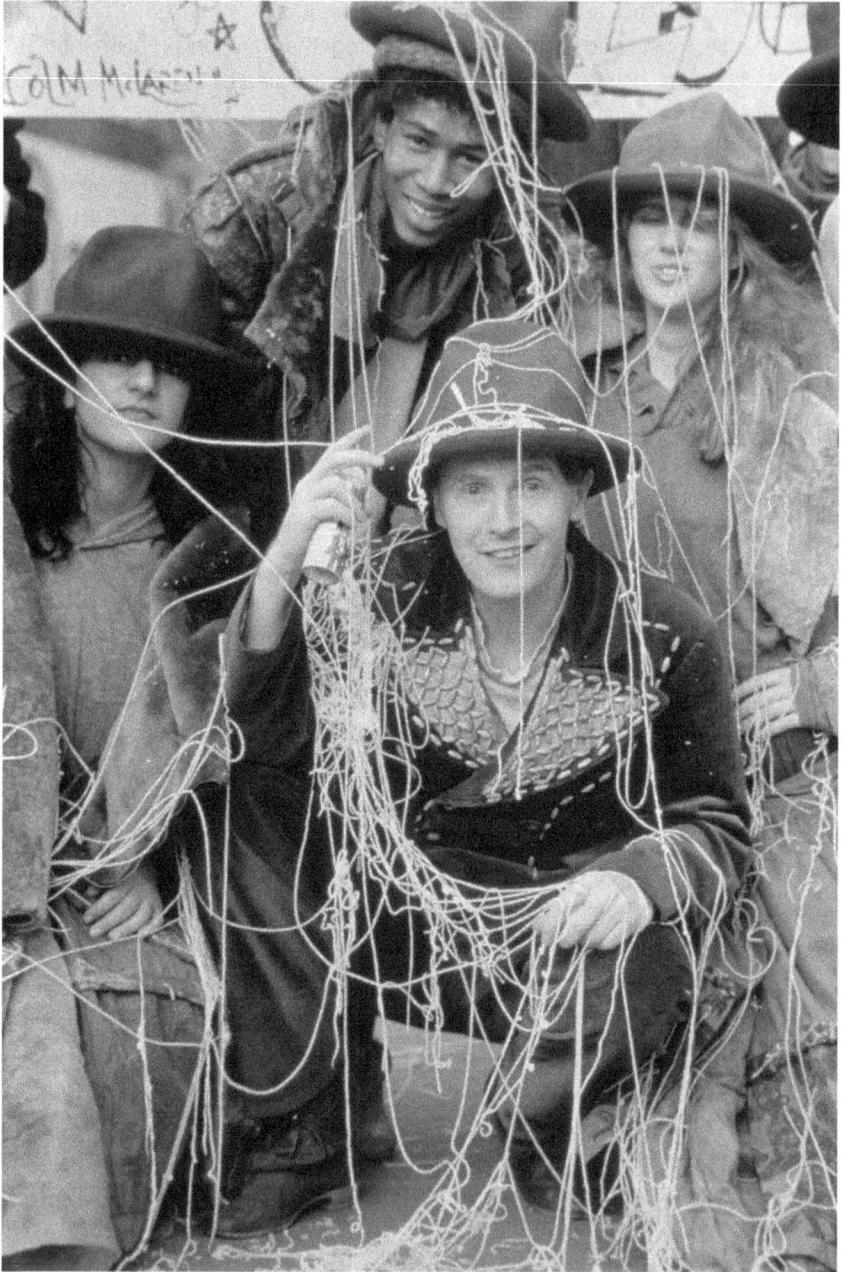

Figure 1 Pop impresario Malcolm McLaren (front, right) and models wearing items from designer Vivienne Westwood's "Buffalo" collection, London, February 1983. Photography Dave Hogan.

along with their now signature items. It was also the continuing popularity that gave Westwood greater confidence to be more outlandish: "All the clothes I wore people would regard as shocking, I wore them because I just thought that I looked like a princess from another planet."[5] A component to this was not only an amalgam of qualities of varying degrees of outrageousness and provocation, but also wearing clothes that were either too small or too large. The intentionally dissonant manipulation of clothing size had the effect of foregrounding the wearing of something, or to put it another way, of showing that to wear clothing was always arbitrary and a product of both culture and choice. The choice in this case was unconventional because it flouted habitual logic.

Moreover, types and orders were desecrated: A schoolgirl uniform would be brought together with fetish wear and other not-so-charming trappings. From the earliest period with McLaren, Westwood had changed her hair to what is now everywhere called the *coup sauvage*, a hacked style that predated the version popularized by David Bowie's Ziggy Stardust, also from "another planet." Black reigned because it represented, in McLaren's words, the "denunciation of the frill."[6] A couple of years later, in 1976, the King's Road shop received another make-over and name change. "Seditionaries–Clothes for Heroes." The sexual themes were toned down in favor of a high-tech look, which entailed bright orange chairs, gray carpet and bright lighting. One wall had a huge image of the bombed city of Dresden, which was opposite an up-ended image of Piccadilly Circus. To follow through on the bombed-out look, a hole was smashed in the ceiling. The brass plaque outside read: "Seditionaries: For soldiers, prostitutes, dykes and punks."[7] While still stocking fetish wear, the clothing in "Seditionaries" had become more refined, its techniques less improvised, yet still keeping its unrefined air. At this time McLaren was managing the punk band The Sex Pistols, and the Seditionaries collection of garments reflected the DIY style that became associated with the punk rock phenomenon: chains, stove-pipe pants, safety pins and ripped T-shirts.

The 1980s marked a turning point for Westwood (who by then had separated from McLaren), changing her focus from streetwear to couture, and altering the name of her King's Road boutique from "Seditionaries" to "World's End" (which remains the name of the boutique today) to reflect her new stand on fashion. Gone were the sexually explicit graffiti, the rubber curtains and fetish gear; instead, the interior was transformed into the cabin of an ocean faring galleon. The floor slanted like a boat deck and a clock hung over the doorway. Its Victorian inspired interiors reflected an old curiosity shop straight out of a Charles Dickens novel and the garments that hung on the rack were not too dissimilar in style: printed weave cotton shirts, muslin stockings, hats of stiffened felt trim and brightly colored silk sashes. Westwood's designs would begin to be a major influence of the New Romantic movement in fashion and music, which was beginning to dominate popular culture.

Boutique bricoleur: the meaning of DIY style

Let us return to the 1970s and the aesthetic that would shortly be known as punk, a style that was unerringly crude, sexually suggestive, even primitive, or primitivist in inclination. But the craftedness and ingenuity at Westwood's hand lent these objects a very different quality of crudeness from that of rags (as we will see in the following chapter a different take on the ruin from Kawakubo). Indeed never had so much care and devotion been spent on garments that were so intentionally ugly from a conventional point of view, and so out of place. Contrariness was king.

Designers such as Chanel and later Yves Saint Laurent had made important steps to downplay, and in a sense downgrade, high fashion by introducing radical simplicity with references to the lower classes (subcultures and rough trade). However Westwood's sensibility is not to be understood as a logical conclusion of such measures. Rather it presented a very new step, in which rips, tears, holes and jagged edges came to have their own autonomy within fashion repertory. This process of readapting materials by one's own hand, known popularly today as "do-it-yourself," in French is known as *bricolage*. As with DIY, bricolage is strongly associated with the garage, the workshop and the hardware store, but it is also used as a theoretical idiom to describe the re-assemblage of concepts. An important instance of this is in the structural anthropologist Claude Lévi-Strauss's book *The Savage Mind* (1962). Lévi-Strauss used the term *bricolage* for the ways in which myths are re-ordered and re-interpreted according to the nature of the one who tells the story and the immediate circumstances that surround the telling.[8] In their subsequent gloss of this work, the interpretation by Deleuze and Guattari is enormously illuminating for Westwood's work:

> When Lévi-Strauss defines bricolage, he proposes a set of well-related characteristics: the possession of a multiple stock or code, heteroclite yet at the same time limited; the capacity to make fragments enter into still new fragmentations; and from this flows a lack of differentiation between production and product, from the instrumental ensemble and the ensemble to be achieved. The satisfaction of the bricoleur when he connects something to an electrical current, when he diverts a water pipe, is poorly explained in terms of the game of 'papa-mama' or as the pleasure in transgression. The rule of always producing production, of attaching production on the product, is the characteristic of desiring machines and of primary production: the production of production.[9]

This is very close to Westwood's notion of "fashion as idea" and her boutique as a think tank and a design lab. "World's End," she commented, "has always been

a crucible for my ideas, political and cultural."[10] For as well as having many striking and confrontational messages, the language of much of Westwood's work, then and now, is as a work-in-progress, as transitioning elsewhere, and as something made, not ideally pre-existent but rather as something fabricated and devised. The tactility in her work bears the traces of production and labor, and it also presages more production to come. Deleuze and Guattari's idea of production to punk styling in general, as it is an aesthetic without a definite beginning or end, and it carries the connotation that it can be altered at any time. There is no longer an original garment: It has been displaced, renamed, reborn and anticipates yet another life.

Punk reflected Britain's dark and turbulent mood of the times, which saw the country still in the grip of a postwar shabbiness reflected in the failure of successive governments to create a modern economy. Uncontrolled and unsustainable debt and double-digit interest rates had pushed inflation to a record high, producing a double-dip recession and creating large-scale unemployment. The fatal combination of state control of the industrial sector combined with union militancy had turned British mines, shipyards and steel works into the least productive in Europe. This climate of discontent gave rise to subcultural bands that became more strikingly visible than ever before: teds, skinheads and punks. The Sex Pistols went on to become one of the most influential bands in the history of popular culture. Inspired after a musician that Westwood and McLaren met in New York whose trade name was "Hell," and aspects of French decadent bohemianism, punk was very much a rough-and-tumble, cobbled together but also orchestrated affair. Musical hits such as *No Future* and *Anarchy in the UK* captured a time when "the party was over" and the dreams of the carefree 1960s were dispelled by the harsh economic realities of the 1970s. A group of public intellectuals whose focus was on the study of the "contemporary," namely, youth cultures, television and advertising emerged during this critical time in British social history under the umbrella of The Centre for Contemporary Cultural Studies (CCCS) at the University of Birmingham. Directed by Stuart Hall, intellectuals of note included culture and race theorist Paul Gilroy; Angela McRobbie, whose interests lay in the intersections of consumption, popular culture and feminism; and Dick Hebdige, whose work concentrated on emerging British youth cultures, their music and style.

Hebdige's seminal book *Subculture: The Meaning of Style* (1979) brought together a supple blend of semiotics that interrogates the way in which culture is communicated (as deduced by Roland Barthes), Louis Althusser's theories of ideology, Lévi-Strauss's idea of bricolage, and the Gramscian notion of conjuncture and specificity. According to Hebdige, subcultures form communal and symbolic engagements organized but not wholly determined by age and class, and are expressed through the creation of styles. These styles are produced within specific historical and cultural "conjunctures" and are not simply

read as resisting hegemony, but rather are cobbled together (bricolage) styles to construct identities from the material culture that is available. These identities offer "relative autonomy" within a social order that is fractured by class and generational differences. Hebdige argues that subcultural identities are formed based on shared values: argot, music and style are all integers in the act of wearing objects laden with meanings (signs) in ways that violate the hierarchies that bind signs into a cultural system. By rearranging and juxtaposing unconnected signifying objects to produce new meanings, he understands bricolage as agency and subcultural style as transgressive acts of resistance. Devoting a large proportion of the text to the study of punk (among other subculture case studies, including the Teds and Rastafarianism), Hebdige argued that punk style was a visual dramatization of British economic and social decline, and an expression of anger and frustration. Punk was a "revolting style" whose perverse garments and accessories, dyed "mohawk" hairstyles, safety pins, graffiti T-shirts, and fetish and bondage gear signified chaos on every level. Through offensive language, anarchic music and clothing, punk "did more than upset the wardrobe. It undermined every relevant discourse."[11] Punk was a visual and social revolution that used fashion, graphics and behavior as a strategy to challenge dominant ideology and capitalism.

Punk and after: the ontology of contemporary fashion

The invitation by Seditionaries to "soldiers, prostitutes, dykes and punks" was typical of punk philosophy, which in seeking to shatter social conventions, claimed for itself new directions in sexual behavior. Gender stereotypes were dealt a particularly hard blow, and while the aggressive male punk was a graspable concept, the codes of aggression when worn on the female body, particularly head-shaving, studs and dark make-up were more confronting. Craig O'Hara in *The Philosophy of Punk* avers that while sexism is far from absent in punk communities, it exists on a far milder scale, given that women had played important roles in punk's very beginnings.[12] Punk women assert that men "will not get their way" and that they resist the stereotypes imposed upon them.[13] Unlike the styles of the Teddies or the Rockers, punk, as Claire Wilcox notes, "gave license for women to dress assertively."[14] As one of punk's major forerunners, Westwood is an eminent model in this regard, although her own personality is a far remove from punk's most outrageous limits.

Coinciding with the opening of Seditionaries was the punk magazine *Sniffin' Glue*, which was primarily about punk bands such as the Sex Pistols, of which McLaren was manager. As founder of the publication Mark Perry would later reflect, "getting into the Sex Pistols was a lifestyle choice. That's how dramatic it

was."[15] Punk in its heyday was a take-it-or-leave-it lifestyle, look and attitude. While today, and in Westwood's later clothing, there is punk styling that exists as part of the semantic surface of the garment, in its origins the surface was seamless with one's self and one's philosophy. Punk styling involved make-up, hair and body modification of all kinds: studs, rings and outlandish tattoos. Such modifications were a cultish orientation, as if initiated into a particular tribe or practice that left one permanently changed. And the practice was anti-practice, it was anti-establishment to its core, disruptive and destructive. Because of its intensity, it drove people insane, to death or elsewhere because the momentum simply could not be maintained (Perry closed the magazine in 1977 after 144 issues). When Westwood launched her first major collection "Pirate" (Autumn/ Winter 1981), punk was an established look whose legends of violence and extremity clung to it, but more as a frisson of energy and less than lived reality.

The way it lives on is not only as a series of recognizable tropes—studs, rings, chains—but also as a challenge to sartorial order. Another residual quality of punk is to mix things up. The easiest approach to the DIY logic is simply to mismatch.[16] The taxonomy of aesthetic components of punk proposed by Monica Sklar in her book *Punk Style* runs as follows: oppositional shapes, patterns (tartan) and iconography (such as badges), color (despite black being legion) and texture. Her "Thematic components of punk style" entails one-of-kind/DIY/vintage, distressed apparel, body modification, radical hair, specific accessories, athletic casual (e.g., skatepunks), shoes and boots, and controversial representations.[17] Punk can also be seen as part of a more widespread postmodern tendency to personalize dress,[18] and as bringing clothing into an ambit of communication, which can be to confront people, but also to suggest a community of engagements, of being a member of a subcultural community.[19]

That punk's historical and socio-political explanation lies in social disaffection is next to self-evident, but its own in-built historicism, from repurposing the old or recontextualizing visual signs, carries a strong sense of mourning that the past can never be again. With punk the references are never nostalgic, and if they are not desecrating or denigrating, they seek to stir in the viewer not only a consciousness of the past, but also of the way in which relics and fragments of the past can be transformed. For this reason, punk reveals a basic ontology of contemporary fashion, inasmuch as it is constantly transforming its references to suit itself in the present. If there is nostalgia, it is as a sign that serves a sign as opposed to an actual feeling. Punk reveals fashion as a site of endless contingency that requires a mythology of an essential framework and a classical style, but only for it to be bent, distorted, contravened, quoted or turned on its head. After all, punk politics at their root are fairly basic, as they depend on authority as something to reject. Now, when punk no longer has the same shock value and has entered into the fold of the fashion establishment, the locus of this anti-authoritarianism is also consigned to the past. But it is the contention of this

book that this does not render a style like punk toothless. In many ways punk was an attempt to obliterate history, and like all philosophies whose sights are on oblivion, it had the seeds of its own exhaustion and self-destruction. (Westwood: "I got tired of looking at clothes from the idea of rebellion—it was exhausting, and after a while I wasn't sure I was right.")[20] Immanent within it was the need for a transition, and if not, its credibility would totter with its own-self-destruction, which on an individual level did occur for many. For the early days of punk have to be seen not as the pure stage, but one stage in its evolution, until it has morphed into an entity whose meanings are subtler than mere contrariness and nihilistic oppositionalism. It lends material life to Deleuze and Guattari's statement that "universal history is not only retrospective, it is contingent, singular, ironic and critical."[21] Punk, as a style that has used history, is now with its own history that can be quoted but also reshaped.

In one respect fashion since the time of Worth has always been highly conscious of history and has played a game of covert or overt referencing. Worth himself drew considerable inspiration from seventeenth- and eighteenth-century painting.[22] But it is with punk that historical referencing becomes intercalated into the very system of the style. Its ethic of loudness, brashness and conflict masks a subtler relationship that is the way in which contemporary fashion, say from the 1980s onward when Westwood and several significant others (such as Kawakubo to be discussed in the next chapter) began their first major collections, is a patchwork of references that amounts to a newly integrated whole, an image that then casts the relics of the past in a different light. Caroline Evans and Minna Thornton write of Westwood that "Fashion as located as a place in which the meaning of dress is revitalized rather than the place in which it is endlessly debunked. When she borrows from history Westwood indicates a sense of the significance of real time by subverting it."[23] In doing so Westwood demonstrates the fragile nature of authenticity. For only by re-invoking an idea with a definable set of mythological truths, that is, by modifying it in the present, can such mythic truths be upheld and maintained.

Westwood in the 1980s

Although McLaren was credited in the first collections, the extent of his involvement (they had formally split and he was absent most of the time) is debatable, and still subject to reactive responses by people who hold to their respective factions. Yet in light of Westwood's achievements, there is not much need to quibble, and it is plausible to assert that without McLaren's input, these early collections would only have been different, but no less significant. Another caveat is that the first designer to place punk on the catwalk was not Westwood, but Zandra Rhodes, making tears, chains and safety pins more than random

aberrations of a dubious countercultural movement, shifting Westwood's conception of punk as "urban guerilla wear" into the penumbra of everyday fashion.[24] It was not something that Westwood resented, as other shops offering punk fashions had begun to surface. While it had its identifiers, punk was and is, not something that can be possessed, as it is more an attitude and a process, and a revealing of process (as production of production).

Westwood's first major catwalk and collection was "Pirate" (Autumn/Winter 1981), which was launched at The Olympia Centre to the accompaniment of canon fire and McLaren's proto-rap music promoted by Bow Wow Wow. Taking a Situationist approach, McLaren organized sponsorships from Sony, which supplied Walkmans for the launch. The idea was quite simple: By connecting the "Pirate" with music, McLaren was commenting on music copyright piracy; in fact, he was supporting it because it was a blow to the distribution company's profit. In many respects Westwood would remain consistent with the conceptual and historicizing methodology of this collection. Stripes, sashes, billowing shirts, stays, gathered fabrics and crescent hats, the "Pirate" collection with its romanticizing overtones of buccaneers and dandies would remain an influence for the rest of the decade, imprinted on the memories of the teenagers of the time who, with the birth of MTV (Music Television) became fans of Adam Ant with his "Apache" make-up and hairstyling, Duran Duran and Culture Club and their associated "New Romantic" dressing styles. Important components to the collection referenced back to the period of the French Revolution. The historical past was reworked into a contemporary aesthetic that played with gender and created a unisex look. By mixing "hunting" pinks with bondage leather and refashioning the male codpiece as a rosette for women, Westwood effectively created an alternative look that was steeped in signs of aristocracy, yet signaled not the bourgeoisie but rather the rag-picker and disenfranchised proletariat. Westwood, an avid reader of history and observer of art, returned to the rebellious *jeunesse dorée* who "wore their wigs and coats back to front and a red ribbon around their throat in memory of The Terror."[25] Hair would be cropped short, "a la victim," which was a variant of her own "coupe sauvage," but also becoming popular with rockers like Keith Richards and Rod Stewart. In "Pirate," while self-consciously a suite of clothes with a common theme, Westwood did not relinquish the material immediacy of punk, and the preoccupation of the way in which messages are worn on the surface of the body, and the way in which clothing can accent and amplify physical states, sensations and preoccupations.

This collection was followed by "Savage" (Spring/Summer 1982) (Plate 2) and "Buffalo" (Autumn/Winter 1982–1983); also called "Nostalgia of Mud" (Figure 2) named after the boutique of the same name the McLaren and Westwood opened on Christopher Street. The collection was timed to coincide with the boutique's opening as well as the release of McLaren's hip-hop single *Buffalo Gals* (1982) with the World Famous Supreme Team. The song consisted of record/vinyl

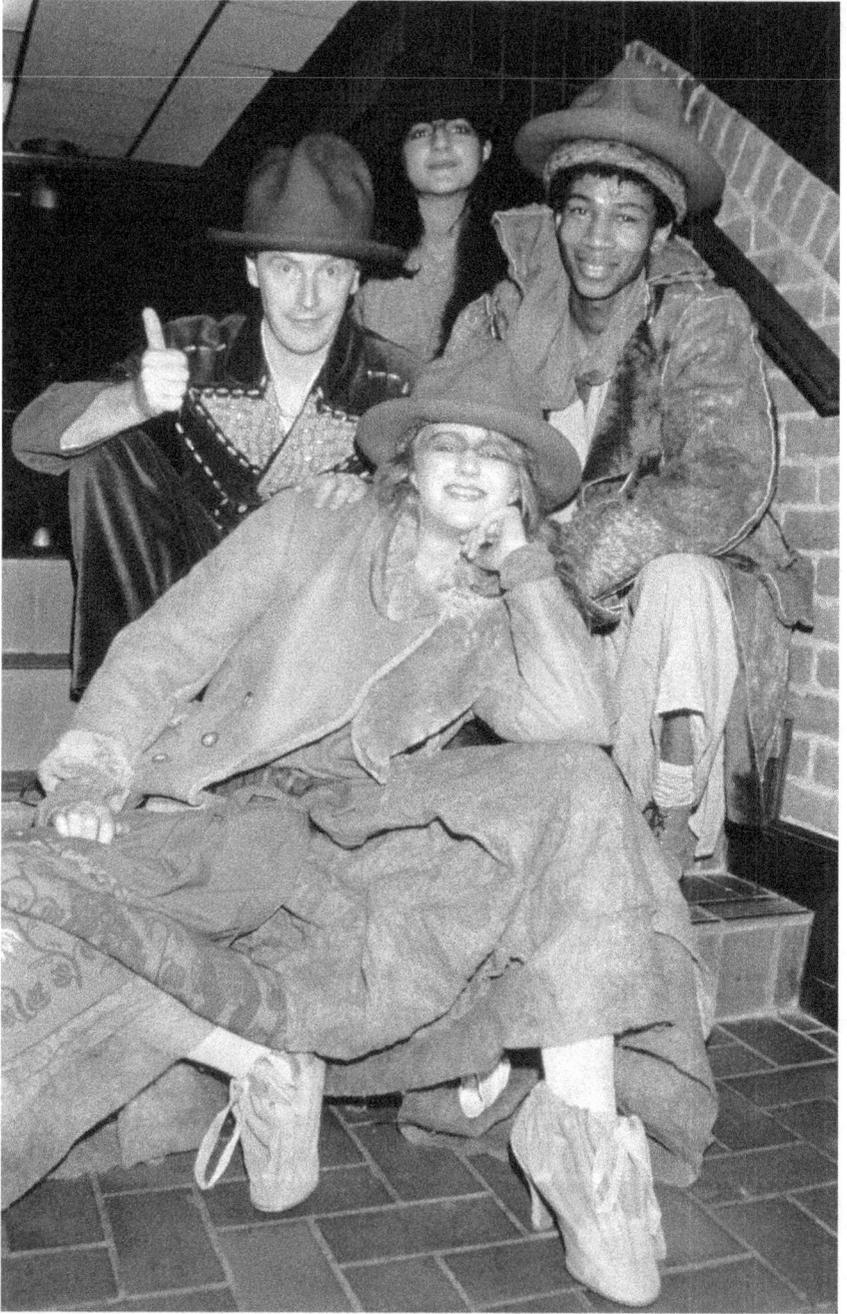

Figure 2 Malcolm McLaren and models wearing garments from Vivienne Westwood's "Buffalo" collection, London, February 1983. Photography David Hogan.

scratching with calls for square dances and featured the Rock Steady Crew. As with all of Westwood and McLaren's boutiques, "Nostalgia of Mud" reflected the duo's design thinking and style of the times. The boutique was covered with a three-dimensional relief of the world covered in mud. The interior reminded one of an archeological dig with scaffolding surrounding the walls and a tarpaulin stretched across the ceiling. The collection itself consisted of multilayered fabrics and billowing unisex skirts, felt "mountain" hats with dents, sheepskin jackets that incorporated elements of primitivism and Rastafarianism. By rearranging and appropriating elements of the Third World in her collection, Westwood was able to evoke a romanticism connected to an imaginary faraway land by mixing "ethnic" style with a "tribal" look.

The Third World had become quite "fashionable" in Britain at the time, with Body Shop commissioning its first community trade product by a supplier in southern India and Oxfam[26] working with volunteers in Nepal on various projects to combat poverty. It was 1983 and the beginning of the environmental movement, and designer Katharine Hamnett had just launched the first of her protest T-shirts that read "Choose Life," "Save the Rainforest," "World Wide Nuclear Ban Now" and "Save the Whales." The T-shirts drew attention to a socio-political issue as a form of active protest, and they highlighted the fashion industry's unethical practices toward animals and humans (sweatshops, child labor, landfills). As a form of anti-fashion (and note that anti-fashion is not outside fashion, but rather a subgroup within it), the T-shirts functioned as a "green" commodity fetish that imbued the wearer with visual codes associated with environmental values and reflective of an eco-conscious lifestyle. "What is interesting about England right now," said McLaren, is that "there's a definite movement to get involved with the Third World; or wear an African Dress, and put it with a Dominican hat, throw in some Peruvian beads, and wear make-up like one of the tribes in New Guinea . . . and relate ourselves to those taboos and magical things that we have lost."[27]

Here, the exoticization of ethnicity is valorized by the fashion industry and sustained by market demand. Investing and desiring to be *Other* allows for the commodification, consumption (and possession) of non-Western peoples by maintaining dominance is through appropriation. Ethnic becomes a descriptor for a weaker Other by collapsing and polarizing cultural identities into an imagined reality. This cut and mix aesthetic that was characterized by Westwood and McLaren's design process creates a monolithic Other, where "African dresses, Peruvian beads and Dominican hats" come together to represent an imagined subject from an imagined place. The same can be said of the "Savage" (Spring/Summer 1982) collection, which contained geometric prints derived from Native American Indian saddlebags combined with French Foreign Legion hats and leather frock coats. The catwalk models were covered with body paint, and mud was combed through their hair to resemble a "native." The title said it all.

Figure 3 Coat ("Witches" collection) by Vivienne Westwood Autumn/Winter 1983–1984. Fashion Arts Society Acquisition Fund. Indianapolis Museum of Art.

The "Buffalo" collection was followed by "Punkature" (Spring/Summer 1983) and then "Witches" (Autumn/Winter 1983) (Figure 3). The common thread in all of these was a downplaying of traditional elegance and a kind of spoliation of style. This was best felt in the "Punkature" (Spring/Summer 1983) collection, also called "Hobo," which elevated the idea of everything discarded and undesirable to a new level of desirability. As Evans and Thornton insightfully put it, "In her approach to the appropriation and recycling of the cultural and industrial effluence of the West, Westwood articulated a contemporary postmodern theme in fashion: the demise of European supremacy."[28] These styles were also prophetic of artistic styles such as grunge, which grew after the market crash of October 1987, neo-conservatism and growing divisions between classes.

For the love of Englishness: "Harris Tweed," "Britain Must Go Pagan" and "Anglomania"

The most defining collections that encapsulate Vivienne Westwood's design aesthetic and her contribution to the development of modern fashion can be best summed up by the following: "Punk, the Harris Tweed" (Autumn/Winter 1987–1988) collection, "Britain Must Go Pagan" (1988–1990) and "Anglomania" (Autumn/Winter 2014–2015) (Plate 3). The collections would become the basis of Westwood's signature style, combining opulent fabrics with traditional tailoring. By inverting dress codes of the conservative establishment and deconstructing sartorial traditions, Westwood produced garments that were anti-establishment with sexual parody bordering on a lurid "cheeky" pornography. In artistic modernism, low had always jostled with high—Manet painting a prostitute instead of a Greek nymph, Picasso's introduction of everyday materials (e.g., chair caning) into painting, Constructivists seeking to make clothing for workers, Duchamp's readymades—but such inversions were another matter altogether when applied to clothing. To elevate the disreputable or undesirable in clothing to the same status as its opposite was a sign of the instability of value: monetary, ethical, social. It was also clothing that drew attention to the performative role of clothing and the ways in which it could be used to occupy different states of being: Clothing could be the key to making one feel more sexual or more alternative. This had to do with a great deal more than upward mobility since the stress was as much on clothing as an instrument of discovery in which body and dress acted together, as it were, in collaboration. As Evans and Thornton observe, "The sexiness she expounds is autonomous: if the wearer *thinks* it is sexy, then it is. Such a position comes close to a kind of sartorial psychosis that has particularly transgressive meanings for women."[29] As far as sexiness was

concerned, the bondage references of the earlier punk years eventuated into a spillage of traditional British fabrics and tailoring combined with Rococo references plundered from the Wallace Collection—one of the great collections of eighteenth-century fine and decorative art—by resurrecting the corset, the crinoline and the bustle. The "Harris Tweed" (Autumn/Winter 1987) collection was an exploration in drapery and classic tailoring techniques using fabric hand-woven in the western isles of Scotland and included gabardines and knits that were produced in English mills. When fashion was being driven by easy care and wear fabrics Westwood turned to natural materials such as cotton and wool to produce garments that parody the establishment; royalty, country clubs and boarding schools. "I've taken the vocabulary of royalty," Westwood said of the collection, "the traditional British symbols, and used it to my own advantage. I've utilized the conventional to make something unorthodox."[30]

Westwood's five subsequent collections became known as "Britain Must Go Pagan" (1988–1990) because of their combination of ancient Greek influences mixed with French Rococo styling and symbols of English nationalism; the Union Jack, the crown and tartan and Harris tweed fabrics (Plate 3). The collections epitomized Westwood's love of parody, sexual liberty, and English culture and traditions. If anyone wished to criticize the "Voyage to Cythera"[31] (Autumn/Winter 1988) collection for its voyeurism or sexualization of women, he or she may have omitted considering the eighteenth century as also an era of matriarchs (Salon hostesses such as Mme. du Deffand) and patronesses—Mme. de Pompadour rose from nothing (her original maiden name *Poisson* translates as "fish") and remained at court well after being Louis XV's mistress. Westwood's subsequent Collection was "Portrait" (Autumn/Winter 1990) based again on paintings from the Wallace Collection. To use Wilcox's words, "using mature models dressed in sumptuous costumes and placed in 10-inch platform shoes, as if on a pedestal, Westwood's intention was to suggest that they had just stepped out of a painting."[32] She used a mixture of opulent fabrics, textures and patterns to build an image of grandeur that was more than real, something from a fantasy or dream. "Recycling historical styles and imagery from the 'theatrical dress up box'."[33]

By now it was the 1990s and Britain was struggling to find a sense of identity after the turbulence of the 1970s and stringent economic policies of the conservative right Thatcher Government in the 1980s, which promoted the privatization of industry and free markets. Although Britain was experiencing a creative and economic resurgence, the country needed change. It required a new national character, one that promoted the good times of the "Swinging Sixties" when London was a global capital buzzing with fashion and cultural activities, and a time of optimism, hedonism and cultural change. Wanting to recreate the good times and bring a sense of confidence back to the people, Tony Blair's ascending Labour government created "Cool Britannia" a catch-all phrase and marketing strategy that recreated the myth of the 1960s, bringing

along with it a cultural renaissance in the arts. "Cook stars," Jamie Oliver and Nigella Lawson changed the drab British palate and recreated a national cuisine. Britpop bands Spice Girls and Oasis ruled the music charts, and artist Damien Hirst was nominated for the prestigious Turner Prize. Vivienne Westwood was among a coterie of fashion designers, including Alexander McQueen, who were garnering international reputations by creating daring and provocative catwalk collections that used shock tactics and controversy. McQueen's was obsessed with death and violence: "Highland Rape" (Autumn/Winter 1995) and Westwood's "Erotic Zones" (Spring/Summer 1995) with its padded busts and metal cage bustiers. Westwood was named the British designer of the year (1991, 1993) and was awarded the Order of the British Empire (OBE) in 1992 for her contribution to fashion. Taking a page out of screen actress Marilyn Monroe's book,[34] after accepting her award from Queen Elizabeth II, Westwood spun around, lifting her skirt to reveal that she wore no underwear, a shock tactic that made headlines and secured Westwood's place as a social and political agitator. The following year, the Autumn/Winter 1993 collection was aptly named "Anglomania" in honor of the French love of everything English and in celebration of the collaborative work between the French and English fashion industry.

Two years later, Westwood's "Erotic Zones" (Spring/Summer 1995) collection was presented at Le Carrousel de Louvre in Paris and featured topless supermodel Kate Moss with frosted powdered make-up typical of prerevolutionary France, licking ice cream suggestively and wearing shoes modeled as penises. "Cementing her status as a true sartorial and cultural revolutionary," writes Hannah Ongley, the "Spring '95 show was a hyper-sexual circus starring a heavily powdered parade of showgirls who both pandered to and parodied the male gaze."[35]

Active resistance to propaganda

In 2010 Westwood collaborated with Lee jeans on an online manifesto project, *100 Days of Active Resistance*. The project called for artists to submit an artwork, slogan or photograph responding to Westwood's manifesto's call to action to stop climate change. Written in the form of a play, or conversation, *Active Resistance*, or simply AR, recounted Alice in Wonderland and Pinocchio in conversation with Art Lover, who is an anthropologist and True Poet the alchemist on a journey to save planet Earth from destruction. On their way they meet the artist Whistler (a leading proponent of the credo, "art for art's sake"), and Greek philosophers Aristotle and Diogenes (the Cynic) who advocated that art and culture is the antidote to propaganda. The same year Westwood's Spring/ Summer collection appropriately titled "Planet Gaia" (after the ancient Greek goddess of the Earth) was her call to action to save the planet and become

involved with DIY as a form of active resistance. "If we're going to keep Planet Gaia cool, we need to get involved in DIY," Westwood announced. "Then our politicians will do what we want."[36] The collection contained distressed fabrics with strong references to street wear and graffiti. The models wore make-up that could only be called space age Rococo: white faces and garishly colored teased high hair. Legs with heavy socks appeared from the frilly frontal V-opening of a dress. In many ways the collection is a personal homage to her career, bringing together the stark ferocity of punk with the insouciance and other-worldly languor of the eighteenth century. The net effect is one of paradox: nostalgic science fiction. But perhaps with past *C*-grade films from the 1940s onward in mind, and with the futuristic styling of designers such as Courrèges, the clothing of the future is now firmly rooted in the past. Westwood had already drawn inspiration from the costumes of *Blade* for her "Punkature" collection. In "Planet Gaia" bricolage is writ large, but unlike punk that reads as little means making the most of what is there, this collection is like the rummaging from the rich after the apocalypse. The grand statements of classic fashion—Dior, Valentino, Givenchy—announce happiness as certainty, as enshrined within the garments, they collude well with advertising and reproduction, which suggest that this happiness, along with undisturbed human relations and a world free of want, actually exists somewhere.

But the image of the world that "Planet Gaia" represents is already highly distorted and fraught. It is the detritus of life made into a pageant, but the traces of what caused that detritus, violence and time, remains imprinted in various ways. There is a Miss Havisham-like madness to the figures and what they wear. They seem to have stepped out of a stupor, and obey a sartorial order devised elsewhere before re-entering the land of the living and the ostensibly sane. The happiness occurs as a creative revelation, the rest as menace in which even gender and personal identities are left uncertain. The collection is testament to fashion's continual violability, as material and as historical statement. But when such violability is announced with certain intensity, its conditions are given a magically permanent and impermeable quality.

2
REI KAWAKUBO'S DECONSTRUCTIVIST SILHOUETTE

To gloss the commercial and newsprint literature on Rei Kawakubo and her depersonalized alias, *Comme des Garçons* (Like the Boys), over several decades is to see a regular misuse of the term *deconstruct*.[1] It is a widespread and therefore pardonable error, and all the more excusable because properly understood deconstruction, or more precisely deconstructivism, is a concept that provides many insights into her work. One of the key designers among those who led the so-called Japanese revolution in fashion that began in the late 1970s, Kawakubo jettisoned the hourglass shape for a silhouette that was jarringly incongruous with the human form, recasting the body-garment relation as well as rethinking fabrics, and the ways in which clothing was made, assembled and hung. Along with contemporaries like Yohji Yamomoto and Issey Miyake, Kawakubo introduced a decidedly lateral attitude to fashion with a strikingly sculptural and architectonic aesthetic. They suggested different ways of wearing a garment and questioned the very conventions of gender by changing the shape of women's silhouettes. By introducing large, loose-fitting garments with no traditional construction, minimum details and oversized proportions, Kawakubo's designs (based on the construction of the Japanese kimono) were in opposition to Western garments, which were designed to fit the contours of women's bodies. As opposed to the geometric, armor-like carapace of the futuristic styling associated with André Courrèges in the 1960s, Kawakubo's clothing engaged in an agonistic, multivalent relationship to the body. Clothing was no longer the body's complement, but was rather worn as a supplement, a notion important to Jacques Derrida, considered the philosophical founder of deconstruction. *Deconstructivism*, the term used alternately to characterize postmodern architecture, is fundamentally allied to Derrida, but grapples with the problem of expressing dysfunctionality, incommensurability and instability in something that is inexorably stable, static and workable. Like Kawakubo, the deconstructivist architect abjures the transparency and simplicity of modernist

forms for those that are oblique, arbitrary. Instead of harmony, deconstructivism expresses discord. It is an aesthetic that can appear deeply troubled at heart. Such styles enjoin us to reflect on the disunity of existence, the cracks in society, and how our life world is a dense composite of paradoxes and contradictions.[2]

Deconstruction

By the 1980s, well before his death in 2004, Derridean deconstruction had become a highly circulated, debated and politicized branch of philosophy that had seeped deep into areas such as feminism and postcolonial studies. Postcolonial theory's founder, Gayatri Chakravorty Spivak was one of Derrida's pupils, and the translator into English (1976) of one of his central early texts, *Of Grammatology* (1967).[3] The common misuse of *deconstruct* is to have it mean "dismantle, disaggregate or pull apart." While as a philosophical method deconstruction does all of these things, when misapplied to art or architecture, it can be misleading. For deconstruction maintains that the history of Western metaphysics since Plato is based on binary systems such as mind-body, presence-absence, speech-writing, but where one of these elements is perennially objectified. Deconstruction is therefore a point of view as well as a procedure in which it attempts to unmask and ultimately reverse, or subvert hierarchies implicit in Western philosophy. Heavily influenced by Husserl and Heidegger, and in response to the huge legacy of Hegel, Derrida would read philosophical texts with a minute closeness, at times concentrating only on a single paragraph or passage, dissecting the etymologies of words to uncover hidden meanings, contexts and contradictions. It was these contradictions that constitute the initially unobserved discontinuities under the surface of thought.

Aporia, coming from the Greek, "unpassable path," is an ongoing motif within Derrida's thought and his uncovering of the inconsistencies of Western metaphysics. These unforeseen dead ends of logic are for Derrida, in the words of Christopher Norris, "the nearest one can get to a label or conceptual cover-term for the effects of *difference* and the 'logic' of deviant figuration."[4] And as Rodolphe Gasché observes, "*Aporia* and *contradiction* must be understood in Derrida as referring to the general dissimilarity between various ingredients, elements, or constituents of the discourse of philosophy as such."[5] It is also a concept that can be easily applied to Kawakubo, especially in garments that actively undermine usages, or reiterate functions in places whose function is no longer needed or possible (similar also to Westwood's non-utilitarian use of straps, buckles and zippers). It is fashion conceived always as an aggregation of elements, but where closure and completeness is impossible. Analogously the attitude of deconstruction to philosophy is the heterogeneity of concepts. In Gasché's words again, this "nonhomogeneity is manifold, caused by the very

process of concept formation and concept use."[6] A garment, like a word, does not exist in a vacuum. It sits as mobile elements among a variety of constituents that define and "name" it.

Derrida became open to criticism that his approach was both parasitic on other texts and therefore also negative since it sought to uncover inconsistencies in philosophers' and writers' arguments or systems, revealing how the inadequacy of a system, or the incompatible presumptions used to found a literary image or philosophical concept. In a "Letter to a Japanese Friend," Derrida defends deconstruction, and the process of "undoing, decomposing, and desedimenting" as "not a negative operation." Speaking in terms as translatable to architecture as they are to fashion, Derrida explains that "Rather than destroying, it was also necessary to understand how an 'ensemble' was constituted and to reconstruct it to this end."[7] These acts of reconstitution and re-assembly were precisely methods that proved deconstruction useful to feminists, postcolonial theorists and other revisionist scholars who were devout on claiming a space within the teachings inherited from those who had, on the surface of it, led to their domination. Derrida's "metaphysics of presence" eventually became transposed into what he himself called "phallogocentrism," a neologism to designate the dominance of men and the primacy given to speech in Western thought.

By default more than design, Derrida became one of the thinkers associated with postmodernism in which the unities of modernism were seen as false, and at their worst, repressively mendacious. When applied to fields other than literature and philosophy, deconstruction was associated with disunity, difference and mobility—everything antithetical to the homogenizing principles of high modernism. In art, deconstruction was alive in strategies that appropriated aesthetic motifs, forms or frameworks that were then treated and manipulated in such a way as to expose certain weaknesses in a style, especially presumptions relating to power and domination that such images helped to perpetuate. This resulted in some dogmatic and quite literal (and angry) art, an art of obloquy at straw men, and where women artists of the past were given credit disproportionate to their actual talent. Of the more subtle and lasting kind is to be seen, for example, in the early work of Cindy Sherman, whose *Untitled Film Stills* (1977–1980) are made up scenes that are evocative of film noir and B-grade postwar film, in which she photographs herself in various roles and guises. Seen as a suite, a pattern emerges that shows the women to be repeatedly depicted as vulnerable, meek and unsure of themselves when without the necessary presence of a man. In doing so, Sherman subtly and artfully suggests that our (men, and how women relate to themselves) ways of looking at, and relating to, women are an aggregate of a very narrow set of precepts, which when extrapolated, are corrosive. (Only a little before these works were conceived, the film theorist Laura Mulvey coined the term *the male gaze* for this selective form of perceptual power and its effects.)[8] Deconstruction, then, when applied to

visual art, was not literally pulling something apart, as a sculptor might do to a three-dimensional form, but rather something much more subtle. It was revealing what was at stake in an image, a manner of thinking and way of seeing, and reminder that the more powerful an image, the less likely it is to be innocent of hidden myths and ideologies. The expression of inner conflict is much easier to perform in abstract configurations such as art, but it faces some basic predicaments in the applied arts such as architecture—or clothing.

The new wave of Japanese designers presented numerous challenges to what had been tested traditions of clothing put in place by Paul Poiret and Jean Patou, and sedimented by Christian Dior. The key designers in the wake of Kenzo Takada and Hanae Mori, Issey Miyake, Yohji Yamomoto and Rei Kawakubo reinterpreted the way clothing was cut and hung, to present an entirely new silhouette, and with it a reinterpretation of the relationship between the body and the garment. Working from Miyake's concept of "a piece of cloth" reflected in his "handkerchief" dresses of 1970, Kawakubo presented her "Wrapped" collection in 1983: These were garments that, as the name suggests, were infinitely variable, and therefore not defined to a predetermined template or schema. Instead of echoing the contours of the body, Kawakubo used swathes of fabric to enclose and alter the body's shape, producing layered and asymmetrical forms. They centralized the very act of wearing in an almost performative way. Wrapping was dictated by gesture and the body itself. Other collections such as Kawakubo's Autumn/Winter 1983 featured distressed wool knits with large holes to invoke the composition of lace. The "lace sweaters" are an agglomeration of masses, sitting asymmetrically so that they resemble neither an animal carapace nor armor, but more an amorphous blob, elemental or biological—much as an abscess or tumor can be seen to be beautiful once shorn of associations of pain, fear or disfigurement. In this regard, Kawakubo's understanding of the body is Spinozist, for Spinoza explained that vermin or diseases are not essentially ugly or evil, rather they are substances with retroactive effects on our own proper substance. That they cause us ill does not make them evil. Similarly, there are forms of beauty that are allowed to come to light freed of negative connotations.[9]

Just as she affords a new angle on what can be considered beautiful, Kawakubo and her contemporaries conceived of fashion according to a different sense of space from that of Western designers, their work far more architectonic and structural. Overall they considered clothing more as a whole, working down to the parts (the limbs, the head) as opposed to the manner in which Western designers would aggregate the parts to lead to the whole. Movement and the body were not contingent but central concerns. Paradoxically, although the work of Japanese designers had a sculptural quality—many of them could stand on their own as independent aesthetic objects—they were largely designed with the living, acting body in mind, much in the way that architecture must account for function, that is, the bodes that inhabit it. Kawakubo's Spring/Summer 1997

collection "Body Meets Dress, Dress Meets Body," referred to as "Lumps and Bumps" because of her use of padding to alter the shape of the body, consisted of tight tops and skirts in stretch gingham that exaggerated the buttocks, torso and shoulders, and made the body appear "distended, extended and relocated" (Plate 4).[10] Much like an architect designing a building with its multiple spaces, Kawakubo's collection was concerned with designing the body rather than the garment. "I wanted to design the body itself, and I wanted to use stretch fabrics," said Kawakubo, "I was keenly aware of the difficulty of expressing something using garments alone. And that is how I arrived at the concept of designing the body."[11] Seventeen years later Kawakubo was still using the concept of "lumps and bumps" to explore bodily limits. In her Autumn/Fall 2010 "Inside Decoration" collection, large pillow-like shapes were affixed to the shoulders, torso, hips and backs, adding bulk and heft to parts of the body that fashion has always sought to flatter.

Deconstruction and architecture

To the deconstructivist architect, buildings were meant to express the fractured and plural nature of the society, and the many gaps and discontinuities in history. In short he or she sought to express conditions that were "out of joint" in a form that nevertheless functioned. Traditional architecture is about harmony, unity and resilience. As Mark Wigley remarks, "The architect has always dreamed of pure form, of producing objects from which all instability and disorder has been excluded."[12] A smooth comparison can be made with modern dress of the twentieth century. But by distinction "It is the ability to disturb our thinking about form that makes . . . projects deconstructive."[13] Correcting a common misperception and semantic misuse, Wigley explains that

> A deconstructivist architect is therefore not someone who dismantles buildings, but one who locates the inherent dilemmas within buildings. The deconstructive architect puts the pure forms of the architectural tradition on the couch and identities the symptom of a repressed impurity.[14]

Applying such principles to Kawakubo is apposite and easy: Her designs (along with others such as Yamomoto and Westwood) imply that the ideal garment is either only a working concept for the multiplication of form. Or, if the ideal form is upheld against others, it will ultimately run into a variety of problems based on stereotypes of gender and culture. Hence deconstruction and deconstructivism allow the skeleton to come out of the closet and join the mainstream.

A watershed in deconstructivism occurred in 1982 (Kawakubo had opened her first Comme des Garçons store in Paris) with the collaborative entry from

Derrida and the architect Peter Eisenmann to the Parc de la Villette architectural design competition. This was followed in 1988 by an exhibition at the Museum of Modern Art in New York, entitled simply *Deconstructivist Architecture*, thereby soldering the term within the public lexicon. In between, in 1986, Derrida wrote a paper on Bernard Tschumi's plan for the Parc de la Villette in which he investigates the possibilities of enmeshing philosophical argument in something not belonging to philosophy proper. Here is not the place to undertake a detail analysis of this text except to draw attention to a curious analogy ready to be extrapolated to the metaphor and material of deconstructivist garment design: "Architect-weaver. He [Tschumi] plots grids, twining the threads of a chain, his writing holds out a net. A weave always weaves in several directions, several meanings, and beyond meaning."[15] Such an approach will always elicit antagonism from some quarters as it is an approach to form in which certain meanings approach nowhere, are unaccountable and carry an air of madness. But as Derrida points out with regard to Tschumi, these perturbations of form are not simply the other of reason. It is not the sign of one madness but plural "madnesses,"[16] as the design is something dedicated to disunity, riven with material and visual redundancies and contradictions.

While there were some disagreements as to whether deconstructivism also meant postmodern architecture, what was sure was that this new architecture favored complexity over reductiveness, and maintained a consciousness of its eventual ruin. Thus in a published letter to Eisenman, Derrida remarks:

> if all architecture is finished, if therefore it carries within itself traces of its future destruction, the already past future, future perfect of its ruin, according to the methods that are each time original, if it is haunted, indeed signed, by the spectral silhouette of this ruin, at work even in the pedestal of its stone, in its metal or its glass, what would again bring the architecture of "the period" . . . back to the ruin, the experience of "its own" ruin?[17]

Here "excess and weakness" are inscribed within the visual notation of the architectural object, an inherent instability within the present stable form. In reply Eisenmann comments that his own work "holds that architecture could write something else, something other than its own traditional texts of function, structure, meaning and aesthetics."[18] This means that deconstructivist architect gestures not only to itself, but to its historical predecessors, and how it will be, which is altered, possibly degraded and ultimately absent. Eisenman writes elsewhere that, as opposed to traditional historicist nostalgia, "it is possible to propose an architecture that embraces the instabilities and dislocations that are today in fact the truth, not merely a dream of a lost truth."[19] Together with Derrida's project, part of which has to do with the failures and inconsistencies in philosophical systems, this interest in the truth residing in discord, in ruins and

voids, has led to accusations that both the philosophy and the architecture are reactionary, parasitic and nihilist. Similar accusations are leveled at Kawakubo, which includes the way in which she made the rag into a coveted (by some) design item.[20]

And the violence and brooding energy in Kawakubo's work can also be paralleled with the deconstructivist architecture's preoccupation not only with ruins, but with the crypt. Classical, "normal" fashion tends to disavow the various but commonplace forms of its concealment. That it exists to cover and conceal is such a given as to be overlooked. However in Kawakubo's work, covering assumes a more sinister role, suggesting an uncertainty as to what is underneath. In Wigley's book on Derrida and architecture, there is a thorough examination of the architectural uncanny and the metaphorics of the crypt:

> Derrida's reading of the crypt does not direct attention to some new kind of architectural figure that might supplant the traditional architectural rhetoric and could be appropriated by architectural discourse. Rather it directs attention to the implicit violence of architecture by identifying the subtle mechanisms with which a space can conceal the precise but elusive geometry of concealment that produces the effect of space by orchestrating a sustained double violence.[21]

Similarly for Kawakubo, clothing is not just a necessity or a luxury, but rather something that has been imposed on us. It has a new meaning after the Fall, that is the age after the Holocaust and Hiroshima (and Nagasaki). It speaks to a certain kind of dissolution of self, in which nakedness is no longer a metaphor for innocence or pleasure, but simply a state of clothing's lack, in all its bald and accusatory guilt.

Deconstruction and fashion

The extent to which the language of destruction and degradation in Kawakubo's designs owes itself, consciously or not, to the legacy of postwar guilt as well as the destruction wrought on Japan at the end of the war with the atomic bomb is open to speculation. Her work has been referred to as "post-Hiroshima" both in its restatement of decay, but at the same time its assertion of a new beginning, especially in the reconfiguration of form, a metaphor for the aftershock of trauma redemptively reshaped as beautiful art. Kawakubo's Autumn/Winter 1983 "Wrapped" collection in Paris, which included a black sweater riddled with holes, and another with twisted stitching, prompted a writer in Le Figaro to express her astonishment. Her clothing was like a cold wind: "Her apocalyptic clothing is pierced with holes, tattered and torn, almost like clothing worn by nuclear

holocaust survivors." Yamomoto, who showed the same year, presented "clothes for the end of the world that look as if they have been bombed to shreds."[22] They were interpreted as decidedly Eastern, or Oriental, if only because they presented an exotic alternative to fashion's mainstream.

However, Kawakubo is unsurprisingly reticent on a number of these issues, just as she deplores being referred to as a "Japanese designer."[23] She is in fact resistant to most delimiting terms, although the term *deconstruction*, which

Figure 4 Rei Kawakubo, *Comme des Garçons*, Black cotton. Gift of Charles Rosenberg. © The Museum at FIT.

came to be used after her first major collection "Destroy" in Spring/Summer 1983 (her very first women's wear collection was unveiled in Tokyo in 1975). Although having far more than stressed and spoiled fashion, fashion columnists and curators quickly alighted onto the term *deconstruction*, also the philosophy fashionable at the time, or used the more quaint phrase, *la mode Destroy*, or the birth of a new *aesthetic of poverty*. Declared to be a "calculated affront to accepted canons of good taste" by the newspaper columnist John McDonald, the collection was "torn and full of holes, asymmetrical and apparently shapeless, with superfluous sleeves, flat shoes and misapplied lipstick. Instead of hugging the body, these garments enclosed it in a package."[24]

Kawakubo's language of destruction differs from that of Westwood, precisely in the manner of deconstruction outlined above. For Westwood the rip, the hole and the tarnished representation are an effort to reinsert the marginal figure, the destitute or the nonconformist, into the syntax of fashion. Kawakubo, while not rejecting these ideas, uses rips, holes and so on, as a register of the permeability of fashion and the alterability of all matter in general.[25] It is also as if Kawakubo subjects the new material of fashion to the depredations of time in advance, so that the garment contains the qualities of time in more than one way.

But in a very striking and decisive way this range, or tendency, in Kawakubo's work makes use of the signifiers of the ruin in a very active and confrontational way. To seek out a garment whose signifiers are of wear and neglect is something unthinkable to fashion and clothing of the past whose virtues were to preserve newness and an absence of wear, to be cast off once marked and worn. Unlike Westwood's violations of fabric and form which hold the residue of violence, the violence in Kawakubo exists very much in the distance, as signified remnant that traces lines of imminence that expressed multiple levels of instability in the physical substance. Raggedness is condition to what is internal to the object/fabric—that it is subject to decay—but anticipates, states in advance its susceptibility to outward stimuli: sun, washing, accidents, wear—all alter the garment from its original state. This then stages a different kind of essence to the idea of the garment, one that is not predicated on an ideal, commodified, preworn garment, but one that is placed within the circuit of wearing the garment and living. In his shorter book on Spinoza, Gilles Deleuze notes that the Spinozist concept of existence is that of shifting modalities that are existence's essence. There is no essence external to existence itself, which means the condition, or modes of life that occupy the passage of life. The body is thereby conceived as a conductor of various expressive qualities, these modalities are states of being that are reciprocal with the world at a particular time.[26] This notion can be easily applied to the philosophy embedded within Kawakubo's ragged clothing. Unlike the classic garment with its platonic claim to a Platonic essence that is divorced and even superior to life, the essence of Kawakubo's garment is fluidly internal to all of life's contingency.

In her account of Kawakubo and the rag aesthetic and its legacy, Caroline Evans draws notice to the many ways in which fabric was manipulated and placed under stress, from loosening slightly the screw on a loom, to submitting a piece of linen to serial rigors:

> submitting it to the ravages of the elements; and she produced hand-knitted black sweaters with lacy holes like moth holes. By these means she introduced the idea of patina and ageing into Paris fashion. In the 1990s the aesthetic of *boro boro*, meaning ragged tattered, worn out or dilapidated, was also introduced by the Japanese textile company Nuno. Their textiles were boiled, shredded, dropped in acid or slashed with blades. Comme des Garçons' Autumn-Winter 1994-5 collection used muted colours and threadbare woolens with frayed sides to bundle the models up in their clothes like Balkan refugees from a phantasmic Eastern Europe. For Autumn-Winter 2001–2 the first issue of *Another Magazine* featured a photograph by Richard Burbridge of five models dressed and posed to look like bales of clothes awaiting collection from the depot.[27]

Only a little after Kawakubo's first sally into marred clothing, in the late 1980s, Margiela cut up old clothing and sewed different pieces together for a rearticulated, hybrid look. Although related, this was different again from Kawakubo as it was breathing new life into fashion's detritus, a resurrection or an undead—sometimes glibly referred to as the "beggar look." The fashion curators at the Metropolitan Museum, Richard Martin and Harold Koda, vouched for deconstruction as a "mode of thought current to our times," although did not elaborate too much further on the assertion.[28] The continuing fashion for presenting clothes of varying degrees of wear was also justified as reflecting a world wasted by technology, waste and overpopulation: It was dystopian fashion for the encroaching dystopian nightmare.[29]

Unclear culture

Whether or not Kawakubo decided to play down the "Japaneseness" of her work, the kinds of challenges she presented were certainly assisted by her as a cultural other, or one in part. In part because she had already begun to join the fold of Japanese designers—Kenzo Takada, Issey Miyake, Yohji Yamomoto, Junya Watanabe, Jun Takahashi, Tao Kurihara—who were bringing about the so-called Japanese revolution in fashion. The Japanese revolution could only take place in Paris, yet it is only by dint of Kawakubo's otherness that the kinds of radical changes that she and her Japanese-born contemporaries were able to instigate were received so enthusiastically. If it was a radical spoliation of fashion,

it was a welcome one. And if their work was consumed and understood as having a "truly" Japanese sensibility, it was one that was generated more retrospectively than prospectively. Their work helped to cement a stronger international grasp of the Japanese aesthetic.

In her analysis of Kawakubo in her influential *A Critique of Postcolonial Reason*, Gayatri Chakravorty Spivak observes that Kawakubo claims a cultural space of global transnationalism, in which Asianness is consumed by "the crowd that goes to museums and hotels and takes high-tech as its plaything" as a multiplicity of signs. "The informed goodwill of the well-dressed radical sutures the asymptote in an aporetic crossing, an impossible chiasmus."[30] In translation, this means that culture is worn and hence embodied and embraced, but in a way that reveals how fragmented and diluted cultural authenticity is. The encounter with culture is constantly mediated, and it is as mediator that Kawakubo makes this encounter desirable and possible, a mediator who nonetheless avers "not to be confined by tradition or custom or geography."[31] Spivak's position on Kawakubo is ambiguous, as it remains unclear whether she sees the designer as complicit in appropriation of culture, or as just a component part in capitalism that renders everything a marketable sign. For culturally speaking, Kawakubo's fashions are "the-same-yet-not-the-same, different-but-not-different."[32] If Kawakubo rejects her anchorage to Japanese culture, it is a disavowal that is made possible by the manner in which Japan, since the Meiji era at the end of the nineteenth century, has tactically marketed specific Asian characteristics of itself to the West.[33] To a great extent, the truth of Japanese cultural style lies in its strategic refashioning of itself. The paradox of Japan is the most racially pure country on earth is determined by multiple levels of artificiality.

The inside and outside of clothing

There is a telling passage in Derrida's famous essay "Linguistics and Grammatology" that uses the metaphor of clothing to develop the concept of the perceive difference between speech and writing, and the binary logic of before and after, core and carapace:

> Writing is the sensory matter and the artificial exteriority: "clothing." It has sometimes been contested speech is the clothing of thought. Husserl, Saussure, Lavelle are not lacking on this point. But has one ever doubted that writing is the clothing of speech? Even for Saussure it was a clothing of perversion, of laxity, garment (*habit*) of corruption and disguise, a party mask (*masque de*) that has to be exorcised, that is, by good speech: "Writing veils language's sight: it is not clothing but a travesty." A strange "image." One already hopes that if writing is an external "image" and "figuration," then this

"representation" is not innocent. The outside communicates a relationship with the inside which, as always, is nothing less than simple exteriority. The sense of the outside has always been on the inside, outside of the outside, and the obverse.[34]

In his quotation of Saussure, the word *travestie* refers in French not just to "travesty" in English, but also implies a perversion of translation, which makes it a term used for dragging. Here Derrida draws on both Saussure and Rousseau to contest the assumed lineage that places speech in the realm of nature, and writing into that of culture. The reversal for which he now famous is to insert writing as prior to speech, turning a venerable assumption on its head.

The analogy with the sartorial reference he employs is to say that clothing comes before the body. This is a highly tenable concept if the conceptual relations of clothing and style are taken into account. Clothing is the mediation on the unmediated body. Styling is mediating the body. To extrapolate these ostensibly simple notions is to reveal that the unmediated body only exists in two incarnations: in a disembodied state, as an idea, or as the dead body (its disintegration is due to a different categorical elements). In any other case it is subject to some form of mediation—washing, cutting of hair and so on—and is therefore, conceptually speaking, clothed. To take this to heart and to apply it to clothing per se is to explode the modernist concept of utility—bearing in mind that modern fashion as with Gabrielle (Coco) Chanel and Patou, emphasized mobility and versatility—since the service to the body can no longer be taken as essential but arbitrary and ideological. The inside and the outside, as exploited by Kawakubo, as well as the corporeal and the sartorial, are no longer subject to the same hierarchy. Instead the assumptions based on these hierarchies are used to striking effect: Thus the outside of an article of clothing is read as the inside made outside, which in turn destabilizes the traditional meaning of the (inside) body that wears it. The same inside-outness occurs frequently enough with deconstructivist architecture from the its earliest years, most famously with the Pompidou Centre in Paris (Piano and Rogers, 1977), or in Frank Gehry's own house in Santa Monica (1979).

Eschewing traditional tailoring, Kawakubo's designs express ideas about the body that emphasize its mutability and its innumerable discontinuities and permeabilities. Pathways in garments go nowhere, some garments have extra sleeves, and the myriad imbalances and asymmetries draw attention to the body as both dynamic and imperfect, as opposed to static and ideal. "I always want to destroy symmetry" says Kawakubo. Moreover, the reassessment of the body as a whole, and the body-clothing binary is also conducted through attention given to transitional regions of the body. In the words of Evans and Thornton, "Although she has designed garments which reveal parts of the body through unexpected vents or holes, they are parts of the body that have, as it were, no

names: the inside of a knee, a section of the ribcage"[35] In other cases "garments may gape only to reveal another layer of fabric beneath."[36] The textile as skin, for after all skin itself has more than one layer.

One good example of this is the way in which Kawakubo petrifies the fabric's folds, in emulation of the flowing but fixed drapery of classical sculptures and bas-reliefs. The fabric is stiffened through a complex of hidden seams that hug it into place, in defiance of gravity and the elements, leaving it in a state of improbable suspensions. As Barbara Vinken relates:

> In this way, Kawakubo brings the dialectic of stone and flesh to its climax. Her dress becomes stone so that, instead of stiffening into a classical marble statue, the body, naked under its wrappings, is allowed to come alive. Paradoxically, this technique of wrapping the body in stone releases it from its marble nudity, making it warm, mobile and sensual—naked under the drapery.[37]

This is one instance of many reversals and reformations that do more than suggest that the body's only place is within the garment. Rather the body is a zone of movements, articulations and vicissitudes.

Kawakubo's "starting from zero" design ethic of working was a means of breaking conventions of garment construction and their appearance. This amounted to a "making strange" of the female body that, like Westwood, set in motion a rethinking of female sensuality in terms of both her own self-image and the presumptions of others. They state that "Kawakubo allows one to 're-see' the body and its possibilities. Emphasising the continuity of the female body, even its contiguity, in space, calls into the practice of 'seeing the body in bits' that has been identified as intrinsic to the representation of the female body in patriarchal culture."[38] But the fractured body, the *corps morcelé* as Kawakubo conceives it, is not quite the same as that of the Surrealists, but one that is in a constant state of reconfiguration, like a mutating molecule. The logic of inside-outside is one of more than two sides, as in the Möbius strip

To return to Derrida, the "clothing" that writing is assumed to be is tantamount to what Rousseau in his *Essay on the Origin of Languages* (1781) calls the "supplement." Writing is supplementary to speech. However, Derrida takes this in a nonderogatory sense and contends that the supplement, in Norris's words "enters into the heart of all intelligible discourse and comes to define its very nature and condition."[39] By extension, clothing, too is supplemental to the body, but indeed crucial to the imaginary extreme of what a pure and unclothed, unmediated body constitutes. In Kawakubo's work, as we will see in subsequent generations, designers such as Aitor Throup, the biological body is articulated on the very surface of clothing. The components of clothing correspond to the body both as a whole and as a sum of different parts. And fabrics suggest the surface

of skin, stretched or sagging, with their own irregularities, maculations, marrings and stains, the natural residual signs of time.

Undead minimalism

Since her first collection, Kawakubo's work has always courted some relationship with death, or better with the undead, which is not complete annihilation per se, but a living on in another state—evidenced also in the analogies to architecture, the rhetoric of the ruin. Further philosophical deconstruction was considered as an afterlife after the end of philosophy, which occurred at precisely the same time as the circulation of Hegel's "death of art thesis" in relation to postmodernist art and its reflection on the failed project(s) of modernism.

An important influence on Kawakubo was Westwood's early "Nostalgia of Mud" (Autumn/Winter 1982). If this sparked *la mode Destroy*, then Westwood's was *la mode hobo*. If art since the 1950s had been identifying with cast-off and crude materials to reintegrate the relationship the body and matter—Gutai in Japan, Arte Povera in Italy, Aktionismus in Austria, Fluxus in Germany— such notions became increasingly central within fashion. Sack cloth, heavy jute, repurposed clothing and so on were no longer the detritus of fashion, but entered into what was a much widened spectrum of constituted stylishness. Just as "Nostalgia of Mud" muddied gender distinctions, Kawakubo, along with Yamomoto and Miyake, produced many clothes that were unisex, or even nonsex at once recalling pre-Meiji era clothing, with clothing that was very large that denied the shape of the body. Other approaches pointed to a futuristic, posthuman body in which gender is variable.

This paring of form, the simplification of tailoring has led to repeated references to minimalism. But this is not the minimalism of classic styling, but a different kind of reduction, which often leads to a "less than nothing" aesthetic, that is, a suggestion of the garment's dissolution. A common approach to clothing is, like Westwood, to subject them to prewear, giving the garments an imprint of time that they had not experienced. In doing so they also evoke a language of wearing that shifts the traditional perception of the transition from new to worn. Such garments have a life in which there was never a beginning, rather they exist as part of a larger continuum in which clothing proper is but one of a series of factors. Clothing as conceived by Kawakubo exists amidst an expanding and contracting system of variants.

As with her Japanese contemporaries, the notion of minimalism also draws heavily from the aesthetic of *wabi-sabi* meaning "simple, austere beauty" (*wabi*) and "lonely beauty" as in "the beauty of silence of old age."[40] It is a Zen Buddhist concept that tells of renunciation, the fragility of beauty, the evanescence of life and especially emptiness. Harold Koda applied *wabi-sabi* to Kawakubo at

which the designer demurred, despite it being in alignment with her inclination for imperfection, austerity and what he calls the "aesthetic of poverty."[41] This also situates Kawakubo in a direction that disavows pleasure and sensuality. When sex appears its connotations are always double-edged, suggesting defilement, libertinage, and as with all her work, a striking absence of innocence. As Valerie Steele comments:

> Widely regarded as one of fashion's least "sexy" designers, she has experimented with lingerie-inspired fashions, creating looks like an avant-garde harlot (Autumn/Winter 2001–2). Her Biker/Ballerina collection of Spring/Summer 2005 paired frothy pink skirts and black biker jackets with hand-sewn Frankenstein stitches that alluded to the physical strength and endurance of ballerinas, implicitly questioning conventional images of the delicate and the strong. Her Bride collection (Autumn/Winter, 2005–6) brought many people to tears.[42]

This was probably because the bride was more Miss Havisham, disturbingly elegiac rather than celebratory. Here the connection between sex and death is not spared us, but brought to the fore.

Kawakubo's forays in love's labors lost were noticeably earlier in a series of photographs produced by Cindy Sherman (*Untitled(s)*, 1994). One in particular depicts a doll wearing a mask wearing a coarse, gray felt garment whose main set of seams support a snake-like protuberance that winds down the right side of its torso to meet a dour-faced mannequin's head it is nursing between two absurdly oversized Mickey Mouse gloves. Except for the beady eyes springing from the openings to the mask, the only life in this images appears to come from the garment itself: part tumescent, part devotional. The presence of such clothing, in oscillation between the sculptural and the pathological, and on lifeless dolls that nonetheless have some uncanny presence, serves to open the door to a more universal observation about Kawakubo that has to do with how she situates the body and the subject. It is never in one place, and no place is assured. Kawakubo's fashion, as fashion, is an expression of who we are and a belonging to a certain sensibility. But who we are, her garments seem to tell us, is staged in renunciation and uncertainty. This may end in horror, but it is a horror made beautiful and ethically retrieved by staring stark uncertainties in the face.

3

GARETH PUGH'S CORPOREAL UNCOMMENSURABILITIES

For Gareth Pugh's Spring/Summer 2016 "Ready-to-Wear" collection, the models all wore masks, their actual face entirely indiscernible (Plate 6). As is characteristic of masks, they gave the entire spectacle an uncanny air, alienating and dissociative. The hair, too, was unnatural, in bright colored shocks behind a raised forehead, clown style (Plate 8). The collection was in homage to the days of disco and to the red light district of Soho in London, once a hub of creativity and now in threat of commercial redevelopment. The collection was accompanied by a short three-minute film directed by long-term collaborator Ruth Hogben that featured the Soho bad girls dressed in glitter, pole dancing and shimmering through the brightly lit streets of Soho. Latex, leather sequins and checkerboard patterns in a color palette of red, white, black and copper heightened the disco theme. The models wore flesh-colored stockings over their face with star shaped make-up painted over their eyes, while others wore star-shaped sunglasses.

Masks have their own consistent history in Pugh's work, where bare faces are a singular rarity. In his short poem "The Mask," W. B. Yeats concocts a dialogue between two lovers, one of whom declares, "It was the mask engaged your mind,/And after sent your heart to beat,/Not what's behind."[1] This can be applied to love and desire, and therefore also to fashion. It is the cover, the outside appearance, and the exterior shell that captivates us. But further, Pugh's interest in emphasizing the empire of appearances leads to speculations on his attitude to the body and humanity itself. The traditional, albeit simplistic and misleading, assumption about clothing is that it serves the subject that wears it. The body is the authentic inner nature, and the clothing, the temporary synthetic cover. For Pugh, this relationship is redundant as the clothing has its own autonomy.

As a play of surfaces, it is an example of the notion of the Body-without-Organs (BwO), which Deleuze and Guattari theorized after the coinage by the French Surrealist dramatist Antonin Artaud. This nonbody is a dissected subjectivity in which memories, associations, expectations, no longer present

themselves in a coherent order. Inasmuch as it disavows the Cartesian myth of hieratic mind-body and an ordered subjectivity, the BwO is a concept that presages contemporary ruminations on the cyborg, the collapsing of the natural body and the doll, the posthuman body. In this regard, the body is no longer an entity in and for itself, but rather raw matter to be subjected to new formations.

Pugh came to the attention of the fashion industry after his Central Saint Martins graduate collection in 2004, which featured oversized red and white balloons, and which made the front cover of British cult magazine *Dazed and Confused*. He then went on to complete an internship with Rick Owens at Revillon in 2004 and participate in the group show for Fashion East, during London Fashion Week in 2005. Pugh's first major collection was Spring/Summer in 2007 for London Fashion Week, in which he sent a masked model down the catwalk wearing a black hat with a spiky cone-shaped protuberance, the garment arrayed with inflatable units. Wearing lucite platform shoes, another model wore a latex mask with a black diamond pattern. There was no sign of skin or individual subjectivity at all, with hands, arms and legs all covered by a tight-fitting black synthetic sheath. Being human scarcely seemed to matter, as no single model showed a face, nor did the clothing in any way seem to have much correspondence to the interior body. Pugh's earlier collections: his beaked clown suit of Autumn/Winter 2005, the black-and-white cashmere dress with the faceless model in the balloon gimp mask with air and eye holes for Spring/Summer 2007, and again macabre chalk-faced models appear in ballooned PVC puffa jackets and clown make-up for Autumn/Winter 2006. Clowns figure heavily in Pugh's catwalk styling. Writing on the medieval "Carnival and Carnivalesque," Mikhail Bakhtin says that the act of the carnival produces a space of oppositionality and ambivalence in which everything is reversed from the subordinated and strict order of everyday life, garments are worn upside down and back to front, household goods act as weapons and the king is a clown. Pugh's attention to volume, oversized proportions and monochrome as well as his fascination with the medieval and the arcane are key aspects to Pugh's designs. "This is why in carnivalesque images," writes Bakhtin:

> there is so much turnabout, so many opposite faces and intentionally upset proportions. We see this first of all in the participant's apparel. Men are travestied as women and vice versa, costumes are turned inside out, and outer garments replace underwear.[2]

During carnival time (much like Mardi Gras), the gloomy and hierarchical order of medieval life is replaced with a period of laughter and freedom during which the sacred and sacrilegious are defiled. Much like Bakhtin's medieval carnival that was a communal performance in a public space, the fashion catwalk still retains

much of the nature and function of the carnivalesque complete with its entire transgressive spectacle.

While definitely outlandish and unexpected, Pugh's designs nevertheless exude confidence in their own form of elegance, but it is an elegance that suggests an exhaustion with the way the notion has been understood before, and with it the kind of subjectivity that helped to drive it. Put simply, Pugh's work prompts the question. "What is sartorial elegance once the human is removed?" Is there elegance absent from the human, and for whom does it then perform? As we saw in the previous chapter, Kawakubo also radically disavowed the traditional contours of the body bending and distorting out if shape such as to make into something bordering on freakish. Taking Bakhtin's notion of the grotesque body as a springboard, Francesca Granata uses the term "body-out-of-bounds" to describe the way in which designers explore the boundaries of the normative body through material applications. She argues that fashion's investigation of the bodily boundaries was heightened during the 1980s onward as a result of feminism and the AIDS epidemic. Examining the work of Rei Kawakubo and the performance artist Leigh Bowery (explained further in the chapter), Granata argues that their work examined and "problematized demarcations between bodily boundaries and questioned the demarcations of the integrity of the subject via references to bodies that deviated from the norm."[3] Pugh works in a similar way to Kawakubo and Bowery with his ballooned proportions and distorted body shapes and sizes. Pugh follows the high degree of performativity to be seen in the work of Alexander McQueen and John Galliano, but with one exception, which is the deletion of subjectivity. While McQueen used a great deal of creative license with carnival make-up and masks, some degree of subjective pathos was regularly retained; there was always some sense of menace, the macabre or melancholy. But with Pugh, sentiment is displaced, and there is no hint of nostalgia. Moreover, with Pugh's immediate predecessors, which also include Vivienne Westwood, there is always some vestigial difference between garment and wearer; there is always the sense that the clothing can be removed and worn by someone else, that it is a mobile and manipulable article. By contrast, there is next to none of this with Pugh: The models and their clothing are a solid unity. They are a homogeneous unit that is autonomous and opaque.

Masks and performance

It remains inconclusive whether masks were always worn in Greek or Roman comedy,[4] but what is certainly true is that they were used to create a dramatic distancing between actor and audience, a means by which to announce the contrivances of the dramatic art. It was also traditionally used as a device by which the actor could more freely assume the character of another, and to

escape him- or herself. It was a mode of stylization that engaged the audience's imagination, the static mask necessitating imaginative work on the audience's part. At the same time, the mask is for the actor a form of affirmation behind which a character can be activated. The actor's appearance is modified, and because the modification is no secret, the transformation is enhanced as opposed to obstructed.

As a learned scholar of Greek theater, Friedrich Nietzsche would regularly return to the theme of masks, and indeed his "paradox of the mask" is replete with important metaphors for his valiant project of overturning Platonism. For Nietzsche, the paradox lay in the illusion that there was, and could be, something to uncover, for everything is appearance. The unmasking should not be seen as measure by which truth is disclosed, but rather just another manifestation of an appearance.[5] What Nietzsche's reading helps to deliver is that masks are not simply a matter of seen and unseen or the typical assumed distinction between appearance and truth, but rather a mixture of both. As David Fisher observes, Nietzsche's paradox can be found in Euripides's *Bacchae* in which Dionysus comes to the world in human form, but wearing a smiling mask. He states to the audience, "Here I stand incognito." But it is clear that his status as a god is made plain by his mask, which signifies his differences from other men. The estrangement of the mask is the same as his own estrangement from common humanity.[6] Similarly, a mask of an executioner is the executioner himself, for without the mask, he would no longer be in an executioner's role. In both cases, the mask is used to signify an appearance of what cannot otherwise be made to appear. On opposing scales, both the god and the executioner do not belong to the orders of common men. One is quite simply not a man, while the other performs a function unbefitting the common order of humanity, that of voluntarily removing life. It is the mask that facilitates action. As E. Tonkin has argued, masks are "a richly concentrated means of articulating power."[7] They are communicative mechanisms, forms of signification that allow, actually or rhetorically, the assumption of a power that is harder to achieve with conventional appearances.

In more recent times, the mask has been used as mechanism for the expression of queer identity, especially with dragging. Until relatively recently and still not in all countries, being queer had always entailed some form of masking, disguise and code. Gay men's style, for example, used the persona of the dandy in the nineteenth century and onward as a vehicle for personal expression and experimentation. With a greater sense of visual force, and far less subtle, dragging begins in the theater, when in Elizabethan and Jacobean times, men played female roles. But it is only in the twentieth century that dragging began to have the transgressive intent that is currently associated with the gay pride movement. The very ontology of drag is the transformation and the over-articulation of traits. It is a form of masking that is a concealment in order to give

birth to something new, the artificial, willed transformation into the authentic self. In this conception, the "undragged" persona is not only naked, but bereft, castrated. With its exaggeration of traits of (for men) womanhood, the drag queen is a performance that is a highly phallic celebration.

A figure that carried the relationship of drag and masking to a new level was Leigh Bowery. Connections have been drawn between Bowery and Pugh, which the designer has resisted. Such objections make little difference as both share the same obsession with concealing or altering faces, Pugh in his designers and Bowery on himself. Bowery designed or repurposed costumes that went well beyond typical drag, and often appeared like a blow-up doll whose gender was entirely obscure, or rather a progenitor of what is now officially recognized as the "third gender." A denizen of the 1980s club scene in London, the Australian-born Bowery would dress in costumes that could only be called a combination of clown and space man. Bowery was a celebrated club performer of his time, and his body type, which one could only describe as corpulent, was a strange and strong counterpoint to the slender club dancers, with whom he shared extroversion and confidence. But the most distinctive feature about Bowery was that he not only wore masks, but also never took them off, and when he did, his face wore such heavy make-up it amounted to the same thing.

When Bowery died of an AIDS-complicated illness in 1994, the craze for body-modification had become something far less taboo and far more demystified. From the end of the millennium onward, the meaning of the natural, unmediated body had begun to falter. There were exceptions, such as Isabella Rossellini famously losing her contract with Lancôme because of her refusal to have plastic surgery, but while she was a standard-bearer of "naturalness" at the time, such a stance is no longer seen as a point of pride or important. Rather, cosmetic treatments are today more likely to be classified according to how effectively they are concealed. Within the topology of the mask, we are returned in covert fashion to the paradox of the indiscernibility, or reciprocity, of mask and face. In the discourse of clothing, the mask acts as a material object and as a trope for concealment that characterizes all dress. For Pugh, the invisibility offered by the mask is embedded in the formulations of garments that obscure the body while simultaneously parodying the very notion of gender itself. In *Fashioning the Frame: Boundaries, Dress and the Body*, Warwick and Cavallaro write that within the language of symbolism, one of the key features of all screening garments is their ability to conceal and expose, insulate and mediate that invites the viewer to unmask the wearer's identity. "The mask magnifies the notion of dress as a structure endowed with autonomous powers, based on the ability either to sustain or shatter the wearer's identity."[8]

Pugh's Autumn/Winter 2015 "Ready-to-Wear" women's collection opened with a film, by long-time collaborator Ruth Hogben, of a thin model wearing a long blond wig toying with a large set of scissors before she sets about hacking

off most of her hair. A modern Joan of Arc preparing for battle, she takes a black bowl of vivid red paint and begins to apply it down the center of her face, across her bare shoulders and arms, and over the small top clothing her breasts. She pauses, then outstretches her arms and throws back her head, the red painting accentuating the cruciform—the red cross of St. George, England's patron saint. With this sinister gesture of martyrdom, she is consumed by fire that abruptly appears around her. Her menacing face covered in red reappears from within the flames, which then turns into billowing red cloth. The image remains on the screen and provides a backdrop for the catwalk. From this somber backdrop emerge the models, their face obscured by severe red cruciform paint across their eyes and down their hair, nose, chin and neck. References to the British Empire and national pride abound in the collection: knee-high black leather military boots, leather bodices that act as shields of armor and fur dresses and woolen military coats that reference the tall bearskin fur hats worn by the grenadiers as part of the British military uniform. Britannia, manifested in an image of the archetypal warrior woman bearing a shield and trident was Pugh's muse for the collection, which marked the celebration of the ten-year anniversary of his label for London Fashion week (Plate 6). The name, which has become a symbol of national pride, was bestowed by the Roman Empire in 43 AD when it began its conquest of the island and established a province called Britannia. "This city [London] is where everything started for me, my entire creative family are here, so it's in everything I do," said Pugh. "It's my home."[9] A model appears on the catwalk wearing a version of a Roman helmet with a thick arch or crescent, similar to that of the image of Britannia. There are several chains that hang down from the hat to the model's ears and flow down across her chest. (The headdress would be used on subsequent models as well.) The clothing is all black and combines fetish styling with retro-Victoriana, with black drinking straws used to create reptilian dresses that swayed as the models moved. The crucifixion masks have a disturbing effect, making the models into effigies of ritual as participants in some kind of rite. Yet it is this very alienation that allows us to find a different, mythological space, which lets us focus on the clothing, giving it an autonomy in an other-worldly space, a notion we will return to, the dematerialization of Pugh's work through representation. And it is this dehumanization through the mask, and the projection of something not real or from the future that prompts reflection on Pugh's relationship to the posthuman and transhuman.

Posthumanity and dolls

Transhumanism is the acceptance, and integration, of technology into the body, which includes cosmetic alterations, prosthetics and other body enhancements. The artificial is thereby incorporated into the natural. With humanism, Pinocchio

wanted to become a boy, with transhamanism, and posthumanism, the boy wants to become Pinocchio.[10] Posthumanism relates to gender and sexuality as much as politics and biology, but central to it all is the way we understand ourselves, our humanism, that entertains and ultimately takes as normal, the integration of the nonhuman and the technological.[11] In addition to Haraway's theories of gender and the cyborg, one of the key forerunners of this concept are Deleuze and Guattari, who conceive the body as an assemblage that is always being reformed and reconceived, and combination of the living and the dead (e.g., nails, hair, but also clothes and cosmetics), the animate and the inanimate. In the words of Elizabeth Grosz, their idea of the body is as a "discontinuous, nontotalizable series of processes, organs, flows, energies, corporeal substances, incorporeal events, speeds and durations."[12] Their idea of the body fits squarely into contemporary theories of the posthuman body as one constantly mediated and variable, which also goes together with the material nature of the doll, a composite of appendages and units that can be replicated, reapplied, repurposed and replaced.

Pugh, like Kawakubo and McQueen before him, eschews previous philosophies of fashion as entering into a relationship with the body, to enhance or complement. Rather, his clothing radically reinvents the body from the outside, to the extent of denying anything inside. In a *Thousand Plateaus* (*Mille Plateaux*, 1981), Deleuze and Guattari borrow Artaud's coinage of the "Body without Organs" (BwO) is to consider a form of being that is not limited to anything codified or essentialized, such as what constitutes a normal female and a normal male.[13] Useful posthuman theory as it is to queer theory, the BwO focuses on the body's mutability, and the spectrum of dispositions, which can apply now to women who aspire to become a Barbie doll, to people who neither identify as straight, gay or bisexual, to people who modify their body to look like animals.

For his first major collection in 2007, Pugh's designs were like a menagerie of robotics. The absence of natural, organic fabrics or materials such fur or feathers was noticeable. Not only was the silhouette of the bodies altered beyond recognition, but many of the garments were also hard to maneuver, forcing the models to make mechanized movements. In taking up the BwO with relation to Pugh, Stephen Seely argues that Pugh's designs echo Deleuze and Guattari's idea of a body without conventional organization and subjective unity. This may

suggest a nihilistic evacuation of bodies: indeed Pugh's use of cold geometric shapes, minimalist colour palate, synthetic textures could certainly seem forbidding and cynical. The BwO, however, is actually the positive attempt to restore the body's access to its inherent virtual reserves by wresting it from hierarchical organization.[14]

Pugh's designs can be seen to rethink the normative ways in which we read and understand the body and gender. Unable to rest from our previous presumptions,

Pugh's designs disorient us. We do not know what they are made of, we do not know who they are and so do not know what they are for. Our mechanisms for communicating with these figures have been destabilized. Seely goes on to point out that Pugh's designs can be aligned again to Deleuze and Guattari's ideas in regard to their critique of "facialization," a process during which we assign meaning, intent and subjectivity even where there might be done.[15] As Seely comments, "By defacializing the body, he untethers fashion from its normative images of beauty, bodies, gender and humanity, allowing it instead to be used for the creative production of entirely new assemblages."[16] For Deleuze and Guattari, the face is different from facialization since the latter is a signifying process by which we constantly try to render the abstract concrete, and the unknown known. Giving things a face is to give them an identity with which we then can be comfortable. Take that face away and we are lost in a limbo of signification. "The face is Christ. The face is the European type, what Ezra Pound called the generic sensual man, in short the regular erotomaniac."[17] Faciality and facialization are the paradoxical processes of assigning masks to things in the process of taking them over, a colonization of sorts. The physical mask has the property of drawing attention to the habitual process of facialization, and the power to stop it in its tracks. The physical mask has the potential to unmask the psychological act of masking.

While it must be acknowledged that his designs for the 2007 collection were intended for women, and were not entirely of the transgender, gender-bender sort in the way of Bowery, they nevertheless point not only to a kind of body, but a manner of being that is irreducible and porous, a body that is the responsive receptacle of technological and aesthetic incorporations, a body that is not complete until it is added to revealing its own inherent lack of wholeness.

Pugh's 2008 "Ready-to-Wear" collection of Autumn/Winter continued to bear out such observations. While this time the models were not wearing masks, they did wear heavy, sci-fi make-up of whited face and blue eyeliner and lipstick, a combination that may have connoted a kind of Terminator warrior woman meets the Predator. This time Pugh did use some conventional fabrics, such as goat's wool, natural fibers, such as feathers and fur, but the use of synthetics was still dominant. There was a great deal of steely gray, and again high sci-fi collars and lines that called to mind decorative futuristic armor (Plate 5).[18]

For Pugh's Autumn/Winter 2014 collection, there was again a reorganization, or disavowal of the "natural" body. The first model to appear was in a dress of a thick white material wearing a long white hat of the same fabric that almost completely obscured her face. But the most remarkable part was the absence of the arms, and where they should have been were undersized lumps, or flaps, vaguely reminiscent of an amputee. Oversized hats that obscured the models facial features recalled Alice in Wonderland in oversized proportions (Figure 5). Several items of the collection incorporated collars raised so high that they

Figure 5 Gareth Pugh Autumn/Winter 2014 fashion show, Paris Fashion Week, February 26, 2014, Paris, France. Photography Catwalking.

Figure 6 A model walks the runway at the Gareth Pugh Autumn/Winter 2014 fashion show during Paris Fashion Week on February 26, 2014, Paris France. Photography Michel Dufour.

required interior supports that swayed with the movement of the models, the heads dwarfed by the almost architectonic structure around them. Another model appeared in what seemed a very traditional sleeveless cream dress, until one discovered that a massive shape like a two-pronged key handle jutted from her back like a wind-up doll at the mercy and whim of its creator (Figure 6).

Pugh is very much enamored of high collars, which were also featured as the end of a sheath with no front opening, and the head only partly discernible. The collection used PVC and plastic, and at one point, a model appeared in a dress that by all accounts was made of large amounts of thin sheeting, layered and bound. While there were pieces that did not conform to the theoretical framework outlined above, these were regularly interspersed with others that pointed to new conceptions of the body, its movement and its biological function (for plastic, after all, is not a material one can wear comfortably for long), which suggested a genetically modified body as the counterpart to that of genetically modified food (a body that perspires less, for example).[19]

Immaterial and imaginary fashion

Since at least the new millennium there has been a large amount of discussion around virtual fashion, which generally means fashion that is both viewed and consumed over the Internet. From an aesthetic point of view, one of the most significant drivers of this form of consumption has been the inception in 2000 of SHOWstudio by the photographer Nick Knight, who had the insight to see that the ease and proliferation of the moving image, and its dissemination over the World Wide Web, was an opportunity to re-invigorate fashion representation away from the static image.[20] The genre that evolved out of SHOWstudio is the fashion film, which can be the basic documentation of a live runway event, or something far more autonomous, with its own inner regulatory logic facilitated by elaborate staging and digital manipulation.

Pugh's work lends itself to such a medium, given the problematized role of the body in his work and the many extreme lines in his clothing. But it is this agonistic and alternative relationship to the body that also lands itself so sympathetic to representation, where, quite simply, the material, corporeal body is absent and is a shadow on a screen. Let us digress at this point for the sake of an analogy. At the conceptual epicenter of the work Gerhard Richter—one of the most celebrated and influential painters of the last decades of the twentieth century— is the photograph. Early in his career he famously declared, "I want to become a photograph." His work is thorough in its range of investigation into the close relationship between photography and painting, in terms of image consumption, affect and cognition. Cognition is central here, as his work is very much a defense of the ways in which our idetic faculty is mediated by photography. With

photography's ubiquity in the everyday world, we see in terms of photographs, they are fundamental to the way we perceive and organize the world. To extend the argument of this chapter, we could say that the intervention of technology is performed in the most covert and immaterial way. Speaking reductively, Richter has two arms to his practice, figurative and abstract (reductively because he approaches his figurative works in ways relative to abstract painting). The meaning of the abstract paintings is at first sight a little baffling and deceptive, as there is something very poised about their construction that is out of keeping with the *sine qua non* of abstract painting, New York Abstract Expressionism. Rather, Richter's abstractions are keenly about the rhetoric of expression within abstraction, and therefore, its instability. But what is also undeniable in these works is that unlike their Abstract Expressionist counterparts which require viewing "in the flesh," Richter's abstractions look so very good in reproduction. They then beg the question as to whether the "real," physical paintings are incomplete until they have been photographed. *They exist for the purpose of being photographed*. Recalling the suggestion made earlier that Pugh's works seem to emanate from an elsewhere, from another realm, we might then go so far as to say that his garments exist for the purpose of being filmed, for existing within the imaginary prism of the fashion film. While there is still something terrestrial, of the world, in Kawakubo, especially in the often brute materiality of her fabrics, there is no such grounding in Pugh. His obsession with synthetics and stark lines lend themselves to being illuminated by colored lights, being replicated or twirled on the screen, or interlocking with one another. Or the garments can manifest on strange lunar landscapes. The body all but annulled, the garment can partake in its own visual conversation.

Fashion film and the moving image have played a major role in the representation of Pugh's collections since his first collaboration with Hogben for his Autumn/Winter 2009 collection. The medium has been apt at capturing the sculptural forms and their dramatic silhouettes, which have been a major element in Pugh's designs, often using a fashion film as a prequel or as a supplement to a catwalk collection. One such example is *A Beautiful Darkness* (SHOWstudio 2015).[21] It begins with an austere, gray barren landscape that then goes to a deep crimson. Embedded within a plain consisting of sand and piles of stones is an inverted pyramid of the same crimson from which clambers a wiry figure. It is dressed head to toe in a tight-fitting suit of the same color with a long spike rising from the head. The face, too, is covered in a thick elastic material. She begins to make jerky, gyrating movements, then the camera cuts to her twirling a crimson headdress that, from the camera's vantage point, looks like a diamond. Cut to a stone outcrop on which stands what at first looks like a black blob decorated with red pom-poms, which turns out to be a bizarre clown figure, also with a conical cap and covered face, but with a splayed, tutu style dress, images of her gesticulating in the air, alternating with the enigmatic red creature. Then to a form

lodged in a landscape of discarded tires: the only trace of humanity are the black arms that appear from a crimson unit of thick circular ribs (a bit like the Michelin Man but to take this comparison further would cheapen things), the head entirely covered by an inverted cone shape. Toward the end, the red figure with the three-pronged hat lies prone and perhaps dead in an insect-like shape against a dry rocky expanse.

There is no point searching for meaning in these films, in the sense of something to be divined within what trace of narrative structure there might be because it won't be found. Rather, the meaning exists within the formal logic of the figures themselves. To return to Deleuze and Guattari, they represent what they called "becoming animal," another paradigm of alterity together with the BwO. The becoming animal is that which reaches to a form of existence that is not loaded with the baggage of humanity and humanism. It is both a different physicalization, and through that, a different way of interacting and grasping the world.

Alexander McQueen had an enduring fascination with animals, which found their way into his catwalks and collections in numerous ways, and in many ways Pugh carries on this tradition. Animalization of bodies occurs again, but with less of the science fiction, in the fashion film that Ruth Hogben directed for Pugh for Pitti Uomo Imaginaire #79 (2011) in Florence, Italy. Themes of metamorphosis abound in Hogben's fashion films as she interrogates how cultural injections such as gender and sexuality and their subject positions might be literally screened onto the flesh of the body.[22] By connecting bodily movements to particular shapes and patterns, Hogben draws attention to the process of becoming android or hybrid by emphasizing the multiple possibilities and fluidity of morphing identities.[23] Screened against the ceiling of the Osanmichelle, a grain marketplace that was converted into a church in 1380, the film plots an eight-minute trajectory of rebirth. Against an inky black ground, the bodies gyrate, crawl and jump in space, eventually appearing as a group, staring down at the camera, giving the viewer the feeling that she or he is about to be their prey. Hogben makes effective use of the mirror-effect, always rather dicey as prone to cliché, in a scene where a woman in a rich blue dress is doubled, her body sideways across the screen. The arms move rhythmically and lyrically up and down, and are subjected to a visual echo effect so that they multiply, to turn her into an Oriental goddess. In another sequence an outlandish but beautiful gold-colored suit, in a futuristically avian style, is replicated and merged in on itself to create shapes that suck up the human body within. Later, in high-contrast black and white, a model in a mask with a Mohawk headdress stands against a white ground billowing a synthetic cloak that captures the air in a way that recalls the inflatables of Pugh's earlier work. The film ends on an operatic wave starting with figures intertwined, the highest one with an arm raised, as might be seen in Late Renaissance or Mannerist sculpture, the pile of bodies calling to mind, say,

Giambologna's celebrated *Rape of the Sabine Women* (1574–1582). All in soft grayscale, these configurations multiply around the screen until it comes to look like a baroque church fresco (as in Andrea Pozzo's for St. Ignatius Church in Rome, 1685–1694). But any suspicion that Hogben and Pugh might be lapsing into a form of humanism quickly vanishes, as the figures begin to stretch and melt away, sucked into a void.[24] In her analysis of the role and function of the nonnarrative fashion films of Hogben and Pugh, Natalie Khan writes that Hogben's films no longer differentiate between object and representation, nor between image and physical presence, real time and projection.[25] Instead, the "boundaries between embodiment and disembodiment are no longer secure, but are breeched by hybrid creatures, or cyborgs, hovering between material and chthonic spheres."[26]

In September 2015 Pugh replaced his Spring/Summer catwalk show with a live immersive multimedia event consisting of film, dance, music and sculpture at Pier 36 in New York City's Lower East Side. Models dressed in body suits and skullcaps contorted and spun to music choreographed by Wayne McGregor in front of three film installations: "Chaos," "Ascension" and "Megalith," which introduced the audience to pagan British folklore and its many cults and rituals. "Megalith" introduces characters found in British folklore, "Chaos," the second film in the trio, features a dark and menacing pagan anarchy and "Ascension" represents rebirth and renewal. "From the opening installation," says Pugh, "a stylised stone circle, we travel through a pagan anarchy, referencing the oppositional forces—black and white, positive and negative, chaos and control— that are all signatures of my work."[27] Pugh's response brings to mind Khan's assertion that by reclaiming the way in which a fashion collection is displayed, such as replacing the catwalk show with a live immersive event, Pugh "gains new control over the way his work is viewed and received."[28] Presented as part of *Lexus: Design Disrupted*, the three film installations are essentially one body of work projected across eight screens and viewed as a triptych. Garments were made from sheer organza and monochromatic harlequin prints. Voluminous silhouettes are teamed with crystal pentagram bodices and cone, and steer skulls made from papier mâché appear as masks and garments that resemble scarecrow deities. A chiffon disc resembles the folkloric costume of the Padstow 'Obby 'Oss, a stylized kind of horse whose function is to catch the young maidens with his disc-like mask and cape as they enter the town. Once again we return to the concept of the mask as a predominant feature in Pugh's oeuvre.

As Vicki Karaminas has written elsewhere, but in the same context, in pagan societies the appropriation of garments that resemble shamanesque figures function as protective or transformative devices. In pagan societies the wearing of garments for sacred rites and rituals, such as the crow or the folkloric Padstow 'Obby 'Oss, is used as a tool to summon the power of supernatural agencies such as the acute instinct of animals. The mask functions as part of a system of

diacritical signs that can only be understood through the correlative and oppositional relationships that binds them. The discourse of masks "and its reliance on harnessing paranormal energies from totemic animals figuratively marks the body through linguistic and sartorial codes and ushers in new ennunciative powers."[29] The garment, complete with mask, allows the wearer to connect to paranormal abilities and aids in the process of initiation into *other* worlds.

The mask also contains the ability to conjure fear and abject horror, but in the case of Hannibal Lector, the lead protagonist and serial killer in Thomas Harris's *The Silence of the Lambs* (1988), the fiberglass mask is meant to act as a protective device against Lector's carnal appetites for human flesh. Lector's mask makes an appearance in Pugh's Autumn/Winter 2016 collection show for London Fashion Week (Plate 7). Along with the Hannibal Lector mask, the models wore tight oversized chiffon coats and stiff shaped clothing reminiscent of postwar fashion with its tailored suits, fitted jackets, pencil skirts, leather gloves and aviator sunglasses as accessories. Pugh's signature high dominatrix collars and saintly halos dominated the catwalk. The models hairstyles were made up in a "victory roll" situated at the top of the head coming back from the forehead and coiled in a stocking. A popular hairstyle in the 1940s for women, the victory roll was coined by American servicemen after the shape that enemy planes made when being shot down in battle. In Pugh's collection, hairstylist Malcolm Edwards said that he wanted to create a "power woman, or a fierce bitch."[30] Make-up artist Val Garland pulled the nylon stocking over the models' face, resting the elastic on their cheekbones to create definition and to pull up the top lip, effectively creating a nylon mask. Garland described the look as if "Joan Crawford was Hannibal Lector's mistress,"[31] a film noir femme fatale and a "macabre illusion suggesting cosmetic surgery's darkest impulse: determined self-mutilation, an erasure of the past as well as the present in the face of too many dues the Devil still has to collect." The collusion of cosmetic surgery with mythological discourses concerning the devil, vampires and monsters is viewed as responsible for the dissolution of corporeal boundaries. The body subjected to cosmetic surgery is a body in pieces, a grotesque and monstrous body reminiscent of Mary Shelley's *Frankenstein* (1818), Bram Stoker's *Dracula* (1897) the flesh-eating Hannibal Lector or Buffalo Bill, the serial killer in *The Silence of the Lambs*. Buffalo Bill, who suffers a form of gender dysphoria, kills and skins his victims to make himself a woman's body suit, which he sutures with a sewing machine in his home basement. He [Buffalo Bill] "rips gender apart and remakes it as a mask, a suit, a costume,"[32] writes Judith Halberstam, "what he constructs is a posthuman gender, a gender beyond the body, beyond human, a carnage of identity."[33]

Interestingly Pugh's collection references film noir's golden age period after World War II when male fears and anxiety of women's liberation and

independence produced pessimism and suspicion. Women were employed in a variety of traditional male roles to help with the war effort while men went to fight in the front. The femme fatale, also known as a vamp, was represented as duplicitous and predatory, subversive and manipulative. In her thirst for power the femme fatale seduces the innocent male hero, who, caught in her web of lies and seduction, leads to his downfall and eventually death. "This collection," says Pugh:

> is exploring the visual codes of power in the corporate and political world. It's not quite a celebration—it's more an observation, and I am looking at the idea of how absolute power can corrupt, and perhaps even make a monster.[34]

Fashion has always been inseparable from the body as a site of disciplinary power and revolt. In a special issue on Body Parts for *Fashion Theory: The Journal of Dress, Body and Culture*, Vicki Karaminas argues that the body has been a privileged site for the study of fashion to which it possible to challenge needs and desires.

> Fashion chose the body, a body that had been displayed, a body that had been groomed and paraded, modified and enhanced. Fashion *acts* on bodies—leaving its signs—brands, disciplines, spectacles, excesses, diets, taboos and transgressions, structuring them in what [Michel] Foucault calls the carnal house of signs.[35]

Monstrous women populate Pugh's Autumn/Winter 2016 collection, dominatrices whose *thirst* and *hunger* for power is embodied in the man-eating femme fatale whose threat to devour, or castrate, necessitates her to be gagged, imprisoned in a mask. Her presence is a perversion that violates and "disturbs identity, system, orders."[36]

From the very beginning of his career, Pugh's work has been a brinkmanship with extremes: identity, subjectivity, emotion, gender, pleasure, pain. Each collection is a challenge to the last. But what all of them share is the persistent reminder of the degrees of transformative, metamorphosing, power of clothes. If "clothes make the man," then Pugh takes another step to suggest how clothes, and the innumerable ways we cover and alter our bodies, help us to realize our power, and that the paradox of transformation is that what we turn into with clothes is in fact the "real" us.

4

MIUCCIA PRADA'S INDUSTRIAL MATERIALISM

There is a photograph of a woman lying on the ground who looks like she is dead. We know this because of the position of her body, legs slightly ajar, arms spread open, palm open. The kind of position that we see corpses placed in murder films or police documentaries. The photographer's signature is all too familiar. Her gray woolen coat is split to the hips revealing her lace slip; she is wearing opaque pantyhose and black stilettos. The detail is not on the body, rather it is on the bag that arrests the viewer's gaze. The bag is open, its contents spread across the floor: a passport, international currency, a compact case and a newspaper clipping folded in a particular way as to reveal the face of a man known as Licio Gelli, the Grand Master of the Propaganda Duo Masonic Lodge. Gelli was an Italian financier involved in numerous scandals, including the failed *coup d'état* to overthrow the Italian president Guiseppe Saragat. Many were aware of Gelli's clandestine activities, including his involvement with the fascist Blackshirts forces sent by Mussolini in support of Francisco Franco's rebellion in the Spanish Civil War. He was the liaison officer between Italy and Nazi Germany during World War II and spent fugitive years in Argentina, where many Nazis, famous and infamous, relocated and went into hiding. A crime had been committed: The woman in the photograph was mysteriously murdered. The evidence is in the Prada handbag on the floor. The photograph of Licio Gelli was a clue, or this is what the photographer Helmut Newton wanted us to believe. What did Licio Gelli and Miuccia Prada have in common? Aside from the obvious of being Italian, they seemed worlds apart. Or so we think. Gelli founded a textile company before his involvement in politics and the war; Prada holds a doctorate in political science and was involved in student and worker uprisings, and protest rallies before becoming involved in fashion in the 1970s. Gelli was a fascist; Prada was a communist. Taken in 1986, Newton's photograph was the first advertising campaign for Prada and it did not last long. Prada received a letter from Gelli's lawyers warning her to pull the campaign off the market or run the risk of being legally sued—a threat that Prada took seriously. Fashion and scandal make excellent bedfellows.

Miuccia Prada came into fashion late, much like Elsa Schiaparelli. It was the 1960s and the women's liberation movement was involved in a series of reform campaigns for women's reproductive rights, maternity leave and equal pay. Prada was an outspoken feminist, attended the University of Milan, where she completed a doctoral degree in political science and joined the Italian Communist Party. Prada was studying mime at Milan's famed Piccolo Teatro in preparation for a career in acting when she was called into the family leather goods business.[1] Shortly after, Prada met Patrizio Bertelli, partner in business and life. Fashion, it seems, was in the cards. "Fashion, it was not the word," she said, "I always say it was the worst place for a Feminist in the sixties."[2]

Miuccia Prada does not follow trends, "she doesn't want to do what the others do,"[3] instead, she likes to disturb. "When I started, everybody hated what I was doing except a few clever people. Because it was not for the classic ones—there was something disturbing. And for the super trendy, avant-garde-ists, it was too classic. I always like to move in that space, never please anybody. There is always something disturbing, which is probably what I am, and I like." Which is exactly was Prada did: She disturbed the tenets and notions of luxury built over centuries by strict sumptuary laws, tastemakers and couturiers, and designed a nylon bag and backpack. The bags were made of Pacone nylon, a new fabric that Prada used to line the interior of the company's trunks. They were light to carry, waterproof, durable and aesthetically pleasing; black, minimalist and industrial with contrasting fabrics and clean lines. The black nylon tote bag with its triangular Prada logo became so popular that counterfeit copies were manufactured worldwide, elevating the status of nylon from industrial to luxury. As journalist Alexander Fury aptly writes, "It was the great nylon renunciation."[4] Prada continued to design luxury bags well into the 1980s when the company diversified into footwear. In 1989 Prada launched her first ready-to-wear collection with minimalist clean lines and big shapes. Four years later came Prada's diffusion line "Miu Miu"—named after Miuccia's childhood nickname. Unlike Prada, "Miu Miu" was more affordable, quirky, eccentric and avant-garde, and was directed to a younger consumer. Miuccia Prada insists that "the creative process in Miu Miu is completely different from that of Prada. Miu Miu is not as complicated and thought out as Prada. Rather than being young, Miu Miu is immediate. Prada is very sophisticated and considered; Miu Miu is much more naïve."[5] This is aided by the brand's advertising campaigns that feature unconventional it-girls such as Drew Barrymore, Chloë Sevigny and Vanessa Paradis, and campaigns shot by bad-boy photographers Juergen Teller, Terry Richardson, Mario Testino and Steven Miesel.

Eight years after Helmut Newton's image of the murdered woman was pulled from circulation, for the Autumn/Winter 1988 Prada campaign, Albert Watson photographed Charlotte Pelle Flossaut sitting at a restaurant table, plates turned upside-down. A glass of water was next to her Prada handbag. We do not

know that this is a photograph of Flossaut because the camera frame has dismembered her body, severed her head just below her nose. Interestingly the audience's gaze is directed at the Prada bag and the model's breasts. Let us digress to another campaign for Prada photographed by Peter Lindbergh for Spring/Summer 1996. The image is of supermodel Christy Turlington standing in front of a row of bushes, a cigarette suspended in her hand and a Prada bag hanging on her other forearm. Yet again we cannot see the model's face; she too has been decapitated, severed at the shoulders. The reading position is made quite explicit: The model in the image is irrelevant; it is the bag that is of importance. Prada's women are fragmented and dispersed bodies in pieces, "images of castration, mutilation, dismemberment, dislocation, evisceration, devouring, bursting open of the body."[6] In her seminal article "Fashion and the Homospectatorial Look," Diana Fuss eloquently argues that the most common type of photographs that are prevalent in women's fashion photography are those of dismemberment and decapitation—in particular, those of headless torsos and severed heads. The headless advertisements construct "an unthinkable body—a body without an identity, a body without a face or sur-face to convey any distinctive identifying features beyond the class-and-gender inflected signifiers of the clothes themselves."[7] The violence of amputation renders the erasure of subjectivity.

Returning to Albert Watson's photograph, the black-and-white image of Flossault captures the nostalgia of the Italian postwar period of optimism and excess that has become known as *la dolce vita* ("the sweet life") after Federico Fellini's 1960 arthouse film of the same name. A film that captures the seductive lifestyles of Rome's rich and glamorous. The reconstruction of Italy after the debris left by World War II was characterized by reconstruction and mass industrialization gaining the moniker "economic miracle," or "boom." It was a period of rapid cultural change, sustained economic growth and modernization characterized by the accelerated growth of urban centers, an increase in industrial production, the expansion of international trade and exports, and increased access to consumer goods. Patrizia Calefato argues that fashion became the leading voice of the Italian economy, the feather in its cap, propelling the country's push for economic and cultural transformation. She writes that "the language of art, photography, cinema, music, television and advertisement became indispensable for fashion, which, in turn, drew its lifeblood from them."[8] The message in Watson's image of Flossaut was quite simple, but risqué: To be able to afford a Prada bag with its associations of glamor and luxury, you simply could not afford to eat, at a restaurant at least.

Twenty years later, photographer Steven Miesel's Spring/Summer 2015 campaign for "Miu Miu," was pulled from magazines after a complaint to the United Kingdom Advertising Standards Agency (ASA). The campaign featured twenty-two-year-old model Mia Goth lying provocatively on a bed in what seems

like a scantily furnished room somewhere, the door is slightly ajar, inviting the viewer inside the room. Mia Goth looked like a child dressed as an adult lying in a sexually suggestive position, which according to the standards agency was "irresponsible and offensive." The add was voyeuristic and contained stylistic elements reminiscent of the reclining nudes of Orientalist oil paintings that contained windows and doors slightly ajar, inviting the white male into the harem with the promise of a sexual tryst. "We considered that the crumpled sheets and her partially opened mouth also enhanced the impression that her pose was sexually suggestive," the ASA commented. "We considered that her youthful appearance, in conjunction with the setting and pose, could give the impression that the ad presented a child in a sexualised way. Therefore, we concluded that the ad was irresponsible and was likely to cause serious offence."[9] Scandal follows Prada.

Making ugly cool

Prada's design oeuvre is often described as postmodern, in the way that she applies unconventional and discordant textures, colors and prints together in a collection. Fabrics clash and stripes are placed next to florals, appearing almost perversely uncomfortable and jarring to the eye. This is what makes Prada's style distinctly unique and is often described as "trashy" and ugly. But this is Prada's intention, to make ugly cool by challenging conventional standards of beauty and exploring good and bad taste. "If I have done anything," she says:

> it is to make ugly appealing. In fact most of my work is concerned with destroying—or at least deconstructing—conventional ideas of beauty. . . . Fashion fosters clichés of beauty, but I want to tear them apart.[10]

For her Spring/Summer 1996 collection, Prada used elevated and obsolete patterns that resembled domestic fabrics that were used for curtains and tablecloths in the 1950s. The patterns were either printed onto cotton or linen tweeds or synthetic materials. "So, as well as being an exercise in elevating ordinary commonplace patterns [in this collection]," says Prada, "it was also an exercise in *trompe l'oeil* illusionism, as the patterns were not in the weaves."[11] The collection featured colors that have not been popular since the 1970s, avocado green mixed with dirty browns. The collection was accompanied by sandals that were considered clunky and awkward, the polar opposite of what was considered sexy at the time. They were made of appliqué leather with an appliqué of flowers, and although considered ugly, the fifty pairs that were available to consumers in the United Kingdom were sold out. "Those shoes weren't nice," wrote Alexander Fury, "they weren't sexy, they weren't like anything

else in fashion at that point. Which is perhaps the crux of their appeal."[12] Similarly, Prada's Autumn/Winter 2010 women's wear collection was a comment of women's obsession with feminine details by using bows and frills at a time when they were considered passé, even to the extent of crude and unpleasant. Prada intentionally chose various shades of fecal brown because it is "difficult and unappealing." For Spring/Summer 1999 Prada designed a women's wear collection that she called "Sincere Chic," which drew on old-fashioned ideas of chic: pleats, scarves, blouses. In fact, you would not call it chic at all, not in the conventional sense, that is. "To eyes accustomed to [Prada's] ugly chic," writes Fury, "her 'Sincere Chic' was, paradoxically, ugly. And that ugliness, that arresting contrast to that which has immediately preceded, is what she strives for,"[13] and does so well. Prada's formula is simple: Take whatever is "out" of fashion and bring it back "in." Plundering the past is a common strategy in the fashion industry, however, like a rag picker or a bower bird, Prada collects stylistic elements from past collections and brings them together in a very distinctive way. A bricolage of classic tailored looks with retro highlights, or postmodern silhouettes with feminine 1940s' shapes such as the garments and styling that appeared in "Miu Miu"'s Autumn/Winter advertising campaign photographed by Steven Meisel. The campaign is full of cool girl gang appeal: Mia Goth, Hailey Gates, Stacy Martin and Maddison Brown. Good girls gone bad. "Subjective Reality" was exactly what the name suggests, a parallel universe of retro and 1980s dressed models on a film set that was rife with 1940s cultural referencing and street style. Typical of Prada's "ugly" aesthetic, discordant colors, fabrics and textures overlap: A burnt orange houndstooth coat is paired with a skirt in ocher reptile, and an alligator pinafore is teamed with a cotton shirt. Shot somewhere on the streets of New York, a passerby stops to clean his glasses; another stops to look at a couple locked in an embrace. Gender is purposely blurred. No passive femininity; for the "Miu Miu" girl knows what she wants and how to get it. "Miu Miu" "is all about the bad girls I knew at school," said Prada, "the ones I envied."[14]

Creative collaborations

In 2001 in collaboration with the architect Rem Koolhaas OMA (Office of Metropolitan Architecture), Prada changed consumers' shopping experience by designing a retail store that doubled as an exhibition space, which offered new ways of shopping. The first in a series of Prada Epicentres, the New York flagship store on Broadway in Soho was a visual statement of the luxury brand's philosophy. In three words: clean, industrial minimalism. Interestingly, yet ironically, in its past incarnation the building served as part of the Guggenheim Museum's administrative offices, galleries and retail space. Prada's choice to

acquire the building as its flagship store was a clear message that the brand was aligned to the arts and a particular taste culture. Conceptual in its approach to architecture and immersed in state of the art technology and spatial design, the Epicentres act as conceptual windows that merge consumption with artistic endeavors. The use of the retail space is reminiscent of an art gallery, with features such as an interactive wall that is updated daily with a mural of Prada wallpaper and a "wave" staircase that connects the floors. Other features include changing rooms that act much like a two-way mirror with sliding doors made from liquid crystal glass that become opaque while the customer is changing. The New York Epicentre was the first of its kind; others soon followed as part of Prada's strategy of global expansion and brand positioning. In 2002 Rem Koolhaas and Ole Scheeren completed the Prada Epicentre in downtown San Francisco, describing the space as "an exclusive boutique, a public space, a gallery, a performance space, a laboratory, a strategy to counteract and destabilize any received notion of what Prada is, does, or will become."[15] The space contains two floating cubes that act as retail spaces separated by a public viewing terrace and coffee bar. There is a gallery space, a showroom and a penthouse on the top floor. Then in 2003 Swiss architects Herzog & de Meuron designed and built the Tokyo Epicentre in the Aoyama District (Figure 7). The six-story glass building's futuristic design is made up of glass diamond-panels that create an optical illusion of movement as the customer walks through the store. Then there was the Los Angeles (LA) Epicentre on Rodeo Drive, also designed by Rem Koolhaas (and Ole Scheeren) and completed in 2004, with its symmetrical hill that supports an aluminum box that surrounds the main retail space. The third floor opens to the Los Angeles city sprawl and the entire wall of the store's façade is nonexistent, merging the street with a commercial space. In the evening, an aluminum wall rises from the ground and seals the building, sealing the store like a compound. Luxury is understood through bold and austere design, maintaining Prada's industrial minimalism characteristic of its brand's design aesthetic. Seoul soon followed with the Prada Transformer, built on the grounds of the Gyeonghuigung Palace (The Palace of Serene Harmony), designed once again by Rem Koolhaas with OMA colleague Ellen van Loon. Erected in 2009, the twenty-meter high temporary pavilion structure is lifted by cranes and rotated to accommodate cultural events. The stark white membrane that is often referred to as an anti-blob is stretched across steel frames of various shapes: a rectangle, a cross, a hexagonal and a circle, and references a circus tent. The structure's concept was that it could be lifted and repositioned, creating unique spaces for art exhibitions, fashion shows and film festivals just like the robotic aliens of children's comic books, films and cartoons *Transformers* who as their name implies shapeshift from dog to train, then to iPod. For a company $785 million dollars[16] in debt that had tried to go public and float on the stock exchange several times without success, it certainly rings true of the old adage

Figure 7 Prada's distinctive store in the Aoyama District in Tokyo, designed by Swiss architects Herzog & de Meuron. Photography James Leynes.

that it is not about how much you earn, but how much you owe that is the measure of success. But it does not end there with state-of-the-art retail and exhibition environments; there is the Fondazione Prada, a nonprofit organization that supports contemporary art and projects in architecture, design, film and science.

When the Prada foundation was set up in 1993, it went by the name of Prada Milano Arte and was located in Via Sportaco 8, an old industrial building that would provide an exhibition space for such artistic luminaries as Louise Bourgeois, Jeff Koons, Anish Kapoor, Michael Heizer and Dan Flavin. The foundation underwent a name change to Fondazione Prada when curator and art critic Germano Celant was appointed its director, and in May 2015, was relocated to its new premises at Largo Isarco in the south of Milan.

Conceived by the Dutch architectural firm OMA and led by Rem Koolhaas, the former 1910 distillery combines seven existing structures with three new ones: Podium, Cinema and Torre, and two new facilities (Figure 8). One is Bar Luce, designed by American film Director Wes Anderson, that recreates the old Milan cafés, and the other a children's play area designed by students from the French École nationale supérieure d'architecture de Paris-La Villette. "The Fondazione is not a preservation project and not a new architecture," said Rem Koolhaas, continuing:

> Two conditions that are usually kept separate here confront each other in a state of permanent interaction—offering an ensemble of fragments that will not congeal into a single image, or allow any part to dominate the others. New, old, horizontal, vertical, wide, narrow, white, black, open, enclosed—all these contrasts establish the range of oppositions that define the new Fondazione. By introducing so many spatial variables, the complexity of the architecture will promote an unstable, open programming, where art and architecture will benefit from each other's challenges.[17]

Curiously, Celant was always suspicious of fashion, especially because of its vexed relationship to art, believing that "fashion sucks the blood of inspiration out of art, while art wants to obtain from fashion fame and success."[18] As we have argued in *Fashion and Art* (2012) since the beginning of the nineteenth century, designers were driven to artistic expression and artists sought collaborative endeavors with designers, such as Salvador Dalì and Elsa Schiaparelli, Yves Saint Laurent and Andy Warhol, or Vanessa Beecroft and Helmut Lang to name but a few. "Fashion might desire to become art, but knows that to become art might lead to its ruin,"[19] for art and fashion harbor different modalities and systems. "A profession that often hankers after transcendence, fashion design may be a creative enterprise, concerned as art is, with identity, but it isn't what artists do."[20] Fashion needed art in order to be taken seriously, and art needed

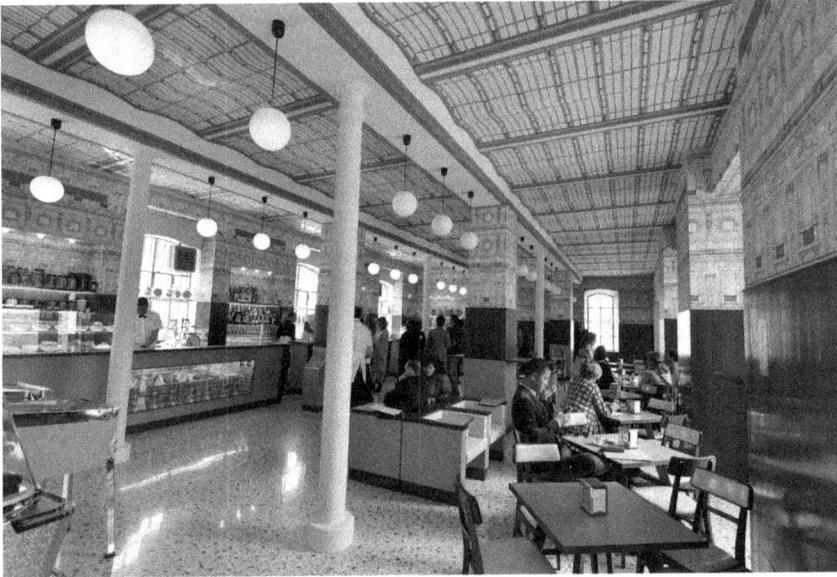

Figure 8 Bar Luce is designed by U.S. film director Wes Anderson and recreates the old Milan cafés' atmosphere in the new venue of Prada's Foundation on May 2, 2015, in Milan. Photography Giuseppe Cacace.

fashion's commercial acumen to reach the appeal of the masses.[21] The Metropolitan Museum of Art recently held an exhibition, *Schiaparrelli and Prada: Impossible Conversations* (2012), which charted Schiaparelli's creative relationships with the Surrealists Dalì and Jean Cocteau, and Miuccia Prada's support for the contemporary arts. Curated by Harold Koda and Andrew Bolton, the exhibition's concept was a series of imaginary conversations between Schiaparelli and Prada that highlighted the similarities between the two designers, although born six decades apart, and to suggest new ways of understanding their creative work, which have had major impact on fashion. Whether Prada is following in the steps of Schiaparelli, considered one of fashion's great innovators, or that Prada is merely following her passion for art, the similarities between the two designers is uncanny, almost genetic.

In her essay "Twin Peaks", which accompanies the exhibition publication, Judith Thurman writes:

> Twins separated at birth sometimes discover that they both play the harp, love Cajun food, and have husbands named Stan. Schiaparelli and Prada are almost alike—indeed virtually identical—in their sovereign ambition to be unique.[22]

Thurman meticulously traces the similarities between the two designers' lives and creative practices in her essay. Schiaparelli and Prada are Italian Catholics born

into wealthy middle-class families with traditional culture values and expectations. They were anti-conformists and feminists; Schiaparelli was introduced to the Dada movement by Man Ray and Marcel Duchamp when she was a divorcée living in New York in the 1920s. A left-wing graduate student of political science, Prada joined the Communist Party and was involved in protests and barricades as part of the student and worker class struggles in the 1960s and 1970s. Later, Prada would complete a doctoral degree in Political Science at the University of Milan, which delayed her entry into fashion till she was forty; Schiaparelli was thirty-seven. The similarities between their two lives do not stop here, but are reflected in their designs and collections. Thurman believes that Prada has followed Schiaparelli very closely because of the striking, almost mimetic resemblances with many of their designs. "A cheeky transparent rain coat, empire waist dresses with *trompe l'oeil* pleats, deadpan mourning wear, cartoonish prints, draped *ombré* gowns, whimsical appliqués and the ubiquitous motif of disembodied lips."[23] The lips to which Thurman is referring appear in the quintessential Surrealist painting, Man Ray's *À l'Heure de l'observatoire: les Amoureux* (On the Hour of the Observatory: The Lovers, 1936), which depicts the lips of his departed lover Lee Miller (along with a female nude) floating away in the sky above the Paris Observatory. Interestingly Prada's feminism and artistic leanings came together in her Spring/Summer 2014 "Ready-to-Wear" women's collection that featured references to political street art and Riot Grrrls[24] feminism (Plate 9). Giant murals by Los Angeles, and South American artists El Mac, Mess, Gabriel Specter, Pierre Mornet and Jeanne Detallante featured on the walls of Prada's Via Forganza venue, but also appeared on the collection itself and its accessories. The artist's brief was to "engage themes of femininity, representation, power, and multiplicity."[25] The collection contained princess coats, cheerleader kilts and tailored tunic dresses in colorways of military khaki and mustard. The message behind the collection? "I want to inspire women to struggle," said Prada.

Like Schiaparelli, Prada's collaborative projects with artists are wide and many. In 2007 Prada commissioned Taiwanese-American illustrator James Jean to create a mural for the Prada Epicentre stores in New York and Los Angeles, and a fabric concept for her Spring/Summer 2008 women's wear collection. The inked drawing depicted a playful and dreamy landscape of eerie fairies, man-eating flowers and hybrid creatures teetering on the edge of a gloomy sexual darkness that was suggestive of the work of Aubrey Beardsley and Art Nouveau. The collection featured silk printed tunics with cropped trousers and cut-away boots. Sarah Mover of *Vogue* described the collection's fabrication as "late sixties, early Art Nouveau-ish—tripping off into the kind of tendrilly doodles girls used to scrawl on their bedroom walls after studying their hippie-romantic rock album covers" (Figure 9).[26]

In any case, Prada and Jean's collaborative ventures included a short animated film *Trembled Blossoms* based on the poem "Ode to Psyche" by the

Figure 9 Actress Shiva Rose wearing Prada Spring/Summer 2008 women's wear collection at the screening of *Trembling Blossoms*, Prada Epicentre Los Angeles March 19, 2008, Beverly Hills, California. Photography Donato Sardella.

English Romantic poet John Keats. Directed by performance artist James Lima, the animated short film used motion-capture technology and was based on Jean's illustrations. Jean wrote the storyboard and worked on the film's visual development, whose aim was to create a classic animated film from Hollywood's Golden Era of the 1930s and 1940s. Much like Walter van Beirendonck's mischievous goat whose eyes flicker with sexual delight when he encounters Heidi wandering alone in the mountains (see Chapter 9), Prada's young nymph wanders through a magical forest and meets Pan, the Greek mythological god of the wild mountains and companion to the nymphs. Pan is represented in Greek frescoes and sculpture as having the hindquarters, legs and horns of a goat with a man's upper torso. Half goat, half human, the hybrid Pan is connected to fertility and spring, and is depicted with an erect penis as symbolic of his sexual prowess. Pan also makes a cameo appearance in Rick Owens's Spring/Summer 2015 menswear collection, referencing Vaslav Nijinsky's choreography of the 1912 ballet *L'Après-midi d'une faune* (Afternoon of a Faun), in which a faun ejaculates over his nymph's lost scarf after a frenzied dance with a group of female nymphs (see Chapter 8). The theme is all too familiar: Pan represents the loss of childhood innocence and the awakening of sexual desire.

Miuccia Prada's first encounter with Damien Hirst occurred at the *Art/Fashion* exhibition, curated by Germano Celant and Ingrid Sischy, in 1996 at Forte Belvedere, in Florence, Italy, and the following year at the Guggenheim Museum, in Soho, New York. In 2013 Prada and Hirst collaborated on the "Entomology" (or bug bag) project by designing twenty exclusive handbags in aid of Reach Out to Asia (ROTA) a nongovernment organization that provides education for those in need in Asia. The handbags are made from a clear plexi-glass shell in which the interior and exterior are assembled insects chosen by Hirst. Each bag is named after a different species. The bug bags are currently on display in the *Prada Oasis and Damien Hirst Pharmacy Juice Bar* (2013) installation in the Qatar desert in Doha. Built inside a traditional *Beduin bayat shaar* tent made of sheep hair, the concept store contains a pharmacy juice bar with human skeletons and light-boxes based on the four elements: earth, wind, fire and air. The exterior of the tent contains a neon sign with the colored carboy logo, Pharmacy Juice Bar. Designed as a reinterpretation of Hirst's restaurant *Pharmacy*, which opened in London in 1988 (and closed in 2003), the installation is meant to create an extraordinary experience in the Arab landscape. Like a desert mirage, or perhaps a simulation, the installation is meant to act as a watering hole inviting visitors to quench their thirst. Welcome to the desert of the real itself.

The project is similar to *Prada Marfa* (2005), an installation of a fake Prada store on Route 90 in the Texan desert (Figure 10). The installation by artists Michael Elmgreen and Ingar Dragset was designed to decompose into a natural landscape. Miuccia Prada selected the merchandise on display as well guided

the corporate design of the store, including the color scheme and logo. The installation is a museum, a hermetically sealed vitrine that houses rarified objects, Prada bags and shoes. One could wonder what a luxury boutique store was doing on a deserted highway in the middle of nowhere? This is precisely the point: The sculpture is conceptually and strategically significant. Marfa is the center of minimalist and land art, and visitors are required to journey to the site to view the sculpture; it was also an exercise in brand positioning. Nicki Ryan believes that "the ambiguous message of *Prada Marfa* did not diminish the status of the Prada brand but rather conflated its image with the innovative, critical and liberal views associated with the artist's work."[27] *Prada Marfa* brings to mind Warhol's gnomic prediction that one day "all department stores will become museums, and all museums will become department stores."[28] *Prada Marfa* (2005) and *Prada Oasis and Damien Hirst Pharmacy Juice Bar* (2013) are fakes—a fake boutique and a fake bar in a desolate landscape— copies and simulations to remind the visitor of the weight of consumerist society. The boutique and bar are *unreal*; they are deliberately created to be *unreal,* a simulation and a representational imaginary isolated from the world of material decay.

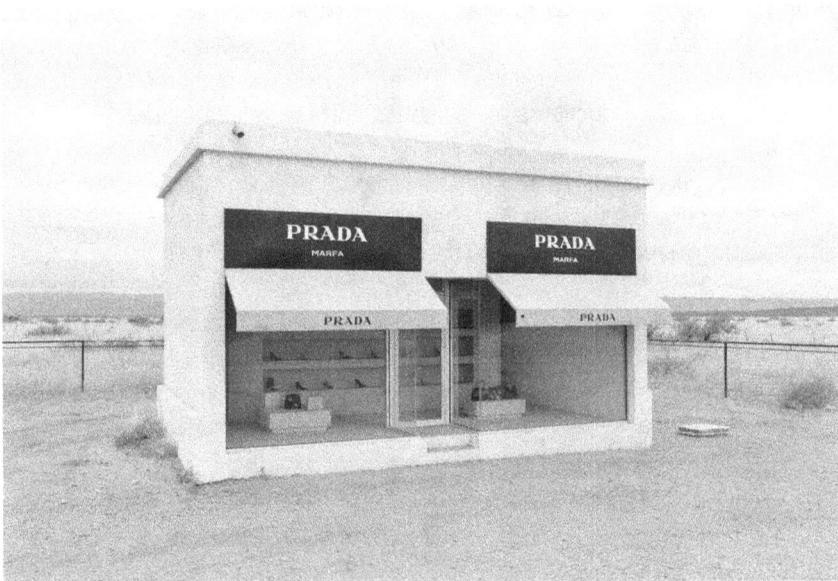

Figure 10 *Prada Marfa* (2005) is a permanently installed sculpture by artists Michael Elmgreen and Ingar Dragset to resemble a Prada store in Marfa, Texas. Photography Scott Halleran.

Prada and cinema

Miuccia Prada's creative collaborations have not been limited to artists and architects; she has also worked with Australian film director Baz Luhrmann and costume designer Catherine Martin on the movie adaptions of Shakespeare's *Romeo and Juliet* (1996) and F. Scott Fitzgerald's *The Great Gatsby* (2013). Film has played a pivotal role in fashion communication since the 1920s and 1930s when movie houses, or cinemas, opened across the world and "going to the shows" became a favorite pastime of young and old—all of which were directly influenced by the fashions and mores projected onto the screen. Fashion designers such as Salvatore Ferragamo realized the power of cinema and its mass appeal and his was the first pioneer designer brand to take advantage of product placement. Ferragamo donated thousands of pairs of sandals to extras in *The Ten Commandments* (1923) directed by Cecil B. de Mille and shoes for films such as *The Thief of Baghdad* (1924). Cinema became a powerful generator of fashion advertising, and more important, brand advertising, and many designers were to follow Ferragamo's lead, such as Givenchy's collaboration with Edith Head for *Sabrina* (dir. 1954), Yves Saint Laurent's creations for *Belle de Jour* (1967), Giorgio Armani's suits worn in *American Gigolo* (1980) and *The Untouchables* (1987), and Ralph Lauren for Jack Clayton's film adaption of *The Great Gatsby* (1974). The forty garments that were designed by Prada in collaboration with Catherine Martin went on display at the Prada Epicentre in New York, before traveling to Prada Epicentres in Tokyo and Shanghai. The installation, *Catherine Martin and Miuccia Prada Dress Gatsby*, featured Jazz Age cocktail and evening dresses that were inspired by contemporary catwalk styles as well as production stills, sketches and backstage footage of the film (Plates 10 and 11).

The interactive mural was replaced by a montage of film stills depicting a party scene. "Our collaboration with Prada recalls the European flair that was emerging amongst the aristocratic East Coast crowds in the Twenties," said Martin, adding:

> The fashions of the time saw the development of a dichotomy between those who aspired to the privileged, Ivy League look of wealthy Long Island and those who were aspiring to European glamour, sophistication and decadence. Our collaborations with Prada reflect the collision of these two aesthetics.[29]

This particular American Ivy League mixed with European glamor style that has been attributed to Prada found its way into the popular imagination with the release of the American comedy-drama television series *Sex and the City* (1998–2004). The series focused on the lives of a group of four successful and upwardly mobile, single thirty-something friends (gal pals) and their daily antics searching for love and adventure (playgirls) in Manhattan—city of high rollers, fashion and

bachelors. Enter *New York Star* sex columnist Carrie Bradshaw (Sarah Jessica Parker), art dealer and romantic Charlotte York (Kristin Davis), lawyer Miranda Hobbes (Cynthia Nixon) and sexually voracious public relations director Samantha Jones (Kim Cattrall). The four friends live enviable lifestyles with stylish apartments, designer wardrobes and disposable incomes. The lead character, Carrie Bradshaw (Parker) was often dressed in Prada or carrying a Prada bag. While the series celebrates conspicuous lifestyles, it simultaneously exposes the superficiality of materialism and consumer culture. The series was perfectly timed to correspond with the explosion of the "chick lit" and "chick flicks" movement of the late 1990s, whose central concern was in exploring what women want. Yet while the series celebrates girl power, it also reminds women of the virtues of traditional women's roles by depicting their characters as lonely, frivolous and misunderstood by men. Although Deborah Jermyn notes that the series engages with third-wave feminist politics, she is cautious in placing a feminist stake in the ground. She argues that young women in the 1990s perceived previous feminist agendas as dogmatic, and that one of the key markers of third-wave feminism was geared around the notion of individualism and choice, unlike second-wave feminism that centered on sisterhood and group solidarity. What has become known as a postfeminist age, Jermyn notes, is that "postfeminist discourses can facilitate a return to prefeminist ideas, according to its tenets [postfeminists] can then use their feminist freedom to 'choose' to re-embrace traditional femininity."[30] In *Sex and the City*, women "choose" to wear Prada, but in choosing to wear Prada they are aligning themselves with all the trappings of luxury brands. Prada becomes synonymous with wordliness. The film *Sex and the City* was released in 2008, followed by a sequel in 2010. If *Sex and the City* made Prada a household name, then the film adaptation of Lauren Weisberger's 2003 novel of the same title, the comedy-drama *The Devil Wears Prada* (2006) secured its place as a leading luxury brand. Once again set in Manhattan, a global center of fashion, the story revolves around the daily dramas and sagas of the fashion publishing world. Andrea Sachs (played by Anne Hathaway), a journalist graduate, lands a job as assistant to editor-in-chief of *Runway* magazine Miranda Priestly (played by Meryl Streep), whose character is loosely based on *Vogue* fashion editor-in-chief Anna Wintour. Not too far into the film, Andrea realizes that the long hours and demands placed on her run the risk of losing her friends and long-term boyfriend and (in true postfeminist fashion) chooses to quit her job rather than lose her man.

5
AITOR THROUP'S ANATOMICAL NARRATIVES

Aitor Throup's fascination with the human anatomy as a subtly articulated composite forms the basis for his design philosophy, a philosophy that cherishes importance of reason and function in the construction of design objects and garments. Taking the body as a fleshy machine, Throup explores the ways in which the human anatomy functions to produce movement and shape, his designs acting as political interventions into cultural narratives. Throup is not interested in the conventional approaches of the fashion industry. He prefers to show his work as a fashion installation rather than as a catwalk performance. "I wanted to know how to make clothing," notes Throup, "but I didn't have any interest in the catwalk or seasons or models. I've never wanted to be a rebel or go against the grain or whatever; it just so happened that I ended up getting very deeply involved with an industry that I wasn't actually interested in."[1] Throup is not interested in fashion per se, that is, the fashion system and the fashion industry and its array of tendentious perceptions and seductive images, rather he can be said to be interested in objects that happen to be garments.

As he states, "If you design an object that can be worn on the body, then people buy it as fashion."[2] Throup is almost exclusively a men's wear fashion designer (an exception is detailed below), whose design process is akin to a product designer. Throup describes how he came to clothing from drawing figures, then feeling dissatisfied with their two-dimensionality, began sculpting the drawings. "Every seam, every dart, every cut, every decision was dictated by the form." Throup explains that his designs are rooted in "process rather than designing a product. So I guess I am somewhere between an artist and a product designer. The re-appropriation of what comes out is fashion."[3] According to this view, fashion for Throup is not the outcome of an intentional process, but a by-product of a tactile analysis of corporeality. This is easier to understand by now after the close discussion of the way Kawakubo shuffles and inverts notions of clothing, body and skin, and how the physical and the abstracted are intentionally confused. In many ways Throup's work is a logical progression from this approach to fashion, as it not only brings into question the clear duality of inside and outside, body and garment, it ventures to a place when such a duality is disturbed

to the point of disappearance. For with Throup, the body is no less a fabrication than the garment. And the garment reflects the body as an organizational unit of mutable parts with an architectonic structure that is in defiance of hierarchy. Working as closely with three-dimensional digital imaging programs as with traditional hands-on methods, Throup's designs, from their conception to fabrication to their final look are more of a piece with the epoch in which genetic engineering, bionic implants and body alteration are now an unremarkable aspect of life. To conceive the body in terms of both process and product is a fundamentally posthumanist as it considers the body as metastable, material and subjectively contingent, not a sum of essential characteristics that amount to a whole, but as a composite of features whose status as whole is a necessary fiction, a fiction itself comprised of numerous subfictions and narratives.

Spinozist fashion

A simplistic but still telling parallel can be drawn between the clothing worn in Descartes's time and his own philosophy, namely, that the outstanding collar on an otherwise dark suit emphasized the head. The standard clothing worn by the middle classes, especially in Holland and Flanders where he lived most of his life, reflected his own concept of mind-body dualism. It is a common, although not exclusive, trait of modern dress to privilege the head, whether through a pronounced collar on one hand or through *décolleté* on the other. Given the importance that humans give to reading and relating to faces, this point verges on being a platitude, except it provides a space for the alternative, which is an approach to clothing in which hierarchies are forgone in favor of relationships, in which qualities of things were determined and measured to things around them and the kinds of effects they exerted.

In philosophical terms, this was precisely Spinoza's variance with Descartes and which also occasioned a *cherem*, or excommunication, of him by Jewish authorities, and to his books also being banned by the Catholic Church. Instead of the mind-body dualism offered by Descartes, Spinoza proposed a systemic way of thinking the body, nature and God. They were to be understood as interrelated sites of exertion and expression, not as autonomous, discrete entities, but as interconnected according to their respective substances and modalities. In doing so Spinoza displaced classic notions of essence, subjectivity and spirit into realms that make them simply component parts to a complex and intricately shifting order. Within this schema, the whole system of goodness and ethics comes into question: Hierarchies, values and likes are not inherent to the thing valued, but rather a reflection of the nature of the subject or agent that does the valuing. A rose is not superior to a skunk because one smells better than another, because there also exist entities attracted more to skunks and are indifferent to

roses. An attribute of something is "what the intellect perceives of a substance as constituting its essence."[4] This basic response leads to important category errors and errors of causality. If a stone falls and hits someone, it is believed by some (or many in Spinoza's time) to have been willed, or fated. The same kind of people, "when they see the human body they are amazed, and as they know not the cause of so much art, they conclude that it was made not by mechanical art, but divine or supernatural art, and constructed in such a manner that one part does not injure another."[5] In other words what are in fact an intricate array of relations are construed according to a plan external to the ways in which things interact, serve and alter one another. To translate this into the language of clothing, clothing is conventionally understood as serving the body. But this presumption ignores that form and function are in fact mutually exclusive.

As one of the more recent major interpreters of Spinoza, Deleuze, explains that "affections are modes themselves. Modes are affections of substance or its attributes."[6] If this is baffling language, it is in part because it brings bodies and nature into a different scale of awareness that draws attention to the complex interplay of causality and the way things communicate with other things and may alter in that exchange. In general terms, this relates to Throup not only in the emphasis on process, but also in the way that the process predetermines the body as a site of multiple surfaces and forms of extensive expression. In Deleuze's words again:

> An individual is therefore always composed of an infinity of extensive parts such that they belong to a singular essence of modality, beneath a characteristic relationship. These parts (*corpora simplicissima*) are themselves not individual; there is no essence to them, rather they are solely defined by the way they are determined from the outside. . . .[7]

Throup's approach and the resultant clothing present the individual as something mediated and always subject to external conditions that in turn reflect and determine the notion of the individual.

To illustrate this point, let us take Throup's film, *A Portrait of Noomi Rapace* (2014),[8] a fashion film of a particular kind, since its emphasis is on making—but not so much making the garment, as making the carapace that leads to the garment. Dubbed to the music of electronic hip-hop musician, Flying Lotus (aka Steven Ellison), Rapace disrobes her normal clothing to don a tight fitting garment with a hood. She stands on dais in a pristine white studio in which Throup and two assistants (in white T-shirts) take casts with plaster cover and gauze of different parts of her body. After the final piece, an impression of her face, is made, the actress departs, and the fragments are sewn together to make an exoskeletal alias, a futuristic human cicada skin. Throup lifts up the figure, now a fragile doll, to take it outside where is sprayed black, returning it, metaphorically,

to its former self of Rapace clad in black, which is how she originally was when she entered. The clothes are then formed around the figure, which is suspended from the ceiling, and allowed to rotate in a manner connotative of a medieval prisoner in an iron cage. The film ends with disembodied/re-embodied figure dangling alone and prone in space.

Hence the portrait is this lifeless object. But that is nothing at all new; in fact it is a commonplace to all traditional figurative sculpture, "petrified in stone" being a standard refrain to refer to marble busts and figures. The main exception in this case is the role that the clothing plays. In traditional portraiture the sitter wears garments that reflect his or her sensibility, status and station. It comes before the fact in electing to have the portrait painted and are subordinate to the subject, whereas here the clothing comes at the very end, indeed as the final consummating component to the portrait, as its very *raison d'être*. It is as if the pre-existing person exists for the sake and purpose of being clothed, and that the subsequent clothing are confirmation, in a retrospective movement, of who the person is. It is clothing that becomes the point of expression and determination. Hence the person's "individual essence," as Noomi Rapace in this instance, is composed of "part'" that eventuate in determinations "from the outside." It is a whole that is nonetheless the sum of its parts and embodies the memories of the process undertaken to make it. In Spinoza's words, "bodies are not distinguished with respect to substance. But that which constitutes the form of an individual consists of a union of bodies. . . . But this union (by the hypothesis), although the change of bodies is continuous, is retained."[9] The body as *corpus* is always a varying ensemble, but preserved as continuity that is coherent and assimilable.

Like Kawakubo who subverts the inside-outside binary and thereby the body-clothing division, Throup's work is a striking example of the way in which clothing, an assembly of a variety of separate units, comes to define what that person "essentially" is, that is, before being clad. And as in this fashion film, the living subject is made absent, and hangs like an empty signified, always elsewhere, outside of the frame. As Deleuze puts in in his earlier study of Spinoza, "What conceals also expresses, but what is expressive still conceals."[10] This means that nothing can be taken as a consistent or autonomous whole, for "everything is a question of nuance."[11] In terms of fashion, such a position reframes that of the "classic item," for both time ("classic") and materiality ("item") are rendered conceptually porous.

Fields of fantasy

Throup's "portrait" is one of many bodily expressions that reposition both body and dress, and the way in which subjectivity, and the images and narratives that flow from them, are either displaced or contained. The rather analytic title of his

first complete ready-to-wear Autumn/Winter 2013 men's wear collection "New Object Research" downplays the hold that fantasy has on Throup's figures and his clothing. In typical Throup styling, black-clad freeze-framed mannequins whose face and hands are covered in ashen gauze are suspended upside-down from the ceiling or in free-fall (Plate 13). Reminiscent of a military combat scene, leather parachute pants, worsted wool hooded coats, skull rucksacks and double-breasted suits with concealed buttons revealed an apocalyptic vision of the city environment. Displayed at the De Re Gallery in London, the collection was more of a fashion installation rather than a catwalk collection, which has always been the preference for Throup who avoids traditional fashion parades and prefers an unconventional approach to the display of garments. His approach to fashion is more like an industrial designer with detailed product development concepts. Brock Cardiner writes that "Aitor's fascination with the human anatomy is continuously at the forefront of his creations, with garments manufactured by combining the pragmatism of product design with the endless creativity offered through art."[12]

Throup's approach to fashion illustration appears to originate in doodling, and of idly inventing characters from out of nowhere. As Throup explains, "The garments are like wearable versions of the characters I create."[13] Built into these garments therefore are narratives, albeit ones that have been withheld, forgotten or which remain in suspension. His drawings have a strong resemblance to those of the Viennese artist of the early twentieth century, Egon Schiele, particularly in the gnarled state of the limbs and the reptilian and simian poses. Commenting on the album cover that Throup did for the alternative rock band, Kasabian, the Internet commentator Kathryn van Beek states wryly that "Throup's images look a little like Schiele's . . . if Schiele had played video games and had an obsession with reptiles."[14] An accurate *aperçu*, except that Schiele's figures share the same reptilian quality. But further, despite the *Sturm und Drang* expressiveness germane to the art of Austria and Germany of this period, many of Schiele's figures lapse into a deadness that makes them resemble dolls: their eyes blank and their limbs limp. In other images his figure(s), often himself, are portrayed boxed within the four walls of the picture plane, as if fending off the outer void, a reflection of existential terror and ennui.[15] If Schiele's figures belong very much in the Vienna of Freud, Klimt and Wittgenstein, Throup's figures—the drawings and the sculptures—represent a different concept of humanity in which the self-fetishizing figure of Expressionism has entered into a different world of psychic uncertainty. While Schiele's bodies are often riven by their own bodily entrapment, Throup's bodies are resigned to this entrapment because they seem to have made peace with the burden of knowledge that their clothing, and by extension all the things that mediate on the body, are integral to their bodily substance and their psychic make-up. Whereas Schiele's figures are frequently naked (as opposed to nude), or offer bared body parts in a state of semi-undress,

as if clothing was only there to be cast off, Throup's bodies are only complete as living entities with the clothing that they wear.

As such, the concept of clothing in Throup's case is different from either the simple act of dressing on one hand (which presupposes a binary of body and clothing), and of masquerade on the other (in which the clothing alters the identity of the wearer). Rather it is the very matter that determines identity, but identity seen here not as cultural or gendered, but as a set of material and experiential facts. Clothing therefore becomes a cipher for the factors inscribed on and embodied by the flesh, the narratives of experience that have become materially transformed.

The video for Throup's "New Object Research" collection depicts two figures hanging in a void, in the manner of the Rapace carapace, but more like his preliminary sketches, in which the bodies are suspended against the blank white ground.[16] The two figures are really the same person, but seen slightly askew from opposite angles, a three-dimensional mirroring. The pale male figure has an uncanny lizard-like slimness that again bears a striking resemblance to Schiele's figures, especially his self-portraits. But whereas Schiele's figures have a raw, unwashed and troubled quality, this body is tranquilized, and in a sterile environment, the collection's title "New Object Research," leading to the presumption that he is exists as a kind of high-tech guinea pig. The sound track ("Trash Can" being the title which brings to the film several connotations of detritus, death and wastage), from Throup's favorite band Kasabian with which he has had numerous collaborations, is alluringly menacing. The clothing on the limp, inanimate figure changes in and out of synch with the musical beat, to mesmeric effect. Beginning as clothed in traditional way, with white shirt and black pants, other garments are added and changed, making the figure's silhouette increasingly unnatural and even surreal; the figure appearing like a captive of garments, while all an inscrutable black, combine a language of winter street wear (hoodies and brimmed hats worn under hoods) and armor (hard lumps and transitions), with a funereal twist (the persistence of jet black).

It is worth pausing briefly and examining Throup's particular approach to fashion film. For the very persistent motif of the limp and inert figure in these films is stark departure from a convention in fashion films, and genre's progenitors, of showing the figure in movement to the point of exaggerated flamboyance. Comparing the recent work from SHOWstudio, such as the work of Ruth Hogben and Gareth Pugh, with films from the early era of film at the turn of the previous century, Marketa Uhlirova sees a continuity of the presentation form that she sees rooted in the serpentine dance. The rich mobility of dress was used as a "physical manifestation of motion and time."[17] Common images were forms that mimicked "flowers, waves, whirls or flames." As she contends, "cinema embraced costume as a device that can mesmerize and hypnotize the spectator, a dramatic and radiant entity with a potential for engendering multiple forms and

optical effects." Such devices were used to bring to harness the power of evocation so as the make the most physicality and tactility.[18] By distinction, Throup's film are everything that "traditional" fashion films are not: pared down, the forms morbidly still and bodily movement only at the behest of the apparatus, the movement of the frames. Whereas other kinds of fashion film use the moving image in order to bring the mannequin to life, it is as if Throup wishes to tame the potential of film, to put it into reverse gear, by putting movement to the service of stasis. The implacable bodies can also be considered as having been extracted from a much bigger continuum, suggested by the titles, which indicate experiences that are well outside the frame, the clothing thus derives from particular stories, or provide metanarratives to existing ones.

Throup's interest in physical metamorphosis through product design is explored in his "Masters Graduation" collection (London Royal College of Art) "When Football Hooligans become Hindu Gods" (2006). The story is a tale of redemption of a group of young British football hooligans who, in a vicious racist attack, kill a young Hindu boy. The collection incarnates this idea in mythological product archetypes that combine the young boys violent past as humans with their divine destiny as gods. Each garment in the series is an interpretation of as aspect of a Hindu god in combination with military influences that serve as a reference to the utilitarian origins of the football uniform. The cultural narrative of racism is also prevalent in Throup's collection "On the Effects of Ethnic Stereotyping," where an object, in this instance the black rucksack, is culturally charged and represents the suicide bomber, a figure of terror and fear in the contemporary political landscape. The collection is a sculpture/fashion installation with a limited edition object launched at Dover Street Market, London. Throup's black rucksack is designed in the shape of a human skull and is functional as a multicompartment accessory. The collection begins with a conventional black T-shirt and plain tight-fitting pants that slowly transforms into an outfit in which the head is obscured and the obtruding backpack all conspire toward some kind of lunar outfit or vaguely insect-like form. This final form marks the ending of the fashion film, in which the figure is shown alone, but upside-down, as if finally put to death or consigned to the clinical vacuum of whiteness.

"The Funeral of New Orleans (Part One)" (Autumn/Winter 2008) collection conveys a narrative of transformation in which clothing morphs from the body to become cases of musical instruments. The work responded to the devastation of Hurricane Katrina in 2005 by drawing on the idea of a traditional New Orleans funeral marching band that sacrifices itself in order to save their instruments. It is through design functionality and physicality that the collection explores the interaction between a musician and their instrument. The interaction is as much literal as metaphorical: the idea that a musician must sacrifice their body in order to save their instrument. The boundaries between flesh and object collapse. The autonomous film "The Funeral at New Orleans Part One" (which Throup

co-directed with Jez Tozer) features the collection and begins with one of the designer's plaster-gauze mannequins wearing a relatively conventional black suit with a small lapel and jodhpur-like pants.[19] But this soon begins to be obscured. The intertitle line reads, "The Musician Protects Himself," and the garment begins to build around the figure like textile armor. At certain intervals the mannequin plays a trumpet, saxophone or trombone, and the intertitles declare, "The Musician Protects His Instrument," whereupon black articles gather around the figure's head, all floating in air, then assemble around the instrument which also hangs in thin air on the right-hand side of the image. This is more than gratuitous art direction; it reminds us of the systematic and highly spatial way in which Throup aggregates clothing to form a recognizable whole. Meanwhile the film is a highly loaded reference to Hurricane Katrina that in 2005 swept New Orleans, causing mass destruction and the death of around a thousand people. (Later in the film is the intertitle: "2:27 pm CDT—Officials Confirm a Breach of the 17th Street Canal Levee 80% of the City is Flooded.") The haunting, elegiac character of the film and its oblique, truncated narration is perhaps a testament to the stories of people who have become swallowed up, not to mention the many deaths from crime and suicide that occurred in the aftermath of the disaster.

The work of fashion in the age of digital reproducibility

Computer modelling is central to the way that Throup designs and creates his clothing and his overall approach to form. His signature android/mannequins bear a striking resemblance to robots and his construction of clothing is analogous to particular methods of digital reconstruction, such as those used to recreate faces. It is a relationship that seems all too understandable once the lines of connection have been drawn, and it is well in evidence in video of the indie musician and friend Damon Albarn's song "Everyday Robots."[20] At its beginning we are presented with a green three-dimensional object, of indeterminate shape, similar to a bent potato chip, floating against a black ground. This is soon joined by three other fragments, one purple, others orange, that remained separate but seem to have some essential relationship to one another. These shapes move in the black void syncopated to the music, and as new segments are added, it begins to form the shape of a skull. Once aggregated, while continuing to move in staccato movements in the space, it begins to be covered by multicolor tubular shapes that begin to take the shape of the organs and tissue beneath the skin. At certain intervals the skull disappears to reveal the tubular apparatus building around the skull, and which bears some remote resemblance to the complex of tubes around the exterior of Piano and Rogers's famous Centre Georges Pompidou in Paris, except more physiognomic in

orientation. The tubes then depart and some kind of digital plasticine begins to creep over the skull eventually leading to a head, which is Throup's portrait of the Albarn himself. The lyrics of the song, include the line, "we are everyday robots getting old": with the animation it leads to the striking sense that we are mechanical creatures subject to the forces of time.

This is a very Cartesian concept, but the way composition follows relationships rather than hierarchies means that the affinity with Spinoza still holds. In his interview on the making of the video, speaks of the process of reconstructing Damon Albarn "to the value of what you see; to not just be the, y'know, the beautiful skin and the layer on top at the end; for you to see that everything comes from, y'know, from somewhere else."[21] Not only is this a portrait, but also the work seeks to express the "antagonism between nature and technology." That Throup pinpoints this is telling, as it this antagonism that his work appears to want to surmount, or displace by casting it into a space where it is not the space of destruction but of creation.

Walter Benjamin's "The Work of Art in the Age of Mechanical Reproducibility" has frequently been cited by theorists of new technologies as an important, if not the, watershed in new media discourses. A long, highly nuanced and much-studied essay, Benjamin's signal contribution was to draw attention to the way that technologies—here visual but his friend Adorno took the lead to write analogously on sound recording—affected the perception of things, from the level of the work of art to the world we live in. In doing so he shows how the way in which we make sense of the world works together with aesthetic frameworks; hence the Renaissance one-point perspective and the genre of landscape painting (which only became an independent genre in the mid-seventeenth century concurrent with the age of imperialism) are themselves technologies. Understood in this way, technology has a systemic relation that is reciprocal with perceptual world views, so that the person accustomed to viewing films has a different way of conceiving the world from one before the age of cinema. The age of mass culture creates new forms of social space made possible through the new availability of virtual filmic spaces.[22] Extrapolating the point, human relations become different after the age of social media, and so on. Benjamin's important work laid the ground for subsequent media theorists such as Marshall McLuhan, who described how the world is moderated, made and understood with and by media, "the things between"; we do not see the world through media but rather in terms of them.[23]

When applied to fashion, digital imaging has altered the approach to body and making on every level, from touch, to the way the in which body and garment is organized. Crucially, digital technologies allow for us to enter into a relationship in which the classic precedence of the body before the garment is essentially shattered. This collapse can be compared to designers such as Kawakubo, but also entering a different stage and field. For whereas Kawakubo destabilizes to the point of reversal the body/clothing (speech/writing) binary through the

garment itself, Throup (and his generation of designers) are able to approach design in which, from the first, neither body nor clothing exists. It is therefore a qualitative shift to a new kind of "starting from zero" approach (Kawakubo), because the garment can be made in virtual space in a way that does not distinguish between body or garment. This is what makes Throup's video "portrait" of Albern so telling, since the head was composed as a garment would be. In fact, the various conceits in the passage of the video, particularly the way the tubing wormed its way in and across the surface of the skull before finally resolving itself into more intelligible lifelike form, mirrors the very process of visual speculation and experimentation that occurs in making a digital prototype. As with many a traditional portrait, then, the artist reveals more about himself than his subject. The composition of his friend's head is really a meditation not only on the way Throup approaches design, but also on the way in which, in his work, body and garment have an agonistic, yet always indissociable relation. It is a relation in which they exist conceptually as separate but (as with the classic speech-writing dynamic) in which they are active and meaningful only in tandem (this reciprocal cross-relation is what Derrida calls *différance*).[24]

In order to grasp changes that digital three-dimensional imaging impose on clothing design, let us consider a short, and perhaps crude genealogy of the body and the garment. "Primitive" or pre-civilized clothing is used to cover the body for the sake of warmth of the protections of vulnerable body parts. With civilization, which encompasses the taboos associated with socialization, questions of excess in terms of both modesty and non-utility (decoration and adornment) enter into the equation. In ancient times, garments were draped over and around the body, leaving no ambiguity as to the body as the initial architectonic support. With modern tailoring, a design is adapted to the body, while *prêt-a-porter* makes assume a variety of bodily types, from large to small. Modern tailoring that is either singular or generic follows the presumption that the garment is assembled from a set of parts. While digital design can follow the same model, it also has the potential for a more lateral approach, in which the variations are infinite, in contrast to the analogue tailoring approach of variations on a theme, modifications according to an ideal model. With digital imaging there is no ideal model only workable relationships.

A relatively early but still relevant text on digital imaging, Lev Manovich's *The Language of New Media*, provides many useful analyses of the particular formations of digital imaging. In the case of digital compositing, it:

Exemplifies a more general operation of computer culture—assembling together a number of elements to create a single seamless object. Thus we can distinguish between compositing in the wider sense (the general operation) and compositing in a narrow sense (assembling movie image elements to create a photorealistic shot). The latter meaning corresponds to the accepted

usage of the term "compositing". For me, compositing in a narrow sense is a particular case of a more general operation—a typical operation in assembling any new media object.[25]

Manovich's explanation is clearly not centered on three-dimensional imaging, however the principles of the way an object is fabricated in virtual space are the same: the fluidity of assembly, the integration of parts into a unit. "Once an object is partially assembled" Manovich continues, "new elements may need to be added; existing elements may need to be reworked. This interactivity is made possible by the modular organization of a new media object on different scales."[26] The limitless variability of the object being designed also assumes a seamlessness with the body at several levels, for the digital garment is itself a body. The same programs are used for cosmetic surgery and for the design of prostheses. As opposed to analogue tailoring whose parts are variants on a convention (the gusset, etc.) subservient to a body within, or as opposed to garment design that upstages the body (deliberately oversized clothing, or Miyake's single piece of cloth, example), with digital there is no distinguishing garment components and body parts as they are just integers of formation. There is no distinguishing between actual body part and prosthesis. Both body and clothing are bound together as a mutating Mobius strip, that is, constantly disaggregating and being reformed. Moreover it is a system in which interim body parts, such as the leg, have the same relevance as extremes, such as the collar or cuff.

He's got legs and knows how to use them

The reference of this subheading to the main lyric to the 1983 song "Legs" by the blues-rock band ZZ Top, is a little more than throwaway since the legs they refer to are, predictably the sexualized and objectified legs of certain women, not men. (Incidentally the same album also had the hit "Sharp Dressed Man.") Comparative to the shirt, coat or shoe, the trouser is arguably the most prosaic item of clothing, and men's legs are seldom fetishized, with the exception of body builders of course. In 2010 Throup sought to readdress this perceived imbalance. Presented at the Galerie Jean-Luc & Takako Richard in Paris, the fashion film *Legs* is a suite of designs for pants in a format that is now recognizably the Throup style, the hunched figure dangling in pristine space, in echo of his drawings, rotating with staccato listlessness to a soundtrack of haunting electronica.[27]

As if the film were an opera without voices, or a tone poem, it begins with a "Prelude: Trumpet Trousers, Anatomy Trousers and Calf-Pocket Trousers." These have a roughly jodhpur-like silhouette, although more baggy, fluid and relaxed. The models are shirtless but are in stylized poses with their head held firmly in

their hands, their elbows inward so that the upper body composes a relatively homogeneous unit. (The poses bear startling resemblance to the mournfully hunched bodies painted by Schiele's contemporary Gustav Klimt in his now destroyed ceiling paintings for the Vienna School of Medicine [1907].) When the camera descends to the feet, the stopgap animation moves a zip at the base of the pant to show that it can be worn interchangeably as hiked at the ankle or as extended onto the feet. Meanwhile close inspection at the animation of the figure reveals that at various points torso and legs are anatomically incorrect, with the feet facing the back. The items are given titles signaled to the far left of the screen, many of which will resurface in the "New Object Research" collection: "Trumpet" (presumable due to the shape of the trouser), "Calf-Pocket," and, more beguilingly, "Anatomy." "Chapter One" is "The Funeral of New Orleans (Part One)" in which a young Negro man, again his face firmly in his hands, is the model. The pants are titled "Trumpet," "Saxophone," "Trombone," "Sousaphone," and at intervals the figure wears the felted carapace equivalents of an instrument on his back.

The component parts, the qualities of these garments, are enumerated as if they were part of the taxonomy or involved in some clinical scientific trial. The traits of "Saxophone" are list as:

i. Multi-paneled weather protection (jacket components);

ii. Traditional pocket hidden in pleat;

iii. Diagonal pleat below mid-thigh;

iv. Foot guards offset inward ninety degrees around ankle construction;

v. Elongated leather-soled foot guards

vi. Top side zips per foot guard

Once again we are made to think that we are witnessing the building of the sartorial robot, in which the fragments are justified according to some common, programmatic goal. The hunched figure is ambiguous in its import: subjectivity annulled but yet at the same time exuding melancholy.

The third "chapter" to the film is titled "Tailoring Concept One: Negative Space Anatomy," which features white pants of "dimpled upholstery fabric," also declaring that it is "Multiple dart and seam construction dictated by dimensions of miniature sculpture." The subsequent "chapter," "Seasonal Character Study," involves (black) pants with modular retractable foot units, to engage the possibility of light shows accommodated by the garment itself. Importantly, the garment in not fixed, rather inherent to it are a series of options that extend in both form and function well beyond that of, say, wearing a coat open or closed, or adjusting a buckle. These are named as "character studies": It is significant the mode of expression is almost entirely the garment itself. The subject's character inheres in the clothing. "Chapter Five" ("When Football Hooligans Become Hindu Gods")

names the items after these gods: "Ganesh," "Varaha," "Skanda." The trousers are a curious mixture of nonhuman android and urban street wear, with a low-flung crotch and the by now familiar but still unusual pocket-like shoes.

The robotic reversal of torso and legs is more pronounced in the video, making the body seem more like a doll subjected to contortions impossible to regular humans. Keeping the most haunting and enigmatic line until last, shortly after the first set of images figure's torso is then "grafted" with a couple stylised skull sculptures, affixed with straps, round and jutting out aggressively like two huge tumours. The "Garuda" pants, with their "gussetted crotch informed by British Army long johns," this time two rotund baggy outcrops on each outer thigh, is accompanied by a "hinged masked cap with eyeholes." This follows the baseball-cap convention but with unmistakably original twist of enabling the peak to be lowered on to the face, transforming the host into an urban Hannibal Lector. The last sequence is called "Mongolia," in which a bald (apparently, as the face is obscured) Asian model wears black trousers now formally acknowledging the reference to jodhpurs, with "Horseriding Study One." The next "study" is covered with "rubberized wood effect sequins" and what all five items from this line share are the "permanent creases around ankles and knees [are] determined by [a] herdsman's pose." Each set of trousers seems purpose-made, but not for an event or an action, but rather to participate in a narrative. But it is a narrative that is tantalizingly undisclosed, forbidden to us. The faces are by and large hidden, withdrawn, perhaps muted by some unspoken law or unannounced tragedy. It is as if the garment is the only clue, or perhaps has escaped from another parallel, and where only wearing it will give any sense of whence it came.

Skulls, armor and renunciation

As the use of armor began to decrease in the sixteenth century, it became successively more ornate. In other words, armor and particularly the most ornate, which we can pore over in museums, is made at a time when it was becoming increasingly ornamental and anachronistic. Or else it was used theaters other than war, such as tournaments and jousts. It was for the sake of the spectacle that the most novel forms of decoration and design were indulged: noses and moustachioed lips on the metal surface of the helmet, overly long conical peaks to the face guard and so on. The spectacles of violence, and the many narratives that haunted them, was literally worn on the armor's surface.

Throup's coats, hats and hoods from Summer/Spring 2013 menswear collection recall Renaissance armor in many of its manifestations. There is a veiled aggression an obsession with death that unites all of these garments, but it is a deathliness markedly different from the punk-Goth style. Rather this is the death that hangs as a climatic pall: This is the clothing of those privileged

to survive the post-apocalyptic wasteland. It is clothing with unconventional features (such as a veil over hood on gauze-like jacket) made in response to hitherto unconventional living conditions. Like the retractable peaked cap that doubles as a gangland mask, some jackets have thick collar apparatus, echoing the large collars on armor. As revealed in the film *Legs*, Throup draws a considerable amount of inspiration from military and other purpose-made utility wear, exaggerating the utility features to a point of gratuitousness, or creating a hybrid between urban elegance and robotic dolls.

A repeating motif is the skull. Thus begins the exhibition of objects on his website: a gray felt cosmic object with the mouth open, a retractable strip raised from the skull unit, some clasps at the base, and various other unaccountable add-ons, making it unclear as to whether this is an accessory or an autonomous, sculptural concept object to act as a coda for the clothes and other articles that follow, gyrating in plain space, bereft (or freed) of the human form. Throup has made several bags in the shape of skulls. One is leather and the death's head discernible by the leather being stretched to create two eye-craters and pinches for cheek-bones. While the skull has been a little overdone in contemporary art, with Damien Hirst's *For the Love of God* (2007) being a sort of vulgar apotheosis, Throup's sundry skull forms as they appear morphed into hats and bags must be understood as embedded within the staging of death itself as the *sine qua non* of life and fashion. Life itself, and the life of fashion, is inscribed by death's immanence. It is conventionally in fashion's best interests to hide, to disavow its death. By placing it at the forefront of his visual language, Throup's designs live in endless permutations of form in second life, as the undead.

But this does not necessarily mean that Throup gestures toward the funereal, rather his style re-invokes yet also updates the paradigm of modern male dress seen in terms of "the great renunciation." In the words of Gilles Lipovetsky:

> Neutral male clothing, sombre, austere, translated the consecration of an egalitarian ideology as the conquering ethic of thrift, of merit, of the work of the bourgeoisie. The precious coat of the aristocracy, the sign of pomp and pageant, has been replaced by clothing expressing the new social values of equality, economy and effort.[28]

In many respects Throup's work is a making contemporary of this renunciation, in which the struggle and pre-apocalyptic anxiety of the contemporary condition appears in and on the shape, additions and disunities of the garment itself. The notations on the garment can always be seen as ornamental, of course, but they combined with a defensive function, as if anticipating a new kind of warfare and the new ecological and social conditions of the anthropocene era. The design features of Throup's garments are not about pleasure; they are about preparation.

6

VIKTOR & ROLF'S CONCEPTUAL IMMATERIALITIES

Viktor & Rolf (Viktor Horsting and Rolf Snoeren), who have been practicing since 1993, first gained serious widespread notice in 1996 with an elaborate ruse. Their *Viktor & Rolf Le Parfum* was contained in a bottle that could not be opened. But it was more than a high-end prank. The launch of the perfume included a marketing and advertising campaign complete with a press release, crisp packaging and alluring photography—but no scent. The concept was quite simple: a candid comment about the power of the advertising industry to produce desirable and seductive lifestyles through images and promises. Yet as if in some perverse irony, the perfume bottle sold out at the Parisian boutique Colette. Like Duchamp, whose readymades came only after he was identified as a serious artist after attention he garnered in The Armory Show in New York in 1912, this was a deliberate gesture by two serious young fashion designers. And in many respects it is a coda for their entire body of work. For a tenacious leitmotif of absence underscores their work. Absence can stand for many things, such as the void that the fetish seeks to disavow; the intangibility and irreducibility of perception and desire (as applied to fashion or anything else); the absence of the precise starting point for the fashion object (doll, mannequin, image or wearer?); or absence the pure thing, the one, since Viktor & Rolf go to elaborate lengths to present themselves as doubles.

In yet another elaborate ruse, for their Autumn/Winter 1996 collection the designers did not produce any clothes at all. Instead they sent a placard to the fashion editors cheekily declaring "Viktor & Rolf on Strike," which they bill-posted through the streets of Paris. Although taken as a prank, the designers' intention was to shed light on garment production in the fashion industry by producing a collection that contained the absence of clothes. It was also what precipitated the notion of them as makers of "conceptual fashion," fashion where the abstract, immaterial idea holds as much sway as the tangible garment, or where the garment exists for the sake of conveying an idea that cannot be constrained by

the thing alone. In many respects, this fecundity and volatility of the idea as it is mobilized in the fashion object is the theme that undergirds this book, but what is particular about Viktor & Rolf (V&R) to this notion is the way in which it always lurks as a question, or defining argument or unrealizable aim. One way of thinking about the conceptual strategy in the work of Viktor & Rolf is as an ongoing hypothesis. For them fashion is not the solution to a question, but rather a means of posing questions, and of provoking wonder and speculation. It is therefore no wonder that an important feature emerging from their work is a resuscitation of the venerable fashion doll, technically the first fashion model. Viktor & Rolf's dolls are not only the vestigial tools for transacting fashion, but exist as a site of anticipated translation, a process in which something is always lost.

Thus, Viktor & Rolf's work exists in liminal space between what has been realized and what could be achieved. This was already the case with *Le Parfum*. On one hand, in true postmodern style, it was an ironic comment on fashion branding, on the other it was also the ultimate perfume, the perfume to end all perfumes, even before it ever began: "The perfume can neither evaporate nor give off its scent, and will forever be a potential: pure promise."[1] The 1990s was a swelling market for perfume production and consumption. What Viktor & Rolf had in mind was that companies seeking to found themselves would frequently begin with a fragrance (Tommy Hilfiger is one example of this). This was not only because it was a product that could have the highest profit differential, but also because almost any image could be built around it. With enough suggestion, a scent could be made to mean anything at all. (Is Beyoncé's perfume the essence of Beyoncé? Of course it is because they say so!) Its powers of evocation are eminently manipulable and abstract. Thus Viktor & Rolf were simply bringing commercial scent to its foregone conclusion. Whereas scents made from original (as opposed to chemical) sources involved isolated, distilled essences, Viktor & Rolf went to the ontological essence of perfume itself, distilling the element of desire that the perfume as product enshrouds. Their unconventional intervention into the perfume market drew attention to the way that the desire and the promise pre-exist the scent itself, in the consumer and in the expectations that the brand, the associated images and the bottle itself all help to create.

Another example of art meeting fashion was their numbered limited edition plastic shopping bags (2,500) that turned mere commercial object into art in one fell swoop. Like limited editions of art, the shopping bags are reproduced and sold as "art" objects. It was, in the words of Malcolm Barnard, "Evidence that fashion can deal with its products as though they were art,"[2] by divesting the shopping bags of any inherent meaning and turning them into cultural artifacts whose status is conferred according to a system of signs and agreements. As we have argued in *Fashion and Art*, art and fashion inhabit different systems and modalities of presentation and reception and have different responses within monetary and desiring economies.[3] However, there have been instances where

art and fashion have diverged slightly, or have a more displaced relationship to one another. For fashion the effect is what can be called fashion installations. When conceptual fashion breaks away from traditional ways of promoting and presenting fashion, when it abandons the catwalk for the gallery space, then fashion becomes an installation. For example Throup, whose work we address in Chapter 5 of this book, prefers to show his men's wear collections in a gallery space rather than a traditional catwalk performance. Or most recently, for Dutch Design Week 2015, British designer Allison Crank created "The Reality Theatre Mall," a virtual shopping center that allows users to commission one-off bespoke garments. The fashion installations concept is quite simple, the disappearance of retail spaces and its replacement by augmented reality and virtual shopping malls.

Conceptual art versus conceptual fashion

The term *Concept Art* is reputed to have been coined in 1961 by Henry Flynt, appearing in the publication *An Anthology of Chance Operations*, designed by George Maciunas. It was defined as "an art of which the material 'concepts' as the material of for ex music is sound."[4] As for the publication itself, the economical title of *An Anthology* was followed with the subtitle, *of chance operations concept art ant-art indeterminacy improvisation meaningless work natural disasters plans of action stories diagrams music poetry essays dance constructions mathematics compositions*. It was a verbal compilation to which Maciunas then gave the overarching title "Fluxus." Beginning with Dada's free gestures and Duchamp's readymade or found objects (*objets trouvés*— "found objects," but which is also the French term for "lost property"). Conceptual art as it came to be termed is, in Thomas Crow's felicitous words, art that "could be said to exist entirely through its textual definition or stipulation."[5] Another contemporary catch cry was "art as idea" and hence phrases like "the dematerialization of the art object," which then resuscitated the so-called "end of art thesis" espoused by Hegel in his *Aesthetics* (1818–1829), one of the foundational theses of what came to be art history.

Art has evidently neither ended nor completely dematerialized, however conceptual art lays the ground for much of postmodern art for which, ostensibly at least, an idea underpins the aesthetic, material object. An important factor in all of this is postmodern historicism, where for art, the meaning of an image is encoded by historical references. These are precedents that color the work's meaning. Thus a painting of a square in not just a painting of a square but conceptually imbibes, by default, preceding works in which a square is featured: the work of Kasimir Malevich, Constructivist or De Stijl artists, or later, Minimalism. Historicism within art declares the image never isolated or innocent. Part of this ethos is that previous art forms basked in the myth that such innocence and

autonomy was possible. Deconstruction, again, enters into this theoretical fray through exposing such myths, and ferreting out the power structures and the habitual assumptions that admitted of such illusions, or what are deemed to be such. The prevalence, or at least the presiding identification of the concept within contemporary art practice suggests that all visual signifiers are floating as the material/conceptual registers of systems of knowledge and language well in excess of what is at hand. To put this another way, whereas in modernism the avant-garde placed themselves aggressively within history, in order to be against it for the purposes of change, postmodern and contemporary art have lost this immersive logic to the order of time, and maintain a displaced, dislocated relationship to history. A painter of abstract paintings, for example, cannot just paint abstract paintings with the same faith of artists of the 1950s, but must be self-reflexive about changes in the way abstract painting is viewed and conditions by which they are understood. This is, however, more theory than practice, as artists increasingly just recreate wheels regardless, and the work is fed to a gullible and incurious public. The conceptual bases for justifying so-called "post-painting" are liable to be circuitous and lame, as a recent exhibition of one such artist, Christopher Wool at the Guggenheim in New York (2013–2014) has revealed. As we have already discussed in the Introduction, art in the mainstream has suffered a severe diminution of credibility in its ability to be critical and conceptual.[6]

Conceptualism in fashion can then be applied to all the areas and designers in this book as well as several others in the past few decades, in particular Miyake, Yamamoto and Kawakubo. Westwood herself has referred to her work as concept driven, and the historicism and intertextuality of her work is impossible to refute. However, conceptual fashion has come to be applied to Viktor & Rolf for interventions into the fashion industry such as the example described above, in which the content is materially withheld, and where absence is used as a catalyst for a series of intellectual deductions and imaginary speculations. Like the artists following the heroic era of conceptualism in the 1960s and 1970s that coincided with the protest era and the height of the Cold War, the material object is never entirely renounced. But the material object, now the object of fashion, sits as but an element among a number of semantic forces. This is always the case with an object and is a linguistic given, however it is the nature of conceptual art, and now conceptual fashion, to bring the network of contextual forces to the fore of legibility. In the case of the work of art, the citing is of key importance, as it draws attention to issues of history, culture and identity. The same is the case for fashion. Hazel Clark argues:

> conceptual art was distinguished by its temporality; the statement was in the performance itself, not in the creation of a lasting object. Here, we can already see the potential parallels with fashion—not defined merely as the production

of clothes, but with fashion's preeminent relationship to time—past, present and future, to its performative aspects—the configuration of body and clothes, to its potentiality to display and also question identity, and to its capacity to serve as a silent reflector of culture and society. . . . The conceptual designer questioned the conventions of fashion, what it was, what it looked like, how it felt on the body, how it was displayed and sold, and, moreover, where it originated.[7]

For their first couture collection, "Défilé Haute Couture" (Spring/Summer 1998), Viktor & Rolf posed the models on plinths that bore their name, thus highlighting the preciousness of one-off pieces, a nod back to Worth and his "creations," and a signal of continuity of their previous work as artistic interventionists and installation artists. Their first collection for men, "Monsieur" (Autumn/Winter 2003) saw the look-alike designers wearing matching tailored garments with models following suit—twins of couture. The designers always present themselves as mirror images of each other: dark rimmed glasses, trimmed moustache and matching hairstyle. For their Spring/Summer 2001 collection they wore matching tuxedos, top hats and canes, and performed a tap dance to "Putting on the Ritz" and "Singing in the Rain." These measures recall Jacques Lacan's famous theory of the mirror stage in which the external image of the body is reflected in the mirror, and gives rise to the notion of self and serves as a gestalt to emerging perceptions of selfhood. The mirror stage establishes the ego, which is dependent on external objects, on an *Other*. In Lacan's view, the image in the mirror does not reflect the individual perception of a "whole" unified body that is the ideal image. The subject is splintered and will strive throughout their lives to achieve this image of perfection. In the case of Viktor & Rolf, perfection is achieved in the reflection of each other.

The appearance of nothing

In a sense, Viktor & Rolf's launch as designers occurred a little over a year before this with the appropriately titled exhibition *Launch* at the Torch Gallery in Amsterdam in October 1996. This is where the empty perfume bottle was exhibited, but alongside the vestigial supports of a fashion show, including a scaled-down catwalk, a boutique, a photographic studio and a hypothetical media release for the ersatz perfume. Viktor & Rolf's actions, argues Bonnie English, highlights how printed exposure and the increasing media-hype surrounding catwalk productions generates a greater value than the garments themselves, or even their simple representations.[8] A much-cited reference point for the empty perfume bottle has been Duchamp's *Air de Paris* (also known as *40cc of Paris Air*) (1919),[9] a tear-like globe of glass. But to this may also be

added a later conceptual intervention, Michael Craig-Martin's glass of water placed on a glass shelf situated above eye-level, entitled *An Oak Tree* (1973).

Launch was the most forcible transposition into fashion to date of what in art is referred to as institutional critique. Including artists such as Michael Asher, Andrea Fraser, Marcel Broodthaers and Hans Haacke, institutional critique investigates the various supports for art, which hitherto are suppressed or ignored in the primacy given to the work of art "itself." Whether it be an artwork detailing the provenance of a still life by Manet (Haacke) or removing a wall dividing the gallery area to reveal the office space (Asher), institutional critique engages in a reversal that makes the institution the work of art, and to disclose how the settings and measures by which an artwork is exhibited and made visible are neither innocent or dispassionate but rather deploy a raft of hidden assumptions and agendas. The audience is made to feel trepidant and self-conscious, as the artist does the best he or she can to unmask the ideological givens that are tacit but forceful factors in the way the work of art is conveyed and interpreted.

In the earliest work of Viktor & Rolf the garment is not the central object; in fact the material garment is largely held in suspension, both literally and metaphorically, the main focus being on the fashion world as an institution, its protocols and gateways, and how hard these were to penetrate. One of their earliest exhibitions, *L'Apparence du vide* (the Appearance of the Void) was at the Galerie Patricia Dorfmann, Paris, in October 1995: Garments, redolent of clown suits but made entirely of gold lamé, inspired after gift wrapping, were suspended with chains, hovering over garments in black organza placed flat on the floor, as if the dark replicas or sinister shadows of the glittering prize. On the wall in gold vinyl was a list of some of the world's top models accompanied with a sound piece of children reciting the names, like learning a lesson in a classroom. At a time when exhibiting garments was still seen as niche, even more questionable than today (because not embodied), and not belonging to art, although it did receive some attention in art and fashion circles.[10] The year after Viktor & Rolf made flyers with the exclamation "Viktor & Rolf on Strike."

When Viktor & Rolf did actually begin to produce fashion pieces—albeit their first collection in 1998 was not recognized by the Chambre Syndicale de la Haute Couture—they would continue to be accompanied by references to absence, to a subtracting or a gesture to something beyond that the garment or the show could not contain, deliver or represent. In their first Spring/Summer 1998 collection "Défilé Haute Couture," the designers placed the models on a plinth that was among other things an act of undermining their status as living, free-thinking human beings and instead placed them as objects subservient to their "makers," which were the designers themselves. The doll, which would continue to rise in importance for Viktor & Rolf (to be discussed in detail shortly), was again troped in the "Russian Doll" collection, which was staged using a single

model, Maggie Rizer, on a revolving dais who was given with ever-growing layers upon layers of fabric by the designers themselves. Like the *matroishka* doll, the inner doll was subdued and dwarfed to near insignificance by the layers around her.

If there was any doubt as to nothingness as a recurring subtext, for their Autumn/Winter Collection 2001, Viktor & Rolf produced works under the unambiguous title "Black Hole." As to be expected perhaps, the collection was entirely jet black, but with an unmistakably science fiction element. But the most striking part of the catwalk was that the models' hair was dyed the same black, and their faces and other exposed flesh painted black as well (Plate 14). It would be too easy to be satisfied with adjectives such as deathly, eschatological or sinister to describe this collection. Rather it might be instructive to return to Kawakubo's "nothing" aesthetic that ends in addition from which there is abstraction, but also to the neutrality of classic, hermetic fashion, fashion that wishes to meld into life with the severest unembellished lines and surfaces. But of course we know that such styling does not disappear, nor is there such a thing as a styleless or universal style, despite arch-modernists such as Adolf Loos and Le Corbusier railing against decoration as the disease of objective, timeless form. Rather this collection seems to put forward the idea it is only through a particular excess that lack can be reached. We are presented with highly discernible and some might say heavily determined styling. But it is in forgoing and muting these forms, by attempting to insert them into an abstract and unutterable homology, or in other words, by ramping up the volume then abruptly turning off the volume that some strong impression of nothingness is reached, much in the way that music's ambition is silence.

Ciphers

One of the most nuanced collections to tarry with the void was the "Long Live the Immaterial (Bluescreen)" collection (Autumn/Winter 2002), where the central concept color was a bright blue (Plate 15).

The catwalk began sedately enough, with a woman in a black dress and an overcoat revealing some blue finishes around the inside pockets. But then the blue trimming changed color as an image was projected over it. This continued to the ensuing models, who also wore black except for small accents or accessories such as a scarf, a feature belt, a belt buckle, hat, handbag, stockings or shoes, which changed colors and patterns from projections that played on them. As the audience became accustomed to the trickery, certain shapes, fragmentary and interrupted, became discernible on surfaces: skies, a desert landscape, a tropical lagoon, whales, tropical fish, a sunset. After a half dozen or so models, the black dominance subsided to garments using fawn and

white, while the blue gained in dominance, largely in diamond patterns (what would be a favorite and recurring reference to the harlequin costumes of the *commedia dell'arte*, culminating in the "Harlequin" collection of Spring/Summer 2008). The projections continued to work off the blue parts, giving the bodies a coolly cybernetic quality, or as if charged by radioactive energy. The patterns became more oriental and floral, making the projected lineaments more hallucinatory. To confound the relationship between tangible and intangible, the models were also projected onto several screens throughout the space, an effect that reached the pitch of its drama when, in drawing to the catwalk's climax, the models came out wearing garments exclusively in blue. When the images were projected over them—now more urban and less picturesque, with city traffic or highway networks seen from above—the heads and hands appeared to be floating mid-air, their bodies merely silhouetted contours containing the images. The end procession is of all the models, their bodies awash with city night landscapes and finally fireworks, their bodies containers for spaces elsewhere.

The bright cobalt blue in question has two principal points of reference. The first, and perhaps more recognizable to a contemporary audience, is that the blue pertains to chroma keying, also called chroma key compositing, color keying, or color-separation overlay. Its most common usage is to insert images behind a figure for special effects, video games or for the more mundane weather forecaster on television. A figure stands on a monochrome ground that is any color, but largely blue or green, preferred because they differ most in tone from human skin color. This is a process that was pioneered as early as the 1930s, but has been superseded by digital chroma keying, which prefers green, to which video cameras are more sensitive. On analogue film it was blue, due to the compositing process using high contrast film responsive only to blue. This is an important distinction to bear in mind, given the futuristic panoply of digital technologies by the catwalk, but which leads to the second point.

The very bright cobalt that they consistently use in this series is unmistakably "International Klein Blue," the color synonymous (or indeed interchangeable) with the French artist, who in a rhetorical gesture, said that he patented it. Yves Klein was already connoted by Viktor & Rolf in *L'Apparence du vide*, which draws from his famous doctored photograph *Saut dans le vide* (1960) in which the artist appears, arms outspread, leaping from a building. This had been preceded by *La specialisation de la sensibilité à l'état matière en sensibilité picturale stabilisé, Le Vide* (The specialization of sensibility to the primary state as stabilized pictorial sensibility, The Void) at Iris Clert Gallery in Paris, in which he removed everything from the gallery space, leaving only a large empty cabinet. For the opening the gallery window was painted the characteristic blue, also the color of the curtain at the entrance of the space. The entrants were served blue cocktails and queued to enter the empty space.

Klein also conducted innovative staged performances of naked women dragging themselves covered in paint over sheets of paper placed on the floor, which he called his *Anthropométries*. The most famous was staged in 1960 in Paris and was accompanied by his own *Monotone Symphony*, twenty minutes of one tone by three cellists broken by twenty minutes of silence. The color the models used was the signature blue. Giving it a name was more than a clever, cryptic ploy; it was underpinned by a desire to investigate the meaning of being an artist and the nature of artistic creation in the postwar era. As he himself put it, "artists of the twentieth century should seek to integrate into society and stop being bizarre people."[11] In his *Anthropométries*, he acted as master of ceremonies, and proudly proclaimed that he "no longer dirtied myself with colour, not even the tips of my fingers."[12] Klein was one of the first artists to work smoothly across media, and to envisage the artist as a curator or program manager. The thread connecting all of his ventures, and which gives them some semblance of coherence is his "own" color blue.

But why blue? Reading the philosopher Gaston Bachelard, who drew attention to Stéphane Mallarmé's mystic implementation of the "azure" as a figural vehicle for exploring the expression of nothingness: in the poem "L'Azur" are to be found lines such as "Fleeing, eyes closed, I feel who looks/with the intensity of staggering remorse/at my empty soul. Where to flee?"[13] And "In vain? The azure triumphs and I listen to who sings/In the bells."[14] Mallarmé, notoriously one of the most obscure and difficult of poets,[15] was interested in the threshold of language and expression, the power of poetic evocation, and equally, the ability for words to generate blankness. His "azure" was a central idiom for disappearance and dissolution, the transformation into the gaseous, the intangible. It is the screen between us and nothingness. Klein also cites Bachelard himself from his book *Air and Dreams* (*L'Air et les songes*): "In the domain of blue air more than anywhere one feels that the world is permeable to the most indeterminate reverie. It is then that reverie really has profundity. The blue sky grows in the dream."[16] Klein used these ideas and related ones as cues for what he called "overcoming the problem of art." The blue in monochrome form, in bright raw pigment (he said that paint "mummified" the color as money mummifies individuals),[17] is meant to generate a totalizing sensory experience of incommensurability. It is the means to the "indefinable" and ultimately—a notion also dear to Viktor & Rolf—the "immaterial."[18] Blue, then, is a cipher for the imperceptible and the impalpable. Ciphers are containers that are nonexistent when not containing. In this case, blue is the symbol for the carrier of what is unable to be carried. Given that the blue was his and his alone (perhaps today it has become so recognizable that the corollary has become more than metaphoric), it was therefore also an avatar, a stand-in for the artist.

Another foray into the void was the concept and performance piece *Zones de sensibilité picturale immatérielle* (Zones of Immaterial Pictorial Sensitivity), which

occurred between 1958 and 1962, where Klein sold empty spaces in Paris in exchange for gold pieces or a gold leaf, the selling point being that they were buying the Void. Only a substance such as gold warranted such an exchange, he believed. The second part of the performance was to cast half of the gold into the river Seine with an art critic as witness. This act was meant to restore balance since the purchase meant that the space was no longer entirely empty. The rest of the gold went onto gold leaf for his artworks. This is a relatively well-known work, but what is missed in the description is the lesser known fact that when gold is captured on analogue color film, its color negative was, in fact, the same unmistakable blue. Klein's act is thus also interpreted as a gradual act of self-immolation, of self-annulment.

Dolls

To continue the theme of absence and miniatures that haunts the work of Viktor & Rolf, dolls are the ultimate conundrum of presence-absence conjuring a person while also signaling that person's absence. Dolls, it seems, have been an obsession of their work from the beginning of their careers, from the improbable clothing in L'Apparence du vide, the props in Launch, the body-as-sculpture on plinths in the first couture collection, the defiance of anthropomorphic shapes in "Atomic Bomb," the interchangeable use of models and mannequins in "Black Light," and then the direct reference in "Russian Doll." Today the doll is an integrated feature in their work acting at its most simple, as an aide-mémoire of past clothing and a solution to the interminable debates and misgivings surrounding the exhibition of fashion and its timelessness. Caroline Evans argues that the doll represents the ghosting of the alienating effects of modernity, specifically in relation to the female image.[19] The doll for Viktor & Rolf is the embodiment of fashion's timelessness captured in a tiny replica and acts as an allegory of the fashion industry's relentless production and manufacturing regime. Let us not forget Adorno who referred to the waxworks museum, the puppet theater and the graveyard as "allegories of the bourgeois industrial world."[20]

In June 2013 The Royal Ontario Museum (ROM) premiered the Viktor & Rolf Dolls exhibition (previously displayed at the Barbican Art Gallery in London), which featured thirty Victorian porcelain dolls, dressed in tiny replica versions of the designers' iconic catwalk collections displayed on a miniature catwalk installation (Figure 11). The seventy-centimeter dolls were styled to resemble models from their shows including hair and make-up. The concept behind the fashion installation was perception of time and the speed at which fashions change, a concept that first appeared in their "No" women's wear ready-to-wear collection (Autumn/Winter 2008). In the "No" collection, the design duo

Figure 11 A general view at the private view of exhibition "The House of Viktor & Rolf," at the Barbican Gallery on June 17, 2008, in London, England. Photography Dave Benett.

was commenting on the fast pace with which fashions go in and out of style. The show opened with a model wearing a gray trench coat with the word "No" featured as a three-dimensional relief from the bodice, followed by a T-shirt with "No" in embroidered sequins and a strapless black tulle dress embroidered with the phrase "Dream On." For Horsting and Snoeren the doll embodies the concept of timelessness. "What appeals especially to us about these porcelain dolls," comments Rolf Snoeren, "is that fashion is so disposable nowadays. It goes so fast. And it feels like we are freezing time by making all of these dolls."[21]

Viktor & Rolf's first foray into the world of miniatures was their Spring/Summer "collection" *Launch* that was shown in the Torch Gallery in Amsterdam discussed earlier in the chapter. Not too dissimilar to theater design models, they presented small maquettes on a miniature catwalk including a shop, atelier photography studio and a lightbox with miniature *Le Parfum* bottles all scaled down in size. Their fashion dream world was executed and realized on a smaller scale. "We created the ultimate goals that we wanted to achieve in Fashion (but unable to). These miniatures represented some of the most emblematic situations in fashion [that] we wanted to become a reality."[22]

Although in a different context, but applicable to the concept of the doll, Susan Stewart writes elegantly of how the miniature offers a world that is limited by space and frozen in time: "The miniature offers the closure of the tableau, a spatial closure which opens up the vocality of the signs it displays."[23] The

miniature comes to represent a replica or a double of the image of the model complete with all the signs of desire. As we suggest in *Fashion's Double: Representations of Fashion in Painting, Photography and Film*, fashion has always embodied the paradox of replication and that representation is fundamental to the transition from clothing to fashion as it marks the change from utility to sign (this is the central insight of Roland Barthes). Thus fashion, as opposed to mere clothing, is a matter of image. Image is to be understood as what the wearer seeks to project, or in this case the desire and seductive power that is wielded by the media and advertising campaigns. This intention is the result of the inherited meanings that have been projected onto the display and consumption of fashion. These largely come from the way fashion is marketed and displayed, from the photograph in fashion magazines to films. The powerful dissemination of fashion imagery determines what is most desirable. These paradigms are far more complex than simply the look of a season, or rhetoric about "what's in," rather they are shaped from a multiplicity of sources; they haunt those more or less interested in fashion, as a representational super-ego, the silent voice of "should" and "could." "It is the representation, not the garment, that goads our desire."[24]

Despite what might seem an eccentric, if highly marketable, obsession, dolls have had a close relationship with the language of fashion since at least the late Middle Ages, when they were used to communicate desirable garment trends across towns and countries. Some of the earliest known dolls, such as those of Roman antiquity, have been compared to Barbie (which also began as a fashion doll before migrating to become a toy), operative in serving as a role model of social and gender mores.[25] One of the earliest records of dolls circulating between courts appears in accounts from Charles VI of France in 1396 making records of payments to Robert de Varennes, embroiderer and valet to Isabeau of Bavaria, for "dolls and their wardrobes for the Queen of England."[26] Another slightly later but highly notable case is in a detailed letter from 1515 by Frederico Gonzaga requesting on behalf of François I a doll from his mother Isabelle d'Este.[27]

By the early sixteenth century, fashion dolls already had their designated specialized craftsmen, the *poupetier* or *poupelier*, who also made masks and theater costumes. And the huge attention to detail increasingly lavished on dolls rules out their use as playthings, as they were treasured as part of courtly dress culture. By the late seventeenth century it was a common practice of French dressmakers to communicate their ideas to people abroad using dolls, a physical and deceptive because diminutive form of advertisement whose persuasion was predicated on the draftsmanship of the doll and the clothing. Given the limited mobility of women, the rigors and dangers of travel, dolls were inestimable features in the transaction and dissemination of fashion and taste.

With modern fashion the relationship between women and dolls becomes more intricate, subtle and complex. While in antiquity the doll had the purpose of

instructing basic codes of appearance and deportment, in modern times the notion of ideal role model was taken to a new level that implied a paring down of action and will. This cross-relation was enforced by the corset, which imposed on the female body an unnatural shape resembling the shop dummy, thereby suggesting an uninterrupted correspondence between fashion doll, fashion model (mannequin) and shop dummy.[28] The living woman had to insert herself somewhere within this artificial universe. The dolls that were made in ever increasing amounts from the mid-1800s were deployed as part of the fashion industry to educate and to disseminate what was proper and desirable. A climax in the history of the fashion doll occurred at the end of World War II. Deprived and depleted, to breathe life back into the industry, Parisian couture resorted to an old concept. Couturiers would clothe meticulously executed fashion dolls placed against dioramas and decorative settings that evoked a carefree, hedonistic Paris of yesteryear.

When asked about their own penchant for dolls, Viktor & Rolf comment that they suggested play and that these "adult toys" were also "like taking control."[29] They were also an effective means of making sense of their growing corpus of work, and a way of homogenizing it:

Ten years down the line our first thought turned to these dolls when we thought of a "retrospective". We felt a strong need to do something that related to our old work, to use it and make it part of a new story, a bigger one, to turn it into something new—and also homogeneous maybe. By showing all of this together in a doll's house, as if it were one big projection of the future or better maybe, a retro-vision of the future, we try to edit our own past and put a spell on our fates. It was also clear to us from the start that we wanted to use the exhibition to create new work, outside of the context and conditions of the fashion system.[30]

It is safe to assert that in every collection, and in everything Viktor & Rolf do, there is a clear articulation of some realm outside the fashion system. This broaching of an outside is also what they do in relation to time, in bringing the threads of past and future in order to create a space of hypothetical possibility. Like any dolls, their own are catalysts for imaginary embellishment, but they also perform as decisive markers that are an assurance that their fashion items are not evanescent, but are firmly grounded in more than one life cycle. It is also the inherently uncanny quality to dolls that tells of place that we may not enter, to a different and unfathomable experience. The dolls stare at us with graceful and seemingly innocent indifference, but they are also divorced from our experience, our bodies and our own aspirations. If a considerable dimension of fashion is about desire, then the desire they enshrine is suspended, or removed from us and existing in a sphere entirely different from our own.

"No" and beyond

After their Autumn/Winter 2008 collection bearing the unequivocal title "No," it could be said that Viktor & Rolf's work takes a less nihilistic, or metaphysical turn, or ostensibly so. While this may be said of some successive collections, the Spring/Summer 2015 collection destabilizes any premonition that the designers are moving in a direction of optimism. The A-line dresses were floral and colorful enough, but they sat awkwardly on the bodies, and the heads were decorated in large and strangely ungainly dried foliage of straw and artificial flowers. Rather than signify bucolic bliss, this collection was about the mutation of nature, and after nature preserved in memories and museums, and hypertrophied for the sake of pageants. In ample splendor, these garments and especially the way they were presented were suffused with an eeriness that comes from tampering with natural forces. Resuming the doll once again, the models were like scarecrows brought mysteriously to life, and the collection had the strangeness that comes from the overcompensation—there was simply *too much* nature here for any naturalness to be registered. It was the nature of compounded clichés in computer games and other virtually generated environments.

No other fashion collection letter exemplifies the relationship between fashion and art, while also offering us a glimpse into the workings of conceptual approach, than the Autumn/Winter 2015 collection "Wearable Art" presented at the Palais de Tokyo during Paris fashion week. (Palais de Tokyo is Paris's main venue for contemporary art.) As the title suggests, the models quite literally wore garments designed as though they were framed artworks. The designers used hinged frames on coats and fabric that doubled as a canvas spilling from portrait frames, creating garments as abstract artworks. But in the vein of Viktor & Rolf's oeuvre, this was not a mere catwalk display, or a conceptual collection, it also acted as performance art with the designers doubled as performance artist unfastening the garments from the models and hanging them on a white wall (Plate 16). The final work was a Dutch still life on a moving model. The crumbled and manipulated suspended structure gave the impression that it was a Dutch masterpiece. The model was effectively annulled. As the designers added, "Art comes to life in a gallery of surreal proportions. A dress transforms into an artwork, back into a dress and into an artwork again. Poetry becomes reality, morphing back into fantasy."[31] As usual, the designers appeared dressed in the same black jeans, T-shirts and white sneakers—identical twins, Double Dutch.

7

RAD HOURANI'S GENDER AGNOSTICS[1]

Fashion has always maintained a guarded self-consciousness regarding gender. While contemporary dress has its repertoire of gender-neutral items such as T-shirts and jeans, they are generally items worn by men, adopted by women in the interests of economy and functionality. Unisex styling reached its zenith in the 1960s and 1970s when androgyny became a visual signifier and a political tool for second-wave feminists as a means of destabilizing masculine power. Yet strictly speaking, "true," or something resembling authentic androgyny would involve a muting, or a melding, of gender-specific garments, accessories and styling methods to obliterate any biological reading of sex.

In the last five years couture fashion has pushed the gender divide by using transgender (trans) models, such as Andre Pejić (now Andreja Pejić), Hari Nef and Lea T as catwalk models for women's wear labels, and Olympic swimmer Casey Legler has signed as a male model with Ford modeling agency. Pejić is the face of cosmetic brand Make Up for Ever, and Lea T holds a contract with Redken hair products. The opening of New York's first transgender modeling agency in 2015, Trans Models, further enhances the shift in perceptions of gender and body ideals in the fashion industry. A new wave of New York based designers, including Ekhaus Latta (Mike Ekhaus and Zoe Latta), Moses Gauntlett Cheng (David Moses, Esther Gauntlett and Jenny Cheng) and Hood by Air (Shayne Oliver) has been pioneering a gender-neutral aesthetic that is inclusive of all genders, race and body types. Oliver of Hood by Air calls his brand "powerwear," rather than "unisex," and Ekhaus Latta's label is considered "postgender." In what is considered a radical move away from the traditional catwalk process of using casting agencies for models, this group of designers recruits its talent from its own social and creative circles. A recent instance of this is Gogo Graham whose fashion brand targets trans/femme women, launched in Spring/Summer 2016 at New York's Ace Hotel. The catwalk used an all trans crew, including models, DJ and photographer (and muse) Sarena Jara. Ekhaus Latta also cast friends and muses in its fashion films and "happenings," now a preferred platform for exhibiting collections over traditional runway shows. Known for its nonconformist and experimental approach to fashion, Ekhaus

Latta's fashion film *Roach*, directed by Alexa Karolinski, was named as one of the most provocative campaign videos for Autumn/Winter 2015 by *Daze* magazine. Filmed using several formats, from professional devices to iPhones, the video features scenes of the designer David Moses (of Moses Gauntlett Cheng) and artist John Mercer Moore kneeling on a bed interspersed with images (seen through a septum piercing) of male genitalia covered with salmon, swarming flies. Another scene has a man urinating in an open field. In addition to Moses and Mercer Moore, *Roach* also stars fellow creative artist Skye Chamberlain, photographer Robert Kulist, and Bobby Andrews. The voice of Nora Slade dubbed the sequences reciting a poem written by the designers. And to draw attention to fashion stereotypes of body and gender ideals, there are creative practitioners Ava Nirui and Alex Lee collaborated on an installation in which Barbie dolls wear miniature garments designed by Eckhaus Latta and Hood by Air. This new wave of gender indifference begs some greater questions about fashion, fashion's history, and with it, the fluid and slippery constructions of gender. Finally in the realm of popular culture, in the sequel to *Zoolander*, the spoof about fashion and commodity culture, an androgynous model is featured in several scenes. In the effort to make their comeback, the veteran male models Derek Zoolander (Ben Stiller) and Hansel (Owen Wilson) are confronted by "the biggest supermodel in the world right now," who goes by the name of "All" (Benedict Cumberbatch) who pronounces that "All is all to all" and they are told that "All just married her/himself." He is an example of a "non-binary individual."[2]

Canadian Rad Hourani, a New York-based designer, is known for his unisex label RAD, which was launched in 2007. Hourani's designs are deliberately genderless: What he calls "agnostic," they concentrate on garments that are staples in men's wear and women's wear such as T-shirts, jackets, jeans and shoes. For his Spring/Summer 2014 collection (Plate 17), Hourani sent models dressed in black down the catwalk wearing silver masks as a deliberate strategy to obscure any overt reading of masculinity or femininity. With this, and various other collections, and his photography and video installations, Hourani has established himself as a designer at the epicenter of gender-neutral fashion.

Unisex, unsex and the tyranny of gender

The gendering of clothing and dress is as old as civilization itself. It follows laws of ritual and of common sense, being relative to the different roles that men and women had to play in the subsistence of their species, ultimately becoming registers not only of utility, but of the spaces they occupied and identifiers of belonging such as totem. Take away subsistence and there is an altogether

different unit of measure. By modernity the signifiers of dress are far more abstract and shifting since it is a site of power and class—and not with any ritual authenticity, but is an elusive and agonistic relationship between the possession of status on the one hand and the desire for it on the other.

The gendering of clothing is not to be taken for granted, however. For it is also true that certain cultures, particularly non-Western, have adopted clothing practices in which genders were indiscernible, or at least not pronounced. One example of this was pre-Meiji Japan in which men and women of the middle and upper classes wore a *kosode*, a wrapped garment often worn in combination, and in muted colors of gray or beige. Courtly dress had provision for the *osode* ("large sleeve"), accents of color of inner layers could be exposed on collar and sleeve. The act of wrapping with a sash (*obi*) dates back to Chinese Tang and Sui court styles. The simplifications in Japanese dress occurred in the Kamakura period, especially with the upper classes, which tended toward a more pared-down dress style to meet the measures of austerity caused by the impoverishment wrought by civil war. The silk inner layers would have references to gender (for example cherry blossoms or cranes for women, dragons or storm clouds for men), but these were not openly displayed. It was this layer that was liberated to an autonomous item, the *kimono*, in the Meiji period. In effect, part of Japan's campaign for competitive modernization was to jettison styles more subtle to the expression of gender to one that made stark divisions. Henceforward the difference would be stark. While the Japanese woman was a pronounced image of Japanese womanhood, as constructed at the time, the man dressed as the international industrial conqueror: black suits, hats, canes and gloves. It was a division that was believed to mirror, but not replicate, those found in the West of the late nineteenth century, where men were dressed for action and women, still corseted, for display.

The development of modern female dress at the end of the nineteenth century unleashed innumerable reproaches for fear that they were becoming too mannish. Suffragettes were synonymous with Bloomerists, the wearers of puffy oriental-inspired leggings that, even when worn with a skirt, seemed to be in direct defiance of the conventions of femininity. Chanel and Patou would take this further with simplified clothing whose premium lay on mobility and versatility, for it was still common into the early twentieth century for the upper middle classes to change several times a day. The emphasis on practical dress also meant a more universal kind of clothing that muddied gender distinctions. Younger generations welcomed the novelty of this, while older ones saw such alterations as serious breaches in social protocols. One very significant watershed in the unisex direction was Chanel's adoption after World War I of the now famous and much-styled long-sleeved, blue and white striped cotton shirt, otherwise known as the *marinière*, after the French mariners who had worn it since navy uniform regulations were put in place in 1858. Sported by Chanel herself, the

shirt would subsequently be made famous by the likes of Picasso, Jean Genet and Marcel Marceau.

Another, less cited factor in Chanel's design tendencies toward dress styles that weakened the once very defined distinctions between the sexes was her own body type: svelte, narrow-waisted and small-bosomed. (And for those who criticize models such as Kate Moss for being too slim, it was Chanel who played a large part in making the emaciated model part of fashion culture.) In the early 1900s, during the early years of her career and her relationship with Etienne Balsan, she often found herself in men's clothes. As Chanel's recent biographer Rhonda Garelick goes on to explain:

> Photographs from this period show Chanel in open-collared men's shirts worn with little schoolgirl ties, oversize tweed coats borrowed from Étienne, and simple straw boater hats, like the ones the men were wearing. These little boaters looked effortlessly chic next to the heavy and ornate concoctions typical of the period ("enormous piece on heads, monuments of feathers, fruits and egrets," as Chanel described them).[3]

Dressing in men's clothing, and noticeably so, was a strategic measure to participate in the "great male renunciation," to resuscitate Flügel's phrase, and to disassociate from the cumbersome, ornate and expensive styles. Her designs at the end of and after the war years were lauded for their economy, a virtue understandably much in demand at the time. While Chanel is a notable forerunner in the development of unisex (and sports) clothing, the concept would only come into its own once a relatively clear line could be drawn between men's and women's wear, that is, unisex and androgyny in the revolutionary and liberationist period of the 1960s and 1970s, when garments were seen as the answer to conquering the inequalities of the gender divide.

Since 2008 Rad Hourani has been actively challenging gender binaries with his futuristic label "Unisex." Narrowing the concept between biological sex and gender as way of movement, acting, performance and being-in-the-world, Hourani outrightly states:

> Androgyny is a style, feminine is a style, and masculine is a style. What I am trying to do are not androgynous clothes. What I am doing is creating a neutral canvas that people can use and adapt to their wardrobe any way they want. Unisex is not a style it is a neutral garment and lifestyle.[4]

Designers such as Paco Rabanne, Pierre Cardin and André Courrèges had been toying with the idea of a unisex egalitarian space-age aesthetic during the 1960s with simple silhouettes and graphic patterns in the new synthetic fabrics such as polyester and nylon that were not historically associated with any particular

gender. Influenced by the women's liberation movement, designers envisioned a future in which fashion was not dictated by one's biological sex. Take for instance the Viennese born, American designer Rudi Gernreich whose avant-garde designs were considered innovative in the 1960s and that reflect an era of frenetic questioning, iconoclasm, revolution and liberation. Well known for his functionalist elasticated knits, Gernreich's design philosophy was to eliminate all extraneous additions and embellishments for the sake of a clean minimalist line. Having studied dance and anatomy before embarking on a career in fashion, Gernreich was highly attuned to the restrictive nature of certain fabrics on the movement of the body. At a time when women were burning bras as a symbolic gesture of freedom against the restriction of gender enforced by patriarchy, Gernreich designed the "no bra bra" made of nylon so that breasts could assume their natural shape rather than be pushed forward and sexually enhanced for the titillation of men. Gernreich envisioned a gender-neutral future of turtle necks, tunics and jumpsuits, and in 1975 created the mono-kini and unisex thong for the British science-fiction television series *Space: 1999*, written by Gerry and Sylvia Anderson and produced by Group Three Productions (ITC/RAI) (Figure 12).

Gernreich's concept of unisex clothing, which he described as "an anonymous sort of uniform in an indefinite revolutionary cast," was further explored in his "Unisex Project" (1970). Male and female models were shaved of all body hair and wore identical garments from bikinis and mini dresses to trousers and Y-fronts (Figure 13).

Androgyny and the different "third terms"

Space-age design, and "his and hers" jumpsuits and ponchos, soon gave way to a sexier androgyny that combined masculine and feminine elements of garment design rather than attempting to avoid gender markers all together. Mainstream fashion also drew inspiration from the subversive image of the (female) androgyne with slicked-back hair and mannish suit as photographed by Helmut Newtown. The image draws on the erotic representation of Marlene Dietrich (who incidentally was bisexual). The iconic cross-dressing image comes from her role in the film adaptation of Heinrich Mann's *Blue Angel* by Emil Jannings in 1930. Dietrich is photographed in the dimly lit street and contains suggestions of desire and power. Designed in 1966 by Yves Saint Laurent (YSL), "Le Smoking," a tuxedo for women, drew inspiration from popular culture and the women's movement, and was the first of its kind to earn attention in the fashion world. "Le Smoking," which was less of a reference to a smoking jacket and more to the fact that it was once considered *outré* of women to smoke in public, was designed as part of Saint Laurent's "'Pop Art" collection. It

Figure 12 "The Thong" by Rudi Gernreich. Gernreich said that the unisex swimsuit evolved from the "string," the "Mawashi" loin cloth worn by sumo wrestlers, a 1930s Austrian worker's swimsuit and a thong sandal. Photography Bettman.

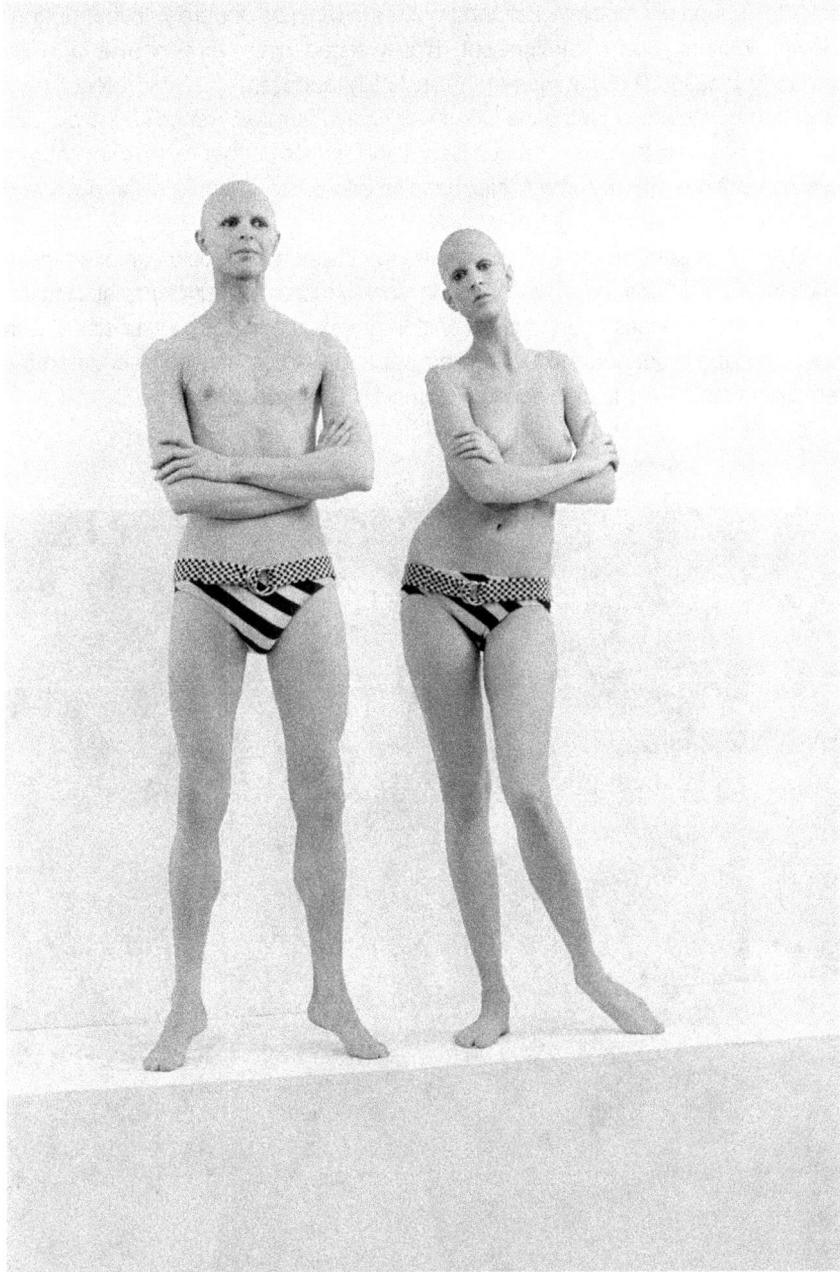

Figure 13 Rudi Gernreich's "Unisex Project," 1970. Photography Bettman.

took the shape of a black jacket and trousers in *grain de poudre* with four button-down pockets, and a straight-cut, high-waisted satin version over a white organdy blouse. The suit was enthusiastically adopted by a chic collective of style icons, including Catherine Deneuve, Betty Catroux, Francoise Hardy, Liza Minelli, Loulou de la Falaise, Lauren Bacall and Bianca Jagger. Yves Saint Laurent would continue to reinterpret this mannish silhouette in khaki safari suits and gangster pinstripes (Figure 14).

By way of parallel, the U.S. designer Roy Halston (Frowlick) exploited clean lines and minimalist designs to create comfortable and functionalist clothing such as shirt dresses and strapless chiffon gowns that became associated with the international jet set, the well turned-out and glamorous who frequented the emerging discotheque club scene (Figure 15).

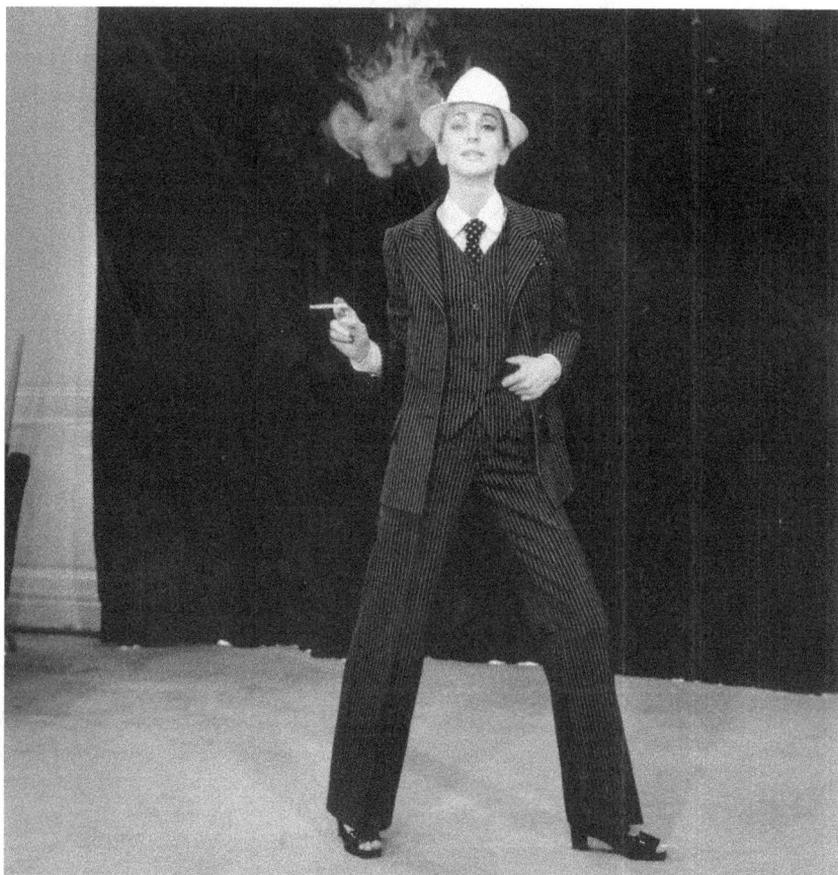

Figure 14 Pinstriped trouser suit by Yves Saint Laurent. His plainer suit for evening wear, known as "Le Smoking," became his signature piece. Photography Reg Lancaster.

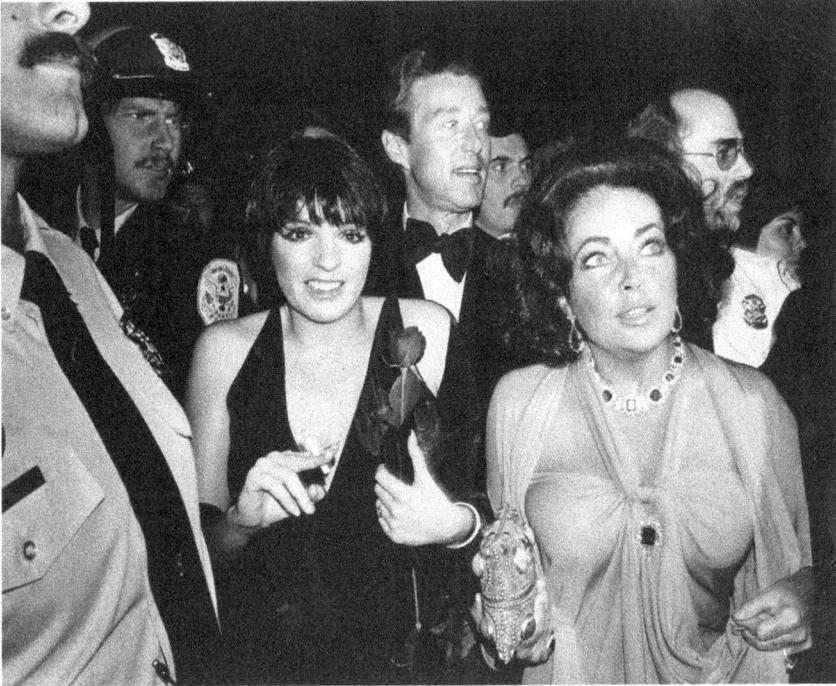

Figure 15 Elizabeth Taylor, Roy Halston Frowick and Liza Minelli are escorted by U.S. Park Police in Washington DC. Credit: *Washington Post*.

This comfortable style was indicative of the liberated working woman, whose pea coats, trousers, trench coats and blazers became wardrobe staples. The influence of street wear on mainstream fashion cannot be underestimated and designers such as Yves Saint Laurent and Halston were influenced by an androgynous style of clothing that was adopted by second-wave feminists as a look that spoke about self-identity and belonging to the "sisterhood" of women's liberation. This androgynous style of dress was "anti-fashion" (which, remember, is not an escape from fashion, but a subcategory within it), and was characterized as comfortable and loose fitting, such as flannel shirts, loose jackets and baggy pants. Its intention was to "hide" women's curvaceous bodies that had been objectified by the male gaze and by media representations of women. Hair was worn cut short, and tennis shoes, Birkenstock sandals or Fry boots were also considered part of this "anti-style."

Although well founded in its intentions as a strategy to destabilize gender along with the bedrock of masculinity, androgyny prioritizes the masculine signifier and its gender-associated sartorial stylings: shirt, tie, short hair, monocle and suit. The concept of androgyny has dipped in and out of fashion since the 1920s "boyish" or masculine flapper look came to be known by a variety of

names, "boyette" or "boy-girl," but it was not about sexual preference as it was about being "modern." This trend toward the wearing of a masculine style of dress and accessories, monocle and cigarette were symbols of freedom and decadence that women embraced after World War I when they had gained the right to vote and wore trousers for the first time. Menswear was also influenced by androgynous styles with Pierre Cardin interpreting the traditional mandarin-collared, button-front Nehru jacket (named after the prime minister of India) and Yves Saint Laurent's cotton khaki safari suit for men. Various other examples of feminine sartorial styling for men have appeared on the catwalk since the 1960s with men wearing skirts as an act of transgression and as a declaration of an alternative lifestyle. In the mid-1990s British footballer and metrosexual icon David Beckham was photographed in a Jean Paul Gaultier version of a sarong. Jean Paul Gaultier's Spring/Summer collection 2002 "Ze Parisienne" contained the "Mussette" ensemble, which consisted of a beaded-striped sweater and a black stretch-wool pants skirt.

Androgyny, meaning having traits of both sexes, is also etymologically consistent combining "man" (anēr, andr–) with "woman" (gunē). In Western thought, it receives its first, lengthiest meditation in Aristophanes' monologue on human sexuality as related in Plato's Symposium. Here Aristophanes explains that the tension between the sexes is due to the fact that once, long ago, they were as one. When sundered, we were forever condemned to try to find the other, complementary, unifying part. But there were originally not two, but three sexes: man, woman "and the union of the two, having a name corresponding to this double nature, which had once a real existence, but is now lost, and the word 'androgynous' is only preserved as a word of reproach."[5] He goes on to describe a fairly outlandish creature, with four arms, two faces, "two privy members" and so on.[6] They displayed extraordinary power, which was seen as a threat to the gods, causing Zeus to devise a solution of splitting them in half, and Apollo refashioning their forms, and healing the wounds caused by the scission. But after this was done each half could not live without the other, and they risked perishing from "hunger and self-neglect."[7] As a solution Zeus placed the genitals in front, so that "they sowed the seed no longer as hitherto like grasshoppers in the ground, but in one another."[8] Thus the opposite sexes could breed, but there was more:

> The male generated in the female in order that by the mutual embraces of man and woman they might breed, and the race might continue; or if man came to man, they might be satisfied, and rest, and go their ways to the business of life: so ancient is the desire of one another which is implanted in us, reuniting our original nature, making one of two, and healing the state of man.[9]

The choice of words is telling, since two-sex coupling is an "embrace" so "they might breed," while the same-sex coupling induces satisfaction and calm. One

is for perpetuity of the species, while the other is for pleasure and for a stable and active life.

But further, according to Aristophanes' allegory, it is the third sex that is the minority, and which in his topology, is queer. The third sex, being the androgyne, is the man in search of woman, or woman of man. The first and second sexes of men-men and women-women are therefore clearly in the majority. Furthermore, the most manly of these are the men once tied to other men: "and while they are young, being slices of the original man, they hang about men and embrace them, and they themselves are the best boys and youths, because they have the most manly nature."[10] And while they have no natural inclination to beget children they obliging do so "in obedience to the law."[11] Love is feeling the harmony of being united with your erstwhile opposite—but if we are to follow Aristophanes' lead the majority of love is queer. Queer is the norm.

Add to this the other "third term" of gender posited far more recently by Donna Haraway in her "Cyborg Manifesto,"[12] which was another way of thinking about the feminine in the postindustrial age that defied the pitfalls of binary reasoning. Another motivation behind her new incarnation was to find another way of thinking gender and femininity that did not fall in the shadow of Cartesian and Kantian reasoning. In the words of Elaine Graham, the cyborg chooses "to fashion an ironic, subversive exemplar to a non-dualistic, post-gender, post-colonial, post-industrial world."[13] And, "Haraway argues that the cyborg's hybrid status as both organism and cybernetic device, calls into question the ontological purity according to which western society has defined what is normatively human."[14] Haraway's notion has proven to be prophetic in light of the technologized, postmillennial body, where the presumptions of what natural humanity consists in have been radically shaken. We are all moderated and mediated by technology to some extent, from our basic physiology to voluntary changes that, through diet, exercise, surgery, supplements and the like, have the capacity to alter our bodies in extreme ways. Sex changes are a part of this, and something that is more or less taken for granted in developed countries. Yet it opens a possibility hitherto unavailable to the human race. It is also a tangible reminder of the mutability of gender. Read against this, Hourani's gender agnosticism presents a central zone of near-neutrality from which emanate ever more extreme variants and possibilities of gender and identity.

The body in movement

Like Throup, Hourani is not only a designer, but also an artist, photographer and filmmaker whose work is primarily concerned with the multifarious ways that the body is in motion. "Movement is as important as design, as much as literature as much as food." Not only does Hourani pose the question what bodies *are* across

different sites, location and practices, but his attention is on what bodies *do*, and in particular on how they are *done*. Moving beyond gendered fashion as his main focus, Hourani looks at the coupling of the body with movement to produce new concepts in thinking the doing and even the undoing of the body as gendered. Hourani explored the moving body in a short film that he directed as part of his multi-channel exhibition *Seamless* (2013), which featured five years of graphics, photography and garments from his "Unisex" haute couture collection. The neo-noir film *Unisex* was choreographed by Édouard Lock and featured ballet dancer Zofia Tujaka. Filmed in Montreal's Phi Centre, the ballerina gesticulates in sharp movements and jolts to a music score by New York composer Nico Muhly. The film's intention was to capture the unisex ethos of the brand and to explore the body as a site of expression and movement. The attention drawn to Tujaka's gestures is carried through into the movements of her body that carve a space of undecidability and possibility. Set on a blacked-out stage, the film begins with Tujaka wearing no a black asymmetrical dress, her hair is short, blond and combed back to reveal her strong androgynous features. The film fades to black, and Tujaka reappears no longer wearing a black woolen dress, but instead her garment is transformed into a suit, and her hair has transformed color from blond to black. While the intention of the film is to draw attention to the slippery categories of gender, Hourani's use of a ballerina was to observe how garments feel on the body, its flexibility and what makes the body feel comfortable.[15]

Collaborative working relationships between fashion and ballet are not new for designers who have long been drawn to the intoxicating and enchanting movement of a ballerina pirouetting across a dimly lit stage. Chanel had a long-standing relationship with Sergei Diaghilev the founder of the Ballets Russes and who not only designed the costumes for the ballet *Le Train Bleu*, but remained an avid supporter of the ballet both creatively and financially for many years. More recently, Christian Lacroix embarked on a serious engagement with Paris Opera Ballet that began in 2011 when the artistic director Brigitte Lefèvre commissioned Lacroix to create seventy-seven costumes using more than a million Swarovski crystals. Lacroix states that he wanted to give the impression that these costumes, as well as the ballet, had come out of a long sleep with their freshness and memories intact, and in addition to have the rustic aspects contrast with the opulence of the brocades, ornaments and jewels.[16]

In 2013 the New York City Ballet organized a ballet teaming choreographers with fashion designers. Iris van Herpen worked alongside Benjamin Millepied on the ballet *Neverwhere*, and Olivier Theyskens with choreographer Angelin Preljocaj on *Spectral Evidence*. Not only have fashion designers created costumes for the ballet, but there have also been ballets created in praise of fashion designers, such as Peter Martins's *Bal de Couture*, which uses Valentino ball gowns and is a tribute to the designer. And there are designers who are

inspired by the ballet such as Christian Louboutin, who designed a pair of pointe shoes as a fundraiser for the English National Ballet. The eight-inch pointe heels feature Louboutin's trademark red soles and are studded with Swarovski crystals.

The two-minute short film *Unisex* is not the first of Hourani's explorations of the body, "Unisex Anatomy—Exit" is a series of photographic stills of cropped naked bodies that juxtapose masculinity and femininity to confound staid assumptions of gender and race. Hourani's choice to photograph flawless and ideal bodies that anatomically resemble one another was grounded in the desire to draw attention to "the division of gender and race as mere illusion . . . before garments there is the body."[17] The series highlights the ways in which bodies are transformed through "touch" and movement. It is through this touch of bodies that Hourani contemplates a space that is abundant with possibilities of *becoming*. The body is never fixed, but is marked by the possibility of mutation, transformation and change. This concept of *movement* shifts the terrain of simply seeing bodies as discursively or socially constructed. For Hourani the body is always in movement and always multiple.

Fashion as installation

The intersection of fashion and art finds a crucial vortex in the conflation of the gallery and Hourani's minimalist design aesthetic. As part of the Arnhem Mode Biennale 2011 in the Netherlands, Hourani chose to present his collection as a multimedia installation rather than as a collection of garments performed on a catwalk. Titled *Unframed*, the film represents a utopian vision of fashion explored through video and sound. Set against a moving urban landscape and using light as the only element, the film acts as a "view finder" into Hourani's creative oeuvre by using simultaneous multiple images of garments and the landscape spliced into a collage. The result is a hybrid mix between fashion as a commodity and its status as a site-specific art object is placed into question. In November 2015 Hourani launched "Neutrality" at the Arsenal Contemporary Art Centre in Montreal, an exhibition of multidisciplinary artworks that expanded on his "Unisex" fashion label and his vision of a neutral world without boundaries or limits. Approached through painting, photography, sculpture, fashion, and sound and video, the thirty-three artworks "advocate non-conformity as the essence of individuality, . . . a world free of nations, gender, age, race, limit, boundaries and conditioning."[18] The exhibition immerses the audience into an interactive experience that is not provided by a catwalk show and allows the garments to be viewed as sculptures rather than just fashion garments. Entering the gallery space the audience is confronted with three open doors that never close and are labeled "All Genders, All Skin Colours and All Social Classes." The hanging sculpture titled *Open Doors*

(2015) is meant to encourage open dialogue while simultaneously acting as an entryway or as "threshold" into the exhibition. Hourani's designs always linger on the threshold between binaries in terms of his philosophical and visual approach to fashion; man/woman, open/close, black/white and open/close. *Limitless* (2015) modifies road signs whose shapes and colors act as warning signs. *Equal* (2015) is four rectangular sculptures that represent a balanced and egalitarian state, and *One* (2015) depicts a land mass where borders and countries do not exist. The gender agnostic aspect of Hourani's work is made evident in *Orientations* (2015), which features PVC and UR3 female and male genitalia in varying shapes and sizes. It was a playful comment on how love should overcome the strict hermetic categories inscribed in Western cultures. And then there is "Unisex" designed in 2015 as part of the first unisex haute couture collection to be shown in Paris fashion week. The collection established new levels of understanding and approaching gender as they had been inscribed by the fashion industry. It resulted in Hourani's invitation to become a member of the Chambre Syndicale de la Haute Couture, France's leading organization that establishes the industry standards in the production of haute couture garments.

Like conceptual fashion, fashion installation is concerned with the primacy of ideas rather than the finished product or the work of art. Similarly, installation artists are more concerned about the presentation of the message, rather than the materials of the artwork itself. However, unlike conceptual fashion, which is experienced in the minds of the audience, fashion installation, like installation art remains grounded in a physical space. Installation has its roots in eighteenth-century interior decoration in which art merges with all the furniture and decorative details of a room; it also originates in the purposive paintings for architectural space such as Monet's *Nymphéas* for the Orangerie in Paris; Kurt Schwitters' room-cum-sculpture, the *Merzbau* (1923–1933); Duchamp's readymades which question the ubiquity, semantics and power of gallery space and non-gallery space. Installation was also a logical by-product of the Minimalism and the rise of performance art in the 1960s, practices in which the position between artwork, place and viewer were made to appear mutually exclusive. Minimalism tended to draw attention to space and context since it was a reaction to the hermeticism of Abstract Expressionism. As such integers such as architectural space, and even gender and history become relevant to the reading of the artwork. With installation, the artwork is multidimensional and porous in its physicality and its signifying power. In their introduction to their anthology of essays on installation art, Adam Geczy and Benjamin Genocchio argue that "installation art is an activity that activates a space. It is less a style than an attitude, tendency and aesthetic strategy in so far as we now read every object as inseparable from the location in which it is placed."[19] This statement has enormous repercussions when considering fashion installation since clothing also has to do with the body on which it is placed and who does the placing. Indeed in retrospect it can be

said that, from an aesthetic point of view at least, fashion and installation are eminently suited to one another, as both operate within a system in which the state of stasis only exists to suggest, or is for the sake of, continuousness and variability. Fashion and installation are also highly marked by time in numerous and often highly subtle ways. Just as with fashion, the meaning of an installation is contingent on the changes around it, and like fashion it is haunted by its impermanence.

Throughout Hourani's practice, the idea of gender is central, although he is primarily interested in unisex as a fashion concept. What marks his installation work is the way in which it simultaneously questions the validity of Western notions of gender, class and race. In 2010 Rad Hourani held his first solo exhibition of work at the Gallery Joyce Palais Royal in Paris. "Transclassic" was a multimedia production consisting of film, audio and photographic installations that introduced his transformable "Unisex" collection. Ten looks were displayed using the same jacket in a combination of styles that contained classic pieces of garments. Functional and wearable, the collection featured garments based on a dark color palette using a minimalist cut, invisible seams, broad hems and geometric lines. The concept behind the exhibition was to envision a world without gender and like installation that has "no theory, no manifesto, no party, no club."[20] Hourani envisions no rules, no seasons, no gender, no race and no religion. Tabula Rasa.

8

RICK OWENS'S GENDER PERFORMATIVITIES

For his 2014 Spring/Summer collection show "Vicious," Rick Owens staged a spectacle that was completely out of the ordinary (Plate 18). Designers such as Alexander McQueen had already laid the groundwork for catwalks as brooding artistic and quasi-cinematic scenes that well surpassed the display of garments alone. In the now legendary runway such as "Voss" (Spring/Summer 2001), McQueen even used a plus-sized model as the centerpiece. Yet she nonetheless served as an aesthetic feature, naked, as opposed to the clothed models who complied to the expected conventions of race and body shape. For "Vicious," Owens contravened all this, ignoring such conventions by using largely mixed-race, plus-sized models. Entering from a stainless steel portico frame in the hangar-like cavern of the Palais Omnisports in Bercy, Paris, the models marched, stomped and beat their chests, scowling and grimacing to a beat amalgamating club techno and tribal drum. In keeping with the models themselves, the designs were a flagrant hybrid of signs uncongenial to the Euro-American sensibility, mixing Muslim headscarves with rapper street clothing, Bedouin cloth wraps with clinical white futuristic garments. The performance culminated in a war dance giving the impression that these intimidating figures had traveled back in time from a not-so-remote postapocalyptic future when gender distinctions had all but broken down. It was like some unforeseen Amazonian cult that had finally given the once dominant race its comeuppance. (Owens: "I like the idea of creating this universe that is thinking of the ancient and futuristic at the same time.")[1] "Vicious" is but one example of Owens's audacity as a designer and the premium his designs place on the performative values in the confluence of art, fashion and gender. With Owens it is often difficult to extricate these factors, for the nature of the runways gives the overwhelming impression that the clothing itself is only a catalyst for the more overriding element of the elaborate performative event.

For the men's wear collection of "Vicious" presented earlier on June 27, 2013, the parameters were no less challenging. The sequence began with a man on a white platform in a black robe with long white hair and a long beard, his facial

features scarcely visible; a cross between a fuzzy Womble[2] and the evil wizard Sauron from the fantasy adventure film series *Lord of the Rings*.[3] To the sound of rhythmic electronic distortions off-stage, he began to shout incomprehensible phrases into the microphone held firmly before his face. Three spotlights appeared before him, which were soon enough filled by men in world championship wrestling outfits (one with a knee brace, the implausibly low-strung singlet, etc.) holding guitars and wearing menacing masks with a long beak-like protuberance, as if the *commedia dell'arte* had gone tribal. To the cacophony of guitar and the inchoate chant, the models began to circle the performers. As a complement to the reversal of expectations enacted by the women's collection, the men were slim, some spindly. When not bald, the hair was trussed up into awkward and unusual hairstyles typical to Goth styling. With the unavoidable presence of the loud music, the debt to rock street style was difficult to ignore, yet the models themselves were of a strikingly un-prepossessing bent. By the end of the performance the guitar players found themselves suspended upside-down by one leg from the ceiling, a metaphor of reversal, most probably unintended, that Owens explores with gender types.

Like many contemporary designers, including Throup and Viktor & Rolf, Owens's history, style and attitude is closely tied to art. But whereas for V & R fashion evolved organically after a series of experiments and interventions, and where Throup sees himself as an artist in which the end-product just happens to be a fashion item, Owens began his education as a painter, but since then his bread-and-butter was in making garments and furniture that he calls the "antithesis" of his clothes. What is curious about the numerous interviews with Owens is the paucity of commentary on his runways, despite the high level of performative invention that is involved in them and which is impossible to ignore.

Minimalism

Rick Owens uses the language of minimalism to transform his concepts into wearable garments and styles. Using the term "glunge" aesthetics (Owens's term to describe his glamor meets grunge style), his collections can best be described as urban-minimalist with architectural layering and a pared down approach to design in gray scale monochromatic colorways. "I'm always interested in architecture and what can make it modern or timeless or convincing," states Owens. "Architecture like *Luigi Morreti*, *Louis Khan* or *Adolf Loos*. . . . I focused on tailoring and my versions of strict black suiting. As architectural and severe as possible, what I considered the more essential shapes."[4]

Minimalism is a familiar concept that many designers have turned to in their collections, including Rei Kawakubo, whose work we have discussed in Chapter 2, and who appropriated the modularity of traditional Japanese

aesthetics in the design of her garments with simple construction techniques. The minimalist art movement, which reached it apogee in the 1960s, has had a lasting effect on Owens's oeuvre. Broadly speaking, the defining aspect of minimalist fashion is a lack of any embellishment and the priority of simple, clean lines and silhouettes. Let us recall Chanel's dictum that simple is best; she liked to strip away unnecessary components of a garment that impaired function. The relationship between the garment and the body is also an important component of the aesthetic and its development of shapelessness. At this point it is important to note that minimalism in fashion design, which holds reduction and simplification as its ultimate goal, is similar to minimalism in art, but essentially holds different tenets at its heart.

As an art movement, minimalism is strongly associated with the postwar American visual artists, primarily living in New York, who rejected traditional representations of painting and sculpture, and pursued a new style that owed as little as possible to the physical existence of an object. Artists such as Donald Judd working in the 1960s used industrial materials to create abstract works that explored color and shape. Other artists include Dan Flavin and his sculptural objects made from commercially available florescent light fixtures and other found objects like crushed cans. Or Tony Smith, whose simple geometric shapes formed on a three-dimensional grid created drama through simplicity and scale. These artists were concerned with geometric abstraction and were the proponents of the movement that became known as "minimal" art. Geometric abstraction is a characteristic of Gareth Pugh's designs, which were discussed at great length in Chapter 3 of this book. In a broader sense, the roots of minimal art can be traced back to the Bauhaus[5] and De Stijl in the 1920s, with artists such as Piet Mondrian, whose geometric shapes and interlocking planes influenced Yves Saint Laurent's A-Line jersey shift "Mondrian Dress" that became an iconic garment in the 1960s. The Bauhaus movement in architecture, which dictated practicality and pragmatism, also influenced fashion designers, (including Rick Owens among others such as Jil Sander, Helmut Lang and Calvin Klein, to name a few) through the use of rhythm, color, proportion, material and form. Simply put: Form dictates function.

A dialogue between time and timelessness often runs through the minimalist aesthetic and in its striving to be futuristic minimalist design often tends to become nostalgic in its historical reference. Take, for example, Yamamoto and Miyake's reference to traditional Japanese work wear in their collections, or the Japanese kimono, which can be found from Poiret to Pugh. Owens turns to the simplicity and cut of traditional monastic garments to emphasize purity of form and silhouette and combines these references with a nod toward futurism. For his Spring/Summer 2011 menswear collection, Owens emphasized monasticism and the aesthete by using fabrics such as sheer jersey, leather and wool crêpe and a color palette that included "habit brown" and "pristine white." Long coats

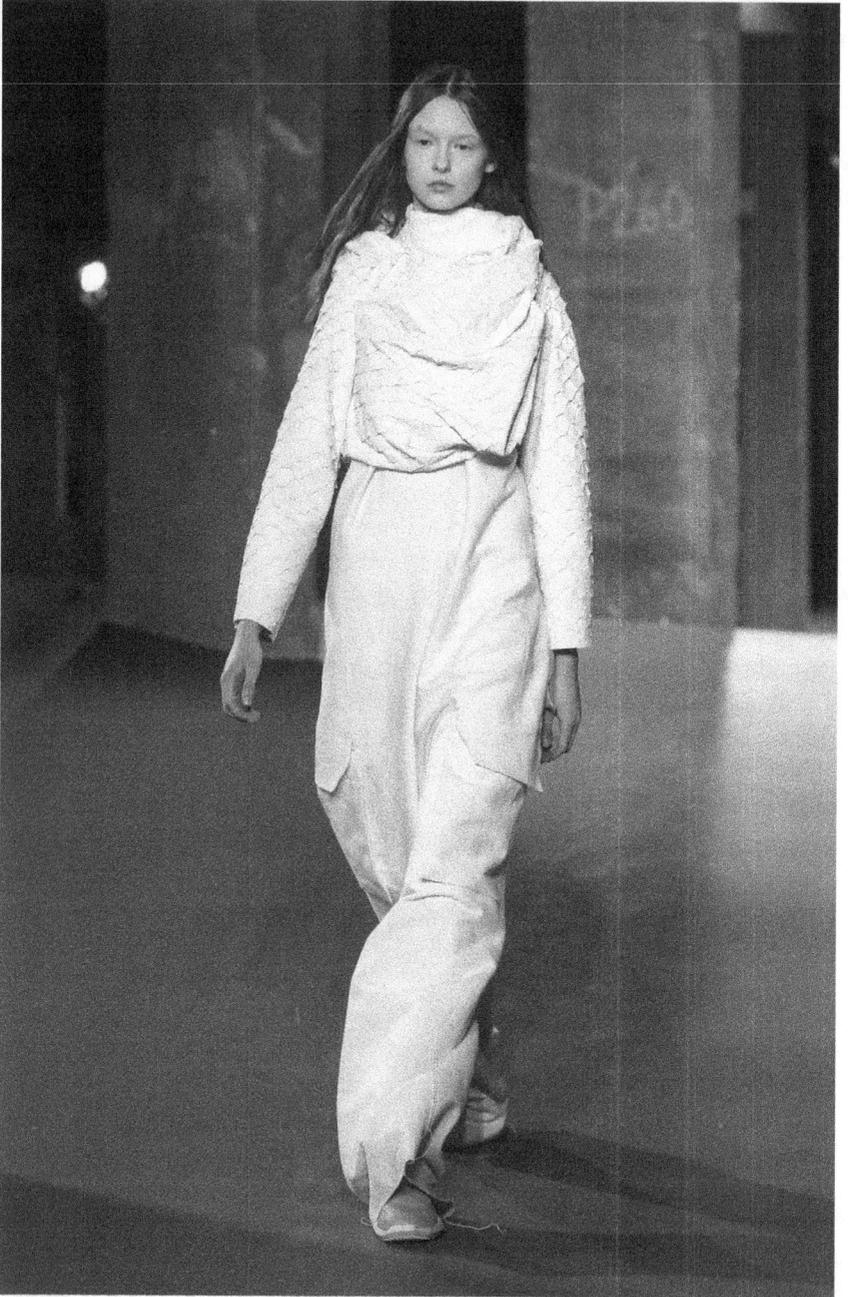

Figure 16 A model walks the runway during Rick Owens's show as part of the Paris Fashion Week women's wear (Autumn/Winter 2016) on March 3, 2016, in Paris, France. Photography Richard Boyd.

were teamed with drop-crotch shorts and high-shafted boots gave the collection a futuristic take (Figure 16).

Owens's aesthetic is often described as dark and macabre because of its influences from monasticism and it is popular with followers of gothic fashion. Often characterized as a Goth designer with a cult following, Owens was influenced by his time spent attending a Catholic high school and as a Goth growing up in California. As he comments: "People in dragging robes, hooded figures doing spiritual things—everything I do comes from that."[6] His multiple layerings of long T-shirts, drop-crotch shorts and skinny pants are considered key stylistic components of the Goth look. Owens's cloak shapes also reference the monk's habit, which he has reworked with layered and wrapped silhouettes. Such historicism, which finds its influence in the practice of monasticism, preaches a lifestyle based on purity and simplicity, and captures the modernist mindset. In writing about minimalist fashion's reference to a historical context, Harriett Walker writes:

> Minimalism is not concerned with progress for the sake of it, it looks to encapsulate the best, most artistic, pragmatic and functional aspects of what has come before, and it is this melding of past success with a thoroughly modern outlook that has seen it transcend the realm of "fast fashion" or throwaway, "of the moment pieces."[7]

Glamour, decadence and decay

Let us return to "glunge," a synthesis of the words *glamour* and *grunge* that Owens uses to describe his design aesthetic. When Owens began designing garments in the early 1990s in New York, he remained largely off the fashion radar, but maintained a cult following in the underground glam rock and grunge communities that valued his layering and juxtaposition of fabrics, and his slim fitting leather jackets, distressed T-shirts and jersey knits. Grunge was a subculture that had its early beginnings in the music scene in Seattle on the Pacific Northwest Coast of the United States with bands such as Nirvana, Alice in Chains and Pearl Jam. They were a generation that had grown up in the excess of the 1980s expressed by the successful well-dressed "yuppie," an acronym for a young professional, and their self-absorbed consumerism. Fueled by disco, fashion and cocaine, yuppies worked hard and played hard, and were excessively consumptive in their pursuit of the American dream. Fredric Jameson wrote that for American society in the 1980s, "they were a new petite bourgeois whose cultural values have articulated a useful dominant ideological and cultural paradigm."[8] Grunge subculture was rooted in discontent against the effects of capitalism. The subculture's disdain of conformity was manifested in a DIY style

that included combat boots and plaid flannel shirts paired with torn jeans, leather jackets and unkempt hair. Like punk that came before it, grunge was a style of revolt and anti-authoritarianism that was expressed in a low-budget anti-materialist philosophy. Followers of grunge were drawn to Owens's dark drape layering that expressed nonconformity and rebellion.

Grunge's relationship to gothic subculture is an obvious one with both subcultures sharing music that contains lyrics of angst, disillusionment and alienation from mainstream culture. The sartorial crossover includes the layering of garments, distressed and ripped denim, baggy cardigans and army surplus boots. It is the gothic fascination of the forbidden sexual practices and the occult, namely the practice of necro-erotica embodied in the metaphor of the vampire, a libertine *avant le lettre*, and the eroticization of death and mourning that finds allegiance to grunge's aesthetic of decay. It is this dialectic between sex-death and decay that lies at the discursive center of normative conceptions of social power and elevates the nonconformist to the level of the decadent and glamorous outcast. "The forbidden and the dangerous," writes Elizabeth Wilson, "were always saturated in glamour."[9] It is the visual interpretation of the gothic and grunge sartorial sensibilities that we find expressed in Owens's collections.

The historical relationship between glamor and consumption is tied to the production of capital and is associated with modernity and the rise of the modern city.

According to Wilson, the word *glamor* has its roots in the Celtic term *gramary*, which meant occult or learning magic, and appeared in the English language in the early eighteenth century, meaning "when devils, wizards or jugglers deceive the sight, they are said to cast a glamour over the eye of the spectator." Wilson contends that the word came into usage "at the same time that industrialism provoked the reaction of the Romantic Movement with its love of gothic."[10] The gothic was in opposition to Enlightenment rationality of progress and reason, but it was also used by the Romantics to critique the new world of production and labor associated with city life as they longed "for an authenticity that seemed to have been lost in commerce and business"[11] (a philosophical concept that is also shared by grunge subculture). A movement toward mysticism, magic and the occult became popular at the turn of the century in response to the financial insecurity and the growing influence of secularism and science. Karl Marx used the image of the vampire as a metaphor to depict the way that human life is turned into dead labor to feed the insatiable machine of capitalist production. Marx borrowed the image from Friedrich Engels, who had made a passing reference to the "vampire property-holding" class in *The Condition of the Working Class in England* (1845). Marx commandeered the image and turned it into an integral element of his condemnation of the bourgeoisie (middle class). He spoke of British industry as vampire-like, living by sucking blood, or the French middle class stealing the life of the peasant. In France the system had "become a

vampire that sucks out the peasant's blood and brains and throws them to the alchemist's cauldron of capital."[12]

The *femme fatale* of the French decadence and the *fin de siècle* was a manifestation of the Romantic Movement that sought to find meaning in this new world of uncertainty. In "Les métamorphoses du vampire," from *Les Fleurs du mal* (1857), Charles Baudelaire writes that modern man is a feeble decadent and is consumed by modern woman, a vampiric *femme fatale*. Their love is an erotic death struggle, in which the active woman devours and destroys the passive male. The dangerous woman, *femme fatale* or *belle dame sans merci* (merciless beautiful woman) emerges in decadent writing from about the 1850s until the end of the century, moving through salons, boudoirs and private clubs embodying the world of corruption, intrigue and decay that became associated with the French decadents and their English counterparts, the aesthetes.[13] Sheridan Le Fanu's *Camilla* (1871) the lesbian vampire who preys on lonely women and Bram Stoker's great horror novel *Dracula* (1897) were written to encapsulate this time of sexual ambiguity and anxiety present in Victorian society where conflicting discourses circulated about proper gender conduct (sexual and otherwise). The vampire embodied the "spirit of the times," namely, decadence, excess, artifice, beauty and aestheticism. As Wilson avers, "The forbidden and the dangerous were always saturated in glamour."[14] But this glamor was always at a price: the *fin de siècle* decadent maintained a rueful relationship to his delights, awaiting their imminent decay. Romantic beauty is almost always haunted, from Dorian Grey's corrupted portrait to Zola's Nana who is reduced to hideousness through the ravages of smallpox (her face "a shovelful of putrid flesh"). And a character in one of Baudelaire's prose poems warns his well-kept mistress that he would like to teach her "what genuine unhappiness really is," and warns her that at any time he could cast her "out of the window like an empty bottle."[15]

Beauty, moreover, was seldom pure, and when it was, it was apt to be defiled. Hence the decadent writer's love of the illicit was evoked by the pornographic writings of the libertines whose heroes and heroines employ seduction as a tool of education. Baudelaire often alluded to the writings of the Marquis de Sade: his novel *Justine, or, The Misfortune of Virtue* (1791) depicts the twelve-year-old Justine who is presented with sexual lessons hidden behind the mask of virtue. Other titles include Leopold von Sacher-Masoch's *Venus in Furs* (1884), Aubrey Beardsley's *The Story of Venus and Tannhauser* (1896) as well as novels by Émile Zola (*Nana*, 1880 (see above); *La Terre,* 1887) and Paul Verlaine. Oscar Wilde's play *The Portrait of Mr. W. H.* (1889) draws on the decadent fascination with libertine literature and details the discovery of a homosexual tradition. We also find Beardsley's illustration *The Toilette of Salomé* in the English book publication of Oscar Wilde's play *Salomé* (1894), which tells the story of the temptress Salomé who requests the head of Jokanaan on a silver platter for her Dance of the Seven Veils.[16] Salomé has much in common with Justine and

Camilla. The Romantic writers found commonalities with the libertines who used sexual representation to challenge the authority of the king and clergy. The gothic continued to be associated with the danger of the erotic and the forbidden and maintained a strong presence throughout the next century in cinema, fashion and music.

Like the libertines, Owens uses sex and sexuality to confront dominant middle class values, so much so that the fashion press often refer to him as the "King of Kink." For his "Sphinx" (Fall/Winter 2015) men's wear collection, Owens sent models down the runway with a "peephole" or "porthole" cut out at the groin of the garment revealing their penis (Figure 17). The concept behind the collection was quite simple: freedom and the control of life and its effect if you were to lose control. "Every man wants to be walking down the street with his dick out," said Owens, "it is such a simple primal effect . . . something that has an impact."[17] The inspiration behind the collection was an old French movie set in a submarine with oversized knit jumpsuits, twisted trench coat skirts and pea coats cut from Berber blankets with a cape back or infected with rust to symbolize the inevitability of decay. As Owens explains, "I kind of fetishized peacoats, nautical peacoats, nautical cable knits. I liked the idea of perverting them, I liked the idea of taking something very classical, and modest, and uniform, and corrupting it."[18] Nautical themes and sailor styles are not unique to fashion and have been heavily featured from couture to more affordable mainstream ready-to-wear collections. Perhaps what is interesting about "Sphinx" is that it situates the collection in the masculine space of a submarine, where in the tight confines and the open sea transgressive sexual practices abound. The sailor has been invested with an erotic presence bound with imagery of the "romance of the open sea" and the prospect of spending long periods of time in isolation. To be on board a floating vessel and away from women often results in wayward and unconventional sexual practices. Recalling Foucault who wrote that "the boat is a floating piece of space, a place without a place that exists by itself that is closed in on itself and at the same time is given over to the infinity of the sea."[19] Out in the open sea, buggery and sodomy are common sexual practices.

Owens's previous men's wear collection (Spring/Summer 2015) referenced the ballet *L'Après-Midi d'un Faune* (Afternoon of a Faun). The ballet stems from a poem from Mallarmé and was originally accompanied by costumes designed by Léon Bakst. "Everybody in the audience, with all their jewels, are just waiting for this guy to hump the scarf," said Owens. "I love that!"[20] His Autumn/Winter 2014 lookbook that accompanied his men's wear collection "Moody" further enhanced Owens's use of confrontational and subversive tactics. A collaborative project with fetish photographer Rick Castro, the book contained images of older male models between the ages of sixty and ninety-three wearing Owens's collection and participating in libertine acts. Photographed in black and white, the models' ecclesiastical silhouettes challenge conventional media

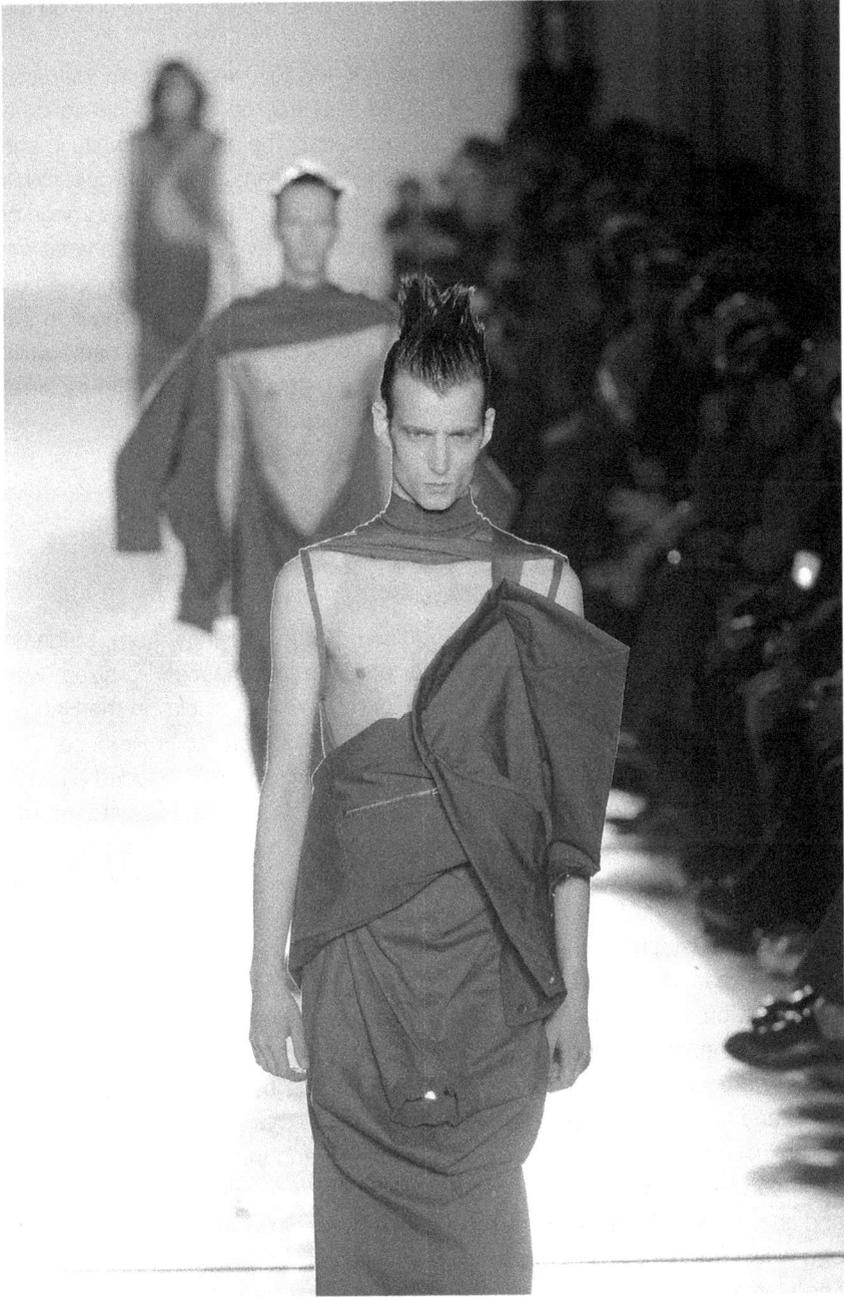

Figure 17 Models walk the runway during Rick Owens's menswear (Fall/Winter 2015–2016) show at Palais de Tokyo as part of Paris Fashion Week on January 22, 2015, in Paris, France. Photography Kristy Sparrow.

representations of beauty and masculinity that have tended to focus only on the beauty of youth.

Subversive acts and full-scale nudity are not new to Owens, who more than a decade ago appeared in the May 2006 issue of *i-D* magazine urinating on a composite image of himself in a decrepit basement. The black-and-white image is a double self-portrait of Owens standing with his jeans dropped down to his knees holding his penis and urinating in the mouth of a kneeling mirror image of himself. Owens said of the image in the interview "Dirty habits, that's what my clothing is all about."[21] For his 2008 photographic campaign Owens mocked up a scene of sitting at a table with a bottle of vodka and shooting himself in the head. Opposite him is his doppelganger sitting on a chair, head slung back, while Owens's decapitated head sits on the table, to be served on a platter recalling the beheading of John the Baptist as offered to Salomé.

Spatial art and design, installation and furniture

In 2006 Owens commissioned the artisan Doug Jennings from Madame Tussaud's wax museum in London to produce a series of life-sized wax sculptures of himself. The first statue Dustpump went on display in the Hangar of Stazione Leopolda at the Pitti Uomo Immagine fashion fair in Florence. The sculpture was part of a multi-platform event Dustulator, which included a men's wear runway show (Autumn/Winter 2006) and two installations Dustdam and Dustpump. A display of Owens's furniture made of resin, plywood, fiberglass, cashmere and bones was simultaneously on display at the Cannoniera in the grounds of the Fortezza (discussed further in the chapter). Owens's first installation Dustdam at the Stazione Leopolda featured thirty iconic garments hung on mannequins that acted as a retrospective of Owens's career. The garments formed a mythological tableau, figures of Greek gods and Olympians frozen in time. His second installation Dustpump was hung in the middle of the Alcatraz area; the sculpture portrayed Owens with his jeans unzipped holding his penis and urinating onto a rug of mirrors and sand. Owens is suspended in the air, an imitation of Zeus the Greek god of the sky and thunder surrounded by a pantheon of deities. The sculpture now resides in Owens's flagship store in Paris and another wax figure of the designer with a long serpent-like tail representative of a writhing tongue is installed in the Tokyo flagship store. In the interior of the free-standing 3,800-square-foot space that is the Hong Kong flagship store, there is a glass coffee table that is a wax statue of Owens kneeling on all fours, his body holds up the weight of the glass in a quintessentially act of sexual submission. The boutique features concrete panels and other industrial elements and is described by Owens as angular and brutalist in concept. He designed the

store to correspond with the idea of emptiness, stone and light. "I saw a wall a long time ago in Berlin and never found it again," said Owen. "I might have dreamt it. This wall became a mythological image to me of a futuristic utopian ruin."[22]

Decay and the inexorable passage of time and its expression are prevalent themes in Owens's oeuvre, but find their purest expression in the one-off limited edition furniture pieces that he designs. Combining early modernist ideas of minimalism and functionality, Owens's furniture pieces are heavy brutalist structures that are imposing and monumental, made from rare and arduous working materials such as alabaster, bones, resin, plywood and marble embellished with human skulls and deer antlers. The structures communicate a certain visual lightness even though they appear to be concrete monoliths. "I wanted my furniture to look immovable," says Owens, "it stays there with you forever—until you die or the house burns down."[23] Titled "Prehistoric," the collection is monochromatic and minimal, and includes a fossil table made from petrified wood and an irregular bones chair in a palette range of deep browns and grays.

Fashion's avant-garde

Like other minimalist designers such as Ann Demeulemeester and Jil Sander, Owens shares their use of neutral color palettes—white, tones of gray and especially black. White because it emphasizes purity and a sense of lightness, sportiness and comfort (as in the designs of Jil Sander), and black because of its introspective, somber and genderless connotations that were favored by the avant-garde group of designers that became known as The Antwerp Six: Walter van Beirendonck, Dries van Noten, Dirk van Saene, Dirk Bikkembergs, Marina Yee and Anne Demeulemeester. Owens is also considered to be an avant-garde designer and is often labeled the "master" or "king" of the avant-garde by the fashion press not only because of his preference for neutral color palettes, but also because of his subversive and maverick approach to design.

At this point it is important to clarify the use of the word *avant-garde* in this discussion. When applied to traditional "fine" arts, it is caught up with modernism, and more particularly, the role of art in social change, which is varyingly connected to the stylistic innovation. A military term, used interchangeably with *vanguard*, the avant-garde were the group of troops sent out in front of the main battalion to scout or skirmish. In art, it was used for art that and artists who sat outside, proudly or uncomfortably, the mainstream styles, ordinarily allied to the academy. In this historical incarnation, the avant-garde is synonymous with the various European "isms": Cubism, Futurism, Suprematism, Constructivism and so on. Surrealism and Dada are also key to the avant-garde, as both were in their way meant to instate social upheaval. Surrealism even referred to itself as a revolution.

The "historical avant-garde," as it is also referred to, begins roughly with Courbet and climaxes with Abstract Expressionism in the United States in the 1950s. The arch-defender of the Abstract Expressionists, Clement Greenberg, devised an elaborate and persuasive itinerary of painting that essentially ended in these artists. It was a tenacious narrative that read modern art as a march toward a style that pretended pure visuality and aesthetic truth. The next phase came with minimalism and the less formal approaches and more conceptual and immaterial to art (Performance Art, Land Art, Art & Language, etc.). Roughly coinciding with the protest era, while forward moving and highly experimental, these were tendencies and practices rather than formal movements, and their foe was no longer necessarily an academy or a particular style, but rather the then conservative forces of society itself. Thus one of the chief characteristics of postmodernism, and what for many marked its so-called crisis, was that lack of a coherent, dominant style, and therefore, an absence of an avant-garde. The mainstream was diverse and more subservient to commerce than stylistic, aesthetic-ideological standards. This is why to use the word *avant-garde* in art is either inappropriate or unrigorous, although it is used in mainstream press and in popular culture. It is here that the term is valid for fashion per se. Fashion's evolution since Worth (ironically contemporary with Courbet) followed a different path, and its association to wealth and status made the traditional concept of the avant-garde a *non sequitur*. Yet it is precisely the impetus of this book to foreground fashion designers' work both within and outside of mainstream impulses and tastes. And it is with this in mind, not in contravention to proper usage in art history and theory, that the phrase is used.

When applying the term *avant-garde* to the domain of fashion, the avant-garde designer is one who breaks away from the traditions or constraints of design and questions the garment and its relationship to the body. Take for instance Kawakubo (whom we discuss at length in Chapter 2 of this book), who changed the face of fashion in the early 1980s by questioning the shape of the "hourglass" silhouette with her simplistic tent-like garments in monochromatic black. Kawakubo was not interested in revealing the body, but in allowing the wearer to be who he or she is. Yamamoto (who brought the Japanese Revolution to Paris and became known as "The Big Three" along with Kawakubo and Miyake) changed the impetus of what constituted women's wear by designing "men's clothes for women." His oversized silhouettes and androgynous style signaled a revolution in design that questioned the representation of gender. Much like Hourani's "asexual, aseasonal, from no place, no time, no tradition"[24] gender-neutral garments in monotones of black and white designed for men and women alike. Viktor & Rolf are known for their conceptualism, from bottling and marketing a nonexistent perfume, designing a collection that contained no garment and a fashion show or an installation that featured gold garments hanging from invisible thread. Viktor & Rolf, along with Westwood who was

responsible for bringing the DIY and punk look to fashion, are discussed at length in this book. And then of course there was Alexander McQueen's invention of the low-rise "bumster" pants and his love of runway drama and extravagance that he shared with John Galliano's historical revivalism. In the same way that fine art questioned the object (such as Duchamp's readymades, turning a found object into art), Pugh's designs provoke the question of whether the garment is fashion at all by distorting the body using different geometric shapes and volumes in silhouettes with nonconventional materials such as synthetic hair, plastic, foam, parachute silk and mink. By covering the faces of his models with masks, Pugh creates Japanese anime characters in bold colors that place into question the limits of the human body and its representation. Owens creates ambiguity by subverting traditional notions of gender. While there are clear similarities, Owens differs from Hourani's "agnostic gender" on a subtle point. For Hourani wishes to tip the gendering of clothing toward the middle; it is a dynamic of convergence, whereas Owens plays a subtle game of brinkmanship with garments that seeks to instate gender, precisely because of, and at the point at which, it is brought into question.

Performance art, performing fashion and gender

Since the 1960s performance art and gender studies have contributed important models in understanding fashion as a cultural performance of a gendered and sexual identity. The concept of performing gender is now synonymous with the gender theorist, philosopher and social commentator Judith Butler, developed in *Gender Trouble* (1990) and *Bodies that Matter* (1993). Butler's recourse to gender as performance was an attempt to resolve two dead ends. The first lay in the interminable recursions that take place with binaries—that is, the peril of feminism when assuming power is that it becomes an echo of the same original power structure. The second is less a binary but more of an abstract overlap: in psychoanalysis, when arriving at questions of gender one is faced with the sex/gender distinction, in which one's gender is not necessarily resolved according to one's sex. Yet how one feels is still determinate on biological sex, but the extent to which various biological and psychic compulsions come to determine gender is well known but impossible to measure. Donna Haraway had already sought to introduce a "third term" of the cyborg in her "Cyborg Manifesto," guided by a desire to find an alternative to the relation of femininity and nature, and to cause us to reflect on gender in a postindustrial universe.[25] While still in currency today, particularly in light of concepts such as technologized body, the posthuman and the anthropocene, Butler's notion of performativity has proved to be more subtle and more easily applied in both theory and practice. Gender,

for Butler, is performed: A subject assumes a series of identifiers and assumes them. This means that how we relate to ourselves and to others entails a series of enactments according to various signs and accouterments such as clothes. But the recourse to the notion of performance means that such signs are not external, like assumed attributes, for when performing, there is very little distinction between inside and outside, fake and authentic; rather it brings both polarities into play.

If everyone acts out gender then, forcibly, everyone is to some level in drag. This is a highly provocative and polemical point that allows Butler to tease out the inessential characteristics that make us what we perceive as our essential selves. But on reflecting on her earlier concept, Butler clarifies that she "never did think that gender was like clothes, or that clothes make the woman," although she does concede that, like fashion, gendering is a process of embodiment, and that "embodying is a repeated process."[26] The caveat that performing gender is unconstrained or limited to clothing is why Butler has not been used in any great detail in previous chapters and applied here to Owens, for our emphasis is on performance "itself," meant literally and figuratively. The gender-play that we find in Owens is not reducible to the garments alone, but to how bodies are placed and how they are made to act. It is in light of Butler's work that we can have a more enriched understanding of the performance practices that emerged from the 1960s and how they have impacted on fashion as a catwalk performance. In *Couture Cultures*, Nancy Troy argues that theater and the fashion catwalk have become increasingly linked as both require "an audience, a discourse, a profile in the public sphere." She writes that

In the modern period the connections between fashion and theatre are multiple, encompassing not only the design of costumes for the stage, or the dramatic potential of fashion shows, or even the performative aspect of wearing clothes, but also the exploitation of the "star" system for the commercial purpose of launching new clothes.[27]

To some extent performance art as we understand it from its very beginnings in Dada, Futurist theater and the Bauhaus at the beginning of the twentieth century is caught up in gender, especially inasmuch as psychoanalysis has taught us that human identity is inextricable from gender identity. Early modernist performance and theater witnesses instances to annul gender through generic or mechanical bodies (as in Hugo Ball's famous futuristic Cubist suit that he wore during his recitations at the Cabaret Voltaire in Zurich in 1917), or to drag (as in Marcel Duchamp's famous alter-ego Rrose Sélavy), but the issue of gender and performance as a critical encounter emerges as part of the many (then) unconventional practices that occurred as part of the protest era. Performance art was a natural outcome of a period of upheaval and experimentation. Artists

such as Carolee Schneemann, Yoko Ono and Marina Abramović highlighted the limits of the body, its physicalization, vulnerability and power, something that is also shared in fashion as an embodied practice. Ono's *Cut Piece* (1965) has the artist sit motionless while the audience is invited to cut her clothing. Abramović's *Rhythm* (1974) was a six-hour performance (performed in Naples) in which the artist stood, also motionless, beside an array of seventy-two objects, which could or could not be used on her. A year later Schneemann twice (East Hampton, New York, and the Telluride Film Festival, Colorado) performed *Interior Scroll* where she painted herself in mud and then slowly extracted a scroll of paper from her vagina as she read from it a quasi-ritualistic, poetic text in celebration of it.

These performances form a small cluster of examples whose radicality remains arguably unmatched, their record over time proving to have a sizeable influence on artists, theorists and designers until this day. The performance of gender in their respective case, and those of others was not limited to dragging per se but rather undertook to examine various forms of physicality. One key aspect that separates performance art from traditional dramatic forms, the genre that in the 1960s and 1970s, at least, it wanted to draw away from, was precisely theatricalization. To be entirely divorced in performance from theater is an impossible task, however what was central to performance art was the manner in which the body is treated as an object or a site. The body becomes like any medium inhabited with a subjectivity, and a living entity, so that boredom, hunger and other natural or necessary drives will eventually creep to the center of the stage. In this regard it also foregrounds the performance of gender by dint of the very excess of materiality that performance art commands. In the body attempting to become pure object, pure matter, it exposes the qualities of gender (and race, personality, identity and so on) as mobile and contingent elements. *It is when such elements are destabilized that they become visible.*

This paradox is precisely what transpires with Owens's work, and in particular when the clothing is imbricated in the staged performances. To take "Vicious" as one of a number of reference points, it is important to observe that, in the women's collection, it was catwalk conventions that were being violated, not necessarily codes of femininity. Owens simply sought to mine the area that is overlooked or spurned by typical fashion shows, in the primacy they give to skinny women with pale skin. Furthermore, it would be absurd and offensive to ascribe masculinity to these women just because they affected anger. Again, Owens mines a deeper reservoir of history reflected in the clothing itself, which draws from ancient forms of dress (Minoan, Mesopotamian, Assyrian, Egyptian) and mixes it up with styles inherited from science fiction, cinema and other popular forms such as music.

As Butler polemically observes, gender performance as such can be located not through biological sex but through dragging, for dragging highlights to the point of exaggeration certain traits of gender.[28] But this argument can also be

extrapolated in more than one direction, for in dragging, in the process and performance of reorienting gender through a set of high-key signifiers, the dragger also draws attention to what she or he is not. It is through over-enactment that the dragger draws attention to her "real" gender, but also the orders by which that reality is a state of being with more than one level. With "Vicious," it is through defying and stretching the prevailing, consensual identifiers of gender that the gender is asserted. There is no doubt that the women's line is the women's line and the men's line the men's. What Owens also does opens up the spaces of womanhood and manhood to being queer: The lines may be butch, Amazonian, and suggest a language of castration and confrontation. The men may be effeminate, and in some cases, left-of-center. But the presence of gay and lesbian does not violate the maleness or femaleness, but rather establishes them as very distinct, yet at the same time always porous sites of self. The connecting thread in all of Owens's runway performances is physicalization. It is here that gender finds space for expression.

In "Cyclopes" (Spring/Summer 2016) ready-to-wear women's collection models were sent down the catwalk carrying other models strapped upside down on their bodies as though they were human rucksacks (Plate 19). Bodies dangle and shake like unanimated mannequin dolls. Situated high and in a box, one Black soul singer and two Black back-up singers begin to incant a soulful melody. The concept behind the collection was that of the strength of sisterhood and the ability of women to support and nourish one another, symbolized by the models carrying each other's bodies, which acted as a visual metaphor for the "burden" that women endure in culture. Like "Vicious," the focused vision was propulsive and aggressive, but when applied to women, Owens sees that vision as:

> being more about nourishment, sisterhood/motherhood and regeneration; women raising women, women becoming women, and women supporting women—a world of women I know little about and can only attempt to amuse in my own small way. . . . Straps can be about restraint.' . . . but here they are all about support and cradling. Straps here become loving ribbons.[29]

The striking arrangement of bodies, and the slow, melancholy music gave the effect of being in a postapocalyptic dream.

Since the 1990s fashion designers such as McQueen, Galliano and van Beirendonck (to name a few) have held spectacular catwalk shows with complex visual displays and performances to heighten the display of their collections. Drawing on performance art, fashion designers have developed a hybrid form of performance art, the catwalk show. Ginger Gregg Duggan writes that in the mid-1990s designers "earned reputations for fashion shows that read like sequences of dream images or fantastical images . . . [creating] elaborately

orchestrated events that rival theatrical productions."[30] In order to present the specific references to performance art, Duggan has developed a list of categories to describe the fashion/performance hybrid; spectacle, substance, science, structure and statement.[31] Spectacle designers such as McQueen or Galliano created catwalk shows that featured more than garments. They contained elaborate plots, interesting lighting, locations, recognizable themes and a grand finale. The substance designer's work is linked to performance by emphasizing process over product and the concept behind the collection is central to an understanding of the show. Viktor & Rolf's Autumn/Winter 2015 collection "Wearable Art" (as discussed in Chapter 6) quite literally wore garments designed as though they were framed artworks. The garments preceded the show's concept, which was the relationship between fashion and art. This was not just a catwalk display, or a conceptual collection, it also acted as performance art with the designers doubled as performance artists unfastening the garments from the models and hanging them on a white wall. Science designers push the limits of fashion through the use of garment construction techniques and fabrics that dictate the performance. Kawakubo is known for her oversized clothing, textured fabrics, somber colors and asymmetrical detailing. They contained flaws and rips, and were draped and cut rather than cut and shaped. Garments were not designed to complement but to supplement the body. Structural designers' primary concern is form

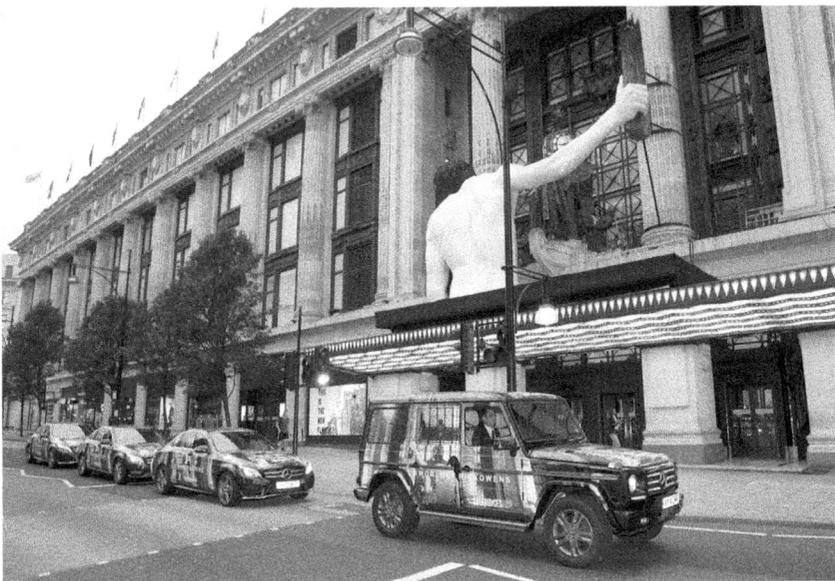

Figure 18 Mercedes-Benz drives London Fashion Week with Selfridges World of Rick Owens C-Class and G-Class Models on September 11, 2014, in London, England. Photography David. M. Bennett.

over function; however, conceptual influences are also important. The fifth category of the fashion/performance hybrid and the one best used to describe Owens's work (although there are multiple crossovers) is that of the statement designer. According to Duggan, statement designers create environments that produce confrontational ideas about the body or gender and are concerned with conveying a message either through the garments or the performance. Owens uses catwalk performances, art installations and photography to convey messages about sexuality, freedom of sexual expression and gender that are confronting; human back-packs, garments with cut out "peepholes," a faun ejaculating over a scarf and urinating on wax sculptures.

In 2014 Owens collaborated with the retail giant Selfridges in London as part of The Masters Campaign that recognized twelve designers' contribution to shaping the current fashion landscape (Figure 18). Included were: Thom Brown, Master of Showmanship; Yohji Yamamoto, Master of Defiance; Jun Takahashi, Master of Subversion; and Rick Owens, Master of the Elements in reference to his play on proportion and volume. "The World of Rick Owens" installation included: a commissioned film by SHOWstudio and limited edition products and a concept store with four window displays that exhibited archival pieces. One window display referenced Richard Strauss's opera *Salomé* and depicted a *femme fatale* with glowing eyes vomiting black blood. On the woman's forehead was a screen that played Alla Nazimova's silent film adaptation of Salomé on a loop. A twenty-five-foot wax statue of Owens's torso imitating the Statue of Liberty was positioned over the store's main entrance. Made from steel, coated polystyrene and leather hair, the statue held a flaming torch that ignited every fifteen minutes. A fitting tribute to a libertine.

9

WALTER VAN BEIRENDONCK'S HYBRID SCIENCE FICTIONS

Walter Van Beirendonck first came to the attention of the fashion industry in 1982 with his collection "Sado," named after his white bull terrier, at the Vestirama trends show in Brussels. Rhyming with "Salò," the birthplace of Mussolini and the title of the film by Pasolini,[1] the collection also had suitably violent overtones. For its concept was heavily influenced by sado-masochism (SM), with the models strutting down the catwalk dressed in long latex jackets, tube skirts and headwear with attached muzzles. From the beginning van Beirendonck established himself as never simply a designer for a cultural elite, but a far more nuanced cultural entity for whom extremes of life and death are always on his compass. Provocative, daring, odd and fantastical, van Beirendonck embraces the human as synthesized hybrid, a body-machine inserted into a diverse technological universe. His work reflects on human diversity, and is often the device for searching social critique and political activism.

Seven years later in 1989, SM fetish wear resurfaced in van Beirendonck's Autumn/Winter Collection "Hardbeat" (1989–1990) by way of bondage masks and knee-high laced boots. Drawn to the clandestine lifestyle of SM and master and slave bondage, fetish wear and accessories have often made their way into many of van Beirondonck's collections. A double-spiked heel appears in "Take a W-Ride," (Autumn/Winter 2010–2011), while in "Paradise Pleasure Productions" (Autumn/Winter 1985–1986) (also known as "The Rubber Show"), men in full latex suits resembling life-sized sex dolls assume a major role. The "Revolution" collection (Autumn/Winter 2001–2002) included gimp masks and leather suits with exaggerated collars redolent of the mannered foppery of the so-called *incroyables* ("incredibles"—"outrageous ones" is closer to a contemporary translation), the group associated with the eccentrics and decadents of the French Directory (1795–1799), also known as "The White Terror," the period of jubilant excess following the Red or Reign of Terror. The *Incroyables* (Figure 19) were anti-Jacobin dandies who combined as street gangs in Paris. Their

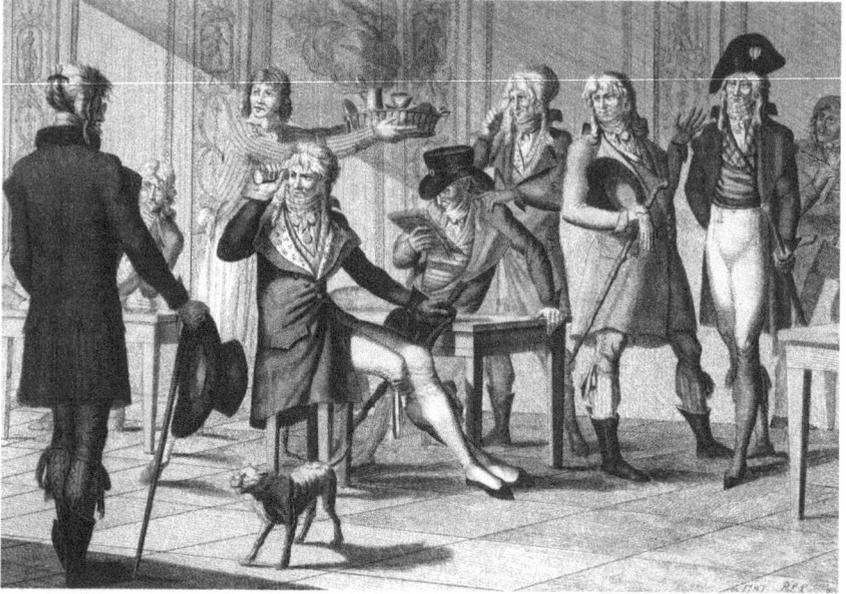

Figure 19 Café des Incroyables. Artist unknown. Public domain.

hallmarks were vividly colorful jackets with exaggerated collars and lapels, large neckties, wide trousers and long hair in place of the ancien régime wig (also worn by Robespierre). They occasionally donned a *bicorne* or *melon* hat that in the military and now in civilian life had come to replace the *tricorne*. While these early examples of subcultural styles—their female counterparts were known as the *merveilleuses* ("marvelous ladies," in our parlance it is perhaps "fabulous dames")—their ebullience at the relief of the end of the Terror should not be construed as overarching optimism, but rather an exhaustion that spawns a nihilistic abandon in the wake of degradation and fear. The period between the Terror and the rise of Napoleon was one of mass corruption and considerable chaos, held in check only by the rigors demanded of the revolutionary wars waged on several fronts. Van Beirendonck's "inspiration" is therefore multivalent and purposely ambiguous. It expresses hedonism that masks a deeper ruefulness and dread. These were fashions from a time when sex and death were very much on people's minds.

Unsurprisingly then, questions of the boundaries between gender and sexuality often arise in Walter van Beirendonck's work. In the catalogue for the Third Berlin Biennial for Contemporary Art, he is described as someone who "loves the extreme, [and] creatures on the verge of crossovers, just like his fashion represents the untamed hermaphrodite."[2] His men's wear collections frequently explore body images that depart from conventional ideas of masculinity, from queer to hybrid subjectivities: *outré* gay bears in "Wonderland" (Autumn/

Winter 1997) models with prosthetic horns in "Believe" (Autumn/Winter 1998) and enlarged and exaggerated penises in "Sex Clown" (Spring/Summer 2008). Experimenting with a number of skirted garments that he unconventionally considers gender-neutral, van Beirendonck has designed midis and maxis in plain and pleated styles. In "Gender?" collection (Spring/Summer 2000), van Beirendonck again questioned popular masculine stereotypes and the extent to which gender and gender-related fashion is largely dictated by society. As part of the collection he designed crocheted skirts worn over floral cotton trousers. In other collections he has dressed men in heels, latex stockings, laced-up corsets and printed skirts. "It is fascinating to play these sorts of games," mused van Beirendonck in a recent interview with *Dazed and Confused* magazine, "to find out where the boundaries lie, but I create without ever wondering whether I'm designing for men or for women. This has nothing to do with transvestism; it's just that I see the sexes as equivalent."[3]

Sadomasochistic paraphernalia such as masks, chains, leather harnesses and collars are often used on his catwalk collections to stylize his models and to register a deliberate mid-zone of gender and sexuality that challenges standard identity stereotypes. As part of Paris Fashion Week, his "Hardbeat" (Autumn/Winter 1989) contained his most explicit references to SM: masks, latex knee-high boots and slogans—"Fetish for Main Course," "Licks and Kisses" and "Great Balls of Fire"—to the background soundtrack *Master and Slaves of Fashion* by the Indie Belgium band Real Men. In the same way that American photographer Robert Mapplethorpe used, as Kaat Debo states, "a visual language to express an aspect of sexuality that society prefers to keep concealed, van Beirendonck softens the elements from the SM wardrobe by producing them not in leather but in soft, colourful tricote."[4]

Van Beirendonck's transgressive design practices embedded in his collections are more about sending a message than they are about shock value despite them being shocking all the same. He uses fashion as a way of drawing attention to important social issues such as safe sex, the environment, and racism. To this end the titles of many collections have the sound of slogans: "Stop Terrorizing Our World" (Autumn/Winter 2105), "Stop Racism" (Autumn/Winter 2014) (Plate 20) and "CCTV in Operation" (Spring/Summer 2015), the last a protest against mass surveillance. Van Beirendonck's protest fashion, if it can be called that, began in his student days at the Antwerp Academy. His fourth-year collection took the inspiration of insects as its theme and used bold graphic prints and political slogans to carry the message. "Killer/Astral Travel/4D Hi-Di" (Spring/Summer 1996) contained masks in the shape of whoopee cushions with printed slogans "Terror Time," "Get Off My Dick," and "Blow Job." This collection drew from the 1992 installation *Heidi* by artists Mike Kelly and Paul McCarthy. The work involved life-sized rubber dolls and references to horror film (a still from the 1931 version of *Frankenstein* by James Whale starring Boris Karloff, when

Frankenstein meets the girl in the wild, is the cover image of the exhibition catalogue). Their "Heidi" was a trenchant travesty of the sweeter tale of the Swiss heroine Heidi (from the eponymous 1881 novel by Joanna Spyri) for the purpose of mounting a scathing critique of the American myth of the purity of modern family life. In van Beirendonck's interpretation, Heidi—who lives in the Alps and falls in love with a baby goat—is actually the reincarnation of the devil who in turn acts as a trope for the HIV/AIDS epidemic. In the catwalk production, innocent Heidi is wandering in the mountains looking for the rare flower edelweiss in an apple meadow with her goat, its eyes lit and flickering with sexual delight. "Innocence and naïvity are shown contrasted with the world of sexuality and even aggression."[5] Heidi can also be read as a sinister version of the fairy tale Little Red Riding Hood from the Brothers Grimm in which a big bad wolf (in place of a goat) stalks the girl and in the process of trying to eat her, eats Red Riding Hood's grandmother, then dresses up in her clothing. Like the Biblical creation story in which the snake tempts Eve, the little girl represents the loss of childhood innocence, while the wolf symbolizes untamed masculine sexual energy.

Van Beirendonck's catwalk shows are spectacular theatrical performances. Human-animal hybrids, science fiction characters and comic book heroes, grotesque and splendid, populate the motley, hybrid Beirendonckian universe. Human and animal relationships abound in Beirendonck's work; take "Weird," his Autumn/Winter 2005 collection in which an inflatable balloon animal falls in love with a hedgehog. This ill-fated, unconventional and unconsummated union materially manifests itself in stuffed removable collars for dresses and suits; the hedgehog and balloon lovers appear in various prints. Cross-species love is also rampant in "Wonderland" (Autumn/Winter 1996), where the motif of the two swans with necks entwined are symbols of eternal love. Although the political message can come across as dark and sinister at times, Beirendonck "always packs [his] messages in a colourful way, full of hope and belief for the future."[6]

The 1980s in London

Graduating in 1980 from the Royal Academy of Fine Arts in Antwerp, van Beirendonck's breakthrough came in 1986 when, along with fellow designers Dries van Noten, Marina Yee, Anne Demeulemeester, Dirk Bikkembergs and Dirk van Saene (the "Antwerp Six," a pastiched reference to early twentieth-century French group of composers "Les Six")[7] he hired a truck to travel to London to participate in the London Designer Show, where he presented his "Bad Baby Boy" collection (Autumn/Winter 1986–1987). Here cherubic models wore red pointed hats and soft woolly sweaters with pompoms decorated with motifs of teddy bears. The message was quite complex yet explicit, namely, there are bad baby boys and there are daddies. Van Beirendonck's collection was tapping into

SM and the exchange of power between submissives, in this case submissive baby boys and dominant daddies. The collection was a sign of what was to follow. Sex and more sex, SM, aggression and violence—the catwalk would become a theater of erotica.

The 1980s was a period of intense outpouring of creativity across the fields of music, fashion and art that challenged ideas of sexuality and gender. The language of advertising shifted from highlighting the qualities and function of a product to associating products to self-improvement and empowerment. Fashion and lifestyle advertisers and marketers began actively to solicit affluent young male consumers through strategies that mobilized images of young ideal bodies living desirable, affluent lifestyles. It was also around this time that new discourses began circulating in Britain about masculinity, with one repeated motif, that of the "New Man." The emergence of the new man signaled the growing cultural and commercial confusion around gender privilege and masculinity as well as subjectivity and sexuality. This shift in discourse and representation of traditional hegemonic masculinity occurred as a result of the social movements from the late 1960s onward, such as feminism, the civil rights movement and gay liberation, which disrupted traditionally held views of race, gender and sexuality, and promoted a model of democratic equality.

Stylistically, the 1980s developed its own sartorial language, which was associated with bright, trashy glamor, excess and success. More noticeably than ever, fashion and style had splintered into a wide variety of subgroups. To wear a certain kind of style was to signal belonging to a particular ideological group: fetish, Rave, New Romantic and high camp, to name a few. In this regard, the fashion and style of the 1980s can be said to reflect the pre-eminently discursive and agonistic nature of political activism. Punk's reaction to the conservative political climate of Thatcherism and Reagan coalesced into a trash and freedom aesthetic built on anarchy and aggression. Although the DIY attitude of punk was stylistically antithetical to van Beirendonck's aesthetic oeuvre, its disposition toward the bondage and fetish wear, latex and its overall harshness nevertheless appealed to his creativity. When in London, van Beirendonck would often visit Vivienne Westwood's World's End boutique and purchase a variety of accessories and garments.

In London, club culture, with its underground wanderlust and psycho-glamor appealed to van Beirendonck's playful and anarchic sense of freedom and his bold aesthetic. Leigh Bowery's London Taboo Club and Club for Heroes captured his appetite for excess and individuality. Van Beirendonck made sure the febrile 1980s mix of music, art and fashion, and the basement dance floor made their way onto the catwalk. The Blitz club in Covent Garden was popular with New Romantics who dressed in the new style of pantaloons and frilly shirts and listened to the music of Duran Duran, Spandau Ballet, Yazoo and Visage. Credited for launching the New Romantic subcultural movement, the club was

run by Steve Strange and was a popular venue for the likes of Adam Ant, Marilyn and Boy George, and designers such as Galliano and Stephen Jones who would become van Beirendonck's collaborator on numerous collections.

This period marked a creative explosion of street and club styles, and a time when British fashion was dominated by young designers, Katharine Hamnett, Stevie Stewart and David Holah of Bodymap, created new looks with innovative shapes and materials that appeared on the club dance floor every Saturday night. As Kathryn Hughes remarks, "Whereas the 1960s clothing revolution had been all about mass production, with copy ability a key part of its appeal, by the 1980s cachet had come to reside in the one-off and the irreplaceable."[8] Magazines such as *Arena*, *The Face*, *i-D* and *Blitz* functioned as style Bibles to a new generation of youth, in the words of Iain Webb, "wishing to overthrow the establishment with their alternative version of the world; part nostalgic and rose-tinted, part broken and dystopic post punk."[9] The rise of club culture reshaped the cultural landscapes and social geographies of many metropolitan cities. Many commentators of club culture signaled the demise of the oppositional youth styles of the 1960s and 1970s. It maintained the clearest manifestations of postmodern style, "pastiche, bricolage, depth-lessness, and the promotion of hyper-individualism within a drug induced Dionysian culture of strobe lights, oxygen smoke and a thumping bass."[10] And in Belgium in the 1980s a new style of music that became known as the New Beat began circulating, which was a mix of House, Acid and Garage that originated from Chicago and Detroit. The New Beaters adopted a style that can be described as industrial new romantic and was influenced by London magazines *The Face* and *I-D*. The 1980s was all about color, bold graphics, music and protest. Van Beirendonck was very much influenced by this cultural climate, which found its way into collections that mixed anything from graphic comics to bondage wear. When the New Beater adopted the Smileys of Acid House, van Beirendonck's graphic style became popular with its iconography of pop and speed.

Although the 1980s was steeped in new music, clubbing and fashion, there was also a dark side. For it was also a period of high youth unemployment when environmental issues were coming to prominence and when nuclear war continued to be a very real and present threat. Such conditions fed designers like van Beirendonck (as well as Katharine Hamnett) with the creative fuel that found its way into the graphic messages that appeared in their collections, which offered optimistic alternatives for the future. In 1989 van Beirendonck launched the diffusion label "Walter Worldwide" under the slogan "Leisure for Pleasure," and a year later he declared that fashion was dead with his Spring/Summer collection of the same name. "The 'Fashion Is Dead Collection' was my reaction to the fashion-system. I was very disappointed with the lies and difficulties of working in fashion."[11]

Van Beirendonck was also deeply affected by the HIV/AIDS epidemic, which was sweeping across the world at a fast pace. The first case of HIV/AIDS in the Western world was diagnosed in 1981 and by the end of the decade, the number of people living with AIDS was eight million, with the highest number of deaths from AIDS-related complications affecting people in the creative industries.[12] Photographers (Herb Ritts), stylists (Ray Petri), fashion designers (Franco Moschino) and musicians (Freddie Mercury) all died because of the virus. The creative industries organized charity events to raise money for research and social services in response to the growing number of people affected by the virus.

Fetishism, clowns, ritual

In many ways van Beirendonck responded to the AIDS crisis like any designer would; he made politically charged statements through his collections to draw attention to HIV protection and to promote safe sex. In "Paradise Pleasure Productions" (Autumn/Winter 1998), which gained the moniker "The Rubber Show," male models were dressed in tight rubber latex body suits that covered their entire bodies, their faces obscured by acid-bright marabou masks. The female models wore rubber latex cat suits emblazoned with David Bowie-style lightning bolts; zippers ran from the back of their head to their crotch. The entire body was quite literally wrapped in a condom or sheath. Jean-Baptiste Mondino immortalized the collection in a photographic shoot that depicted the models immersed in in a bed of balloons complete with large inflated penises and a giant sex doll.

Apart from van Beirendonck's intention to raise awareness of HIV/AIDS, the show's visual graphology of sex clowns made a bold statement about queer sex and coulrophilia (the sexual attraction toward clowns, mimes and jesters) by drawing on traditional kinship rituals as a form of storytelling. "I'm not interested in porn" he comments, "but the rituals that take place within the fetish world, which is something very different. I'm interested in rituals of domination, which are also quite close to ethnic rituals."[13] Clowns have be used across cultures to pass on social messages, such as the Edu clowns in India, where cultural and religious rigidity forbids sex-related issues to be addressed in the public arena, making any discussion about sexuality or health difficult to discuss or address. As part of HIV awareness, the not-for-profit group the Blossom Trust initiated a public program in Tamil Nadu that used Edu clowns, a traditional theater group, to raise awareness of safe sex. "With painted red noses that symbolize the fury of seeing certain unacceptable situations and lifestyles in the community [the Edu-Clowns] campaign for child health and sexual education."[14] Similarly, the Pueblo clowns, or "Delight Maker" of the Mayo-Yaqui Indians of the American

Southwest performed sacred roles, provoking laughter by making light of serious issues. The clowns would conceal their identity by painting their bodies and faces, and wearing elaborate head masks. In describing the rituals of the Pueblo clowns, American anthropologist Ralph L. Beals writes:

> these masked men teased one another; they fell over dogs and rolled in the dust; they displayed mock fear; they set a doll on the ground to venerate it as a saint; and they simulated eating and drinking the excreta they would pretend to catch in their wooden machete from the body of passing burro or horse or man or woman, even of one kneeling in prayer. This last diversion was a variant on the filth eating and drinking practices of the Pueblo clowns[15]

Clowns circulate within the liminal space of profanity and sacredness; they can be kind and hilarious, or unsettling and evil, with their gestural mimicry. Clowns and fools feature prominently in Mikhail Bakhtin's *Rabelais and his World* (1965), as they are part of the everyday life of the Renaissance carnival season. The carnival season is a moment when almost everything is permitted and thus marked by excess rejoicing and outlandishness. It is a type of communal performance with no boundary between the audience and the performer and creates a type of alternative space that is characterized by freedom and abundance. According to Bakhtin, at carnival time the laws of common day life are altered to become new laws, "the laws of its own freedom."[16] Carnival and fêting is a type of communal performance with no boundary between the audience and the performer. It creates a type of alternative space that is characterized by freedom and abundance. Clowns, the human embodiments of carnival, represented for Bakhtin "a certain form of life, which was real and ideal at the same time. They stood on the borderline between life and art, in a peculiar midzone as it were, they were neither eccentrics nor dolts, neither were they comic actors."[17] Clowns made their first appearance as the "fools" in early Greek and Roman theater and were further developed as masked characters in the *commedia dell'arte*, which began in Italy in the mid-sixteenth century (Figure 20).

While clowns may act as a form of comic relief among kingship traditions, there is also a perverse and sinister side of the clown in Western popular culture. Take for instance the evil Joker in the Bob Kane's DC graphic novels *Batman* who is portrayed as a psychopath with a sadistic sense of humor, or the deviant and demented Pogo the Clown persona of American serial killer John Wayne Gacy who raped and murdered thirty-three teenage boys and buried their bodies in the crawl space of his home. And then of course there is Stephen King's horror novel *It* (1986) adapted into a two-part television film (1990).[18] An evil life form manifests itself into the sadistic Pennywise the Dancing Clown and terrorizes the American town of Derry, Maine. To returning to van

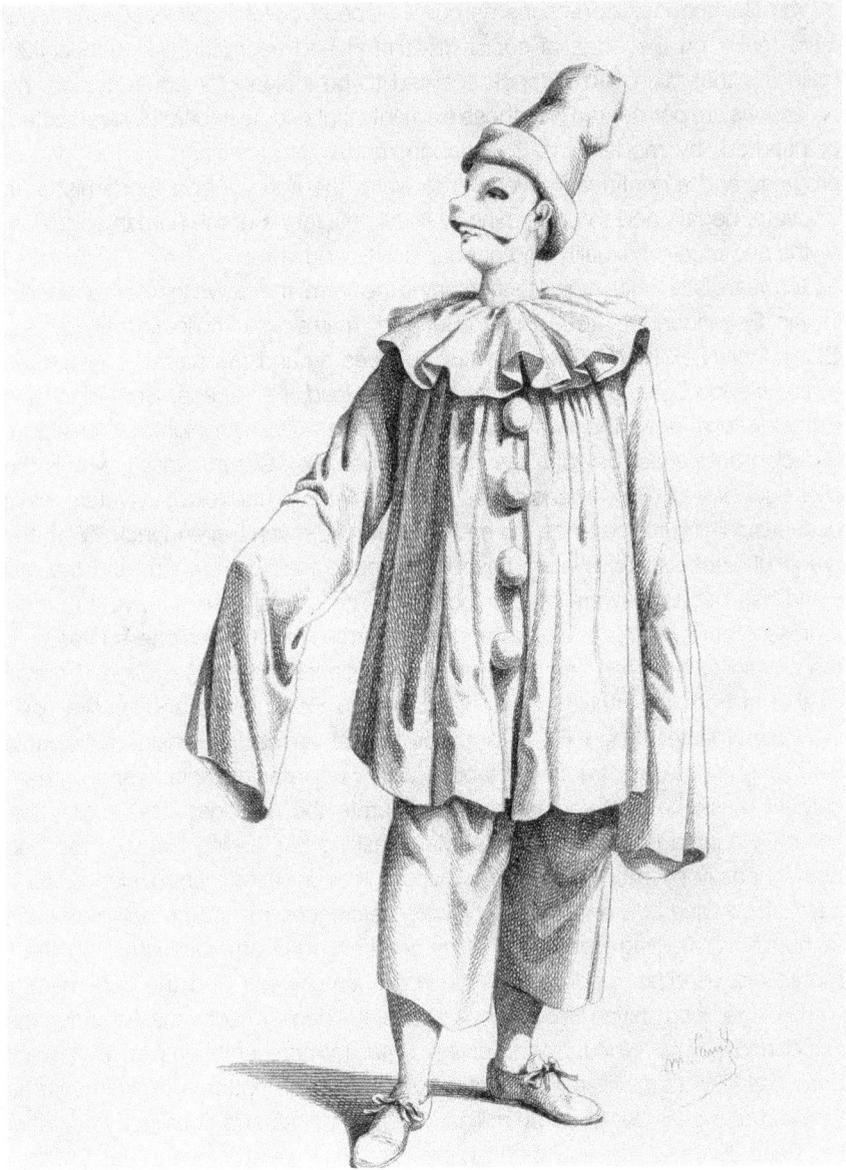

Figure 20 The Italian *Pagliacco* of c. 1600 (Maurice Sand, *Masques et bouffons [Comedie Italienne*, 1860*]*). Public Domain.

Beirendonck and the "Paradise Pleasure Productions" collection: while head-to-toe latex body suits represent a prophylactic that figuratively protects the body from the AIDS virus, the clown itself acts as a metaphor for the trauma and horror of the virus itself.

Van Beirendonck collections harbor a place of collective unease where our fears teeter on the edge of social discomfort and acceptability. Luc Derycke observes that "Van Beirendonck seemed to be looking for confrontation, his collections are permeated with those elements that had been carefully eradicated, or negated, by modernism."[19] Although modernity is defined by the idea of progress and a continual movement forward, the agenda of a modernist is to innovate, negate and to undermine all traditional forms of the human condition, myths and rituals, sexuality and gender, codes and laws.

Ten years later when digital technology is the norm, the clown theme reappeared in van Beirendonck's 2008 Spring/Summer men's wear collection titled "Sex Clown," or "Sex King." The collection revolves around the narrative of sixteen avatar friends bearing names such as Dick *Head,* F***k-Face, Sex-Angel and Butt-Boy who leave their virtual world to attend a Parisian nightclub called Le Bataclan on the last day of Paris Fashion Week. Sex Clown himself, who is the alter-ego of van Beirendonck, has invited them to the club. "Avatars have been fascinating to me since the mid-nineties," says van Beirendonck. "With the arrival of Second Life, avatars have finally found their own world, and the real world has become aware of their power."[20] The animal masks serve as carnal representations of digital beings and are informed by the designer's interest in the crossover between sexual fetish and traditional rituals. "Sex Clown" draws its theme from the rituals of the colorful Sogo Bo puppets and masks used in Malian theater. Sogo Bo is a major festival in Mali at which participants wear brightly colored traditional fabrics with wood carved animal and human-shaped masks in a street parade to celebrate the practices of everyday life. For the Banama peoples of central Mali masking has a long history. Practiced predominately by men, either as a part of their initiation ceremonies or as a form of masquerade and play, it typically references masculine activities such as hunting or fighting—both with close proximity to death. Unsurprisingly then, masks are used as mediators between the living world and the supernatural world of the dead. In van Beirendonck's case, the papier mâché masks bridge the virtual and natural worlds, and act as symbolic representations of giant erect phalluses. The fantastic animal motifs also appear as patterns on knit wear as well as head gear designed by milliner Stephen Jones and corsets by corsetier Mr. Pearl (Plate 21) "If you didn't know that they were a reference to African masks, you would wonder what these papier-mâché penises are doing on people's heads."[21]

Headgear and masks

The process by which masks and clothing act as channeling devices between the supernatural and the natural world is explained by Warwick and Cavallaro as

a process of embodiment and disembodiment similar to the processes attached to shamanistic initiation rites. This process of initiation, write Warwick and Cavallaro:

> . . . may include the dismemberment of the subjects body, the removal and substitution of flesh; a ritual that could be read as metaphorically redolent of the phenomenon of decorporealization triggered by the entry into the symbolic, which dress both ratifies, by posting itself as a substitute skin or flesh, and challenges, by foregrounding its own irreducible materiality.[22]

This is a process that is indissolubly linked to venerable rituals of the masque and masquerade, where the masking of "real" identity allows for a jettisoning of inhibitions and for pushing taboos. For Bakhtin:

> the mask is connected with the joy of change and reincarnation, with gay relativity and with the merry negation of uniformity and similarity; it rejects oneself. The mask is related to transition, metamorphosis, the violation of natural boundaries, to mockery and familiar nicknames. It contains the playful element of life; it is based on a peculiar interrelation of reality and image, characteristic of the most ancient rituals and spectacles. Of course it would be impossible to exhaust the intricate multiform symbolism of the mask. Let us point out that such manifestations as parodies, caricatures, grimaces, eccentric postures, and comic gestures per se derived from the mask. It reveals the essence of the grotesque.[23]

Moreover, the mask as an analytical tool creates a subjective space that has ramifications to codes of gender and sexuality, and highlighting what Theresa de Lauretis calls "technologies of gender."[24] For the mask tends to highlight certain fictions and constructions of identity by dint of its very artificiality.[25] This doubling function of the mask is used by Bakhtin to explain the differing ways that masks have been used historically and of shifting and cultural attitudes. He writes of the mask as an "involvement shield," protecting individual privacy while simultaneously allowing for interaction with others. "The mask," he writes, "is related to transition, metamorphoses, the violation of natural boundaries . . . it is based on a peculiar interrelation of reality and image."[26]

Masks and headgear proliferate in van Beirendonck's collections. For his Autumn 1997 show "Avatar," he asked milliner Stephen Jones "to create 120 hats, one for each model in the show. Hats made from computer parts, kinetic hats that flew off the models' head and cartoon leaves with caricatures of insects."[27] Designed under the label W.&.L.T. (Wild and Lethal Trash), a collaboration between van Beirendonck and the German denim label Mustang from 1993 to 1999, "Avatar" was shown at the Éspace St. Denis, Paris and used

three parallel catwalks to display the collection's themes. Forty models wore transparent blindfolds emulating superheroes; forty African Avatar models wore metal head frames and war make-up, and forty Asian Avatars introduced the label's first women's wear collection.

For Winter 2012 van Beirendonck called his men's wear collection "Lust Never Sleeps," subverting classic tailoring with references to SM, voodoo masks and Papua New Guinean shields within a colonial subtext. Carrying canes with chains and with padlocks around their necks, Black models paraded on the catwalk wearing brightly colored suits with British bowler hats, gloves and gimp masks made of Elastoplast pink to mimic Caucasian skin (Plates 22 and 23).

Whether the references to slavery were intentional or not, they are disturbing. The combination of SM ritual, Black bodies, Western suits and British bowler hats is given a heightened allure by the mastery of tailoring. Approached as a textual system, the collection draws attention to colonial discourses concerned with "civilizing the native" and brings to mind the work of Mapplethorpe, who has been a major influence on van Beirendonck since he met the photographer in the 1980s. Mapplethorpe was notorious in fetishizing naked Black male bodies, abstracting them and representing them as passive through visual representations that privilege the white male gaze. By cropping the image of the body in particular ways, the representational image of the black male nude is objectified in such a way that makes it seem to the manipulation of the (white) artist. Kobena Mercer eloquently writes that in Mapplethorpe's photography, the "essence" of Black male identity lies in the domain of sexuality. "Whereas the photography of S/M rituals invoke a subcultural sexuality that consists of *doing* something, Black men are *confined* [our emphasis] and defined in their very *being* as sexual and nothing but sexual, hence, *hypersexual*."[28]

Although the transgressive quality of van Beirendonck's design aesthetic is to *épater les bourgeois* (shock the bourgeois), and to draw attention to social and political issues, it is "hard to resist the idea the idea," notes Tim Blanks, "that his sleeky civilized tailored suits were also a mask for a whole repertoire of beastly impulses."[29] Consider *Black Skin, White Masks* (*Peau noire, masques blancs*, 1952), Frantz Fanon's study of the detrimental impact of slavery and colonialism on the African psyche under the French Colonial Empire (1534–1980). Fanon argues that the process and discourse of colonialism dehumanizes the Black subject, making him [*sic*] feel inadequate in a dominant white world. The impact of colonization removes and severs the Black subject from his [*sic*] native identity and results in the Black subject embracing the culture of the Imperial center in order to belong. The inferiority complex produced renders the Black subject feeling inadequate against the White ruling class and in order to be accepted, appropriates and imitates the dress, mannerism and deportment of the White ruling class. "Every colonized people," Fanon writes:

in other words, every people in whose soul an inferiority complex has been created by the death and burial of its local cultural originality—finds itself face to face with the language of the civilizing nation; that is, with the culture of the mother country. The Colonized is elevated above his jungle status in proportion to his adoption of the mother country's cultural standards. He becomes whiter as he renounces his blackness, his jungle.[30]

Although Fanon criticizes the pretentiousness of Martinicians in adopting the French colonizers ways, mimicry should not be viewed as a negative act but rather as a subversive tactic of resistance, which exposes the artificiality of the dominant power.

Van Beirendonck is quite clear about his intentions in "Lust Never Sleeps": His voodoo and Papua New Guinean warrior shields that he made in fabric then constructed into suits are a kind of futuristic dandyism. These fashions are of electrifying eccentric outsiders, but meticulous and self-reveling, qualities that all good dandies ought to have. And such considerations call to mind the Sapeurs, or la SAPE of the African Belgium Congo, in short, *Société des Ambianceurs et des Personnes Élégantes*, or the Society of Tastemakers and Elegant People. Centered around the town of Kinshasha and Brazzaville where the movement originated in the 1930s, the SAPE imitate the deportment and dress codes of their French and Belgium colonizers (Plate 24). Like any club, its membership has strong rules concerning harmony of color, elegance, beauty, taste and style, and owes much to the concept of the nineteenth-century dandy.

Sima Godfrey identifies the dandy's character and entire state of being as "an eccentric outsider or member of an elite core, he defies social order at the same time that he embodies its ultimate standard in good taste."[31] The dandy is, in this respect, an exaggerated figure of fashion itself, standing above the crowd, while representing an aspiration of what the crowd should become. In *The Painter of Modern Life* (1863), Charles Baudelaire writes of the "modern' phenomenon of the dandy in nineteenth-century Paris." He describes the dandy as an aesthete, who is "wealthy," "blasé" and "elegant," and is defined by luxury and "the perpetual pursuit of elegance." [32] He writes that "these beings have no other calling but to cultivate the idea of beauty in their person, to satisfy their passions, to feel and to think."[33] For Baudelaire, dandyism contains a discrete set of rules that requires self-discipline: "Dandyism, an institution beyond the laws, itself has rigorous laws which all its subjects must obey, whatever their natural impetuosity and independence of character"[34] Such laws go beyond the "excessive delight in clothes and material elegance" and are more about cultivating "distinction, aristocratic superiority and simplicity in the habit of command."[35] The dandy belongs to a "brotherhood" and is "a high priest" of "the cult of the ego." As members of the "cult of the self," the *sapeur* has much in

common with the Victorian dandy, embodying the "spirit of the times," namely, decadence, excess, artifice, the cult of beauty and aestheticism, all vaunted at a time of great social and economic upheaval. The dandy is most likely to appear "in transitory eras when democracy is not yet dominant and when the aristocracy is but slightly unstable and discredited."[36] In her study of mass consumption in nineteenth-century France, Rosalind Williams argues that the dandies described by Baudelaire as the "last spark of heroism amongst decadence," were responding to what they considered to be "encroachments of bourgeois and even mass vulgarity by reasserting traditional virtues of daring, élan and poise."[37] "These last courtiers, the dandies," writes Williams, "were rebelling against the future, and yet in redefining aristocracy they became social prophets."[38] Like the dandy, the sapeur's attention to detail in dress has become a means to cope with colonial rule and stringent assimilation policies as well as a method of rebellion and resistance. The ongoing conflict in the Congo is a result of the Great War of Africa, which began in 1998 and ended in 2003, and has killed more than 5.4 billion people and made hundreds refugees.

The Congo has experienced ongoing instability and war since it was colonized by the Belgian Empire in 1876. Initially the private dominion of King Leopold II, the Belgian government confiscated the region due to widespread murder and torture under Leopold's rule. Christian missionaries and organizations managed the country as part of colonial rule until its independence in 1960. As part of the "civilizing mission" the missionaries forced the adoption of Western dress on the Congolese and executed a moral economy of body and mind, preaching principles of purity and abstinence. These are principles that are still practiced by the sapeurs who follow strict rules of conservative dress, cleanliness and abstinence from drugs. "The outward display of self was an important aspect of colonial society," argues Patty Chang:

> Sapeurs understood how crucial it was to assert (affirmer) oneself and make an elaborate entrance (débarquer). Even the sapeur's walk was an individualized form of art. Young men would taunt the crowd with their difference and then saunter the length of the stage, head held high, shoulders rolling, displaying their clothes.[39]

Was van Beirendonck's "Lust Never Sleeps" intended to draw attention to the dark side of Belgium's colonial history? Or was the collection with all its sexual references simply highlighted aspects of African culture (war shields and voodoo masks) appropriated in a Western context, rendering them ahistorical by removing them from their original meaning. The gathering of symbols and motifs by van Beirendonck and the assemblages of Other worlds reflects wider cultural rules of aesthetics and power. Although writing about collections in the context of museums rather than fashion, although the same formula still applies, James Clifford argues:

the notion of collecting, at least in the West where time is thought to be linear and irreversible, implies a rescue of phenomenon from inevitable loss or historical decay. The collection contains what deserves to be "kept", remembered and treasured. Artifacts and customs are saved "out of time".[40]

In "Lust Never Sleeps" motifs are selected, gathered and detached from their original temporal occasions and given enduring value in a new arrangement. Susan Sontag's study *On Longing* (1992) negotiates the gap that separates language from the experience that it encodes by exploring certain strategies pursued by the West since the sixteen century, the beginning of imperial expansionism. Paralleling Marx's account of the fetishistic account of commodities, Sontag argues that "the modern museum [collections] are an illusion of a relation between things [which] take the place of social relations."[41] Collections create the illusion of a representation of the world by removing objects (Voodoo mask) motifs (Papua New Guinean shield) and signs out of cultural, social and historical contexts making them abstract wholes. "Lust Never Sleeps" becomes a metonym for an imagined Africa. A system of classification is then put into place that overrides the original meanings of masculinity intended in the Papua New Guinean war shields and completely erases the religious contexts of the masks. "The object world is given, not produced and thus historical relations of power are occulted."[42] In a similar vein, Oscar Wilde (a quintessential dandy) once observed that "the whole of Japan is pure invention. There is no such country. There is no such people."[43] In a different context, Patrizia Calefato notes that "cinema is a potent generator of social-imagery, [because] it constructs futuristic science-fictional settings, often visualizing eternity and time through signs of luxury."[44] The same can be said about fashion collections, especially those of van Beirendonck.

Bodily mutations, shapes and beauty

"Is it a fashion gag? A sick joke—or an inventive idea in human decoration for the new millennium?"[45] Such was the incredulity of Suzy Menkes after seeing van Beirendonck's Spring/Summer 1998 collection "Believe" at Paris Fashion Week. Models wore prosthetic attachments to their faces, changing the shape of their noses, cheeks and chins in homage to the French avant-garde artist Orlan who has undergone and filmed various cosmetic surgeries to reinvent her own body. "It was like Halloween on the club scene," continued Menkes, "typified by the make-up which was a fashion first: prosthetics used to transform the models' faces by elongating a nose, adding a Star Trek molding to the cheeks or planting protuberances as big as golf balls."[46] Thus van Beirendonck crossed boundaries of beauty, gender and even species in his collections, transforming representations

of masculinity and what it means to be human or otherwise. Make-up artist Inge Grognard comments that she is "used to the way that Walter is thinking about beauty as something different. He is always making question marks about beauty."[47] In the "Black Beauty" (Spring/Summer 1998) collection, van Beirendonck raises a number of interesting questions about accepted standards of beauty and the possibilities offered by plastic surgery in manipulating and altering the body to create new looks and shapes. "I wanted to show that standards can be re-thought, or changed. I also think the body of the future will be different from the body we know today, which means [that] clothing will look different to."[48]

It is during times of conflict that van Beirendonck often returns to concepts of beauty as political statements to warn audiences of the fragility of life. When al-Qaeda terrorists stormed the Paris offices of the satirical magazine *Charlie Hebdo*, killing ten employees and two police officers, van Beirendonck made a powerful statement with his Autumn/Winter 2015 collection, "Stop Terrorizing Our World." Male models with Egyptian eye make-up paraded down the catwalk with protest slogans emblazoned on clear plastic T-shirts "Demand Beauty" and "Explicit Beauty." The message was unambiguous: The collection was a call for visual and creative freedom. "We have the need and the right to have beautiful things around us—increasingly people are not given the opportunity to see these things."[49] It was also a reminder that the world is a better place by embracing beauty in all its forms (Figure 21).

Unconventional concepts of beauty emerge as hybrid mutations in van Beirendonck's collections. The designer himself appeared on the catwalk as Puk Puk the crocodile man of the Latmul in his Spring/Summer 1998 collection "A Fetish for Beauty," then there is Duk Duk a mask from a secret man's society in New Guinea that was incorporated in several collections, including "Glow" (Autumn/Winter 2009). The entire collection of "Welcome Little Stranger" (Spring/Summer 1997) is based on the concept of alien spirits that visit earth and behave in strange ways.

Van Beirendonck's message is plain: It is a call to step up and be *different*. The politics of difference are associated with social movements such as feminism, civil rights, and gay and lesbian liberation whose aim was to decenter white male hegemonic power by asserting and celebrating their own cultural specificities. The key concept in this argument is that the theoretical formation of difference itself is embedded in language and is crucial to the production of meaning. In the structuralist and poststructuralist tradition, difference is understood to be constitutive of identity because identities are produced and rendered meaningful through the interplay of differences. Identities are not fixed, but are constantly in deferral, shifting and evolving in meaning according to culture. Van Beirendonck interweaves human, animal and alien to produce new hybrid identities that challenge the validity of essentialist notions of what it means to be human. These

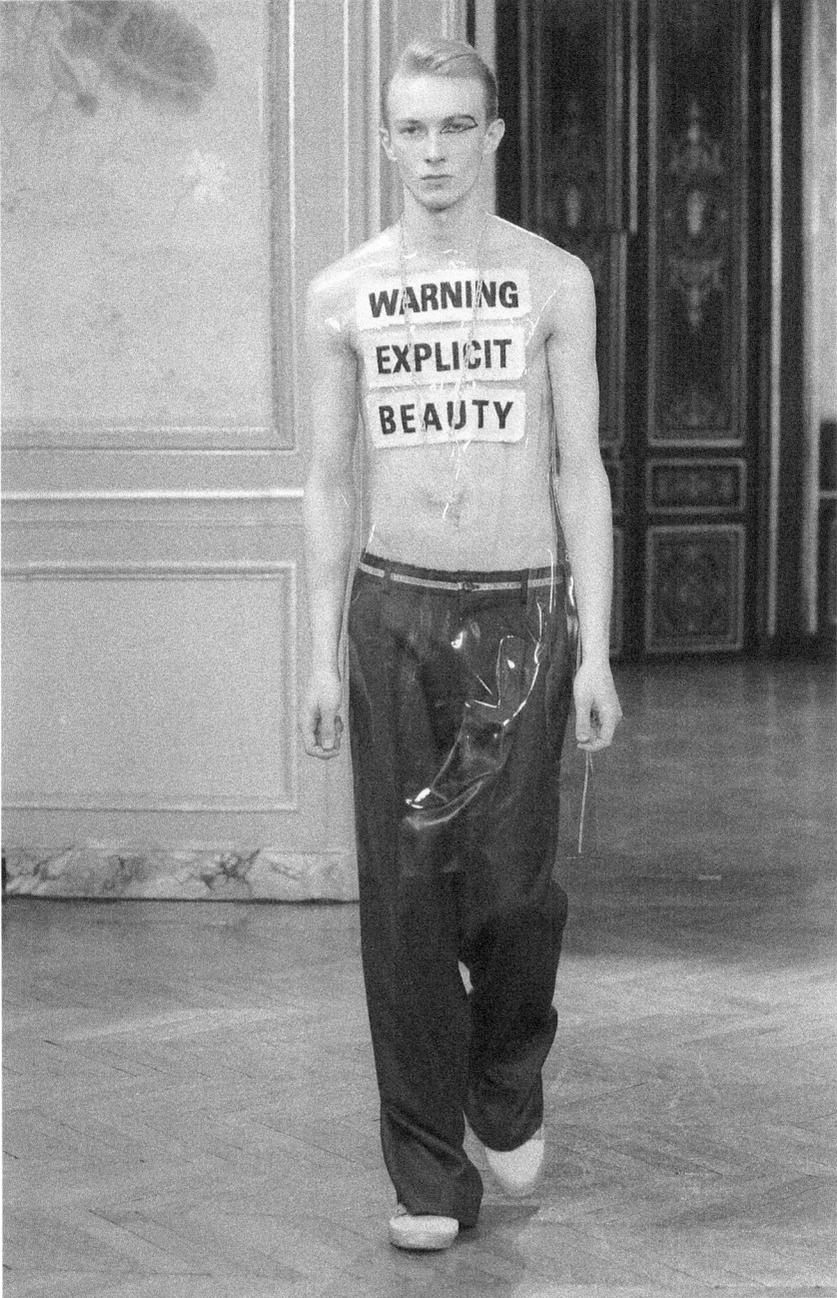

Figure 21 Walter van Beirendonck, "Stop Terrorizing Our World," Autumn/Spring 2015. Photography Francoise Durand.

new identities produce multiple spaces that engender new possibilities in re-imagining new forms of cultural meaning that call into question existing limitations and boundaries in culture and identity. Van Beirendonck's ambiguous identities traverse material and nonmaterial spaces, human, animal and alien, and are able to mediate across cultures and language to find a common ground. In a world in which technology offers us limitless possibilities to re-imagine our bodies, van Beirendonck reminds us that in the great scheme of things there are more important things that matter.

CONCLUSION: TO ALEXANDER McQUEEN, IN MEMORIAM

After Alexander McQueen took his own life on February 11, 2010, it became somewhat a commonplace to make a great deal of the messages of death in his work. To be sure they were there, but to take them as a sign of the imminence of an untimely death was distasteful, yet somehow impossible to avoid. His graduating work was entitled "J is for Jack the Ripper (Stalks His Victims)" (1992), which sets the tone of his work to follow, which is obsessed with violence, violation or a haunting state of undeadness. Along with the older Margiela and Chalayan, who were his contemporaries, and other figures mentioned in this book such as Westwood and Kawakubo, McQueen was one of the central figures in shaping the knowledge that fashion has the ability to do more than flatter and please. Fashion also has the capacity to startle, to jog the memory and to open up complex and stimulating discourses on class, gender, value, structure, method and more. It informs us about life and helps to jettison habits and clichés. The reason why McQueen has been singled out is because the pre-eminence of death's many faces in his work helps to isolate the connecting thread. Death's omnipresence is what binds all of these designers, and certainly all in this book, together. This can be death seen in visual syntax of destruction, or it can be death as the "death of man" and the introduction of the posthuman cyborg. It can be death seen in the present absence of the body, or it can be death in resuscitating the ancient past, the worlds long past.

One explanation for this connection is a mildly romantic and humanist one, namely, that great art must share in the world's terror and be imbibed with the pathos of humanity. This is pathos meant in the stronger sense of the *pathétique*, with connotations of soulful depth that penetrates to the imprecise and unfathomable reaches of human suffering. Identifying human suffering as at the core of the human condition is a Judeo-Christian concept, but one with which we in the present era still find it hard to dispense. With contemporary art being more the bedfellow of entertainment and the show-pony of corporate marketing,

its post-pop cynicism and its elevation of visual platitudes, has a certain kind of fashion designer taken over the mantle of duty? This is a large and highly elevated question and one that most probably leads in the wrong direction. Suffice it to say that death is a concept that over-reaches epochs and styles. What remains is that for an exercise to be serious it must take it into account. Death is in fashion's very fabric, being and meaning. To say something is fashionable is to presage the moment when it falls out of fashion and into obscurity, to prescribe a rise and an unavoidable fall. One only needs to think of Giacomo Leopardi's famous "Dialogue Between Fashion and Death" (1824), which represents them as sides of the same coin or as siblings.

Death is central to the so-called time of fashion, but it is also inscribed within clothing itself, which was required in response to the shame and modesty introduced after the Fall. As Giorgio Agamben describes:

> The time of fashion, therefore, constitutively anticipates itself and consequently is also always too late. It always takes the form of an ungraspable threshold between a "not yet" and a "no more". It is quite probable that, as the theologians suggest, this constellation depends on the fact that fashion, at least in our culture, is a theological signature of clothing, which derives from the first piece of clothing that was sewn by Adam and Eve after Original Sin, in the form of a loincloth woven from fig leaves. (To be precise the clothes that we wear do not derive from this vegetal loincloth but from the *tunicae pelliceae*, the clothes made from animals' skin that God, according to Genesis 3:21, gave to our progenitors as a tangible symbol of sin and death in the moment he expelled them from Paradise.)[1]

Until only recently, fashion had disavowed its manifold relationship to death. In Worth's time, the many quotations from the past, brazen and intricate, were meant to embolden the notion that his fashions were imbued with a timeless quality. The Orientalism of Poiret sought recourse to distant mysteries defiant of time. Vionnet's use of ancient Greek dress was meant to do the same, using the powerfully time-resilient alibi of classicism. The pared styles of Chanel and Patou were meant to be adaptable and resistant to trends and whims. To some extent casual classics like the T-shirt and jeans have this quality as well, as do the unobtrusive fashions of Jil Sander, Helmut Lang or Giorgio Armani. On a base level, it is congenial to fashion to play down death since this will help not to deter people from buying it. It is also practicable to do hermetic, clean, classic fashion with only infinitesimal changes from season to season as the wider market cannot afford to update their wardrobe from year to year.

It is only very recently, and something that this book has navigated, that death has become inscribed within the aesthetic and the phenomenality of fashion. From the rip to the robot, life is situated as undeniably contingent and as indelibly

fragile. Instead of thinking of the fashions analyzed in this book, and others that operate in the same way, in terms of a romantic nostalgia, or a return to older truer values, it is better to look at a simpler relationship that Agamben helps to broach. This is that clothing had traditionally been for modesty and/or for pleasure. It compensated for shame and/or for displeasure. While these concepts may still be invoked to a greater or lesser extent obtrusive, critical fashions engage in no such denial but place shame, terror, perversity, otherness at the epicenter of the garment's logic. It is as if clothing had become liberated after the Fall, that the binary of body and garment could be forgone and that fashion could have an independent life, unencumbered by the old prejudices and expectations, and with the ability to craft its own myths and to bring its own illusions to life.

NOTES

Introduction: From Subculture to High Culture

1 Vivienne Westwood and Ian Kelly, *Vivienne Westwood*, Oxford and London: Phaidon, 2014, 134.

2 Theodor W. Adorno, *Prisms*, trans. Sam and Shierry Weber, Cambridge, MA: MIT Press (1981) 1990, 19.

3 Ibid., 20.

4 Ibid., 27.

5 Michel Foucault, "What is Critique?" trans. Lysa Hochroth, in *Politics and Truth*, ed. Sylvère Lotringer and Lysa Hochroth, New York: Semiotext(e), 2007, 25.

6 Julian Stallabrass, *High Art Lite*, London and New York: Verso 1999.

7 See Adam Geczy and Jacqueline Millner, *Fashionable Art*, New York and London: Bloomsbury, 2015.

8 T. J. Clark, "Modernism, Postmodernism, and Steam," *October* 100, Spring 2002, 161.

9 Hal Foster, "Post-Critical," *October* 139, 4–8.

10 David Geers, "Neo-Modern," *October* 139, 13.

11 Ibid., 14.

12 Mario Perniola, *Art and Its Shadow* (2000), trans. Massimo Verdicchio, New York and London: Continuum, 2004, 5.

13 See Adam Geczy and Vicki Karaminas, *Queer Style*, chapter one, New York and London: Bloomsbury, 2013.

14 See Adam Geczy, *Fashion and Orientalism: Dress, Textiles and Culture from the 17th to the 21st Century*, London and New York: Bloomsbury, 2013.

15 See, for instance, Monica Sklar, "Is Punk Style Still Extreme?" in *Punk Style*, London and New York: Bloomsbury 2013, 146–148.

16 Colin Crouch, *Post-Democracy*, London and New York: Polity, 2004; Pierre Rosanvalon, *Counter-Democracy*, trans. Arthur Goldhammer, Cambridge and London: Cambridge University Press, 2008.

17 Michel Maffesoli, *The Time of Tribes*, London: Sage, 1996.

18 Katherine Hayles, *How We Became Posthuman: Virtual Bodies in Cybernetics, Literature and Infomatics*, Chicago and London: Chicago University Press, 1999; Stefan Herbrecheter, *Posthumanism: A Critical Analysis*, London and New York: Bloomsbury, 2013.

1 Vivienne Westwood's Unruly Resistance

1 In the words of Westwood, her shop World's End "opened at maybe one o'clock. A couple of people would put on music and [someone] got a cup of tea. Models maybe would come for a photo shoot—Justine de Villeneuve or Twiggy: the King's Road was like a film set then, a kid's dream. I was where it was all happening. There'd be people looking out for the pop stars who came by: Jagger and Bianca, and Keith Richards and Peter Sellers, Rod Stewart, Freddie Mercury, Marianne Faithfull, Jerry Hall, Britt Ekland, Elton John." Westwood and Kelly, *Vivienne Westwood*, 140–141.

2 Luca Beatrice, "Walking in My Shoes," in Luca Beatrice and Matteo Guarmaccia eds., *Vivienne Westwood: Shoes*, trans. David Smith, Bologna: Damiani, 2006, 7.

3 Westwood and Kelly, *Vivienne Westwood*, 145.

4 Ibid.

5 Brenda Polan and Roger Tredre, *The Great Fashion Designers*, Oxford and New York: Berg, 2009, 184.

6 Westwood and Kelly, *Vivienne Westwood*, 160.

7 Fred Vermorel, *Fashion and Perversity: A Life of Vivienne Westwood and the Sixties Laid Bare*, London: Bloomsbury, 1996, 80–81.

8 Claude Lévi-Strauss, *La Pensée sauvage*, Paris: Plon, 1962, 26ff.

9 Gilles Deleuze and Félix Guattari, *L'Anti-Œdipe*, Paris: Minuit, 1972, 13.

10 World's End. 430 King's Road London, http://worldsendshop.co.uk/about/, accessed November 22, 2015.

11 Dick Hebdige, *Subculture: The Meaning of Style*, London: Methuen, 1979, 108.

12 Craig O'Hara, *The Philosophy of Punk: More than Noise*, London and San Francisco: AK Press, 1999, 102ff.

13 Ibid., 109.

14 Claire Wilcox, *Vivienne Westwood*, London: V&A Museum, 2004, 14.

15 Mark Blake ed., *Punk: The Whole Story*, London and New York: Mojo, 2006, 61.

16 Monica Sklar, *Punk Style*, London and New York: Bloomsbury, 2013, 27.

17 Ibid., 28–45.

18 Ibid., 75.

19 Ibid., 73.

20 Cit. Caroline Evans and Minna Thornton, *Women and Fashion: A New Look*, London and New York: Quartet Books, 1989, 148.

21 Deleuze and Guattari, *L'Anti-Œdipe*, 164.

22 See Adam Geczy and Vicki Karaminas, *Fashion's Double: Representations of Fashion in Painting, Photography and Film*, London and New York: Bloomsbury, 2016, especially chapter one: "Painting Fashion."

23 Evans and Thornton, *Women and Fashion*, 147.

24 Westwood and Kelly, *Vivienne Westwood*, 208–209.

25 Ibid., 236.

26 Oxfam is an international confederation of seventeen organizations founded in Oxford in 1942 whose mission is to eradicate social injustices and poverty.

27 Wilcox, *Vivienne Westwood*, 17.

28 Evans and Thornton, *Women and Fashion*, 148.

29 Ibid., 149.

30 Wilcox, *Vivienne Westwood*, 21.

31 The Greek island of Cythera, which lies to the south of the Peloponnese Peninsula in the Ionian Sea, is reputed to be the birthplace of Venus, known as Aphrodite, the goddess of love in Greek mythology.

32 Wilcox, *Vivienne Westwood*, 22.

33 Caroline Evans, *Fashion at the Edge. Spectacle, Modernity and Deathliness*, New Haven and London: Yale University Press, 2003, 297.

34 On September 15, 1954, in a scene from *The Seven Year Itch* (1955, dir. Billy Wilder, 20th Century Fox), American actress Marilyn Monroe made media history when she stood on top of a New York subway grate wearing a white dress that caught the upward breeze, lifting the fabric and revealing her white underwear.

35 Hannah Ongley, "Penis Shoes and A Topless Kate Moss at Vivienne Westwood's 1995 'Erotic Zones'," http://blog.swagger.nyc/2015/04/30/tbt-penis-shoes-and-topless-kate-moss-at-vivienne-westwoods-1995-erotic-zones/, accessed November 24, 2015.

36 http://www.vogue.co.uk/fashion/spring-summer-2010/ready-to-wear/vivienne-westwood, accessed November 27, 2015.

2 Rei Kawakubo's Deconstructivist Silhouette

1 Take as one recent example, Robin Givhan in *Newsweek*, June 11, 2012: "When she debuted in Paris in 1981, during the height of the Dynasty period of ostentation, she caused a stir with a deconstructed collection she called 'Destroy'." "Rei Kawakubo: The CFDA fêtes a fashion sphinx," *Newsweek*, 159.24, http://search.proquest.com.ezproxy1.library.usyd.edu.au/docview/1017537996?pq-origsite=summon, accessed May 18, 2015.

2 Other designers who have come to be associated with the term *deconstruction* due to "unfinished" garments include Karl Lagerfeld, Martin Margiela, Ann Demeulemeester and Dries van Noten. See Alison Gill, "Deconstruction Fashion: The Making of Unfinished, Decomposing and re-Assembled Clothes," *Fashion Theory*, Vol. 2, No. 1, 1998, 25. Gill also discusses the looser adaptations of the word *deconstruction* by fashion and other design discourses, 26ff. However, this essay departs from Gill on several fronts, starting with preference for the use of *deconstructive* and *deconstructivist* over *deconstruction fashion*.

3 Jacques Derrida, *De la Grammatologie*, Paris: Minuit, 1967; *On Grammatology*, trans. Gayatri Chakravorty Spivak, Baltimore and London: Johns Hopkins University Press, 1976.

4 Christopher Norris, *Deconstruction: Theory and Practice*, London and New York: Routledge (1982), revised edition, 1991, 49.

5 Rodolphe Gasché, *The Taint of the Mirror: Derrida and the Philosophy of Reflection*, Cambridge, MA: Harvard University Press, 1986, 129.

6 Ibid., 130.

7 J. Derrida, "Letter to a Japanese Friend," in Jonathan Culler ed., *Deconstruction: Critical Concepts in Literary and Cultural Studies*, London and New York: Routledge, 2003, 1: 25.

8 Laura Mulvey, "Visual Pleasure and Narrative Cinema," *Screen*, Vol. 16, No. 3, Autumn 1975, 6–18.

9 See Gilles Deleuze, *Spinoza: Philosophie pratique*, Paris: Minuit, 1981, 68–72, 74–77.

10 Louise Mitchell, "The Designers," in *The Cutting Edge. Fashion from Japan*, ed. Louise Mitchell, Sydney: Powerhouse Publishing, 2005, 55.

11 Ibid., 55.

12 Mark Wigley, "Deconstructivist Architecture" in Jonathan Culler ed., *Deconstruction: Critical Concepts*, 3: 367.

13 Ibid., 368.

14 Ibid., 370.

15 Jacques Derrida, "Point de Folie—*Maintenant L'Architecture*," in ibid., 412.

16 Ibid., 404.

17 J. Derrida, "A Letter to Eisenmann," trans. Hilary Hanel, *Assemblage* 12, 1990, 11.

18 Peter Eisenman, "Post/El Cards: A Reply to Jacques Derrida," *Assemblage* 12, 17.

19 Peter Eisenman, "Blue Line Text"' in Jonathan Culler ed., *Deconstruction: Critical Concepts*, 3: 419.

20 See, for example, Kim Hastreiter, "Mopping the Street": "Sometimes even the homeless have inspired looks for the street. For years Rei Kawakubo of Japan's Comme des Garçons has been offering the ragged look of ladies." *Design Quarterly*, 159, Spring 1993, 34–35.

21 M. Wigley, *The Architecture of Deconstruction: Derrida's Haunt*, Cambridge MA: MIT Press, 1993, 147.

22 Janie Samet, "Printemps/Été 1983, 6 Jours de Mode," *Le Figaro*, October 21, 1982, cit. Akiko Fukai, "Future Beauty: 30 Years of Japanese Fashion," in Catherine Ince and Rie Nii eds., *Future Beauty: 30 Years of Japanese Fashion*, exh cat, New York and London: Merrell and the Barbican Centre, 2010, 14.

23 Yuniya, Kawamura, *The Japanese Revolution in Paris Fashion*, Oxford and New York: Berg, 2004, 96.

24 John McDonald, "Future Beauty: 30 Years of Japanese Fashion Chronicles Couture Visionarie",' *Sydney Morning Herald*, January 9, 2015, http://www.smh.com.au/entertainment/art-and-design/future-beauty-30-years-of-japanese-fashion-chronicles-couture-visionaries-20150105-12hyyz.html, accessed January 5, 2016.

25 Gill does not agree with these terms: "About 'destroy' it could be said [sic] that there are explicit references to a punk sensibility of ripping, slashing and piercing clothing as well as an artificially enhanced 'gringy' or 'crusty' dress, thus setting up a fantasy dialogue with urban zones of the dispossessed and disaffected." "Deconstruction Fashion," 33.

26 Gilles Deleuze, *Spinoza: Philosophie pratique*, Paris: Minuit, 1981, 102–103.

27 Caroline Evans. *Fashion on the Edge*, New Haven and London: Yale University Press, 2009, 249.

28 Richard Martin and Harold Koda, "Analytical Apparel: Deconstruction and Discovery in Contemporary Costume," in *Info-Apparel*, New York: Metropolitan Museum of Art, 1993, 105. See also Evans, ibid., 250.

29 See also Evans, ibid., 260.

30 Gayatri Chakravorty Spivak, *A Critique of Postcolonial Reason: Toward a History of the Vanishing Present*, Cambridge, MA: Harvard University Press, 1999, 341.

31 Cit. Spivak, ibid., 339.

32 Ibid., 340.

33 See also Geczy, *Fashion and Orientalism: Dress,* 168–174.

34 Jacques Derrida, *De la grammatologie*, Paris: Minuit, 1967, 52.

35 Evans and Thornton, *Women and Fashion*, 157–159.

36 Ibid., 159.

37 Barbara Vinken, "The Empire Designs Back," in Ince and Nii eds., *Future Beauty*, 39.

38 Ibid.

39 Norris, *Deconstruction*, 33.

40 See also Valerie Steele, "Is Japan Still the Future?" in Valerie Steele ed., *Japan Fashion Now*, New Haven and London and New York: Yale University Press and Fashion Institute of Technology, 2010, 5.

41 Harold Koda, "Rei Kawakubo and the Aesthetic of Poverty," *Dress: Journal of the Costume Society of America* 11, 1985, 8.

42 Steele, in Steele ed., *Japan Fashion Now*, 81.

3 Gareth Pugh's Corporeal Uncommensurabilities

1 William Butler Yeats, "The Mask," http://www.online-literature.com/yeats/800/, accessed February 8, 2016.

2 Mikhail Bahktin, *Rabelais and His World*, trans. Helene Iswolsky, Bloomington: Indiana University Press, 1984 (1965), 410–411.

3 Francesca Granata, "Mikhail Bakhtin. Fashioning the Grotesque Body," in *Thinking Through Fashion. A Guide to Key Theorists,* ed. Agnes Rocamora and Anneke Smelik, London: I.B. Tauris, 2015, 105.

4 Michael Lippman, "'Embodying the Mask: Exploring Ancient Roman Comedy Through Masks and Movement," *Classical Journal*, Vol. 111, No. 1, October–November, 2015.

5 See also David Fisher, "Nietzsche's Dionysian Masks," *Historical Reflections*, Vol. 21, No. 3, Fall 1995, 520.

6 Ibid., 524.

7 E. Tonkin, "Masks and Powers," *Man*, 14, 1979, 246. See also Donald Pollock, "Masks and the Semiotics of Identity," *Journal of the Royal Anthropological Institute*, Vol. 1, No. 3, 1995, 581–597.

8 Alexandra Warwick and Dani Cavallaro, *Fashioning the Frame: Boundaries, Dress and the Body*, Oxford: Berg, 1998, 129.

9 Gareth Pugh, http://www.dezeen.com/2015/02/23/gareth-pugh-autumn-winter-2015-va-museum-london-fashion-week/, accessed February 20, 2016.

10 This line is taken from the introduction of Adam Geczy, *The Artificial Body in Fashion and Art: Models, Marionettes and Mannequins*, London and New York: Bloomsbury, 2016.

11 See Katherine Hayles, *How We Became Posthuman: Virtual Bodies in Cybernetics, Literature and Infomatics*, Chicago and London: Chicago University Press, 1999, and Stefan Herbrecheter, *Posthumanism: A Critical Analysis*, London and New York: Bloomsbury, 2013.

12 Elizabeth Grosz, *Volatile Bodies: Toward a Corporeal Feminism*, Indianapolis: Indiana University Press, 1994, 164.

13 Gilles Deleuze and Félix Guattari, *L'anti-Œdipe*, Paris: Minuit, 1972, chapter 1.

14 Stephen Seely, "How Do You Dress a Body Without Organs? Affective Fashion and Nonhuman Becoming," *Women's Studies Quarterly*, Vol. 41, No. 1/2, Spring/Summer, 2012, 260.

15 Gilles Deleuze and Félix Guattari, *Mille Plateaux*, Paris: Minuit, 1981, 205ff.

16 Seely, "How Do You Dress a Body Without Organs? Affective Fashion and Nonhuman Becoming," 261.

17 Deleuze and Guattari, *Mille Plateaux*, 216.

18 Gareth Pugh: Fall 2008 Ready-to-Wear, https://www.youtube.com/watch?v=M8laGi3Llw.

19 Gareth Pugh Autumn/Winter 2014 Runway Collection, SHOWstudio, https://www.youtube.com/watch?v=ZqTM0dqKu-Y.

20 For an in-depth discussion of Nick Knight and SHOWstudio and the new genre of fashion film, see Geczy and Karaminas, *Fashion's Double*.

21 Ruth Hogben and Gareth Pugh, *A Beautiful Darkness*, Showstudio 2015, https://www.youtube.com/watch?v=IgFqriIMDWA.

22 Vicki Karaminas, "Image- Fashionscapes—Notes towards an Understanding of Media Technologies and their Impact on Fashion Imagery," ed. Adam Geczy and Vicki Karaminas, *Fashion and Art*, Oxford and New York: Berg, 2012, 184.

23 Karaminas, *Fashion and Art*, 184.

24 Ruth Hogben, *Gareth Pugh Pitti 2011*, SHOWstudio, https://www.youtube.com/watch?v=Qo5wdMiXHQ4.

25 Natalie Khan, "Stealing the Moment: The Non-narrative Fashion Films of Ruth Hogben and Gareth Pugh," *Fashion, Film and Consumption*, (2012): 253.

26 Geczy and Karaminas eds., *Fashion and Art*, 183–184.

27 Gareth Pugh, http://uniquestyleplatform.com/blog/2014/10/13/pagan/, accessed February 25, 2016.

28 Natalie Khan, *Stealing the Moment*, 253.

29 Vicki Karaminas, "Übermen, Masculinity, Costume and Meaning in Comic Book Heroes," ed. Peter McNeil and Vicki Karaminas, *The Men's Fashion Reader*, Oxford: Berg, 2009, 180.

30 Sian Ranscombe, "Gareth Pugh Injects 'Pillow Face' into London Fashion Week Using Tights," Lifestyle and Beauty, *Daily Telegraph*, http://www.telegraph.co.uk/beauty/make-up/gareth-pugh-beauty-aw16/, accessed February 29, 2016.

31 Ibid, Ranscombe.

32 Judith Halberstam, "Skinflick: Posthuman Gender in Jonathan Demme's *The Silence of the Lambs*," *Camera Obscura*, September 9, 1991, (3: 27), 51.

33 Ibid, Halberstam, 41.

34 Gabriella Daris, "Fall 2016 Collections: Marie-Agnés Gillot Stars in Gareth Pugh's LFW Show," *Blouinartinfo*, February 23, 2016, http://www.blouinartinfo.com/news/story/1336602/fall-2016-collections-marie-agnes-gillot-stars-in-gareth, accessed February 29, 2016.

35 Vicki Karaminas, Letter from the Editor, *Fashion Theory*, Vol. 16, No. 2, 137.

36 Julia Kristeva, *Powers of Horror: An Essay on Abjection*, New York: Columbia University Press, 1982, 4.

4 Miuccia Prada's Industrial Materialism

1 The company was established in 1913 by Mario and Martino Prada under the name Fratelli Prada (Prada Brothers) and specialized in handcrafted luxury leather items and goods. Steamer trunks, walrus leather cases, handbags, beauty cases and a range of accessories, walking sticks and umbrellas were sold. In 1919 Fratelli Prada was appointed a supplier to the Italian royal family.

2 Alecxander Fury, "Is Miuccia Prada the Most Powerful and Influential Designer?" *Independent*, Wednesday October 7, 2015, Fashion http://www.independent.co.uk/life-style/fashion/features/is-miuccia-prada-the-most-powerful-and-influential-designer-in-fashion-a6683801.html, accessed March 12, 2016.

3 Alexander Fury, *Independent*, ibid.

4 Alexander Fury, *Independent*, ibid.

5 http://www.businessoffashion.com/articles/intelligence/miuccia-prada-unravels-difference-prada-miu-miu, accessed March 15, 2007.

6 Jacques Lacan, *Écrites: A Selection*, trans. Alan Sheridan, New York: Routledge, 1977, 11.

7 Diana Fuss, "Fashion and the Homospectatorial Look," *Critical Inquiry*, Vol. 18, No. 4, *Identities*, Summer 1992, 718.

8 Patrizia Calefato, "Italian Fashion in the last Decades: From Its Original Features to the 'new Vocabulary'," *Journal of Asia Pacific Pop Culture*, Vol. 1, No. 1, 2016.

9 http://www.stuff.co.nz/life-style/fashion/68327252/Prada-adverts-banned-for-sexually-suggestive-images-of-youthful-model, accessed March 14, 2015.

10 Miuccia Prada, *Schiaparelli and Prada: Impossible Conversations*, New York: Metropolitan Museum of Art, 2012, 68.

11 Ibid., *Schiaparelli and Prada: Impossible Conversations,* 74.

12 Alexander Fury, "Miuccia Prada: The Master of Ugly," SHOWstudio, June 12, 2014. http://showstudio.com/project/ugly/essay_alexander_fury, accessed March 15, 2016.

13 Ibid., "Miuccia Prada: The Master of Ugly," accessed March 15, 2016.

14 Laia Farren Graves, *The Little Book of Prada,* London: Carlton Books, 2012, 49.

15 OMA Office Work Search, http://oma.eu/projects/prada-epicenter-new-york, accessed March 2, 2016.

16 Galinsky, People Enjoying Buildings World Wide, Prada Flagship Store New York, http://www.galinsky.com/buildings/prada/, accessed March 2, 2016.

17 http://www.fondazioneprada.org/visit/visit-milan/?lang=en, accessed March 3, 2016.

18 Gian Luigi Paracchini, *The Prada Life*, Rome: BC Delai, 2010, 144.

19 Geczy and Karaminas, "Introduction," ed. Adam Geczy and Vicki Karaminas, *Fashion and Art*, 5.

20 Judith Thurman, "Twin Peaks," *Schiaparelli and Prada. Impossible Conversations*, New York: Metropolitan Museum of Art, 2012, 26.

21 See Geczy and Karaminas, *Fashion and Art*.

22 Thurman, "Twin Peaks," 26.

23 Ibid.

24 The Riot Grrrls was a feminist hard-core punk movement that began in the 1990s. It combines feminist consciousness, punk style and guerrilla style politics and is associated with third wave feminism and a DIY ethic.

25 http://www.vogue.co.uk/fashion/spring-summer-2014/ready-to-wear/prada, accessed March 4, 2016.

26 Vogue.com http://www.vogue.com/fashion-shows/spring-2008-ready-to-wear/prada, accessed March 5, 2016.

27 Nicki Ryan, "Prada and the Art of Patronage," *Fashion Theory*, Vol. 11, No. 1, 2007, 8.

28 Ryan, "Prada and the Art of Patronage," 14.

29 Catherine Martin, https://senatus.net/article/miuccia-prada-designs-prada-and-miu-miu-costumes-great-gatsby/, accessed March 5, 2016.

30 Deborah Jermyn, *Sex and the City*, Detroit: Wayne State University Press, 2009, 3.

5 Aitor Throup's Anatomical Narratives

1 "Aitor Throup: New Object Research 2013," https://www.youtube.com/
watch?v=stwE71ZMp-A http://www.basenotes.net/ID26123491.html http://
contributormagazine.com/interview-walter-van-beirendonck/, accessed October 25,
2015.

2 Ibid.

3 "Aitor Throup: London Collections S/S13." https://www.youtube.com/
watch?v=4xDpWwQZUqA.

4 Baruch Spinoza, *Ethics*, trans. Andrew Boyle, revised G. H. R. Parkinson, London:
Everyman, (1959) 1993, part 1, def. 4, 3. In his reading of Spinoza's influence on
Hegel, Yirmiyahu Yovel states: "The so-called 'attributes' too, cannot be construed
as inner specifications of one substance, and therefore, we must dismiss them as
products of our subjective minds, products that we project on the structure of the
substance. In this criticism, again, Hegel gives a fundamental interpretation to a
well-known Spinozistic problem. Spinoza defines an attribute as "what the intellect
perceives of a substance, as constituting its essence" (*Ethics*, pt. 1, def. 4), and
Hegel reads this as if the attribute is only subjective, explaining this by the lack of
inner negativity in the absolute, which deprives it of objective self-differentiation.
Hegel here again takes sides in a well-known controversy over the nature of human
attributes; indeed, he starts it." *Spinoza and Other Heretics: The Adventures of
Immanence*, Princeton, NJ: Princeton University Press, 1992, 37, emphasis from
the author.

5 Ibid., 34.

6 Deleuze, *Spinoza: Philosophie pratique*, 68.

7 Ibid., 110.

8 https://www.youtube.com/watch?v=BMVMPiFLPy8.

9 Spinoza, *Ethics*, 51–52.

10 Deleuze, *Spinoza et le problem de l'expression*, Paris: Minuit, 1968, 44. So as not to
take these words out of context, Deleuze's discussion here centers on "divine names
and the attribues of God," however they can be productively reapplied.

11 Ibid.

12 Brock Cardiner, "Take a look Inside Aitor Throup's Studion," Highsnobiety, http://
www.highsnobiety.com/2014/06/23/b-and-o-play-home-styling-aitor-throup/.

13 Lucie Greene, "It's a Man's World," *Women's Wear Daily*, Vol. 194, No. 54,
September 11, 2007, Internet source.

14 Kathryn van Beek, "Kasabian—*Velociraptor!* (Sony)," *13th Floor*, http://13thfloor.
co.nz/reviews/cd-reviews/kasabian-velociraptor-sony/.

15 Alessandra Comini, *Egon Schiele*, New York: George Brazillier, 1976, 17.

16 https://www.youtube.com/watch?v=stwE71ZMp-A.

17 Marketa Uhlirova, "The Fashion Film Effect," in Djurdja Bartlett, Shaun Cole and
Agnès Rocamora, eds., *Fashion Media: Past and Present*, London and New York:
Bloomsbury, 2013, 123.

18 Ibid., 125.

19 https://www.youtube.com/watch?v=rqoWMjpe5I8.

20 Aitor Throup, "Damon Albarn, 'Everyday Robots'," https://www.youtube.com/watch?v=rjbiUj-FD-o.

21 "Everyday Robots: A digital portrait of Damon Albarn by Aitor Throup," https://www.youtube.com/watch?v=HxUkeOq0D2o.

22 As Benjamin states, "The orientation of reality to the masses and of the masses to reality is process of unlimited scope both for thinking as for seeing." Walter Benjamin, "Das Kunstwerk im Zeitalter seiner technischen Reproduzierbarkei," in *Medienästhetische Schriften*, Frankfurt am Main: Suhrkamp, 2002, 357.

23 Marshall McLuhan, *Understanding Media: the Extensions of Man* (1964), London and New York: Routledge, 2001.

24 As the term first appeared in "Le Cogito et histoire de la folie": "He writes more than he says, he *economises*. The economy of this writing is a relationship set between what exceeds and the totality exceeded: the *différance* of absolute excess." Jacques Derrida, *L'écriture et la difference*, Paris: Seuil, 1967, 96.

25 Lev Manovich, *The Language of New Media*, Cambridge, MA: MIT Press, 2001, 139.

26 Ibid.

27 *Legs*, https://www.youtube.com/watch?v=RkkgJhxZBBU.

28 Gilles Lipovetsky, *L'empire de l'éphémère: la mode et son destin dans les sociétés modernes*, Paris: Gallimard, 1987, 106.

6 Viktor & Rolf's Conceptual Immaterialities

1 Cit. http://www.basenotes.net/ID26123491.html.

2 Malcolm Barnard, *Fashion Theory: An Introduction*, New York: Routledge, 2014, 23.

3 Geczy and Karaminas eds., "Introduction," *Fashion and Art*.

4 Cit. Thomas Crow, *The Rise of the Sixties*, London: Weidenfeld and Nicholson, 1996, 131.

5 Ibid., 103.

6 See Adam Geczy's introduction and rationale in the first chapter in Adam Geczy and Jacqueline Millner, *Fashionable Art*.

7 Hazel Clark, "Conceptual Art," edited by Adam Geczy and Vicki Karaminas, *Fashion and Art*.

8 Bonnie English, *Japanese Fashion Designers: The Work and Influence of Issey Miyake, Yohgi Yamamoto and Rae Kawakubo,* London: Bloomsbury, 2011, 159.

9 For example, Caroline Evans, in Caroline Evans and Susannah Frankel, *The House of Viktor & Rolf*, exh. cat. Barbican Centre, London and New York: Merrell, 2008, 12.

10 A review in *Artforum* (December 1995), fashion magazine *Visionaire* (no. 17).

11 Yves Klein, "L'évolution de l'art vers l'immatériel: Conference à la Sorbonne," in *Le dépassement de la problématique de l'art et autres écrits*, Paris: École Nationale Supérieure des Beaux-Arts, 2003, 145.

12 Cit. Crow, *The Rise of the Sixties*, 122.

13 Stéphane Mallarmé, "L'Azur," *Œuvres completes*, Paris: Gallimard, 1945, 37.

14 Ibid., 38.

15 This even the title of an important study on him by Malcolm Bowie, *Mallarmé and the Art of Being Difficult*, Cambridge: Cambridge University Press, 2008.

16 Cit. Klein, "L'évolution de l'art vers l'immatériel," 137.

17 Ibid., 146.

18 Klien, "Le dépassement de la problématique de l'art," in *Le dépassement de la problématique de l'art et autres écrits*, 83.

19 Caroline Evans, *Fashion at the Edge*, New Haven: Yale University Press, 2003, 166–167.

20 Ibid., Evans. 166.

21 Lauren Le Rose, "Dutch Design Gurus Viktor and Rolf bring their 'Dolls' Collection to the Royal Ontario Museum for Luminato," Style, National Post, April 9, 2013, http://news.nationalpost.com/life/dutch-design-gurus-viktor-rolf-bring-their-dolls-collection-to-the-royal-ontario-museum-for-luminato, accessed November 18, 2015.

22 Viktor and Rolf, cited by Angel Chang, "Viktor and Rolf," edited by Valerie Steel, *The Berg Companion to Fashion*, Oxford: Berg, 2010, 710.

23 Susan Stewart, *On Longing. Narratives of the Miniature, the Gigantic, the Souvenir, the Collection,* Durham and London: Duke University Press, 1993, 48.

24 See Adam Gezcy and Vicki Karaminas, *Fashions Double: Representations of Fashion in Painting, Photography and Film*, London: Bloomsbury, 2015.

25 Fanny Dolansky, "Playing with Gender: Girls, Dolls, and Adult Ideals in the Roman World," *Classical Antiquity*, Vol. 31, No. 2, October 2012, 256–292.

26 Cit. Yassana Croizat, "'Living Dolls': François Ier Dresses His Women," *Renaissance Quarterly,* Vol. 60, No. 1, Spring 2007, 98.

27 Ibid., 94.

28 See also Marianne Thesander, *The Feminine Ideal*, London: Reaktion, 1997, 81ff.

29 Interview with Susanna Frankel in Evans and Frankel, *The House of Viktor & Rolf*, 23.

30 Ibid., 24.

31 Fashion or Art? Viktor and Rolf's Autumn/Winter 2015 Haute Couture Collection. http://www.graphics.com/article/fashion-or-art-viktor-rolfs-autumnwinter-2015-haute-couture-collection, accessed November 20, 2015.

7 Rad Hourani's Gender Agnostics

1 This is a harmless neologism to chime with the adjectival structure of all the other chapter titles.

2 *Zoolander 2*, dir. Ben Stiller, Red Hour Productions, 2016.

3 Rhonda Garelick, *Mademoiselle: Coco Chanel and the Pulse of History*, New York: Random House, 2014, 48.

4 Rad Hourani, http://www.vice.com/read/fashion-designer-rad-hourani-is-dismantling-the-gender-binary-456, accessed February 9, 2016.

5 Plato, *Symposium*, in *Plato: Five Great Dialogues*, ed. Louise Loomis, New York: Gramercy Books, 1942, 179.

6 Ibid.

7 Ibid., 180.

8 Ibid.

9 Ibid.

10 Ibid., 181.

11 Ibid.

12 Donna Haraway, "Manifesto for cyborgs: science, technology, and socialist feminism in the 1980s." *Socialist Review* 80, 1985, 65–108, reprinted as "A Cyborg Manifesto: Science, Technology and Socialist-Feminism in the Late Twentieth Century," in Donna Harraway, *Simians, Cyborgs and Women: The Reinvention of Nature*, London and New York: Routledge, 1991.

13 Elaine Graham, "Cyborgs or Goddesses? Becoming Divine in a Postfeminist Age," in Eileen Green and Alison Adam eds., *Virtual gender: Technology, Consumption and Identity*, London and New York: Routledge, 2001, 307.

14 Ibid., 308.

15 Rad Hourani, http://www.sleek-mag.com/print-features/2015/02/rad-hourani-interview-fashion/, accessed February 15, 2016.

16 Christian Lacroix, https://theballetblogger.wordpress.com/2015/08/23/fashion-in-ballet/, accessed February 16, 2016.

17 http://www.radhourani.com/blogs/projects/15063485-unisex-anatomy-exit, accessed February 16, 2016.

18 Rad Hourani, http://montrealgazette.com/entertainment/arts/pop-tart-designer-rad-hourani-launches-art-exhibition-in-montreal, accessed February 20, 2016.

19 Adam Geczy and Benjamin Gennochio, *What is Installation: An Anthology of Writings on Installation Art in Australia*, Sydney: Power Publications Sydney, 2001, 2.

20 George Alexander, ibid., 61.

8 Rick Owens's Gender Performativities

1 "Rick Owens Interview," 2012, https://www.youtube.com/watch?v=ikU1dxuQPYY.

2 A Womble is a fictional pointy nosed fluffy creature, created by author Elizabeth Beresford, that appeared in a series of children's books in 1968. Wombles live in burrows and look after the environment by cleaning and recycling rubbish.

3 *The Lord of the Rings* film series was directed by Peter Jackson and produced by Wingnut Films. Based on the novel by English novelist J. R. R Tolkien, the film trilogy includes *The Lord of the Rings* (2001), *The Two Towers* (2002) and *The Return of the King* (2003).

4 Hervia online, http://www.hervia.com/blog/in-focus-monochromatic-minimalism-from-rick-owens/, accessed December 9, 2015.

5 Germany's Bauhaus art and design school that was founded in 1919 in the aftermath of World War I. It was a cultural think tank and salon that brought together prominent artists and architects such as Wassily Kandinsky, Paul Klee and Mies van der Rohe. Founded by the German architect Walter Gropius from 1919 to 1932, the Bauhaus approach to design was to combine art, craft and technology, creating a new approach to teaching that was philosophical and liberated from historicism. The Bauhaus became synonymous with functional purity and form which found its way into fashion.

6 Valerie Steele, *Gothic: Dark Glamour*, New Haven: Yale University Press and the Fashion Institute of Technology New York, 2008, 92.

7 Harriet Walker, *Less is More: Minimalism in Fashion*, London and New York: Merrell, 2011, 15.

8 http://eightiesclub.tripod.com/id295.htm, accessed December 17, 2015.

9 Elizabeth Wilson, "A Note on Glamour," *Fashion Theory*, Vol. 11, No. 1, Oxford: Berg, 2007, 99.

10 Wilson, "A Note on Glamour," 99.

11 Ibid.

12 Karl Marx, *Capital*, New York: Appleton, 1889, 816.

13 For a comprehensive study of the "belle dame sans merci," see Mario Praz, *The Romantic Agony*, trans. Angus Davidson, 2nd edition, London and New York: Oxford University Press, 1970.

14 Wilson, "A Note on Glamour," 99.

15 C. Baudelaire, "The Savage Wife and the Kept Woman," *The Poems in Prose*, Francis Scarfe ed. and trans., London: Anvil Press (1989) 1991, 57.

16 Based on the Orientalist veil dances, The Dance of the Seven Veils was incorporated by Oscar Wilde in the play *Salomé* (1891) and refers to the dance performed by Salomé in front of Herod Antipas in the biblical story of the execution of John the Baptist.

17 http://journal.antonioli.eu/2015/01/rick-owens-about-fw15-sphinx-collection/, accessed December 18, 2015.

18 Ibid.

19 Michel Foucault. "Of Other Spaces," *Diacritics,* Vol. 16. No. 1, Spring 1986. 23, 22–27.

20 http://www.dazeddigital.com/fashion/article/22274/1/beyond-the-surface-rick-owens-ss15, accessed December 18, 2015.

21 http://www.highsnobiety.com/2015/08/27/rick-owens-moments/, accessed December 19, 2015.

22 http://www.joyce.com/hk-press/joyce-opens-rick-owens-freestanding-store-in-hong-kong/, accessed December 20, 2015.

23 Jan Kedves, *Talking Fashion. From Nick Night to Raf Simons in Their Own Words,* London: Prestel, 2013, 25.

24 http://www.blouinartinfo.com/news/story/973689/fashions-new-avant-garde-guards, accessed December 14, 2015.

25 Harraway, *Simians, Cyborgs and Women.*

26 Judith Butler, *Bodies that Matter*, London and New York: Routledge, 1993, 231.

27 Nancy Troy, *Couture Cultures. A Study of Modern Art and Fashion*, Cambridge, MA: MIT Press, 2002, 81.

28 "As much as drag creates a unified picture of 'woman' (what its critics often oppose), it also reveals the distinctness of those aspects of gendered experience that are falsely naturalized as a unity through the regulatory fiction of heterosexual coherence. *In imitating gender, drag implicitly reveals the imitative structure of gender itself—as well as its contingency.*" Judith Butler, *Gender Trouble: Feminism and the Subversion of Identity*, London and New York: Routledge, 1990, 137, emphasis in the original.

29 Dazed, http://www.dazeddigital.com/fashion/article/26800/1/women-wear-other-women-at-rick-owens, accessed December 9, 2015.

30 Ginger Gregg Duggan, "The Greatest Show on Earth: A Look at Contemporary Fashion Shows and their Relationship to Performance Art," *Fashion Theory: The Journal of Dress, Body and Culture*, 5:3 (2001), 243–270, at 244.

31 Duggan, "The Greatest Show on Earth".

9 Walter Van Beirendonck's Hybrid Science Fictions

1 Pier Paolo Pasolini, *Salò, or the 120 Days of Sodom*, Les Productions Artistes Associés, 1975.

2 Third Berlin Biennial for Contemporary Art, Exhibition Catalogue, KW Institute for Contemporary Art: Berlin, 2000, 40.

3 Walter van Beirendonck, Natalie Riff, *Dazed*, http://www.dazeddigital.com/fashion/article/19822/1/the-da-zed-of-walter-van-beirendonck, accessed October 19, 2015.

4 Kaat Debo, "Walt's World of Wonder," *Dream the World Awake*, Exhibition Catalogue, Belgium: Lanno Publishers, 2011, 24.

5 Luc Derycke and Sandra Van De Veire (eds) *Belgian Fashion Design*, Ghent: Ludion, 1999, 140.

6 Walter van Beirendonck, Paula Di Trocchio, *Manstyle,* Exhibition Catalogue, National Gallery of Victoria, Melbourne, 2011, 40.

7 Georges Auriac, Louis Durey, Arthur Honegger, Darius Milhaud, Francis Poulenc and Germaine Tailleferre.

8 Kathryn Hughes, "How London Dressed Up for the 1980s," *Guardian*, June 22, 2013, http://www.theguardian.com/culture/2013/jun/22/club-catwalk-london-fashion-1980s, accessed October 21, 2015.

9 Iain R. Webb, *Blitz: As Seen in Blitz — Fashioning the 80s Style*, Suffolk: ACC Editions, 2013, 8.

10 Ben Carrington and Brian Wilson, "Dance Nations: Rethinking Youth Subcultural Theory," in Andy Bennett and Keith Kahn-Harris, *After Subculture: Critical Studies in Contemporary Youth Culture*, Hampshire: Palgrave, 2004, 66.

11 Walter van Beirondonck, *The Secret History of Walter Van Beirendonck's Invitations*, *Dazed* Digital, http://www.dazeddigital.com/fashion/article/19867/1/the-secret-history-of-walter-van-beirendoncks-invitations, accessed October 30, 2015.

12 See Dylan Thomas, *The Eighties: One Day, One Decade*, London: Random House, 2013.

13 http://contributormagazine.com/interview-walter-van-beirendonck/, accessed October 25, 2015.

14 Lee Higgins, *Community Music in Theory and in Practice*, Oxford: Oxford University Press, 2012, 38.

15 Elsie Clews-Parsons and Ralph L. Beals, "The Sacred Clowns of the Pueblo and Mayo-Yaqui Indians," *American Anthropologist*, Vol. 36, No. 4, October–December, 1934, 491.

16 Mikhail Bakhtin, *Rabelais and His World*, trans. by Helene Iswolsky, Bloomington: Indiana University Press, 1984, 7–8.

17 Ibid., 8.

18 Directed by Tommy Lee Wallace and distributed by Warner Bros Television.

19 Luc Derycke and Sandra Van De Veire, eds., *Belgian Fashion Design*, Ghent: Ludion, 1999, 10.

20 Jean Paul Cauvan, *Walter Van Beirendonck Menswear Spring 2008: Well Endowed Fetish Avatars*, http://www.fashionwindows.net/2007/07/walter-van-beirendonck-menswear-spring-2008/, accessed October 30, 2015.

21 Tim Blanks, "Walter and the Bears," *Dream the World Awake*, Exhibition Catalogue, Belgium: Lanno Publishers, 2011, 94.

22 Alexandra Warwick and Dani Cavallaro, *Fashioning the Frame: Boundaries, Dress and the Body*, Oxford: Berg, 1998, 129.

23 Mikhail Bakhtin, *Rabelais and His World*, trans. Helene Iswolsky, Cambridge, MA: MIT Press, 1968, 39–40.

24 Theresa de Lauretis, *Technologies of Gender*, Bloomington and Indianapolis: Indiana University Press, 1987.

25 See also Efrat Tseëlon: In work deeply indebted to both Bakhtin and de Lauretis, she notes that the mask, "deals with literal and metaphorical covering for ends as varied as concealing, revealing, highlighting, protesting [and] protecting in the field where social practices are carried out." "From Fashion to Masquerade: Towards an Ungendered Paradigm," in Joanne Entwistle and Elizabeth Wilson, eds., *Body Dressing*, Oxford: Berg, 2001, 108.

26 Bakhtin, *Rabelais*, 40.

27 Tim Blanks, "Walter and the Bear," *Dream the World Awake*, Exhibition Catalogue, Belgium: Lanno Publishers, 2011, 97.

28 Kobena Mercer, "Reading Racial Fetishism: The Photographs of Robert Mapplethorpe," Jessica Evans and Stuart Hall, eds., *Visual Culture: The Reader*, Sage: London, 2006, 436.

29 Tim Blanks, "Fall 2012 Menswear, Walter van Beirendonck," *Vogue*, January 21, 2012, http://www.vogue.com/fashion-shows/fall-2012-menswear/walter-van-beirendonck, accessed November 5, 2015.

30 Frantz Fanon, *Black Face, White Mask,* New York: Grove Press, 1967, 18.

31 Sima Godfrey, "Dandy as Ironic Figure," *SubStance*, Vol. 11, No. 3, Issue 36, 1982, 24.

32 Baudelaire, C., "The Painter in Modern Life," in, *The Painter in Modern Life and Other Essays*, trans. Jonathan Mayne, London: Phaidon, 1987, 26.

33 Ibid., 27.

34 Ibid.

35 Ibid., 26–27.

36 Charles Baudelaire, "Le Dandy," *Le Peintre de la vie moderne, Œuvres complètes*, ed. Y.-G. Le Dantec, Paris: Pléiade, 1954, 906–909.

37 Rosalind H. Williams, *Dream Worlds: Mass Consumption in Late Nineteenth-Century France*, Berkeley, Los Angeles: University of California Press, 1982, 111.

38 Ibid.

39 Patty Chang, "A Matter of Style," *Fashion Projects. On Fashion, Art and Visual Culture*, May 6, 2009, http://www.fashionprojects.org/?p=570#more-570, accessed November 8, 2015.

40 James Clifford, "On Collecting Art and Culture," Simon During, ed., *The Cultural Studies Reader*, London: Routledge, 1993, 67.

41 Susan Sontag, cit. James Clifford, ibid, 53.

42 Vicki Karaminas, "Imagining the Orient: Cultural Appropriation in the Florence Broadhurst Collection," *International Journal of Design*, Vol. 1, No. 2, 2007, 16.

43 Wilde, O., "The Decay of Dying," Hazard Adams, ed., *Critical Theory since Plato*, New York: Harcourt Brace, 1992, 664.

44 Patrizia Calefato, *Luxury, Fashion, Lifestyle and Excess*, London: Bloomsbury, 2014, 50.

45 Suzy Menkes, *Herald Tribune*, January 27, 1998, in *Kiss the Future: Believe. Walter Van Beirendonck and Wilde and Lethal Trash,* Exhibition Catalogue, Museum Boijmans Van Beuningen: Rotterdam; Nai Publishers, 1998.

46 Ibid.

47 Inge Grognard, ibid.

48 Walter van Beirendonck, in Luc Derycke and Sandra Van de Veire, eds., *Belgian Fashion Design,* Ghent: Ludion, 237.

49 Suzy Bubble, http://www.dazeddigital.com/fashion/article/23322/1/walter-van-beirendonck-aw15.

Conclusion: To Alexander McQueen, in Memoriam

1 Giorgio Agamben, *Nudities*, trans. David Kishik and Stefan Pedatella, Stanford: Stanford University Press, 2011, 16.

BIBLIOGRAPHY

Abelove, H., M. Aina Barale, and D. Halperin, *The Lesbian and Gay Studies Reader,* New York and London: Routledge, 1990.

Adams, Hazard, *Critical Theory since Plato*, New York: Harcourt Brace, 1992.

Adorno, Theodor W., *Ästhetische Theorie*, Frankfurt am Main: Suhrkamp, (1970) 1973.

Adorno, Theodor W., *Prisms*, trans. Sam and Shierry Weber, Cambridge MA: MIT Press, (1981) 1990.

Adorno, Theodor W., and Max Horkheimer, *Dialectic of Enlightenment*, trans. Edmund Jephcott, Stanford: Stanford University Press, 2002.

Agamben, Giorgio, *What is an Apparatus? And Other Essays*, trans. David Kishik and Stefan Pedatella, Stanford: Stanford University Press, 2009.

Agamben, Giorgio, *Nudities*, trans. David Kishik and Stefan Pedatella, Stanford: Stanford University Press, 2011.

Ainley, R., *What is She Likes: Lesbian Identities from the 1950s to the 1990s*, London: Cassell, 1995.

Aldrich, R., ed., *Gay Life and Culture: A World History*, London: Thames and Hudson, 2006.

Aldrich, R., and G. Wotherspoon, eds., *Gay and Lesbian Perspectives IV: Essays in Australian Culture*, Sydney.

Alexander McQueen: Savage Beauty, exh. Cat., New York: Metropolitan Museum of Art, 2011.

Altman, D., *The Homosexualisation of America: The Americanisation of the Homosexual*, New York, 1982.

Bakhtin, Mikhail, *Rabelais and His World,* trans. Helene Iswolsky, Cambridge, MA: MIT Press, 1968.

Bartlett, Djudja, Shaun Cole, and Agnès Rocamora, eds., *Fashion Media: Past and Present*, London and New York: Bloomsbury, 2013.

Baudelaire, Charles, *Œuvres complètes*, ed. Y-G. Dantec, Paris: Gallimard Pléiade, 1954.

Baudelaire, Charles, *The Painter in Modern Life and Other Essays*, trans. Jonathan Mayne, London: Phaidon, 1987.

Baudelaire, Charles, *The Poems in Prose*, ed. and trans. Francis Scarfe, London: Anvil Press, (1989) 1991.

Beatrice, Luca, and Matteo Guarmaccia, eds., *Vivienne Westwood: Shoes*, trans. David Smith, Bologna: Damiani, 2006.

Bech, H. *When Men Meet: Homosexuality and Modernity*, Cambridge, UK: Polity, 1997.

Beek, Kathryn van, "Kasabian — *Velociraptor!* (Sony)," *13th Floor*, http://13thfloor.co.nz/reviews/cd-reviews/kasabian-velociraptor-sony/.

Beirendonck, Walter van, and Natalie Riff, *Dazed*, http://www.dazeddigital.com/fashion/article/19822/1/the-da-zed-of-walter-van-beirendonck, accessed October 19, 2015.

Beirondonck, Walter van, *The Secret History of Walter Van Beirendonck's Invitations*, *Dazed* Digital, http://www.dazeddigital.com/fashion/article/19867/1/the-secret-history-of-walter-van-beirendoncks-invitations, accessed October 30, 2015.

Benjamin, Walter, *Medienästhetische Schriften*, Frankfurt am Main: Suhrkamp, 2002.

Berube, A., *Coming Out Under Fire: The History of Gay Men and Women in World War Two*, New York.

Blake, Mark, ed., *Punk: The Whole Story*, London and New York: Mojo, 2006.

Blanks, Tim, "Walter and the Bears," *Dream the World Awake*, Exhibition Catalogue, 87–97. Belgium: Lanno Publishers, 2011.

Blanks, Tim, "Fall 2012 Menswear," Walter van Beirendonck, *Vogue*, January 21, 2012. http://www.vogue.com/fashion-shows/fall-2012-menswear/walter-van-beirendonck, accessed November 5, 2015.

Bowie, Malcolm, *Mallarmé and the Art of Being Difficult*, Cambridge: Cambridge University Press, 2008.

Brunette, Peter, and David Wills, eds., *Deconstruction and the Visual Arts: Art, Media and Architecture*, Cambridge: Cambridge University Press, 1994.

Bubble, Suzy, http://www.dazeddigital.com/fashion/article/23322/1/walter-van-beirendonck-aw15, accessed November 12, 2015.

Burana, L. R., and D. Linea, ed., *Dagger: On Butch Women*, San Francisco: Cleis Press, 1994.

Butler, Judith, *Bodies that Matter*, London and New York: Routledge, 1993.

Calefato, Patrizia, *Luxury, Fashion, Lifestyle and Excess*, London: Bloomsbury, 2014.

Carrington, Ben, and Brian Wilson, "Dance Nations: Rethinking Youth Subcultural Theory," in Andy Bennett and Keith Kahn-Harris, 65–78, *After Subculture. Critical Studies in Contemporary Youth Culture*, Hampshire: Palgrave, 2004.

Carroll, David, ed., *The States of "Theory": History, Art, and Critical Discourse*, Stanford: Stanford University Press, (1990) 1994.

Cauvan, Jean Paul, *Walter Van Beirendonck Menswear Spring 2008: Well Endowed Fetish Avatars*, http://www.fashionwindows.net/2007/07/walter-van-beirendonck-menswear-spring-2008/, accessed October 30, 2015.

Chang, Patty, "A Matter of Style," *Fashion Projects. On Fashion, Art and Visual Culture*, May 6, 2009, http://www.fashionprojects.org/?p=570#more-570, accessed November 8, 2015.

Clark, T. J., "Modernism, Postmodernism, and Steam," *October* 100, Spring 2002, 155–174.

Clews-Parsons, Elsie, and Ralph L. Beals, "The Sacred Clowns of the Pueblo and Mayo-Yaqui Indians", *American Anthropologist*, Vol. 36, No. 4, October–December, (1934): 491–519.

Clifford, James, "On Collecting Art and Culture," ed. Simon During, *The Cultural Studies Reader*, 57–76, Routledge: London, 1993.

Cole, S., *Don We Now Our Gay Apparel*, Oxford and New York: Berg, 2000.

Comini, Alessandra, *Egon Schiele*, New York: George Brazillier, 1976.

Croizat, Yassana, "'Living Dolls': François Ier Dresses His Women," *Renaissance Quarterly*, Vol. 60 No. 1, Spring 2007, 94–130.

Crouch, Colin, *Post-Democracy*, London and New York: Polity, 2004.

Culler, Jonathan, ed., *Deconstruction: Critical Concepts in Literary and Cultural Studies*, vols. 1 and 3, London and New York: Routledge, 2003.

Daris, Gabriella, "Fall 2016 Collections: Marie-Agnés Gillot Stars in Gareth Pugh's LFW Show," *Blouinartinfo*, February 23, 2016, http://www.blouinartinfo.com/news/story/1336602/fall-2016-collections-marie-agnes-gillot-stars-in-gareth, accessed February 29, 2016.

Debo, Kaat, "Walt's World of Wonder," *Dream the World Awake*, exn cat., Belgium: Lanno Publishers, 2011.

Debord, Guy, "One More Try If You Want to Be Situationists (The S.I. *in* and *against* Decomposition)," trans. John Shepley, *October* 79, 85–89.

Derrida, Jacques, *De la Grammatologie*, Paris: Minuit, 1967.

Derrida, Jacques, *L'écriture et la difference*, Paris: Seuil, 1967.

Deleuze, Gilles, *Spinoza et le problem de l'expression*, Paris: Minuit, 1968.

Deleuze, Gilles, and Félix Guattari, *L'Anti-Œdipe*, Paris: Minuit, 1972.

Deleuze, Gilles, *Spinoza: Philosophie practique*, Paris: Minuit, 1981.

Deleuze Gilles, and Félix Guattari, *Mille Plateaux*, Paris: Minuit, 1981.

Derrida, Jacques, "A Letter to Eisenmann," trans. Hilary Hanel, *Assemblage* 12, 1990, 7–13.

Derycke, Luc, and Sandra Van De Veire, eds., *Belgian Fashion Design*, Ghent: Ludion, 1999.

Di Trocchio, Paula, *Manstyle,* Exhibition Catalogue, National Gallery of Victoria, Melbourne, 2011.

Dolansky, Fanny, "Playing with Gender: Girls, Dolls, and Adult Ideals in the Roman World," *Classical Antiquity*, Vol. 31, No. 2, October 2012, 256–292.

Duggan, Ginger Gregg, "The Greatest Show on Earth: A Look at Contemporary Fashion Shows and Their Relationship to Performance Art," *Fashion Theory: The Journal of Dress, Body and Culture* Vol. 5, No. 3 (2001): 243–270.

Eisenman, Peter, "Post/El Cards: A Reply to Jacques Derrida," *Assemblage* 12, 1990, 14–17.

English, Bonnie, *Japanese Fashion Designers: The Work and Influence of Issey Miyake, Yohgi Yamamoto and Rae Kawakubo,* London and New York: Bloomsbury, 2011.

Entwistle, Joanne, and E. Wilson, eds., *Body Dressing*, Oxford: Berg, 2001.

Entwistle, Joanne, and Agnès Rocamora, "The field of fashion materialized: a study of London Fashion Week," *Sociology* Vol. 40, No. 4 (2006): 735–751.

Epstein, J., and K. Straub, eds., *Body Guards: The Cultural Politics of Gender Ambiguity*, New York: Routledge, 1991.

Evans, Caroline, *Fashion on the Edge*, New Haven and London: 2009.

Evans, Caroline, and Minna Thornton, *Women and Fashion: A New Look*, London and New York: Quartet Books, 1989.

Evans, Caroline, and Susannah Frankel, *The House of Viktor & Rolf*, exh. cat. Barbican Centre, London and New York: Merrell, 2008.

Feinberg, L., *Stone Butch Blues*, New York: Firebrand, 1993.

Filler, Martin, *Makers of Modern Architecture*, New York: *New York Review of Books*, 2007.

Fisher, David, "Nietzsche's Dionysian Masks," *Historical Reflections*, Vol. 21, No. 3, Fall 1995, 515–536.

Fogg, Marnie, *When Fashion Really Works*, Sydney: Murdoch Books, 2013.

Foster, Hal, "Post-Critical," *October* 139, 4–8.

Foucault, Michel, "What is Critique?" trans. Lysa Hochroth, in *Politics and Truth*, ed. Sylvère Lotringer and Lysa Hochroth, New York: Semiotext(e), 2007.

Franz Fanon, *Black Face, White Mask,* New York: Grove Press, 1967.

Garber, M., *Vested Interests: Cross Dressing and Cultural Anxiety*, London and New York: Penguin, 1992.

Garelick, Rhonda, *Mademoiselle: Coco Chanel and the Pulse of History*, New York: Random House, 2014.

Gasché, Rodolphe, *The Taint of the Mirror: Derrida and the Philosophy of Reflection*, Cambridge MA: Harvard University Press, 1986.

Geczy, Adam, *Fashion and Orientalism: Dress, Textiles and Culture from the 17th to the 21st Century*, London and New York: Bloomsbury, 2013.

Geczy, Adam, *The Artificial Body in Fashion and Art: Models, Marionettes and Mannequins*, London and New York: Bloomsbury, 2016.

Geczy, Adam, and Benjamin Gennochio, eds., *What is Installation: An Anthology of Writings on Installation Art in Australia*, Sydney: Power Publications, 2001.

Geczy, Adam, and Vicki Karaminas, eds., *Fashion and Art*, New York and London: Bloomsbury, 2012.

Geczy, Adam, and Vicki Karaminas, *Queer Style*, New York and London: Bloomsbury 2013.

Geczy, Adam, and Vicki Karaminas, *Fashion's Double: Representations of Fashion in Painting, Photography and Film*, London and New York: Bloomsbury, 2015.

Geczy, Adam, and Jacqueline Millner, *Fashionable Art*, New York and London: Bloomsbury, 2015.

Gill, Alison, "Deconstruction Fashion: The Making of Unfinished, Decomposing and Re-Assembled Clothes," *Fashion Theory*, Vol. 2, No. 1, 1998, 25–49.

Givhan, Robin, "Rei Kawakubo: The CFDA fêtes a fashion sphinx," *Newsweek*, Vol. 159, No. 24, June 11, 2012, http://search.proquest.com.ezproxy1.library.usyd.edu.au/docview/1017537996?pq-origsite=summon.

Gluck, Mary, *Popular Bohemia: Modernism and Urban Culture in Nineteenth-Century Paris*, Cambridge, MA: Harvard University Press, 2005.

Godfrey, Sima, "Dandy as Ironic Figure," *SubStance*, Vol. 11, No. 3, Issue 36, 1982, 21–32.

Green, Eileen, and Alison Adam, eds., *Virtual Gender: Technology, Consumption and Identity*, London and New York: Routledge, 2001.

Greene, Lucie, "It's a Man's World," *Women's Wear Daily*, Vol. 194, No. 54, September 11, 2007, Internet source.

Grosz, Elizabeth, *Volatile Bodies: Toward a Corporeal Feminism*, Indianapolis: Indiana University Press, 1994.

Habermas, Jürgen, *Philosophical Discourse of Modernity*, trans. Frederick Lawrence, Cambridge MA: MIT Press 1985.

Halberstam, Judith, "Skinflick: Posthuman Gender in Jonathan Demme's *The Silence of the Lambs*, *Camera Obscura*, Vol. 3, No. 27, September 1991, 9, 37–52.

Haraway, Donna, "Manifesto for Cyborgs: Science, Technology, and Socialist Feminism in the 1980s," *Socialist Review* 80, 1985, 65–108, reprinted as "A Cyborg Manifesto: Science, Technology and Socialist-Feminism in the Late Twentieth Century," in Donna Harraway, *Simians, Cyborgs and Women: The Reinvention of Nature*, London and New York: Routledge, 1991.

Hastreiter, Kim, "Mopping the Street," *Design Quarterly*, 159, Spring 1993, 33–37.

Hayles, Katherine, *How We Became Posthuman: Virtual Bodies in Cybernetics, Literature and Infomatics*, Chicago and London: Chicago University Press, 1999.

Hebdidge, Dick, *Subculture: the Meaning of Style*, London: Methuen, 1979.

Herbrecheter, Stefan, *Posthumanism: A Critical Analysis*, London and New York: Bloomsbury, 2013.

Higgins, Lee, *Community Music in Theory and in Practice*, Oxford: Oxford University Press, 2012.

Hughes, Kathryn, "'How London Dressed Up for the 1980s," *Guardian*, June 22, 2013, http://www.theguardian.com/culture/2013/jun/22/club-catwalk-london-fashion-1980s, accessed October 21, 2015.

Ince, Catherine, and Rie Nii, eds., *Future Beauty: 30 Years of Japanese Fashion*, exh cat, New York and London: Merrell and the Barbican Centre, 2010.

Jivani, A., *It's not Unusual: A History of Lesbian and Gay Britain in the Twentieth Century*, London: 1997.

Jones, Terry, *Rick Owens*, New York: Taschen, 2012.

Jones, Terry, and Avril Mair, eds., *Fashion Now, ID Selects the Worlds 150 Most Important Designers*, Cologne: Taschen, 2003.

Joselit, David, "On Aggregators," *October* 146, Fall 2013.

Katz, J. N., *Gay American History: Lesbians and Gay Men in the USA*, New York:, 1992.

Kaufmann, Vincent, "Angels of Purity," October 79, Guy Debord and the *Internationale situationiste,* Special Issue, Winter 1997, 49–68.

Kawamura, Yuniya, *The Japanese Revolution in Paris Fashion*, Oxford and New York: Berg, 2004.

Kermode, Frank, *Romantic Image*, London: Routledge and Kegan Paul, 1957.

Khan, Natalie, "Stealing the Moment: The Non-narrative Fashion Films of Ruth Hogben and Gareth Pugh," *Fashion, Film and Consumption*, 2012, 251–262.

Kirk, K., and E. Heath, *Men in Frocks,* London:, 1984.

Klein, Yves, *Le dépassement de la problématique de l'art et autres écrits*, Paris: École Nationale Supérieure des Beaux-Arts, 2003.

Koda, Harold, "Rei Kawakubo and the Aesthetic of Poverty," *Dress: Journal of the Costume Society of America* 11, 1985, 5–14.

Kristeva, Julia, *Powers of Horror: An Essay on Abjection*, New York: Columbia University Press, 1982.

Lauretis, Theresa de, *Technologies of Gender*, Bloomington and Indianapolis: Indiana University Press, 1987.

Lefevbre, H., "The Production of Space" (1991: 292) in J. J. Gieseking, W. Mangold, C. Katz, C. Low and S. Saegert, *The People, Place, Space Reader*, London and New York: Routledge, 2014.

Le Rose, Lauren, "Dutch Design Guru's Viktor and Rolf bring their 'Dolls' Collection to the Royal Ontario Museum for Luminato," Style, National Post, April 9, 2013 http://news.nationalpost.com/life/dutch-design-gurus-viktor-rolf-bring-their-dolls-collection-to-the-royal-ontario-museum-for-luminato, accessed November 18, 2015.

Levine, M. P., *Gay Macho: The Life and Death of the Homosexual Clone*, New York and London.

Lévi-Strauss, Claude, *La Pensée sauvage*, Paris: Plon, 1962.

Lipovetsky, Gilles, *L'empire de l'éphémère: la mode et son destin dans les societies modernes*, Paris: Gallimard, 1987.

Lippman, Michael, "Embodying the Mask: Exploring Ancient Roman Comedy Through Masks and Movement," *The Classical Journal*, Vol. 111, No. 1, October–November, 2015, 25–36.

Loscialpo, Flavia, "Fashion and Philosophical Deconstruction: A Fashion in-Deconstruction." *1st Global Conference: Fashion–Exploring Critical Issues, Session*. Vol. 1., 2003.

Lukács, Georg, *History and Class Consciousness*, trans. Rodney Livingstone, 1919–1923, http://www.marxists.org/archive/lukacs/works/history/.

Maffessoli, Michel, *The Time of the Tribes: The Decline of Individualism in Mass Society*, London: Sage, 1996.

Martin, Richard, and Harold Koda, eds., *Info-Apparel*, New York: Metropolitan Museum of Art, 1993.

McLuhan, Marshall, *Understanding Media: the Extensions of Man* (1964), London and New York: Routledge, 2001.

McNeil, Peter, and Vicki Karaminas, eds., *The Men's Fashion Reader*, Oxford: Berg, 2009.

Melville, Stephen, *Philosophy Beside Itself: On Deconstruction and Modernism*, Manchester: Manchester University Press, 1986.

Mercer, Kobena, "Reading Racial Fetishism: The Photographs of Robert Mapplethorpe," ed. Jessica Evans and Stuart Hall, 435–444, *Visual Culture: The Reader*, Sage: London, 2006.

Meyer, Moe, ed., *The Politics and Poetics of Camp*, New York: Routledge, 1994.

Miller, Sanda. "Fashion as Art; is Fashion Art?" *Fashion Theory: The Journal of Dress, Body and Culture* Vol. 11, No. 1 (2007): 25–40.

Mitchell, Louise, ed. *The Cutting Edge: Fashion from Japan*, Sydney: Powerhouse Publishing, 2005.

Muggleton, D., *Inside Subculture. The Postmodern Meaning of Style*, Oxford and New York: Berg, 2000.

Muggleton, D., and R. Weinzierl, ed., *The Post-Subcultures Reader*, Oxford and New York: Berg, 2003.

Mulvey, Laura, "Visual Pleasure and Narrative Cinema," *Screen*, Vol. 16, No. 3, Autumn 1975, 6–18.

Munt, S., "The Butch Body," in R. Holliday and J. Hassard, eds., *Contested Bodies*, London: Routledge, 2001.

Nixon, Natalie W., and Johanna Blakley, "Fashion Thinking: Towards an Actionable Methodology," *Fashion Practice: The Journal of Design, Creative Process and the Fashion Industry,* Vol. 4, No. 2 (2012): 153–176.

Norris, Christopher, *Deconstruction: Theory and Practice*, London and New York: Routledge (1982), revised edition, 1991.

O'Hara, Craig, *The Philosophy of Punk: More than Noise*, London and San Francisco: AK Press, 1999.

Ongley, Hannah, "Penis Shoes and A Topless Kate Moss at Vivienne Westwood's 1995 'Erotic Zones'," http://blog.swagger.nyc/2015/04/30/tbt-penis-shoes-and-topless-kate-moss-at-vivienne-westwoods-1995-erotic-zones/, accessed November 24, 2015.

Owens, Rick, *Rick Owens*, New York: Rizzoli, 2011.

Peers, Juliette, *The Fashion Doll: From Bébé Jumeau to Barbie*, Oxford and New York: Berg, 2004.

Perniola, Mario, *Art and its Shadow* (2000), trans. Massimo Verdicchio, New York and London: Continuum, 2004.

Plato, *Plato: Five Great Dialogues*, ed. Louise Loomis, New York: Gramercy Books, 1942.

Polan, Brenda, and Roger Tredre, *The Great Fashion Designers*, Oxford and New York: Berg, 2009.

Polhemus, T, *Body Styles,* New York: Luton, 1988.

Polhemus, T., *Streetstyle: From Sidewalk to Catwalk*, New York:, 1994.

Pollock, Donald, "Masks and the Semiotics of Identity," *Journal of the Royal Anthropological Institute*, Vol. 1, No. 3, 1995, 581–597.

Praz, Mario, *The Romantic Agony*, trans. Angus Davidson, Oxford: Oxford University Press, 2nd edition, 1970.

Probyn, Elsbeth, "Queer Belongings: The Politics of Departure," in Elizabeth Grosz and Elsbeth Probyn, eds, *Sexy Bodies: Strange Carnalities of Feminism*, London: Routledge, 1995.

Ranscombe, Sian, "Gareth Pugh Injects 'Pillow Face' into London Fashion Week Using Tights," Lifestyle and Beauty, *The Daily Telegraph*, http://www.telegraph.co.uk/beauty/make-up/gareth-pugh-beauty-aw16/, accessed February 29, 2016.

Reinhardt, Leslie, "Daughters, Dress, and Female Virtue in the Eighteenth Century," *American Art*, Vol. 20, No. 2, Summer 2006, 32–55.

Rolley, C., *Lesbian Dandy: The Role of Dress and Appearance in the Formation of Lesbian Identities.* New York: Continuum, 1997.

Rosanvalon, Pierre, *Counter-Democracy*, trans. Arthur Goldhammer, Cambridge and London: Cambridge University Press, 2008.

Secrest, Meryle, *Elsa Schiaparelli: A Biography*, New York: Knopf, 2014.

Seely, Stephen, "How Do You Dress a Body Without Organs? Affective Fashion and Nonhuman Becoming," *Women's Studies Quarterly*, Vol. 41, No. 1/2, Spring/Summer, 2012, 247–265.

Skidmore, Maisie, "Aitor Throup the Anomalous Designer: We Meet Aitor Throup in His Studio to Discuss his Unusual Practice," http://www.itsnicethat.com/features/aitor-throup-the-anomalous-designer-we-meet-aitor-thoup-in-his-studio-to-discuss-his-unusual-practice, accessed November 16, 2015.

Spinoza, Baruch, *Ethics*, trans. Andrew Boyle, revised G. H. R. Parkinson, London: Everyman, (1959) 1993.

Steele, Valerie, *Fifty Years of Fashion: New Look to Now*, New Haven and London: Yale University Press, 2000.

Steele, Valerie, ed., *Japan Fashion Now*, New Haven and London and New York: Yale University Press and Fashion Institute of Technology, 2010.

Steele, Valerie, ed., *The Berg Companion to Fashion*, Oxford and New York: Berg, 2010.

Steele, Valerie, "Fashion Prescribes the Ritual," *Dream the World Awake*, Exhibition Catalogue, Belgium: Lanno Publishers, 2011, 135–143.

Stern, Radu, et al., *Against Fashion: Clothing as Art, 1850–1930*, Cambridge, MA: MIT Press, 2004.

Stewart, Susan, *On Longing. Narratives of the Miniature, the Gigantic, the Souvenir, the Collection,* Durham and London: Duke University Press, 1993.

Taylor, Melissa, "Culture Transition: Fashion's Cultural Dialogue between Commerce and Art," *Fashion Theory: The Journal of Dress, Body and Culture*, Vol. 9, No. 4 (2005): 445–460.

Thesander, Marianne, *The Feminine Ideal* (1994), trans. London: Nicholas Hills, Reaktion, 1997.

3rd Berlin Biennial for Contemporary Art, exn cat., Berlin: KW Institute for Contemporary Art, 2000.

Thomas, Dylan, *The Eighties: One Day, One Decade*, London: Random House, 2013.

Thomas, Dylan, "Space Ships, Drugs Everywhere, and Freddie Mercury Trying it on with Bono: The Live AID Story You've Never Heard Before, *Mail Online*, May 25, 2013, http://www.dailymail.co.uk/home/event/article-2329571/Freddie-Mercury-trying-Bono-The-Live-Aid-story-youve-heard-before.html, accessed October 20, 2015.

Thornton, Sarah, et al., *The Subcultures Reader,* Routledge, 1997.

Thurman, Judith, "The Misfit," *New Yorker*, July 4, 2005, http://www.newyorker.com/magazine/2005/07/04/the-misfit-3, accessed November 29, 2015.

Tonkin, E., "Masks and Powers", *Man*, 14, 1979, 237–248.

Tseëlon, Efrat, "From Fashion to Masquerade: Towards an Ungendered Paradigm," ed. by Joanne Entwistle and Elizabeth Wilson, 103–120. *Body Dressing*, Oxford: Berg, 2001.

Uroskie, Andrew, "Beyond the Black Box: The Lettrist Cinema of Disjunction," *October* 135, 21–48.

Vattimo, Gianni, *Art's Claim to Truth*, ed. Santiago Zabala, trans. Luca D'Isanto, New York: Columbia University Press, 2008.

Vermorel, Fred, *Fashion and Perversity: A Life of Vivienne Westwood and the Sixties Laid Bare*, London: Bloomsbury, 1996.

Viktor and Rolf: The Couture Laboratory, *Dazed*, http://www.dazeddigital.com/fashion/article/18190/1/viktor-rolf-the-couture-laboratory, accessed November 18, 2015.

Warwick, Alexandra, and Dani Cavallaro, *Fashioning the Frame: Boundaries, Dress and the Body*, Oxford: Berg, 1998.

Waugh, Evelyn, *Unconditional Surrender* (1961), Harmondsworth: Penguin, 1979.

Webb, Iain R., *Blitz: As Seen in Blitz—Fashioning the 80s Style*, Suffolk: ACC Editions, 2013.

Westwood, Vivienne, and Ian Kelly, *Vivienne Westwood*, Oxford and London: Phaidon, 2014.

Wigley, Mark, *The Architecture of Deconstruction: Derrida's Haunt*, Cambridge, MA: MIT Press, 1993.

Williams, Rosalind H., *Dream Worlds: Mass Consumption in Late Nineteenth-Century France*, Berkeley and Los Angeles: University of California Press 1982.

Wilson, Elizabeth, *Adorned in Dreams: Fashion and Modernity,* London: Virago, 1985.

Wilson, Elizabeth, *Bohemians: Glamorous Outcasts*, London: I. B. Tauris, 2000.

Wilcox, Claire, ed., *Radical Fashion*. London: V&A Museum, 2001.

Wilcox, Claire, *Vivienne Westwood*, London: V&A Museum, 2004.

Yovel, Yirmiyahu, *Spinoza and Other Heretics: The Adventures of Immanence*, Princeton, NJ: Princeton University Press, 1992.

Filmography

Hogben, Ruth, and Gareth Pugh, *A Beautiful Darkness*, ShowStudio, 2015, https://www.youtube.com/watch?v=IgFqrilM.

Jannings, Emil, *The Blue Angel [Der blaue Engel]*, UFA, 1930.

Pasolini, Pier Paulo, *Salò, or the 120 Days of Sodom*, Les Productions Artistes Associés, 1975.

Stiller, Ben, *Zoolander 2*, Red Hour Productions, 2016.

Internet sources not already listed

"Aitor Throup, Damon Albarn, 'Everyday Robots'," https://www.youtube.com/watch?v=rjbiUj-FD-o

"Aitor Throup The Funeral of New Orleans Part One," https://www.youtube.com/watch?v=rqoWMjpe5l8

"Aitor Throup: London Collections S/S13" https://www.youtube.com/watch?v=4xDpWwQZUqA

"Aitor Throup: New Object Research 201'", https://www.youtube.com/watch?v=stwE71ZMp-A http://www.basenotes.net/ID26123491.html http://contributormagazine.com/interview-walter-van-beirendonck/, accessed October 25, 2015.

Christian Lacroix, https://theballetblogger.wordpress.com/2015/08/23/fashion-in-ballet/, accessed February 16, 2016, http://www.radhourani.com/blogs/projects/15063485-unisex-anatomy-exit, accessed February 16, 2016.

"Everyday Robots: A Digital Portrait of Damon Albarn by Aitor Throup," https://www.youtube.com/watch?v=HxUkeOq0D2o

Fashion or Art? Viktor and Rolf's Autumn/Winter 2015 Haute Couture Collection. http://www.graphics.com/article/fashion-or-art-viktor-rolfs-autumnwinter-2015-haute-couture-collection, accessed November 20, 2015.

Gareth Pugh, Fall 2008 Ready-to-Wear, https://www.youtube.com/watch?v=MM8laGi3Llw

Gareth Pugh, Autumn/Winter 2014 Runway Collection, ShowStudio, https://www.youtube.com/watch?v=ZqTM0dqKu-Y

Gareth Pugh Autumn/Winter 2015 by ShowStudios, https://www.youtube.com/watch?v=UtksAyyPRnU

Gareth Pugh, http://uniquestyleplatform.com/blog/2014/10/13/pagan/, accessed February 25, 2016.

Legs, https://www.youtube.com/watch?v=RkkgJhxZBBU

Portrait of Noomi Rapace (Throup, 2014), https://www.youtube.com/watch?v=BMVMPiFLPy8.

Rad Hourani, http://www.sleek-mag.com/print-features/2015/02/rad-hourani-interview-fashion/, accessed February 15, 2016.

Rad Hourani, http://montrealgazette.com/entertainment/arts/pop-tart-designer-rad-hourani-launches-art-exhibition-in-montreal, accessed February 20, 2016.

"Rick Owens Interview," 2012, https://www.youtube.com/watch?v=ikU1dxuQPYY http://www.vogue.co.uk/fashion/spring-summer-2010/ready-to-wear/vivienne-westwood, accessed November 27, 2015.

World's End, 430 King's Road London, http://worldsendshop.co.uk/about/, accessed November 22, 2015.

INDEX

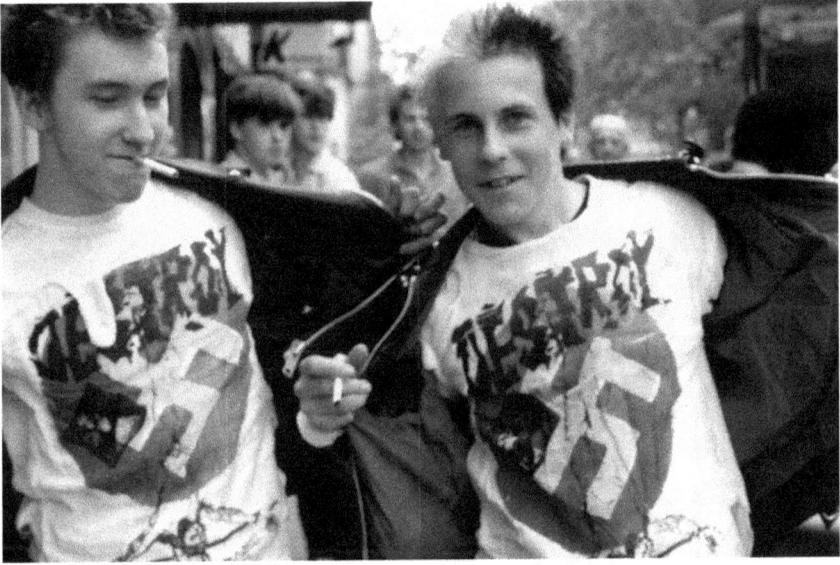

Plate 1 Two boys wearing Vivienne Westwood's "Destroy" T-shirts, King's Road, London, circa 1980s. Credit: Universal Images Group.

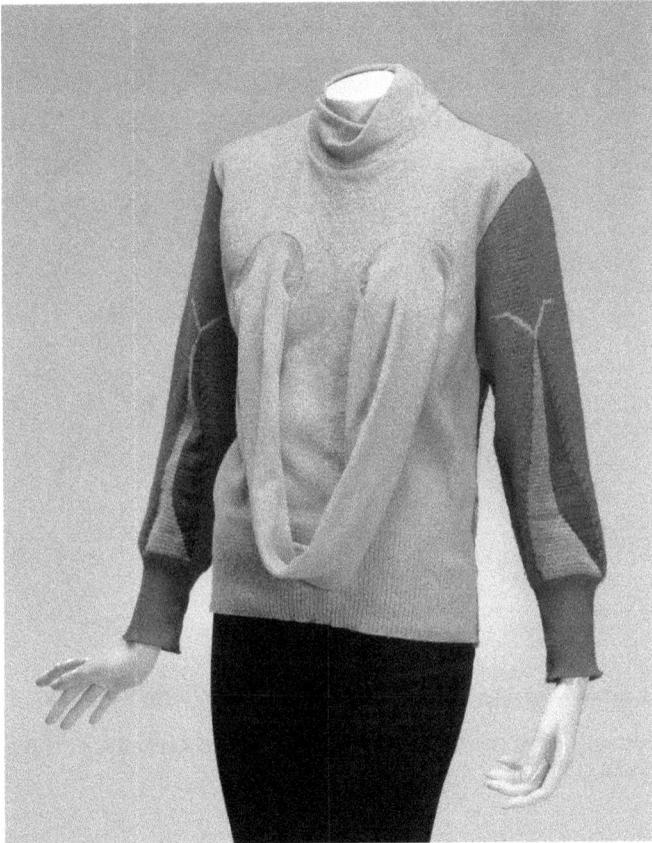

Plate 2 Boob Sweater (Savage Collection) by Vivienne Westwood, Spring/ Summer 1982, Nancy Foxwell Neuberger Acquisition Endowment Fund. Credit. Minneapolis Museum of Art.

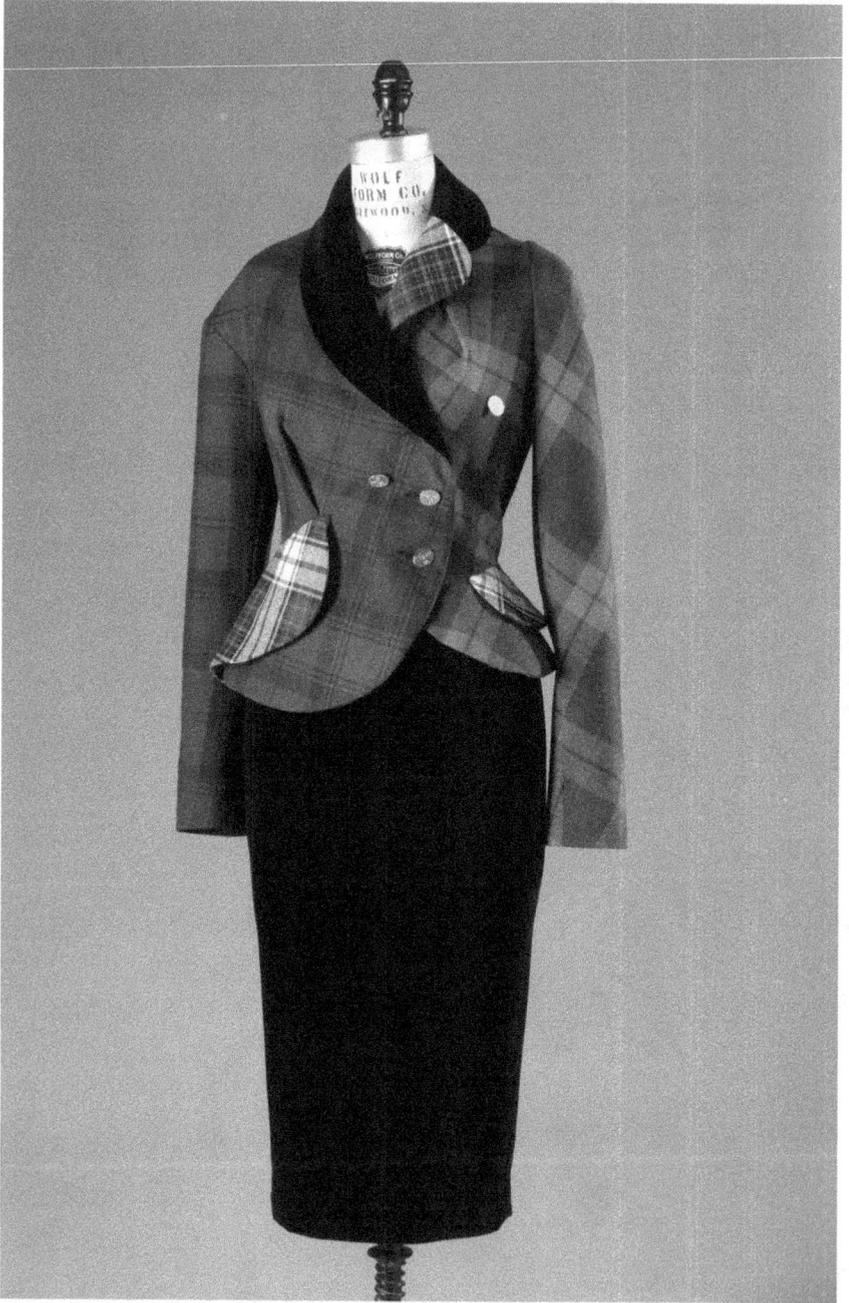

Plate 3 Vivienne Westwood, Wool tartan plaid and black silk velvet, Autumn/Winter 1993. © The Museum at FIT.

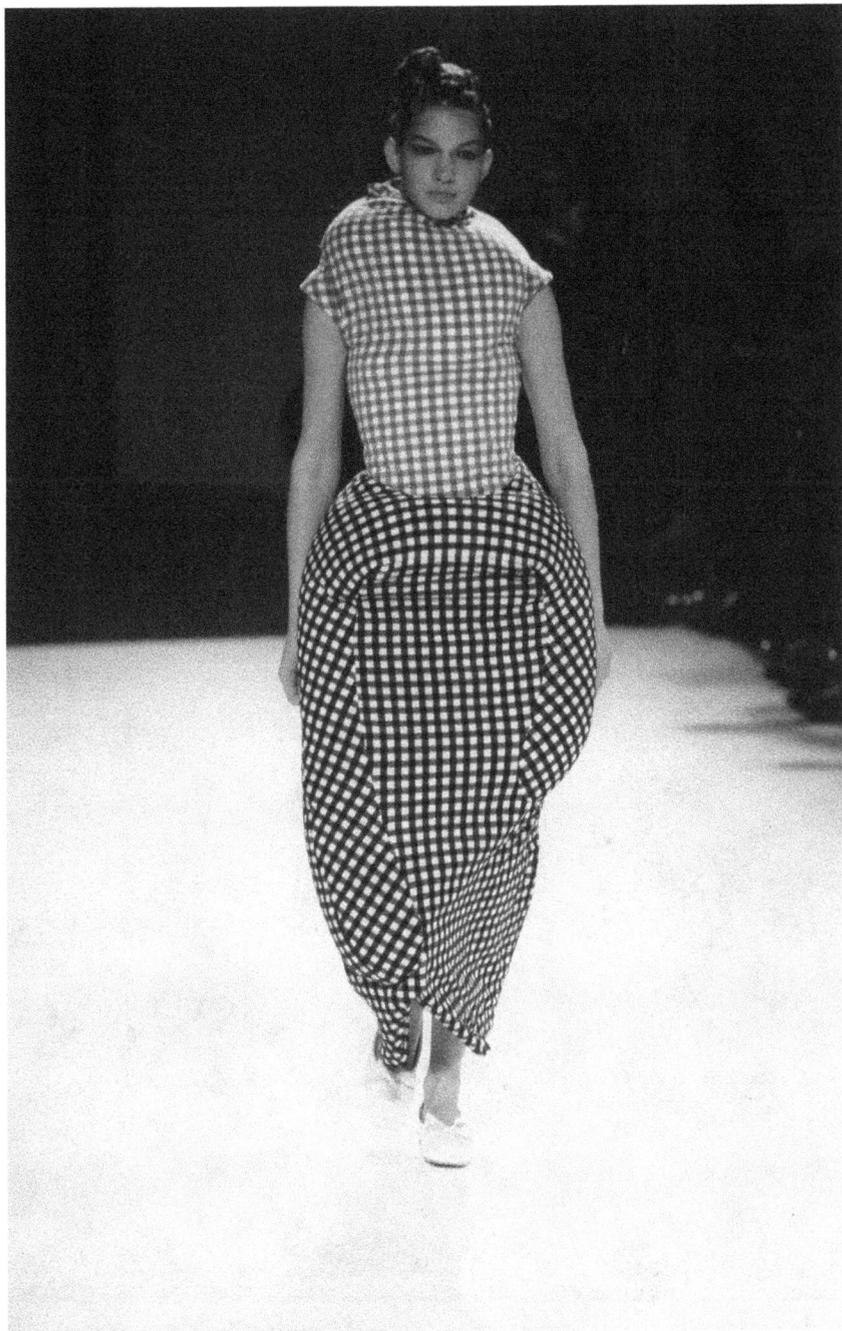

Plate 4 Rei Kawakubo, Spring/Summer 1997 collection "Lumps and Bumps." Bloomsbury Archives.

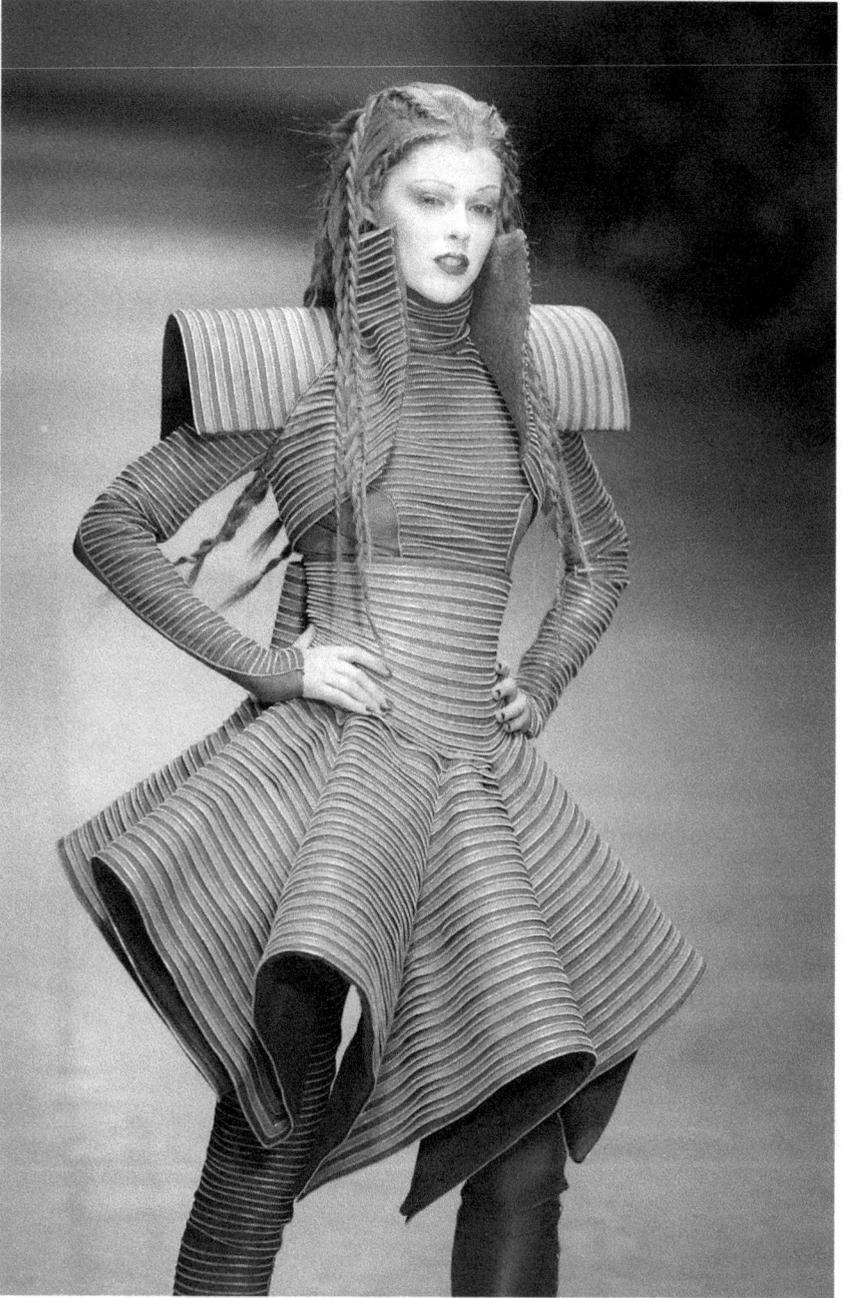

Plate 5 A model poses at the Gareth Pugh catwalk show as part of London Fashion Week at the BFC Tent, February 14, 2008, London. Photography Antonio de Moraes Barros Filho.

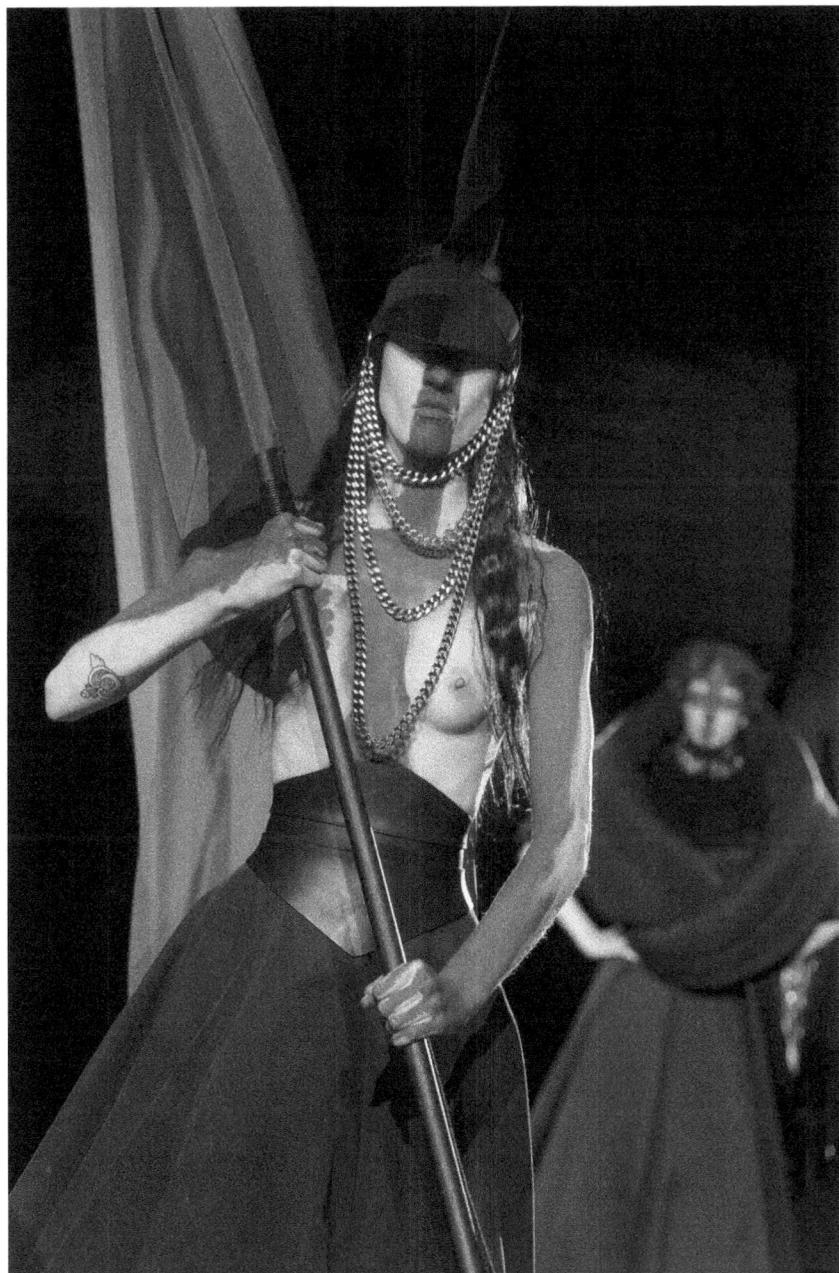

Plate 6 A model walks the runway at the Gareth Pugh show during London Fashion Week, Autumn/Winter 2015 at the Victoria and Albert Museum on February 21, 2015, London, England. Photography Antonio de Moraes Barros Filho.

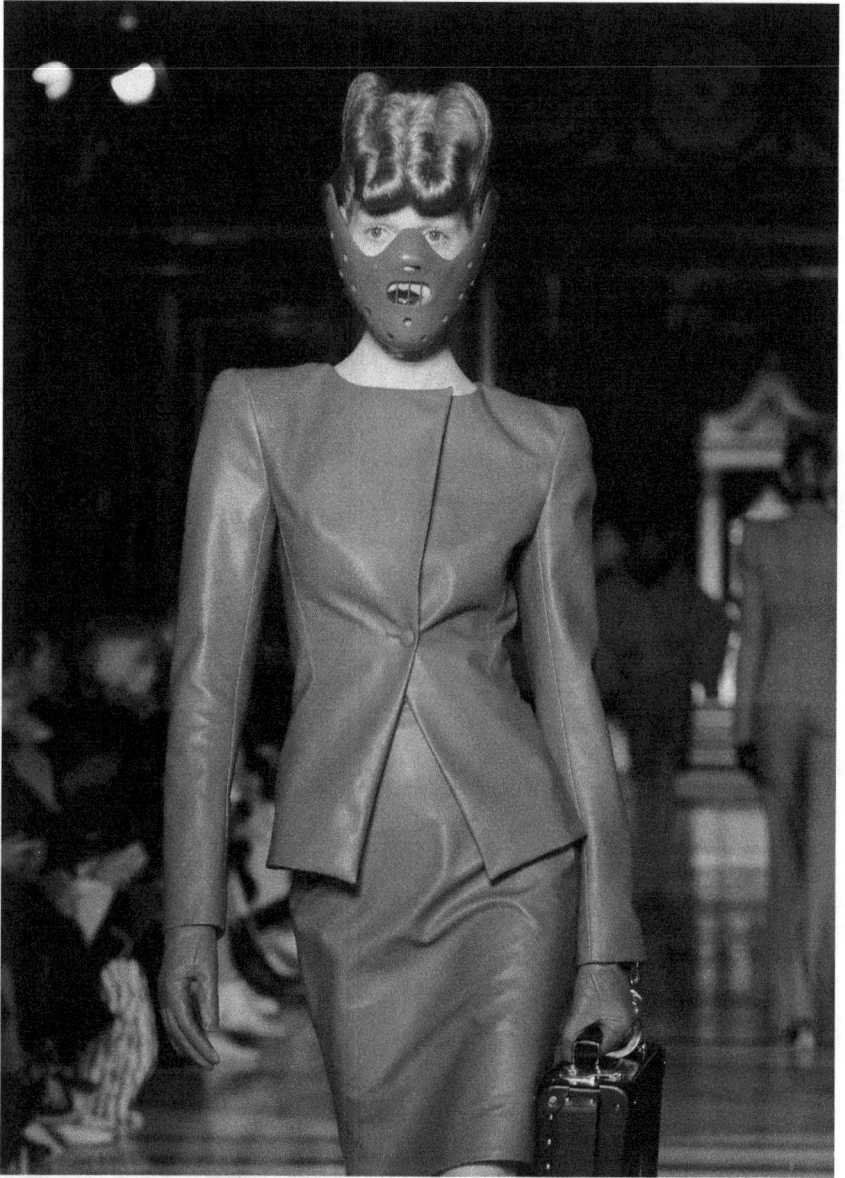

Plate 7 Gareth Pugh, Autumn/Winter 2016, London Fashion Week, February 20, 2016. London.

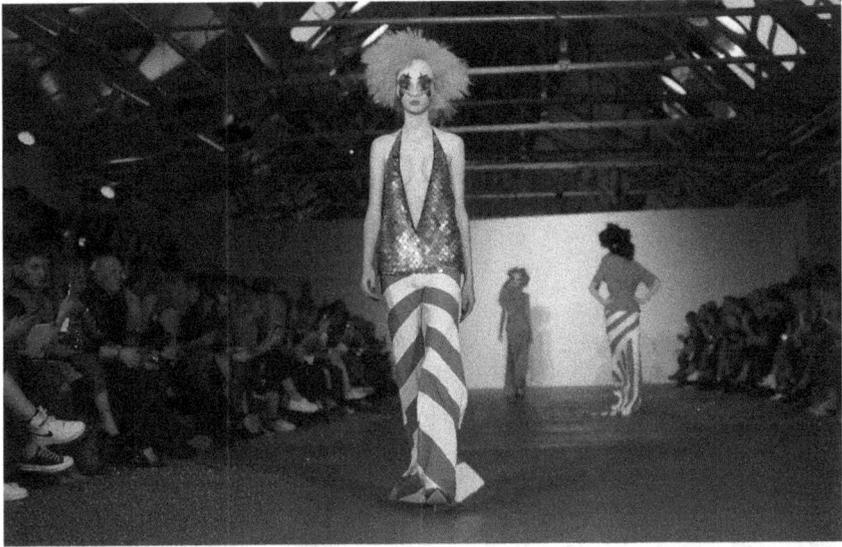

Plate 8 Gareth Pugh, Spring/Summer "Ready-to-Wear" 2016. Photography Stuart C. Wilson.

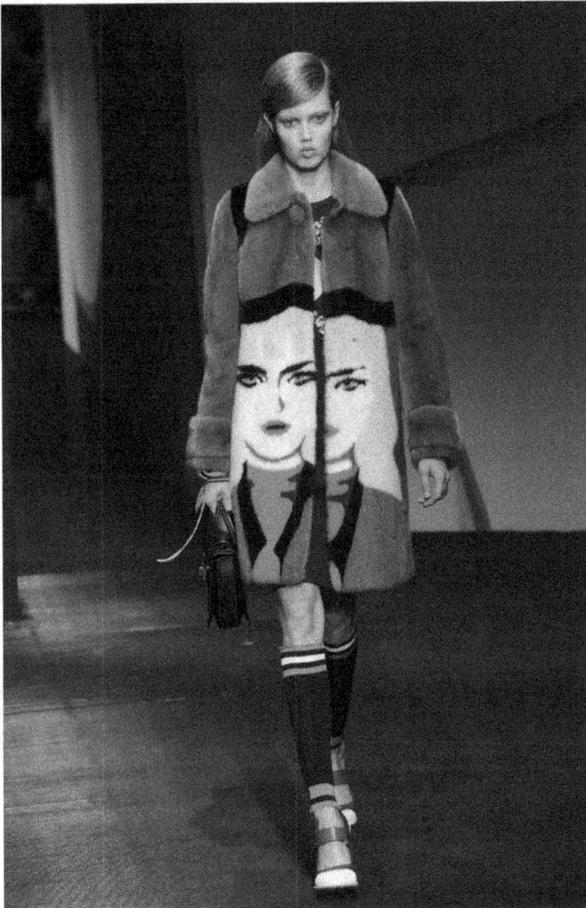

Plate 9 Prada, Spring/Summer 2014 "Ready-to-Wear" women's wear collection, September 19, 2013, Milan, Italy. Photography Catwalking.

Plate 10 Director Baz Luhrmann, actresses Carey Mulligan and Jennifer Meyer, actor Tobey Maguire and designer Miuccia Prada attend *Catherine Martin and Miuccia Prada Dress Gatsby* Opening Cocktail on April 30, 2013, in New York City.

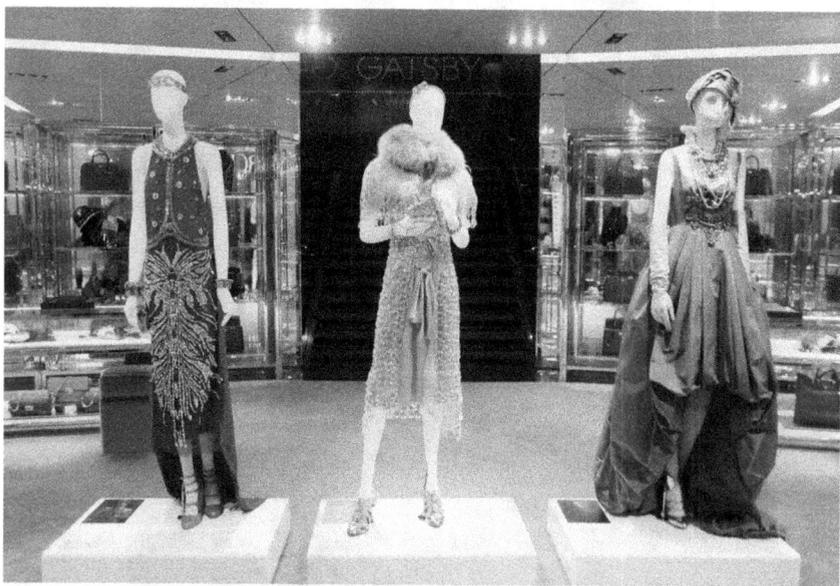

Plate 11 A general view of *Catherine Martin and Miuccia Prada Dress Gatsby* in the Prada store, September 10, 2013, Shanghai, China. Photography Hong Wu.

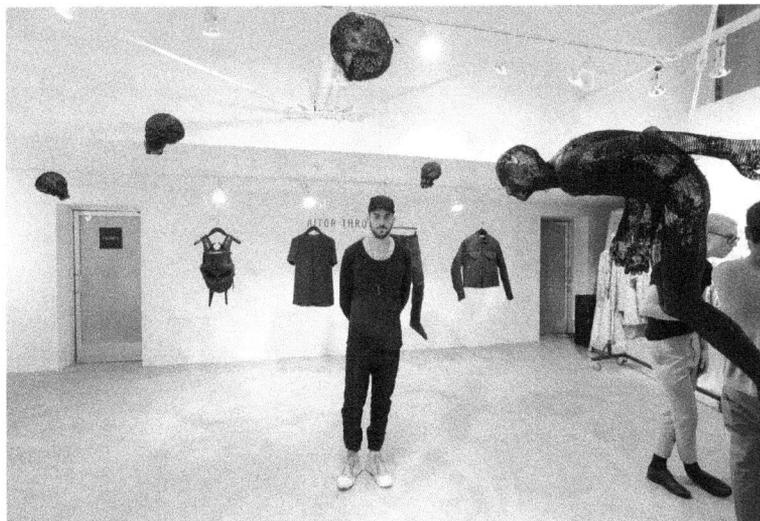

Plate 12 Aitor Throup at the British Fashion Council's International showcasing initiative LONDON Show ROOMS LA, Ace Gallery, October 25, 2012, Los Angeles, California. Photography Stewart Cook.

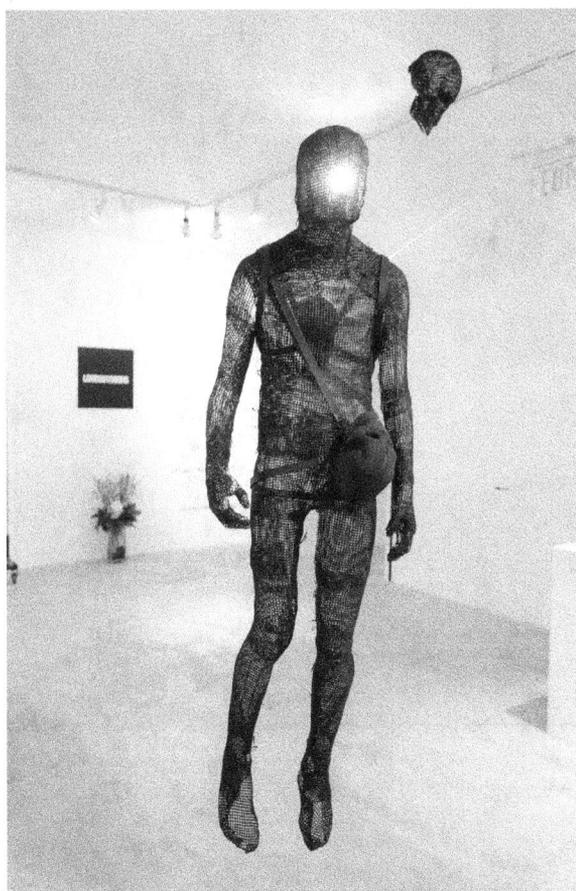

Plate 13 Aitor Throup designs at the British Fashion Council's International Showcasing Initiative LONDON Show ROOMS LA at Ace Gallery on October 25, 2012, in Los Angeles, California. Photography Stewart Cook.

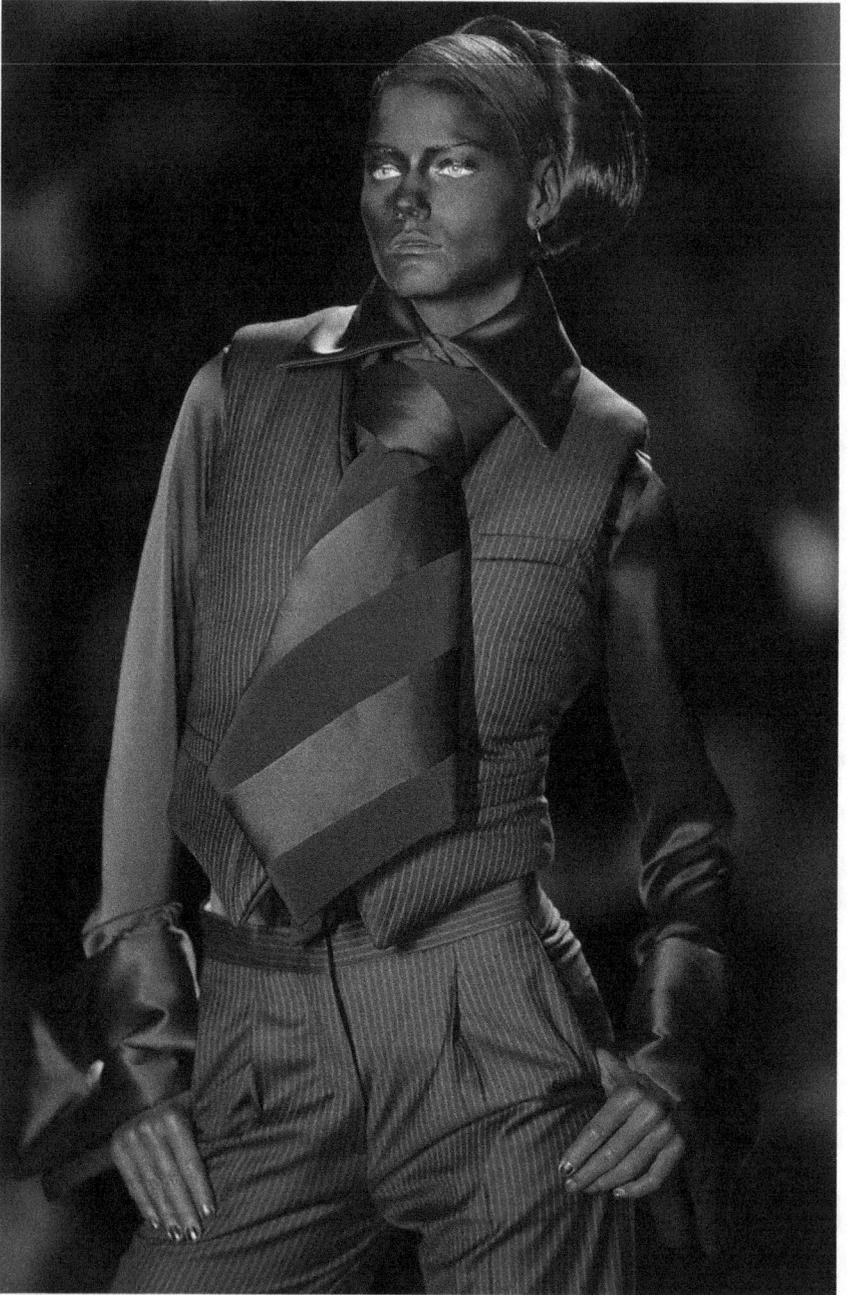

Plate 14 A model presents an ensemble for Dutch designers Viktor & Rolf March 10, 2001, in Paris during the Autumn/Winter 2001–2002 ready-to-wear collections. Photography Pierre Verdy.

Plate 15 Dutch designers Viktor & Rolf acknowledge the audience after their show in front of giant video screens on March 9, 2002, in Paris during the Autumn/Winter 2002–2003 ready-to-wear collections. Photography Pierre Verdy.

Plate 16 Viktor Horsting, a model and Rolf Snoeren pose on the runway during the Viktor & Rolf show as part of Paris Fashion Week Haute Couture Autumn/Winter 2015–2016 on July 8, 2015, in Paris, France. Photography Pascal le Sagretain.

Plate 17 Models present creations by Rad Hourani during the Haute Couture Spring/Summer 2014 collection show, on January 22, 2014, in Paris. Photography Patrick Kovarik.

Plate 18 Rick Owens, Spring/Summer 2014 fashion show during Paris Fashion Week on September 26, 2013, in Paris, France. Photography Catwalking.

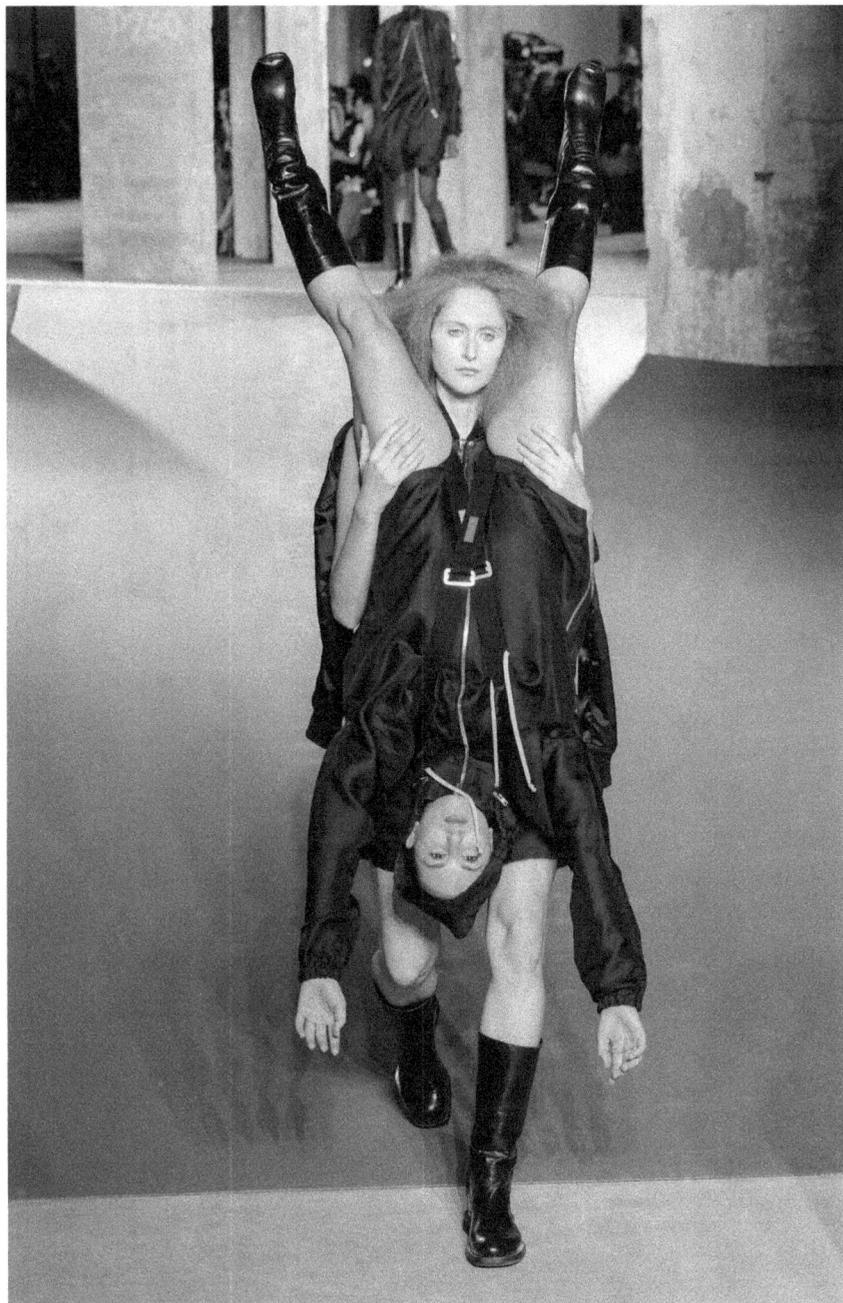

Plate 19 A model walks the runway at Rick Owens's Spring/Summer 2016 fashion show during Paris Fashion Week on October 1, 2015, in Paris, France. Photography Catwalking.

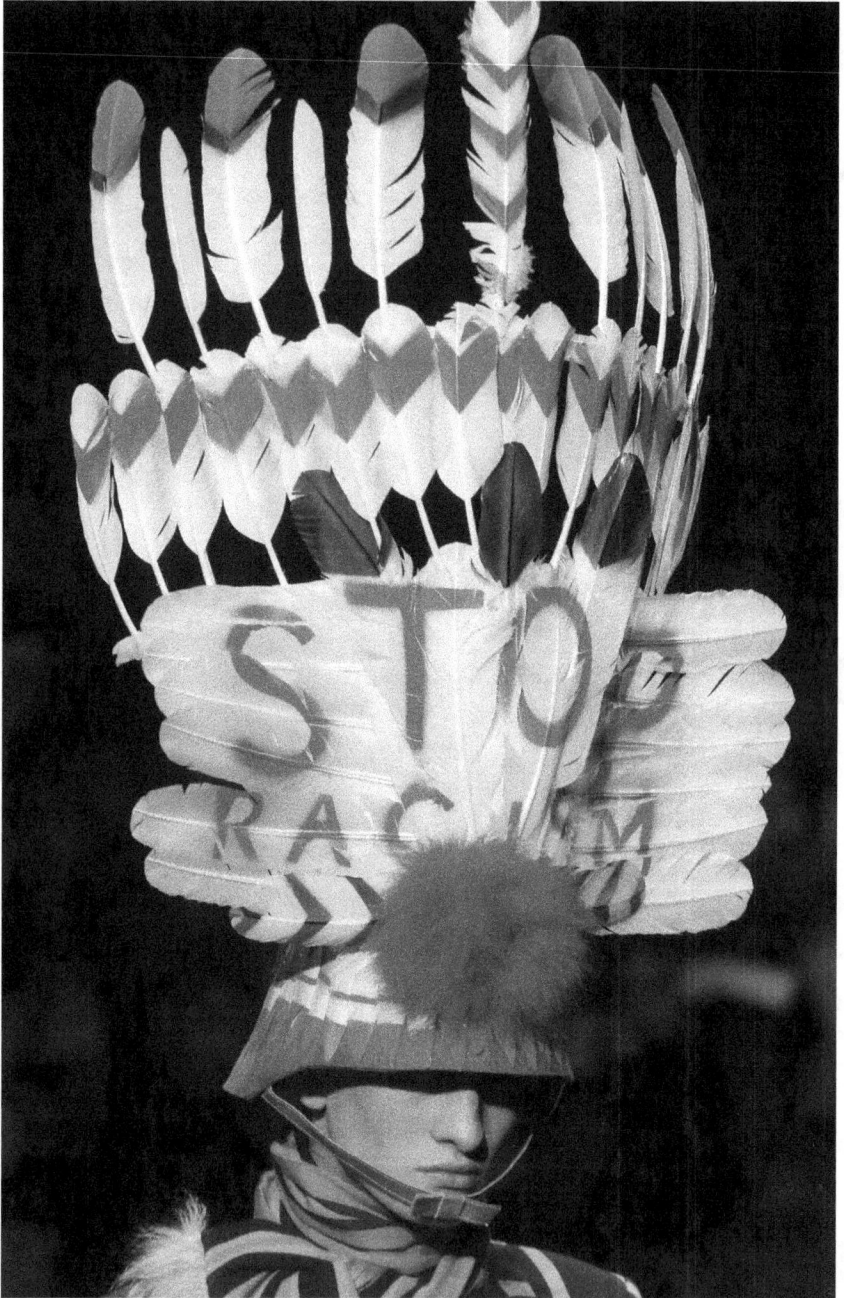

Plate 20 Walter van Beirendonck menswear, Autumn/Winter 2014. Paris Fashion Week. Photography Francois Guillot.

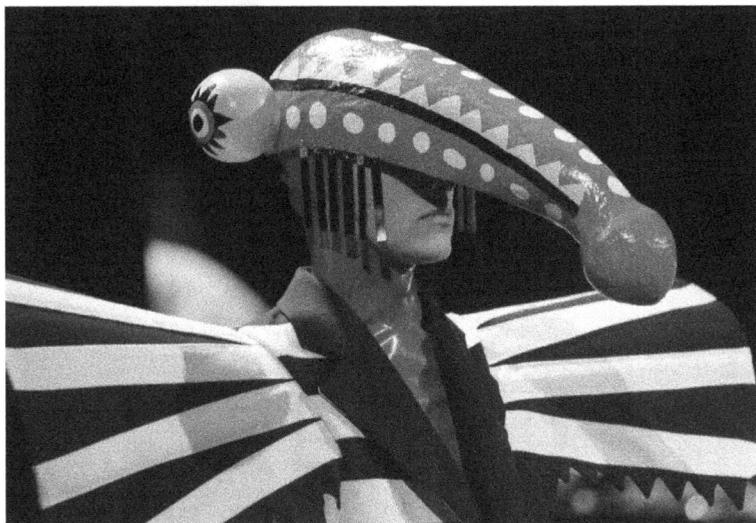

Plate 21 Walter van Beirendonck, Spring/Summer 2008 ready-to-wear collection, Paris, France. Photography Francois Guillot.

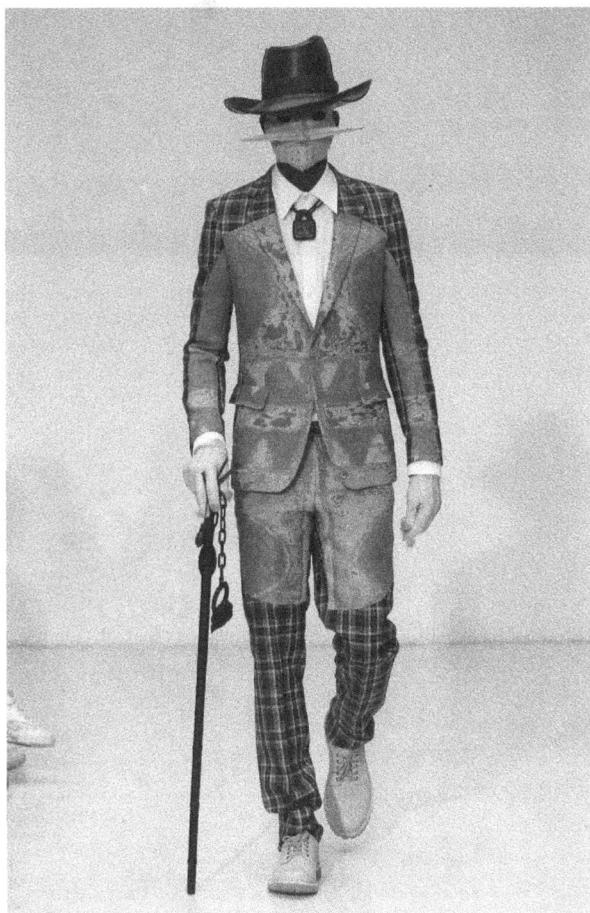

Plate 22 "Lust Never Sleeps" menswear (Autumn/Winter 2012), Paris Fashion Week at Espace Commines, January 28, 2012. Photography Antonio de Moraes Barros Filho.

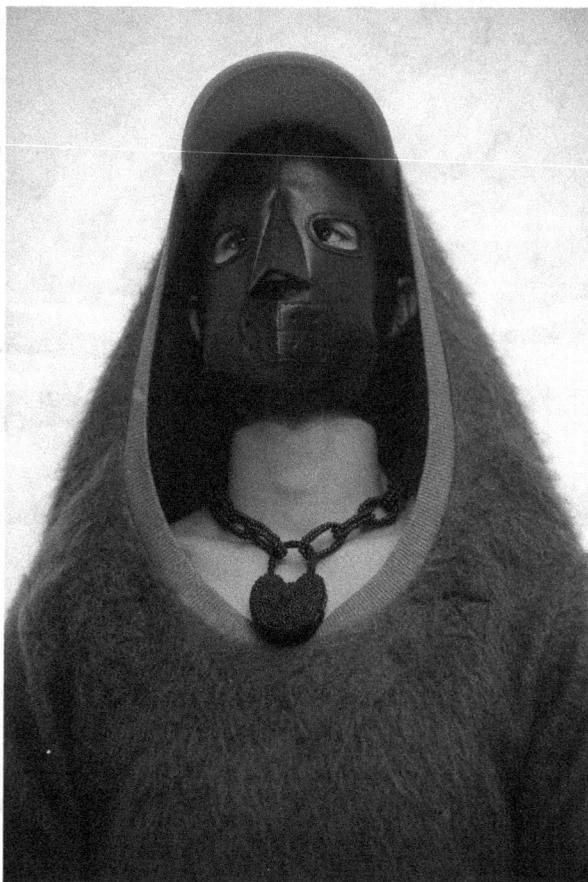

Plate 23 "Lust Never Sleeps" menswear (Autumn/Winter 2012), Paris Fashion Week at Espace Commines, January 28, 2012. Photography Antoine Antoniol.

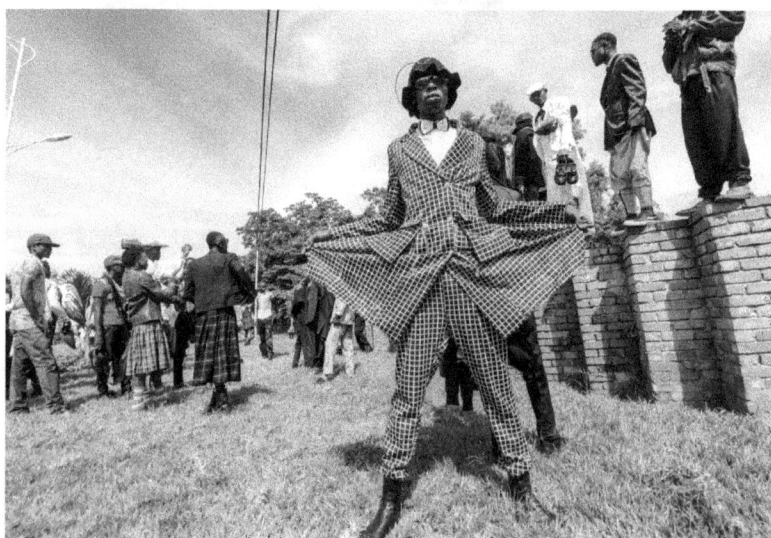

Plate 24 Sapeur members of "La Sape" movement, the acronym for *Société des Ambianceurs et des Personnes Élegantes* take part in a tribute to the founder of the movement Stervos Niarcos Ngashie, on February 10, 2014, at the Gombe Cemetery in Kinshasa. Credit AFP.